MW00999353

FINAL FANTASY.

ULTIMANIA ARCHIVE

I II III IV V VI
VOLUME 1

"The time for their journey had come.
The time to cast off the veil of darkness and
bring the world once more into the light . . . "

"Your Highness,
please allow us to join
the rebel forces!"

"No! You can't ask us to . . .
Doga, Unei . . .
We can't fight you!"

"Stay back. This is a fight for
me and me alone. My
atonement for all the sins
I've wrought—my test. And
one I do not mean to fail!"

"Exdeath!
No way we'll let you
get away with this!"

"I'll fight! I'll make this world
a place where life can flourish,
and children can grow up in peace!"

"Even as you die again and again,
I shall return!"

"This world can have
but one emperor, and
I am he!"

"With the flood of darkness,
we will bring the Void to
this world, and to your
world of light as well . . ."

"So, you are Cecil. Allow me to
give you something—a gift, to
remember our meeting by."

"Finally, it is in my grasp!
The greatest power known
to man . . . the power to
control the universe! The
power of the Void!"

"Life . . . Dreams . . . Hope . . .
Where do they come from? And where do they
go . . . ? Such meaningless things . . .
I'll destroy them all!"

FINAL FANTASY

ULTIMANIA ARCHIVE

I II III IV V VI

VOLUME 1

FINAL FANTASY ULTIMANIA ARCHIVE VOLUME 1

CONTENTS

✛ This book abbreviates "*Final Fantasy*" as "*FF.*"

✛ Titles within each game's data pages without a designated seller are sold by Square Enix (named "Square" prior to March 31, 2003).

✛ Character quotes are based on dialogue from the original versions of each title, but may have been revised for easier reading.

✛ This book uses the following abbreviations for video game consoles:

FCFamicom
SFC..........Super Famicom
NESNintendo Entertainment System
SNES.......Super Nintendo Entertainment System
GBAGame Boy Advance
DS...........Nintendo DS
PSPlayStation
PS3..........PlayStation 3
PSP..........PlayStation Portable
PSV..........PlayStation Vita
WSCWonderSwan Color

✛ The handwritten text in some images has been replaced with typeset translations, and may appear to differ from that seen in original sketches.

✛ Text in in-game screenshots uses translations from the most recent versions available at the time of printing. As a result, the dialogue, statistics, and names of characters, locations, items, etc. may differ from those found in the original English versions of the video games.

✛ Some of the games in this book are not currently available for purchase.

FINAL FANTASY

I

FINAL FANTASY

IV

FINAL FANTASY II

FINAL FANTASY III

FINAL FANTASY V

FINAL FANTASY VI

CREATORS' VOICES

USA Logo (NES 1990) | FINAL FANTASY™

FC Version: Final Fantasy I & II (Japan)

ファイナルファンタジーI・II
FINAL FANTASY
I・II™

WSC Version

PS/Mobile Version

PS Version: Final Fantasy I & II

GBA Version: Final Fantasy I & II

PSP/Smartphone Version

The revolutionary work that opened up a new frontier in role-playing games

The celebrated starting point of the *Final Fantasy* series. Warriors of light embark on an adventure to restore brilliance to the four crystals. A dramatically unfolding story, side-view battles showing character movement, and a job system with upgradable classes created a new evolution of RPGs on the Famicom and the Nintendo Entertainment System.

Famicom/NES	MSX2	Famicom	WonderSwan Color	WonderSwan Color (Console Bundle)

Final Fantasy

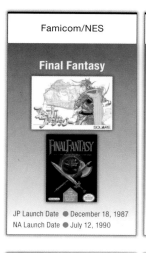

JP Launch Date ● December 18, 1987
NA Launch Date ● July 12, 1990

Final Fantasy

Seller ● Microcabin
Launch Date ● December 22, 1989

Final Fantasy I • II

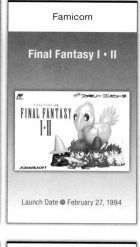

Launch Date ● February 27, 1994

Final Fantasy

Launch Date ● December 9, 2000

Final Fantasy WonderSwan Color Limited Edition Set

Seller ● Bandai
Launch Date ● December 9, 2000

PlayStation	PlayStation (Limited Edition)	i-mode	Game Boy Advance	EZweb Mobile Phone Service

Final Fantasy

JP Launch Date ● October 31, 2002
NA Launch Date ● April 8, 2003

Final Fantasy I • II Premium Package

Launch Date ● October 31, 2002

Final Fantasy

Launch Date ● March 1, 2004

Final Fantasy I • II Advance

JP Launch Date ● July 29, 2004
NA Launch Date ● November 29, 2004

Final Fantasy

Launch Date ● August 19, 2004

Yahoo! Mobile	PlayStation Portable	Wii • Wii U (Virtual Console)	PlayStation 3/ PlayStation Portable/ PlayStation Vita (PS one Classics)	PlayStation Portable (Ultimate Hits)

Final Fantasy

Launch Date ● July 3, 2006

Final Fantasy

JP Launch Date ● April 19, 2007
NA Launch Date ● June 26, 2007

Final Fantasy (Famicom/NES Version)

JP Launch Date ● May 26, 2009
NA Launch Date ● October 5, 2009

Final Fantasy (PlayStation Version)

Launch Date ● June 24, 2009
�֎ Available on PS Vita from August 28, 2012

Final Fantasy

Launch Date ● July 30, 2009

iPod touch/iPhone/ iPad	PlayStation Portable/ PlayStation Vita (Digital Download)	Android	Windows Phone	PlayStation (Limited Edition)

Final Fantasy

Launch Date ● February 25, 2010

Final Fantasy (PlayStation Portable Version)

Launch Date ● February 22, 2011

Final Fantasy

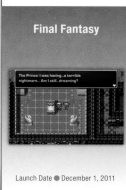

Launch Date ● December 1, 2011

Final Fantasy

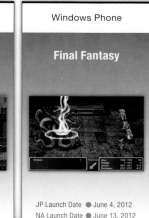

JP Launch Date ● June 4, 2012
NA Launch Date ● June 13, 2012

Final Fantasy 25th Anniversary Ultimate Box

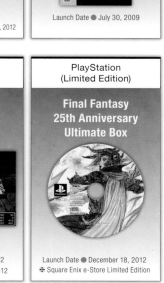

Launch Date ● December 18, 2012
✖ Square Enix e-Store Limited Edition

ART

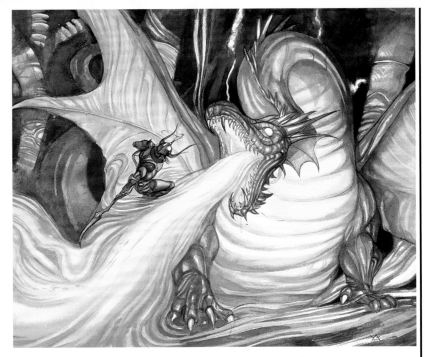

Battling the Dragon

Battling the Ochu

Battling the Kraken

The Cloudsea Djinn
Warriors of Light in combat with the Fiend

Uncharted Lands

Flying Fortress

Battling the Behemoth

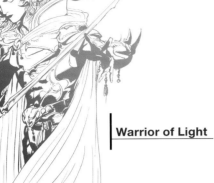

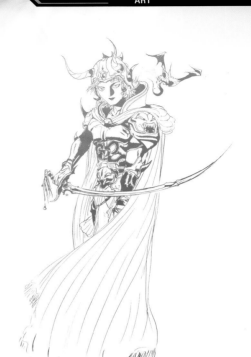

Warrior of Light

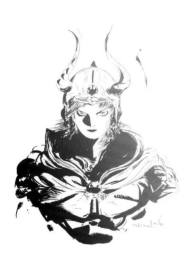

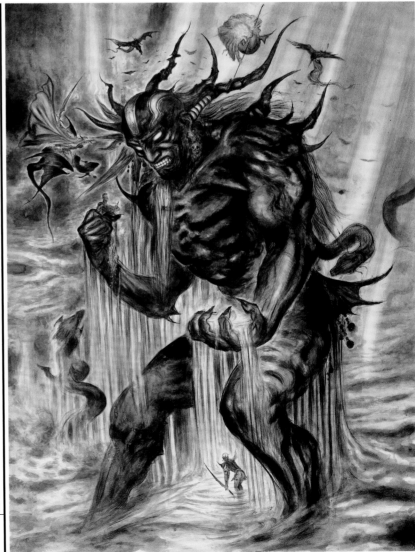

Warriors of Light in combat with the Fiend

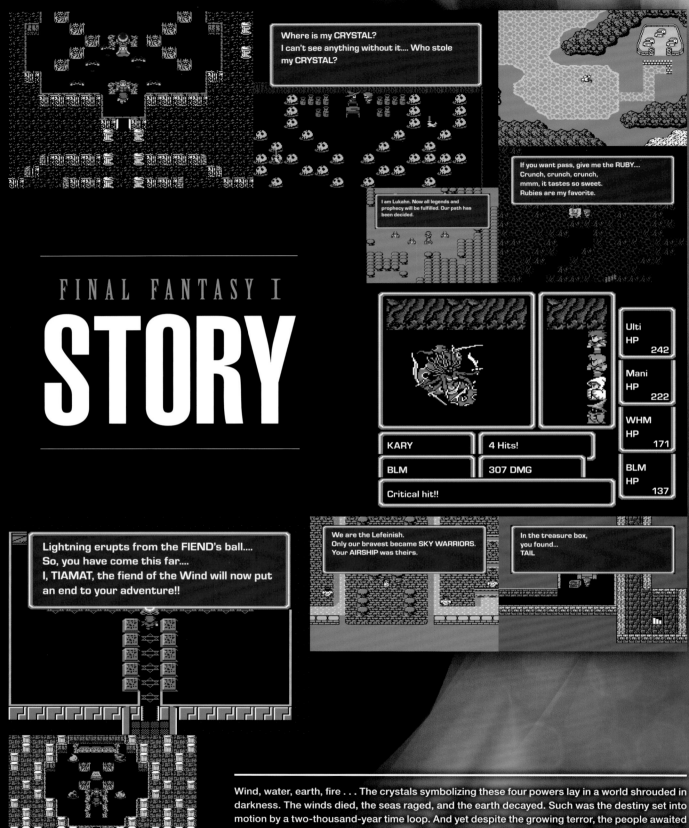

Where is my CRYSTAL?
I can't see anything without it.... Who stole
my CRYSTAL?

If you want pass, give me the RUBY....
Crunch, crunch, crunch,
mmm, it tastes so sweet.
Rubies are my favorite.

I am Lukahn. Now all legends and
prophecy will be fulfilled. Our path has
been decided.

FINAL FANTASY I
STORY

		Ulti HP 242
KARY	4 Hits!	Mani HP 222
BLM	307 DMG	WHM HP 171
Critical hit!!		BLM HP 137

Lightning erupts from the FIEND's ball....
So, you have come this far....
I, TIAMAT, the fiend of the Wind will now put
an end to your adventure!!

We are the Lefeinish.
Only our bravest became SKY WARRIORS.
Your AIRSHIP was theirs.

In the treasure box,
you found...
TAIL

Wind, water, earth, fire . . . The crystals symbolizing these four powers lay in a world shrouded in darkness. The winds died, the seas raged, and the earth decayed. Such was the destiny set into motion by a two-thousand-year time loop. And yet despite the growing terror, the people awaited the fulfillment of a single prophecy . . . "When darkness veils the world, four Warriors of Light shall come." The people held out hope for the arrival of these beings.

And soon, four young travelers arrived in the land of Cornelia at the end of a long journey. The Warriors of Light, legendary heroes guided by the four powers to restore the crystals. Without knowing their origins, the youths threw themselves into an adventure against darkness, just as the prophecy foretold.

On their journey, the warriors discovered not only the truth of the four powers, but the hidden source of the darkness that covered the land. The heart of a man changed into the personification of hatred had closed the world within a time loop. The Warriors of Light crossed time and space to stand against that hatred. They vowed to restore the power of the crystals and save the world.

CHARACTERS I

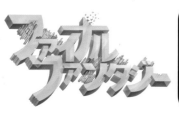

✥ Images are from the PSP version

FOUR FIENDS

LICH

MARILITH

TIAMAT

KRAKEN

VAMPIRE

COMMANDS

LUFENIA

LUFENIANS

RESEARCHES
LUFENIAN LANGUAGE

BUILT

ROBOTS

400
YEARS AGO
DECIMATED

STOLE THE
OCEAN'S LIGHT

MERMAIDS

STOLE THE OCEAN'S LIGHT
INTO THE FUTURE

DR. UNNE

BAHAMUT

DEFEATS

DEFEATS

TEACHES LUFENIAN
LANGUAGE

BATS
(LUFENIAN WARRIORS)

CURSES

SENDS POWER TO THE PAST
TO RESURRECT

SEEKS OUT

OFFERS CLASS
UPGRADES

WARRIORS OF LIGHT

OPPOSES

DEFEATS

GARLAND (CHAOS)

ENTRUSTS WITH
SAVING THE WORLD

SAVES

AWAKENS

PRINCE OF ELFHEIM

CURSES INTO SLUMBER

ASTOS

STEALS CRYSTAL EYE

MATOYA

KING OF CORNELIA

MARRIED

QUEEN JAYNE

FAMILY

SIBLINGS

SARAH'S SISTER

PRINCESS SARAH

KIDNAPS OUT OF UNREQUITED LOVE

**CIRCLE OF
SAGES**

LUKAHN

PROPHESIES THE COMING OF THE
WARRIORS OF LIGHT

CORNELIA

Warrior of Light

Warrior of prophecy
guided by the crystals.

光の戦士 [Hikari no Senshi]

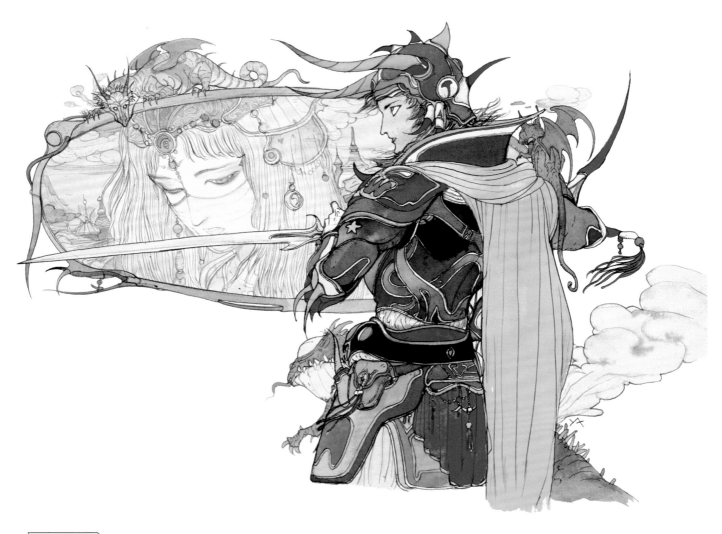

► **Job Sprites**

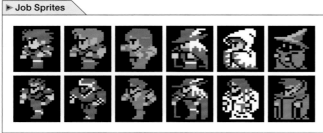

First row: Warrior, Thief, Monk, Red Mage, White Mage, Black Mage
Second row: Knight, Ninja, Master, Red Wizard, White Wizard, Black Wizard

Four youths are foretold to appear when the world is plunged into darkness. And appear they do, arriving in the land of Cornelia carrying crystals once gleaming with light. Upon saving Princess Sarah of Cornelia from the evil clutches of Garland, the warriors set out on a journey to restore light to the crystals and return peace to the world.

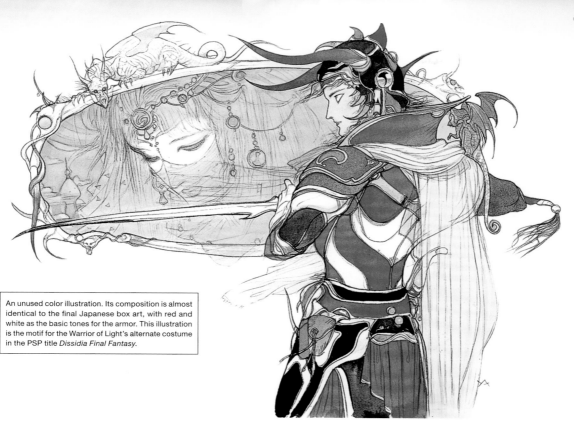

An unused color illustration. Its composition is almost identical to the final Japanese box art, with red and white as the basic tones for the armor. This illustration is the motif for the Warrior of Light's alternate costume in the PSP title *Dissidia Final Fantasy*.

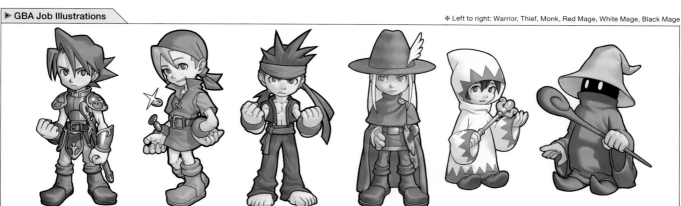

▶ GBA Job Illustrations

✦ Left to right: Warrior, Thief, Monk, Red Mage, White Mage, Black Mage

A Token of Valor: Class Changes

The player receives upgrades by overcoming the trial put forth by Bahamut, the King of Dragons. Jobs reach a higher rank, and each one takes on a more heroic appearance.

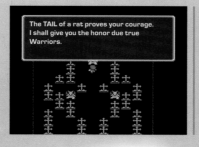

The TAIL of a rat proves your courage. I shall give you the honor due true Warriors.

So, you are the LIGHT WARRIORS! Thank you.

▶ WARRIOR OF LIGHT

Memorable **Scenes**

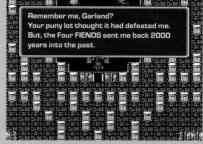

Remember me, Garland? Your puny lot thought it had defeated me. But, the Four FIENDS sent me back 2000 years into the past.

Rescue from the Fallen Knight

The warriors battle with Princess Sarah's kidnapper, Garland, at the request of the king of Cornelia. They force the powerful foe to yield, and bravely rescue the princess.

Traveling Two Thousand Years

The Warriors of Light travel into the past to confront the one who engulfed the world in darkness. Who awaits them there but Garland, a man they had defeated once before.

Princess Sarah

セーラ [Sēra/Sarah]

The kindhearted princess beloved by the people of Cornelia. She is saved from her abduction at the hands of Garland by the prophesied Warriors of Light. As the warriors set out on their journey, she entrusts them with a lute passed down for generations within the royal family.

Memorable **Quote**

"Together with me here . . . no, it's nothing."

—In the Cornelia region, to the Warriors of Light
as they prepare to depart.

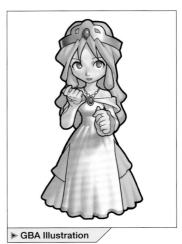

▶ GBA Illustration

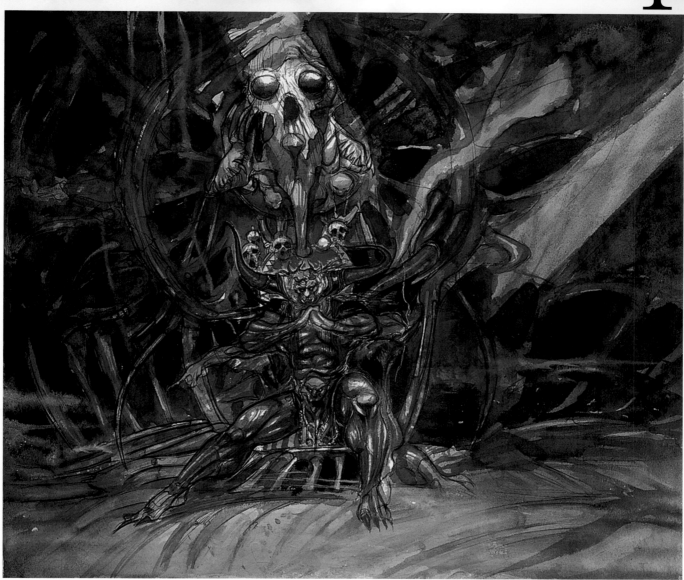

Garland (Chaos)

ガーランド（カオス）[Garando (Kaosu)]

A knight that spirits Princess Sarah away to the Chaos Shrine. Once a proud, noble knight of Cornelia, a trivial encounter led to a drastic change in him. When defeated by the Warriors of Light he travels two thousand years into the past, where he is resurrected as Chaos. He schemes to live forever by stealing the powers of earth, fire, water, and wind.

Memorable **Quote**

"I will live forever, and you shall meet your doom!"

—In the Chaos Shrine of the past, declared upon appearing again before the Warriors of Light.

▶ GBA Illustration (Garland)

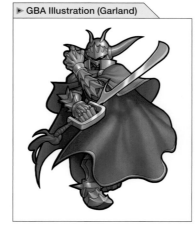

WORLD

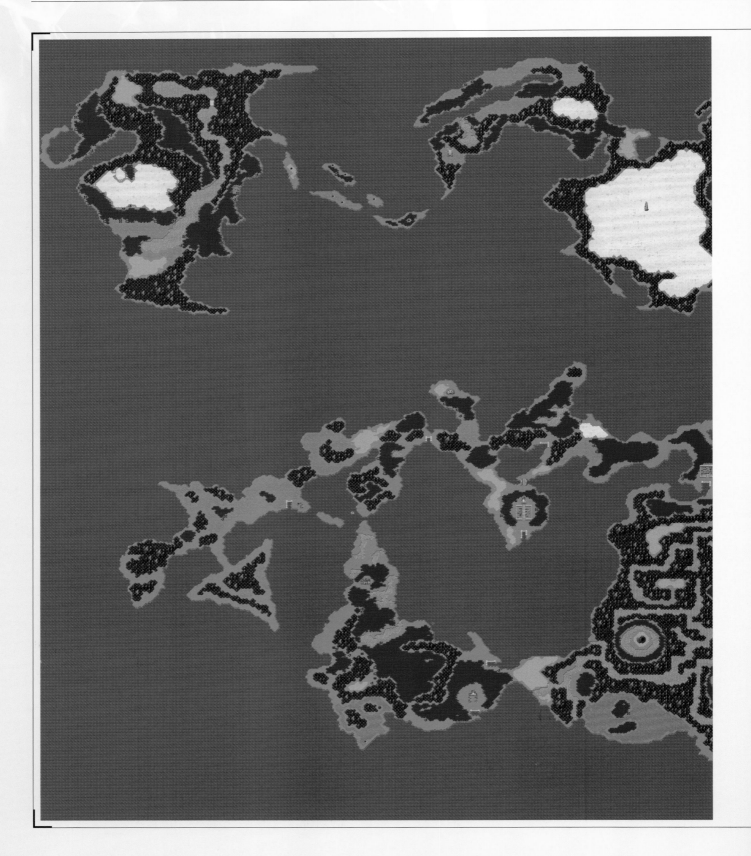

A land of three continents in the northwest, northeast, and south. The southern continent is separated from east to west by the Aldean Sea, so you can consider this world divided into four regions. In each region, various civilizations flourished using the power of their crystal.

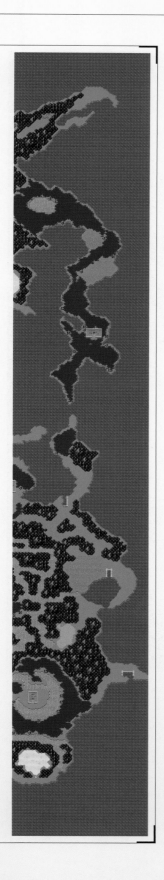

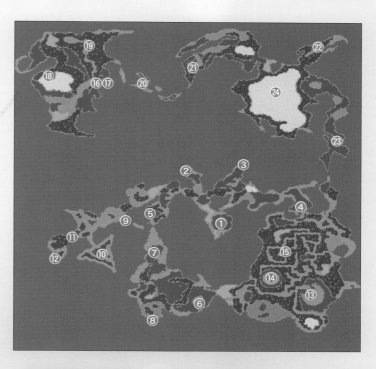

1. Cornelia
2. Chaos Shrine (※ 1)
3. Matoya's Cave
4. Pravoka
5. Mount Duergar
6. Elfheim
7. Western Keep
8. Marsh Cave
9. Melmond
10. Cavern of Earth
11. Giant's Cave (※ 2)
12. Sage's Cave
13. Crescent Lake
14. Mount Gulg
15. Cavern of Ice
16. Onrac
17. Sunken Shrine
18. Caravan
19. Waterfall Cavern
20. Cardia Islands
21. Citadel of Trials
22. Summit Town (※ 3)
23. Lufenia
24. Mirage Tower

※ 1 Also known as "Temple of Chaos"
※ 2 Also known as "Titan's Tunnel"
※ 3 Also known as "Gaia"

MONSTERS

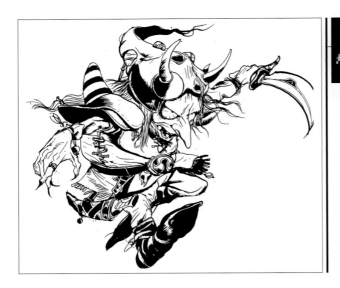

Goblin

ゴブリン [Goburin]

Crazy Horse

クレイジーホース [Kureijīhōsu]

Skeleton

スケルトン [Sukeruton]

Gigas Worm

ギガースウォーム [Gigāsuu~ōmu]

Black Widow ブラックウィドウ [Burakkū~idō]

Zombie
ゾンビ [Zonbi]

Anaconda
コブラ [Kobura]

Lizard
リザード [Rizādo]

Shark
シャーク [Shāku]

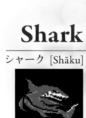

Sahagin
サハギン [Sahagin]

Scorpion
サソリ [Sasori]

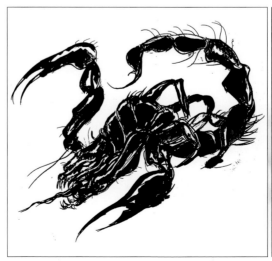

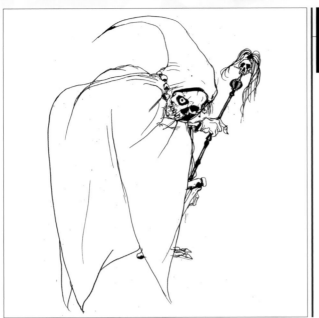

Shadow

シャドウ [Shadō]

Gargoyle

ガーゴイル [Gāgoiru]

Piscodemon

ピスコディーモン [Pisukodīmon]

Astos

アストス [Asutosu]

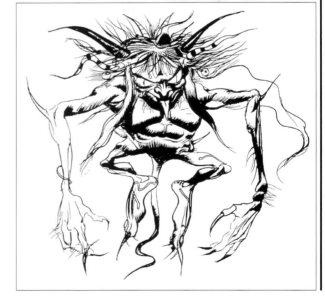

Mummy

マミー [Mamī]

Memorable **Feature**

At Death's Door

The first excruciating boss battle in the adventure is Astos of the Western Keep. His Black Magic spell Death can instantly kill any member of the party, throwing the heroes into a dire crisis.

Heynadon
ハイエナドン [Haienadon]

Lesser Tiger
キティタイガー [Kititaigā]

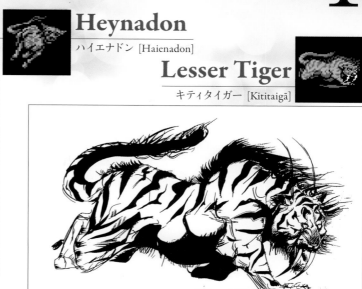

Minotaur
ミノタウロス [Minotaurosu]

Hill Gigas
ヒルギガース [Hirugigāsu]

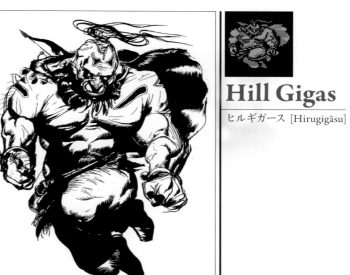

Ochre Jelly
オーカーゼリー [Ōkāzerī]

Troll トロル [Tororu]

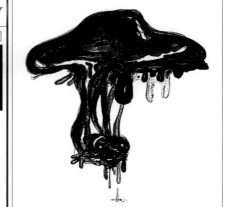

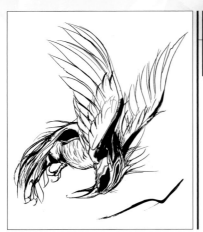

Cockatrice

コカトリス [Kokatorisu]

Crocodile

クロコダイル
[Kurokodairu]

Sphinx
スフィンクス [Sufinkusu]

Memorable **Feature**

Petrified with Fear

Not only do Cockatrices appear in groups, but their normal attack has the ability to petrify the target, turning them to stone. The original game lacked a way to undo petrification during battle, causing many players to face a serious challenge.

Ochu

オチュー [Ochū]

Hydra

ヒドラ [Hidora]

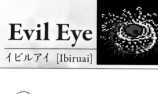

Evil Eye
イビルアイ [Ibiruai]

Red Dragon
レッドドラゴン [Reddodoragon]

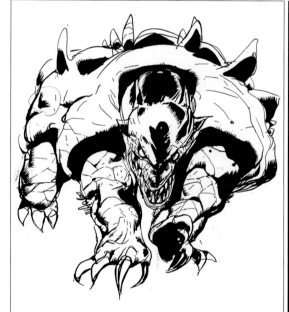

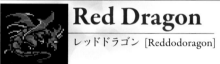

Allosaurus
アロザウルス [Arozaurusu]

Baretta
バレッテ [Barette]

Weretiger
ウェアタイガー [U~eataigā]

Medusa
メデューサ [Mede~yūsa]

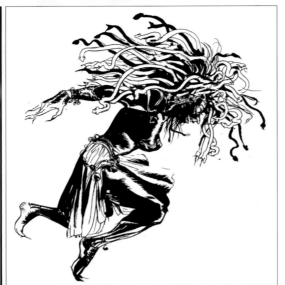

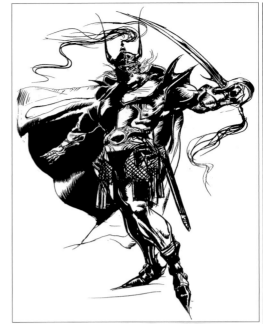

Water Naga
ウォーターナーガ [U~ōtānāga]

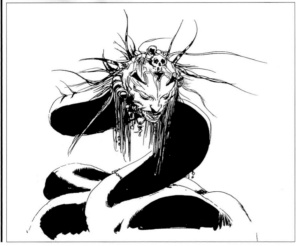

Black Knight
ブラックナイト [Burakkunaito]

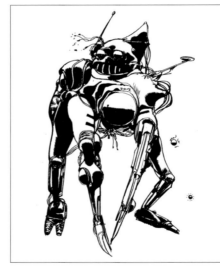

Guardian
ガーディアン [Gādian]

Chimera
キメラ [Kimera]

ストーンゴーレム [Sutongoremu] **Stone Golem**

Lich
リッチ [Ritchi]

Marilith
マリリス [Maririsu]

Kraken
クラーケン [Kuraken]

Tiamat
ティアマット [Tiamatto]

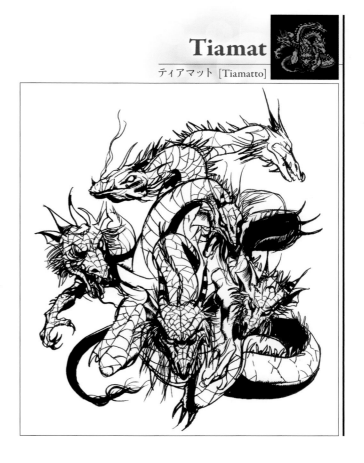

EXTRA CONTENT

SPRITE MATERIALS

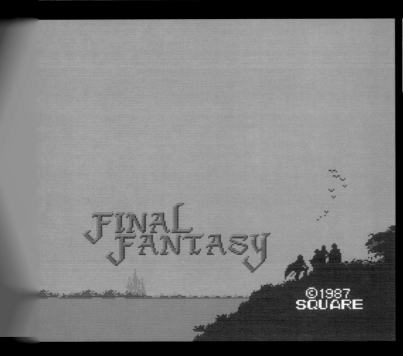

Opening Screen

Pixel art of the moment our heroes cross the drawbridge to the north of Cornelia, as envisioned by graphic designer Kazuko Shibuya. A message window is displayed in the wide-open portion on the upper left side.

Map Image

An image of Cornelia Castle's corridors crafted to fit the dimensions of the map. This room and hallway composition are just placeholders, but the walls, pillars, throne, and stairwells are the same design as the final product.

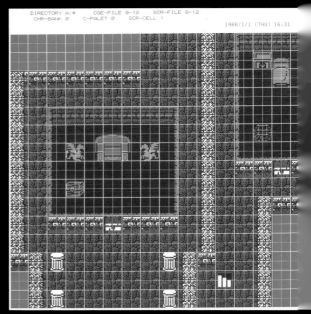

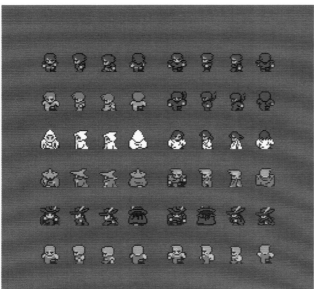

Field Sprites

Character sprites displayed when moving through the field. To save on memory, each job only has four sprites, with the left-facing sprites mirrored when the character moves to the right. A single sprite is mirrored vertically when going up or down, giving the appearance of moving arms and legs.

Sprite Data

In-game sprites are displayed by lining up 8x8-pixel blocks. The image below shows character sprites and other objects split up into their respective blocks. In-battle character sprites use three vertical and two horizontal blocks, while field sprites are displayed in a 2x2 block formation.

► Battle Blocks ①

DIRECTORY A:¥ CGE-FILE CHA-1
CHR-BANK 1 C-PALET 0
1987/10/17 (SAT) 11:26

► Battle Blocks ②

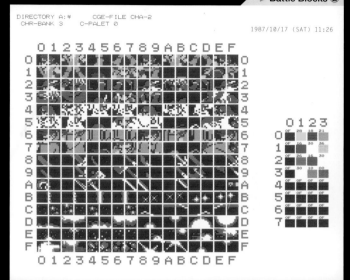

DIRECTORY A:¥ CGE-FILE CHA-2
CHR-BANK 3 C-PALET 0
1987/10/17 (SAT) 11:26

► Field Blocks

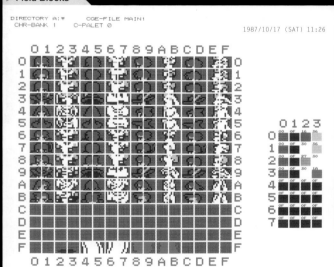

DIRECTORY A:¥ CGE-FILE MAIN1
CHR-BANK 1 C-PALET 0
1987/10/17 (SAT) 11:26

► Shopkeeps and Text

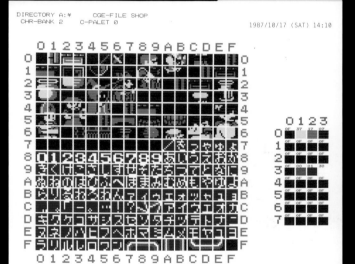

DIRECTORY A:¥ CGE-FILE SHOP
CHR-BANK 2 C-PALET 0
1987/10/17 (SAT) 14:10

► Map Emblem Blocks

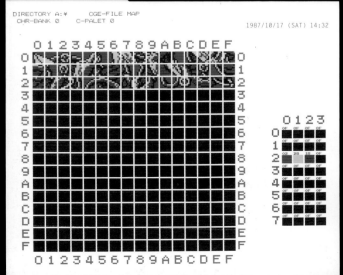

DIRECTORY A:¥ CGE-FILE MAP
CHR-BANK 0 C-PALET 0
1987/10/17 (SAT) 14:32

► Map Emblem

Emblems are displayed in the four corners of the world map when you open the screen by pressing the B button and Select. This emblem is quite large, composed of eight blocks vertically and six horizontally, enough to fit eight in-battle character sprites.

Categorized Map List

A list of locations the party travels to during the game, separated into categories like towns, ruins, and caves. The "Palette" column shows which color palette will be used for that part of the map. The Sunken Shrine and Mount Gulg change up their palettes midway, giving players an evolving atmosphere as they progress through the dungeons.

■ BG Data

	TOWN	CGE	Palette	Notes
01	Cornelia			
02	Pravoka			
03	Elfheim			
04	Melmond	TOWN	TOWN	
05	Crescent Lake			
06	Summit Town			
07	Onrac			
08	Lufenia			
09	Castle Cornelia 1F			
19	2F			
0A	Elven Castle			
0B	Gilmon's Castle	CASTLE	CASTLE	
0C	Citadel of Trials 1F			
1A	2F			
1B	3F			
0D	Chaos Shrine Ruins			
2B	Sunken Shrine 1F		RUINS	
2C	2F	RUINS		
2D	3F			
2E	4F		RUINS 2	
2F	5F		RUINS 3	
0E	Cavern of Earth B1			
1E	B2		DUNGEON 2	
1F	B3	DUNGEON		
20	B4		DUNGEON 3	
21	B5			

3D	Giant's Cave	DUNGEON	DUNGEON	
0F	Mount Gulg B1			
22	B2		DUNGEON 4	
23	B3	DUNGEON		
24	B4		DUNGEON 5	
25	B5			
10	Floating Fortress B1			
26	B2		CAVE 2	
27	B3			
11	Cardia Islands		CAVE 3	
12	King's Cave			
28	B2		CAVE 4	
13	Waterfall Cavern	CAVE	CAVE 5	
14	Mount Duergar		CAVE	
15	Matoya's Cave		CAVE 6	
16	Sage's Cave		CAVE 7	
17	Marsh Cave B1			
1C	B2		CAVE 8	
1D	B3		CAVE 9	
18	Mirage Tower 1F			
29	2F	TOWER	TOWER	
2A	3F		TOWER 2	
30	Flying Fortress 1F			
31	2F			
32	3F	BASE	BASE	
33	4F			
34	5F			

35	Past Chaos Shrine			
36	2F			
37	3F			
38	B1	SHRINE	SHRINE	
39	B2			
3A	B3			
3B	B4			
3C	B5			

■ MONSTER COLOR

Palette 1. 2

0	Goblin / Wolf	36 27 16	F	Earth Medusa / Ogre Chief	23 29 19
1	Goblin Guard / Warg Wolf / Lizard	36 22 13	10	Hyenadon / Ogre Mage	17 31 1C
2	Werewolf / Hill Gigas	25 29 18	11	Cobra / Minotaur	36 26 14
3	Fire Hydra / Fire Elemental / Fire Lizard / Fire Gigas	33 26 16	12	Anaconda / Troll	25 2B 19
4	Winter Wolf / Air Elemental / Ice Gigas	24 30 22	13	Sea Snake / Sea Scorpion / Water Elemental / Water Naga	30 2C 13
5	Basilisk	26 2B 19	14	Blue Dragon / Sea Troll	30 22 12
6	Gilmon	3A 16 1B	15	Scorpion / Ankheg	2B 26 16
7	Ghost / White Dragon / White Shark	30 31 22	16	Dragon Zombie / Zombie / Minotaur Zombie / Death Eye	16 2C 18
8	Sahagin Chief / Big Eye	37 26 16	17	Death Knight / Ghoul / Beholder	23 30 00
9	Sahagin / Shark / Deepeye	30 2B 1C	18	Wraith / Ghast	30 28 1C
A	Buccaneer	36 21 12	19	Specter / Wight / Lava Worm	30 2A 18
B	Sahagin Prince / Pirate	30 28 19	1A	Shadow / Black Widow / Gray Ooze / Sabertooth	32 1C 0C
C	Skeleton / Crawler / Remorazz	30 23 1B	1B	Purple Worm	37 23 13
D	Bloodbones / Gigas Worm / Hellhound / Red Dragon	37 25 16	1C	Earth Elemental / Sand Worm / Desert Baretta	16 37 18
E	Medusa / Ogre	38 26 14	1D	Weretiger / Manticore / Lesser Tiger	30 28 17

1E	Rakshasa	25 2B 19	32	Piscodemon / Crazy Horse	30 27 18
1F	Vampire / Gargoyle	30 12 16	33	Mindflayer / Nightmare	14 30 22
20	Vampire Lord / Horned Devil	37 16 13	34	Clay Golem	36 26 16
21	Green Slime / Tarantula / Green Dragon	30 28 1A	35	Stone Golem	36 10 00
22	Ogre Jelly / Baretta	36 26 16	36	Lich	16 3B 13 / 27 3B 13
23	Sphinx	30 37 1A	37	Marilith	16 14 30 / 16 14 28
24	Black Flan / Black Knight / Dark Wizard	30 32 1C	38	Kraken	27 30 23 / 3B 13 23
25	Mummy / Pyrolisk	30 26 16	39	Tiamat	16 3B 13 / 27 3B 13
26	King Mummy / Cockatrice	30 27 12	3A	Chaos	23 28 18 / 30 28 18
27	Wyrm	30 27 16			
28	Wyvern / Tyrannosaur	30 2C 1C			
29	Allosaurus	36 26 16			
2A	Piranha / Hydra	26 3C 1B			
2B	Crocodile / Ochu	25 2A 1A			
2C	Red Piranha / Neochu	1B 27 16			
2D	White Croc / Spirit Naga	37 32 00			
2E	Guardian / Dark Fighter / Iron Golem	37 10 1C			
2F	Soldier / Death Machine	30 26 00			
30	Chimera	17 38 18			
31	Gorgimera	13 37 1B			

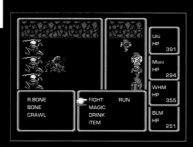

Monster Color Assignments

A table designating the color palettes used for each monster. Numbers like "36 27 16" are color designations, with a single monster composed of black and three other colors. A maximum of six colors besides black (two palettes' worth) can be used on monsters during battle. By sharing a single palette among a group of monsters, more than three types of enemies can appear onscreen in battle as in the picture above. Large bosses like the Lich and Chaos do not appear onscreen with other monsters, so their palettes contain six colors each.

Battle Background Sprites

There are sixteen total backgrounds displayed during battles. Besides black, each background only uses three colors to represent the atmosphere of their respective areas.

BATTLE BG

Palette 0

0	Plains	0C 17 07	8	Castle	30 10 00
1	Marsh	1C 2B 1B	9	River	31 29 10
2	Sea	30 3C 22	A	Tower/Space	37 10 00
3	Forest	18 0A 1C	B	Sunken Shrine	21 12 03
4	Shrine	3C 1C 0C	C	Flying Fortress	31 22 13
5	Desert	37 31 28	D	Mount Gulg	26 16 06
6	Swamp	27 17 1C	E	Waterfall Cavern	2B 10 0C
7	Cavern of Earth	1A 17 07	F	Marsh Cave	31 29 30

▶ Specs

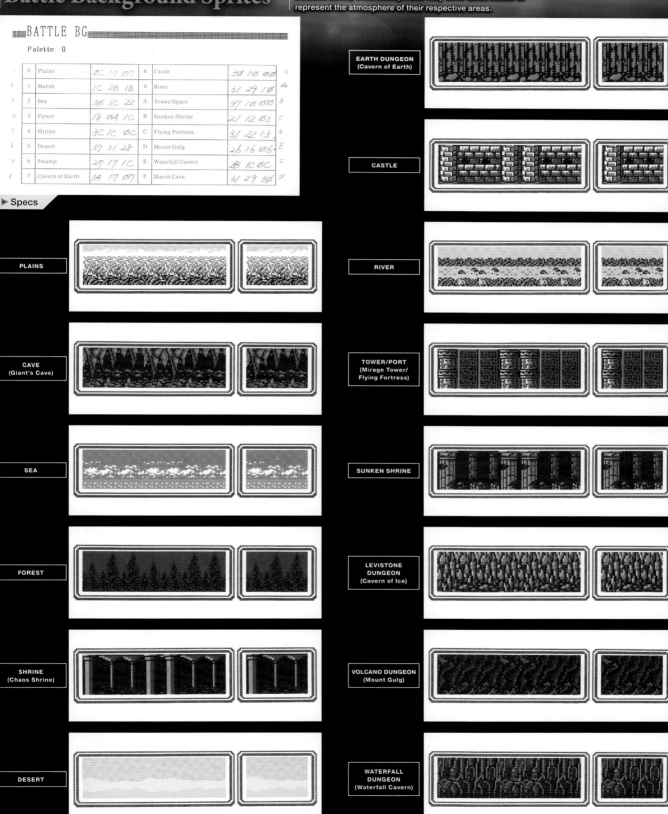

PLAINS

CAVE (Giant's Cave)

SEA

FOREST

SHRINE (Chaos Shrine)

DESERT

MARSH

EARTH DUNGEON (Cavern of Earth)

CASTLE

RIVER

TOWER/PORT (Mirage Tower/Flying Fortress)

SUNKEN SHRINE

LEVISTONE DUNGEON (Cavern of Ice)

VOLCANO DUNGEON (Mount Gulg)

WATERFALL DUNGEON (Waterfall Cavern)

MARSH DUNGEON (Marsh Cave)

BATTLE PLANNING

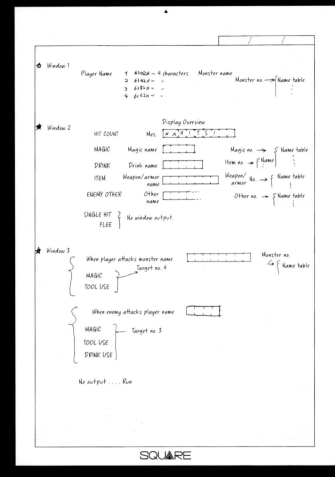

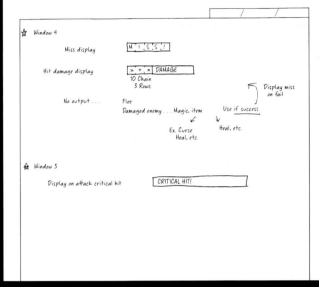

Battle Window Specifications

Documentation of the types and display order of windows that show messages during battle. In addition to message details, each window size is determined by considering the maximum character limits for item and spell names.

Weapon and Armor List

A list of weapons and armor created during development. Some of these armor names do not appear in-game, such as the Ray Gauntlets and Claire's Ribbon (just "Ribbon" in the actual game).

File Name = 'weapon.man' Tue Sep 08 13:50:51 1987 Page = 001/001

WEAPON-DATA

#	Name	Description
1	Nunchaku	Wooden nunchaku.
2	Knife	A small knife.
3	Staff	A wooden staff.
4	Rapier	A sword with a slender blade.
5	Hammer	A hammer made for battle.
6	Broadsword	Sword with a wide, double-edged blade.
7	Battle Axe	An axe made for battle.
8	Scimitar	A sword with a curved blade.
9	Iron Nunchaku	Nunchaku made of iron.
10	Dagger	A large knife.
11	Crosier	A staff topped with an iron ring.
12	Saber	A long sword made for piercing.
13	Longsword	A large, double-edged sword.
14	Great Axe	A large axe made for battle.
15	Falchion	A sword that widens toward its tip.
16	Mythril Knife	A knife wrought from mythril.
17	Mythril Sword	A sword wrought from mythril.
18	Mythril Hammer	A hammer wrought from mythril.
19	Mythril Axe	An axe wrought from mythril.
20	Flame Sword	A sword that dances with flame.
21	Ice Brand	A sword gripped by winter's chill.
22	Wyrmkiller	A sword effective against dragons.
23	Great Sword	A broadsword effective against giants.
24	Sun Blade	A sword of light effective against undead.
25	Coral Sword	A saber effective against aquatic foes.
26	Werebuster	A sword effective against werebeasts.
27	Rune Blade	A sword effective against spellcasters.
28	Power Staff	A staff with good attack power.
29	Light Axe	An axe that casts Diara when used.
30	Healing Staff	A staff that casts Heal when used.
31	Mage's Staff	A staff that casts Fira when used.
32	Defender	A sword that casts Blink when used.
33	Wizard's Staff	A staff that casts Confuse when used.
34	Sharp Sword	A falchion with a sharp blade.
35	Cat Claws	A weapon with razor-sharp blades.
36	Thor's Hammer	Hammer that casts Thundara when used.
37	Rey's Saber	A special saber.
38	Sasuke's Blade	A small katana used by a ninja.
39	Excalibur	Sword crafted from a legendary metal.
40	Masamune	A legendary katana without peer.

ARMOR-DATA

#	Name	Description
1	Clothes	Ordinary clothing.
2	Leather Armor	Armor made of hardened leather.
3	Chain Mail	Mail of interwoven chain links.
4	Iron Armor	Armor made of thinly hammered iron.
5	Knight's Armor	Armor crafted from steel plate.
6	Mythril Mail	Mail crafted from mythril.
7	Flame Mail	Mail infused with the power of fire, strong against cold.
8	Ice Armor	Armor infused with the power of ice, strong against heat.
9	Diamond Armor	Armor specially crafted from diamond.
10	Dragon Mail	Mail fashioned from dragon scales.
11	Copper Armlet	An armlet crafted from copper.
12	Silver Armlet	An armlet of worked silver.
13	Gold Armlet	An armlet of worked gold.
14	Ruby Armlet	An armlet ornamented with rubies.
15	Diamond Armlet	An armlet adorned with diamonds.
16	Wizard Clothing	Clothes that increase Black Magic power.
17	Leather Shield	A shield made of hardened leather.
18	Iron Shield	A shield wrought from iron.
19	Mythril Shield	A shield crafted from mythril.
20	Flame Shield	A shield alive with the power of fire.
21	Ice Shield	A shield alive with the power of ice.
22	Diamond Shield	A shield made of diamond.
23	Aegis Shield	A shield polished to a mirror that guards against stone.
24	Buckler	A small shield.
25	Protect Cloak	A large cloak worn over armor. Can no longer use shields.
26	Leather Cap	A cap made of leather.
27	Helm	A small helm.
28	Great Helm	A helm that covers the entire head.
29	Mythril Helm	A helm wrought from mythril.
30	Diamond Helm	A helm made of diamond.
31	Healing Helm	A helm that casts Heal when used.
32	Claire's Ribbon	Ribbon that wards off special attacks.
33	Leather Gloves	Gloves made of leather.
34	Bronze Gloves	Gloves made of bronze.
35	Steel Gloves	Gloves made of steel.
36	Mythril Gloves	Gloves made of mythril.
37	Ray Gauntlets	Completely refills HP.
38	Giant's Gloves	Gloves that cast Saber when used.
39	Diamond Gloves	Gloves made of diamond.
40	Protect Ring	Ring that guards against instant death.

```
-------------------------------------------------
                  MAGIC DATA
-------------------------------------------------
HITE MAGIC **********
: Restores a little HP to one ally.           P1 hpt
: Deals damage to all undead foes.            E  all hp-
: Raise one ally's defense.                   P1 absorb
: Free ally from sleep or paralysis.          P1 status change
: Prevents all foes from casting spells.      E  all status change
: Protect one ally from an Ice attack.        P1 inval status change
: Restores HP to one ally.                    P1 hpt
: Cures Silence.                              P1 status change
: Protect one ally from a Fire attack.        P1 inval status change
: Cures Poison.
: A stronger version of Dia; deals damage to all undead foes.
: Raises party's defense.
: Restores a lot of HP to one ally.
: Revives one KO'd ally.
: Protect against a Thunder attack.
: Cures Petrify.
: Transports party out of dungeons.
: Drives all foes away in terror.
: Restores a lot of HP to one ally.
: A stronger version of Diara; deals damage to all undead foes.
: Protect against magic.
: Revives one ally and fully restores HP.
: Damages all foes with holy light.
: Protect against all special attacks.            L    W   B

ACK MAGIC **********
: Fire a small arrow of flame.                    1    T1  T4
: Puts all foes to sleep.
: Lowers one foe's evasion, making them easier to hit.    T2  T5
: Deals lightning damage to one foe.                      T3  T6
: Blinds all foes with Darkness.
: Raises one ally's attack.
: Deals fire damage to one foe.
: Paralyzes one foe.
: Doubles one ally's number of attacks.
: Deals ice damage to one foe.
: Reduces all foes' number of attacks.
: Inflicts Confuse on all enemies.
: A stronger version of Thunder; deals lightning damage to all foes.
: Wrap an enemy in a poison cloud.
: Transports party far distances.
: A stronger version of Fire; deals fire damage to all foes.
: Instantly kills one foe.
: Calls an earthquake to swallow foes.
: Stronger version of Blizzard; deals ice damage to all foes.
: Petrifies one foe.
: Raises Caster's attack and accuracy.
: An atomic blast of incredible light and heat.    BL 5 shop
: Stops time and paralyzes all foes.
: Banishes foes to another dimension.              5 type
```

```
***************** Possible Magic Primers *****************

Colors :  Orange   (one ally)
          Red      (all allies)
          Purple   (self)
          Blue     (one enemy)
          Green    (all enemies)

    All magic in this world is split into two schools: Black Magic and White Magic.
    White Magic uses the spirit slumbering in all humans as its source of power. Whether healing wounds
or repelling evil, this magic is about bringing peace and happiness to all.
    Black Magic takes control of the four basic elements that make up the natural world, manipulating them
to the Caster's own ends as spells.
    Black Magic is powerful, but very few can actually wield it. They are overwhelmed by its power and are
destroyed by it before they can master it.
    Both schools have basic and master-class spells in their arsenal. Still, it is said that none have been able
to master the entire spectrum of magic.
```

Early Development Magic List

A document from the early stages of development listing White and Black Magic spells. Each level seen here has three magic spells, but that number increased to four in the actual game. The final in-game spell names and levels also vary greatly from those in this list.

Magic Settings

A list of detailed settings and effects for magic. Each spell is implemented into the game with thoughtful details like these.

1 . 1	Cure	: (one ally)	Adventurers take lots of damage in battle. Resting at an inn will heal most injuries, but that can't be done on the road. In such cases, you can use magic to briefly increase a living being's natural recovery power to quickly heal HP. (Heals 16–32 HP)
2	Dia	: (all enemies)	Undead monsters like skeletons and zombies consider magic users that respect their hated enemies. Good-natured White Mages will, in turn, cast this magic against the undead without hesitation. (Does 20–80 damage against the undead)
3	Protect	: (one ally)	This magic wraps the body in a thin, transparent film. This film will blunt sharp attacks from enemy weapons, claws, and fangs. (Raises defense by 8 points)
4	Blink	: (self)	This magic creates mirror images of your body, making it easier for enemy weapons and claws to miss. (Raises evasion by 80)
5	Fire	: (one enemy)	The most basic of all fire-wielding spells, it throws a small fireball at one enemy. (Does 10–40 damage)
6	Sleep	: (all enemies)	Magic that manipulates an enemy's spirit to put them to sleep. Won't work against undead monsters, since they have no souls. (Has a chance to put each enemy target to sleep)
7	Focus	: (one enemy)	Monsters love dark places. This magic makes a clear outline around the enemy, making them easier to hit. (Lowers an enemy's Evasion by 10)
8	Thunder	: (one enemy)	The same type of magic as Fire, one that manipulates lightning. A small bolt erupts from the palms at the enemy. (10–40 damage)
2 . 1	Blindna	: (one ally)	In ancient times, Sages would save those who only knew darkness with the touch of their hand using this method. (Cures Blind)
2	Silence	: (all enemies)	In magic school, those who cast spells without good reason have this spell cast on them as punishment. Until the spell wears off, they are unable to speak. (Prevents all foes from casting spells)
3	Bathunder	: (all allies)	Usually getting hit by lightning is no laughing matter, but this protective magic is sure to save your life. (Cuts thunder damage by 25–50%)
4	Invisible	: (one ally)	Many creatures in the natural world possess camouflage to protect themselves from predators. In the same way this magic blends you into the surroundings to avoid attacks. (Raises evasion by 20%)
5	Blizzard	: (one enemy)	The weakest among ice-wielding magics, but has a greater effect than Fire and Thunder in the same tier. Magic that saps power from enemies with blistering cold winds. (Does 20–80 ice elemental damage)
6	Dark	: (all enemies)	Spells that harm living creatures are not rare in the realm of Black Magic. This vicious magic is no different, wrapping enemies in darkness and robbing them of their sight. (Inflicts Blind)
7	Temper	: (one ally)	This magic wraps a weapon in an aura that increases its sharpness, letting you cut even sturdy armor like butter. (Raises ally's attack by 14)
8	Stop	: (all enemies)	Multilimbed or quick foes can get in many attacks at a time. This magic slows their movements and reduces their hit counts. (Stops time and paralyzes all foes)

3 . 1	Cura	: (one ally)	Healing magic stronger than Cure. (Heals 33–66 HP)
2	Diara	: (one enemy)	Magic stronger than Dia. This type of magic bombards enemies with life energy, which damages the undead. (Does 40–160 damage to undead enemies)
3	Bafire	: (all allies)	Same type of magic as Bathunder, protecting the body from roaring flames. (Reduces fire damage by 25–50%)
4	Heal	: (all allies)	Restores a little HP to entire party. (Recovers 12–24 HP)
5	Fira	: (all enemies)	Magic stronger than Fira, but it will not work underwater. (Does 30–120 damage)
6	Hold	: (one enemy)	Magic that manipulates an enemy's spirit to paralyze them. Like Sleep, it doesn't work on some monsters. (Paralyzes one foe)
7	Thundara	: (all enemies)	Magic stronger than Thunder. It is said that this lightning magic works even better underwater. (Does 30–120 damage)
8	Focara	: (all enemies)	Magic stronger than Focus. (Lowers evasion of all foes by 10)
4 . 1	Poisona	: (one ally)	Some snakes and spiders are venomous creatures. Poison courses through the body before killing their victims, but this magic cleanses blood tainted by their venom. (Cures Poison)
2	Fear	: (all enemies)	There are some monsters that should be wiped off the face of the planet, but many White Mages like to avoid pointless killing. This magic strikes fear into the hearts of enemies, causing them to run away. (Forces enemies to leave battle)
3	Bacold	: (all allies)	Same type of magic as Bathunder, protecting the body from fearsome cold. (Reduces ice damage by 25–50%)
4	Vox	: (one ally)	Some nasty foes will use Silence, robbing ally mages of their voices. When that happens, this magic will restore them back to normal. (Cures Silence)
5	Sleepra	: (one enemy)	Magic stronger than Sleep. Even enemies unaffected by Sleep will succumb to this upgraded spell. (Puts one foe to sleep)
6	Haste	: (one ally)	There is a limit to how fast living beings can move, but this spell removes that limit and lets them move twice as quickly. Also returns allies afflicted with Slow to normal. (Doubles one ally's number of attacks)
7	Confuse	: (all enemies)	Full moons are said to have an adverse effect on the mind. This spell increases the effect to the point of confounding foes into fighting each other. (Causes foes to turn on each other)
8	Blizzara	: (all enemies)	Magic stronger than Blizzard, though some enemies still have a natural resistance to the cold. (Does 40–160 ice elemental damage)

5 . 1	Curaga	: (one ally)	Healing magic stronger than Cura (Heals 64–128 HP)
2	Life	: (one ally)	Even if a living creature appears to have died, an iota of life energy remains in their bodies. This energy that vanishes on its own imbues the body with magic power. That's why this magic appears to revive the target. Can't be used in battle, as it requires a fair bit of concentration. (Revives one KO'd ally with 1 HP)
3	Diaga	: (all enemies)	Magic stronger than Adia. Skeletons, zombies, ghouls, and shadows are inferior undead and harmed by this spell. (Does 60–240 damage to undead)
4	Healara	: (all allies)	Magic stronger than Heal. (Recovers 24–48 HP to entire party)
5	Firaga	: (all enemies)	Magic stronger than Fira (Does 50–200 fire elemental damage)
6	Clouda	: (all enemies)	Smoke pours out of the Black Mage's hands. Most smaller creatures enveloped in this poisonous smoke die.
7	Teleport	: (all allies)	A Black Mage's transcendent brain power allows them to remember the layout of each dungeon floor. This magic will teleport them to the previous floor.
8	Slowra	: (one enemy)	Magic stronger than Slow. Works on enemies unaffected by Slow.
6 . 1	Stona	: (one ally)	Monsters that turn bodies to stone are quite fearsome. This magic will transform petrified bodies back to their natural state. Can't be used in battle. (Cures an ally of Petrify)
2	Exit	: (all allies)	Even if you defeat an enemy in a deep cave, losing your life on the way out is entirely possible. Mages will grab a handful of earth from the entrance on their way into a dungeon, letting them teleport back to where they claimed it. This magic can't be used during battle. (Teleports party outside of dungeons)
3	Protera	: (all allies)	Magic stronger than Protect. (Raises party's Defense by 12 points)
4	Invisira	: (all allies)	Magic stronger than Invisible. (Raises party's Evasion by 40 points)
5	Thundaga	: (all enemies)	Magic stronger than Thundara. (Does 60–240 lightning elemental damage to all foes)
6	Death	: (one enemy)	A healthy person can die suddenly due to a heart attack. With but a word, a Black Mage can command an enemy's heart to stop beating, though this only works on those that possess hearts in the first place. (Attempts to inflict Instant Death on one enemy, with a low success rate)
7	Quake	: (all enemies)	Even monsters fear natural phenomena like earthquakes. Black Mages can localize a quake around enemies, opening a fissure to swallow them. (Attempts to inflict Instant Death on each enemy, with a low success rate for each)
8	Stun	: (one enemy)	Black Magic wields the power of words at their full potential. Simply saying "Stun!" will stun an enemy. (Paralyzes one foe)

EARLY PLANNING

Design Document

A document explaining the details of the original *Final Fantasy*. Areas such as Cornelia, the Sunken Shrine, and the Mirage Tower already existed at this early stage.

Early Town Design

An image conveying the feel of a typical town: houses, trees, and flower beds are just some of the elements used to depict a cozy fantasy village. The numbers underneath the picture show how much of the town can be displayed onscreen.

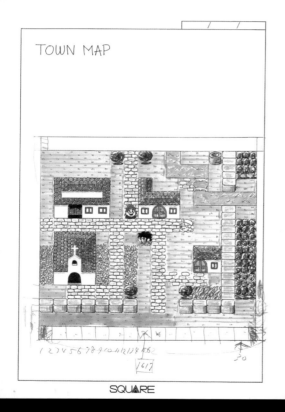

Battle Screen Prototype Image

A battle image by Takashi Tokita and Koichi Ishii. Early in development, nighttime environments were explored. Here you can see a full moon in the upper portion of the screen.

ORIGINAL GAME SOFTWARE

FINAL FANTASY

Design/setting: Square, Inc.

BASIC STORY WORLD

▷ STORY SETTING

A fantasy world. The story is centered on Cornelia Castle, inhabited by a king possessed of good conscience, common sense, and hope. The story progresses through several situations in a world of raging seas, deserts, an undersea shrine, a deep maze of earth and stone, caves, a bog of scrap, a mirage tower, and a volcano (see separate map reference document).

At the start of the story, this world is thrown into chaos by an evil monster. Its influence reaches underground, through the earth and the heavens, and across space and time (and even another dimension). Regions like Cornelia Castle are barely holding on to life, but even these are in a precarious state.

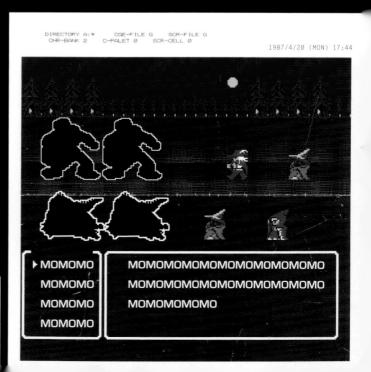

GBA ILLUSTRATIONS

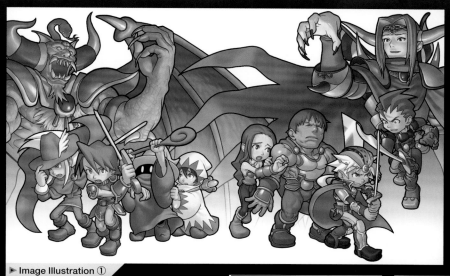

► Image Illustration ①

New illustrations created for *Final Fantasy I & II: Dawn of Souls*. This title included both *FFI* and *FFII*, so characters from both games appear on either side.

► Illustration ②

Illustrations of the Four Fiends and the boss monsters that appear in the *FFI: Dawn of Souls* "Soul of Chaos" bonus dungeons. Aside from the bosses shown here, the dungeons also include Ahriman, Echidna, Two-Headed Dragon, and Cerberus from *FFIII*.

► Boss Monster Illustrations

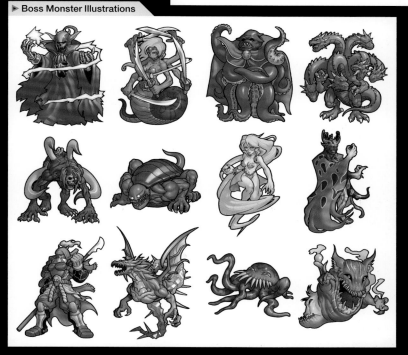

First row: Lich, Marilith, Kraken, Tiamat
Second row: Scarmiglione, Cagnazzo, Barbariccia, Rubicante (from *FFIV*)
Third row: Gilgamesh, Shinryu (both from *FFV*), Ultros, Typhon (both from *FFVI*)

035

FINAL FANTASY I
MEMORIES

What would happen if you read it backward . . . ?
"Tceles B hsup."
—IN MATOYA'S CAVE

Crossing the bridge, the Warriors of Light set out on the beginning of an incredible journey.
—AT THE CORNELIA DRAWBRIDGE

Did you happen to play this while riding the ship? Earn extra gil with the hidden game "15 Puzzle."
—ON THE OCEAN

Search all over the town to see an unexpected message.
—IN ELFHEIM

You're in for a world of hurt if you run out of potions and antidotes while exploring here!
—IN MARSH CAVE

The FIEND's ball cracks open.... An ominous cloud rises, and an evil shape congeals.... It is LICH, the Fiend of Earth.

Just as you sigh a breath of relief upon beating the Vampire, along comes the Lich, the true cause of the rotting land.
—IN THE CAVERN OF EARTH

On top of being paralyzed by the Mindflayers, our heroes fall one after another to their Death attacks.
—IN THE CAVERN OF ICE

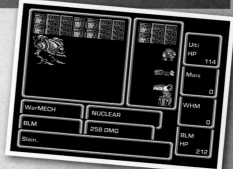

Taken aback by changes in character models as a result of class changes!
—IN CARDIA ISLANDS

What incredible speed! The exhilaration of blasting aimlessly across the world in your own airship.
—ON THE WORLD MAP

Encountering the rare monster Death Machine (Warmech) turns into a one-sided massacre for the player . . .
—IN THE FLYING FORTRESS

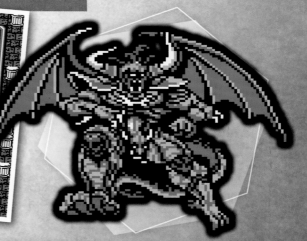

Jump two millennia into the past to break the time loop created by Garland, who has become Chaos!
—IN THE PAST CHAOS SHRINE

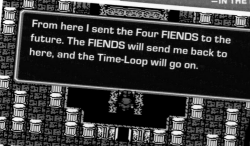

From here I sent the Four FIENDS to the future. The FIENDS will send me back to here, and the Time-Loop will go on.

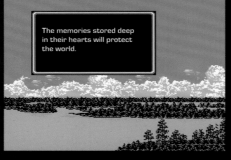

The Time-Loop is now broken! The 2000 year long battle is over. Peace prevails.

The memories stored deep in their hearts will protect the world.

The End

FC Version: Final Fantasy I & II (Japan)	WSC Version	PS/Mobile Version
FINAL FANTASY I·II	FINAL FANTASY II	FINAL FANTASY. II

PS Version: Final Fantasy I & II	GBA Version: Final Fantasy I & II	PSP/Smartphone Version
FINAL FANTASY.	FINAL FANTASY. I·II ADVANCE	FINAL FANTASY. II

Establishing innovations in each new game

This title cements a staple of the *Final Fantasy* series: the active incorporation of new systems into every release. Firion and his rebel companions aim to overthrow the Palamecian emperor. Unique elements include the experience-based leveling system and the new Word Memory system, which lets you converse using words you've learned.

Famicom	Famicom	WonderSwan Color	WonderSwan Color (Console Bundle)	PlayStation
Final Fantasy II	**Final Fantasy I • II**	**Final Fantasy II**	**Final Fantasy II** WonderSwan Color Console Bundle	**Final Fantasy II**
Launch Date ● December 17, 1988	Launch Date ● February 27, 1994	Launch Date ● May 3, 2001	Seller ● Bandai Launch Date ● May 3, 2001	JP Launch Date ● October 31, 2002 NA Launch Date ● April 8, 2003

PlayStation (Limited Edition)	Game Boy Advance	i-mode	EZweb Mobile Phone Service	Yahoo! Mobile
Final Fantasy I • II **Premium Package**	**Final Fantasy I • II** **Advance**	**Final Fantasy II**	**Final Fantasy II**	**Final Fantasy II**
Launch Date ● October 31, 2002	JP Launch Date ● July 29, 2004 NA Launch Date ● November 29, 2004	Launch Date ● March 4, 2005	Launch Date ● December 15, 2006	Launch Date ● December 1, 2006

PlayStation Portable	Wii/Wii U (Virtual Console)	PlayStation 3/ PlayStation Portable/ PlayStation Vita (PS one Classics)	PlayStation Portable (Ultimate Hits)	iPod touch/iPhone/ iPad
Final Fantasy II	**Final Fantasy II** (Famicom Version)	**Final Fantasy II** (PlayStation Version)	**Final Fantasy II**	**Final Fantasy II**
JP Launch Date ● June 7, 2007 NA Launch Date ● July 24, 2007	Launch Date ● June 16, 2009	JP Launch Date ● July 8, 2009 NA Launch Date ● January 10, 2012 ✚ Available on PS Vita from August 28, 2012	Launch Date ● July 30, 2009	Launch Date ● February 25, 2010

PlayStation Portable/ PlayStation Vita (Digital Download)	Android	PlayStation (Limited Edition)
Final Fantasy II (PlayStation Portable Version)	**Final Fantasy II**	**Final Fantasy 25th Anniversary Ultimate Box**
Launch Date ● February 22, 2011	Launch Date ● February 1, 2012	Launch Date ● December 18, 2012 ✚ Square Enix e-Store Limited Edition

 # ART

Call to Arms
Comrades and the emperor

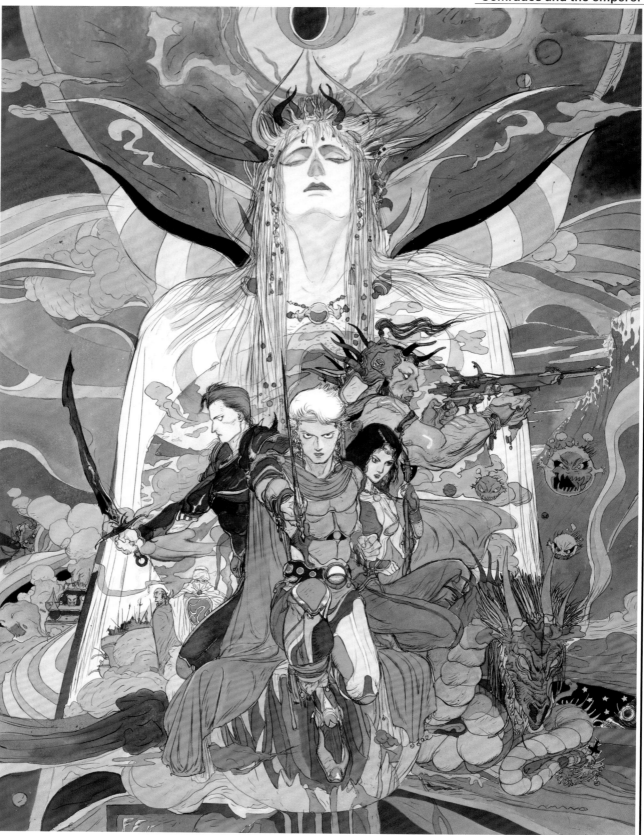

Red Sword
Firion (FC package illustration)

Demon Battle
Ricard vs. Leon

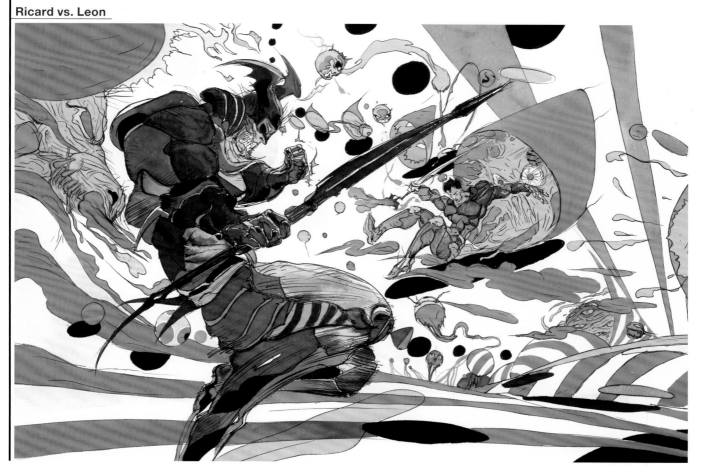

Fracas in the Frontier
Rebels fight the demons

Monster, Monster

Comrades

Emperor Mateus

Hilda: Our password is wild rose.
Remember it well.

Ask
Learn
Items

Soldier: So...you're rebel soldiers...are you?
My name is Scott. I am a prince of Kashuan.
Firion: Prince Scott? We were told you fell in the
battle. Thank goodness you're still alive!

Ask
Learn
Items Wild Rose

Dark Knight: Don't think you've won just yet!
Maria: What?
Brother, could it be you?
Firion: We've got no time for that now!

FINAL FANTASY II
STORY

Ooooh, looky your weird face.
Why you no weary mask?

Firion: Hey, but it's for free! Miss, we'd like to take
up your offer. Please take us to Deist!
Leila: Now you're talkin'. I'll be waitin' for you
outside the town, okay?

Ask
Learn
Items

	HP	MP	
Firion	499/499	57	Fight
Maria	430/430	91	Run
Guy	578/578	87	Magic
Gordon	293/293	5	Item

You have entered Pandaemonium!

So good to see you again.
But this time, you are the ones
who will die.

This is the tale of a far-off world . . .

A world where a long-standing peace suddenly comes crashing down. The emperor of Palamecia summons an endless stream of creatures from Hell to fulfill his desire for world domination.

Deist, Kashuan, Bafsk, Salamand . . . one by one the towns and keeps of each land fall under his militaristic heel. Although a rebel army arises in Fynn to oppose the Palamecian invasion, the stronghold of Fynn Castle is lost to the Empire's offensive, forcing the rebels to retreat to the far-off city of Altair.

Three youths of Fynn—Firion, Maria, and Guy—no longer have a home to return to, thanks to the imperial raid. Their rescue at the hands of the rebel commander Hilda and her associate Minwu sets the youths on a path of conflict with Palamecia. This is the start of a harrowing battle, one that requires our heroes to overcome the pain of their comrades' sacrifices . . .

CHARACTERS II

✤ Images are from the PSP version
✤1 Name added to the GBA version

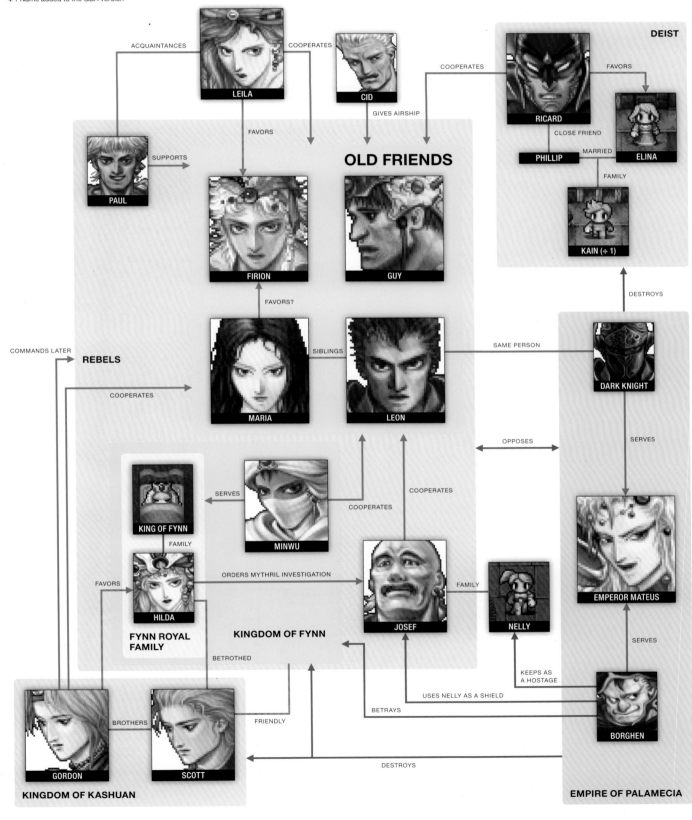

DEIST

ACQUAINTANCES — LEILA — COOPERATES — CID — COOPERATES — RICARD — FAVORS

SUPPORTS — PAUL — FAVORS — GIVES AIRSHIP

CLOSE FRIEND — PHILLIP — MARRIED — ELINA

FAMILY — KAIN (✤1)

OLD FRIENDS

FIRION — GUY

FAVORS?

COMMANDS LATER

REBELS

COOPERATES

MARIA — SIBLINGS — LEON — SAME PERSON — DARK KNIGHT

DESTROYS

OPPOSES — SERVES

SERVES — KING OF FYNN — FAMILY — MINWU — COOPERATES — COOPERATES

HILDA — ORDERS MYTHRIL INVESTIGATION — JOSEF — FAMILY — NELLY — EMPEROR MATEUS

FAVORS

FYNN ROYAL FAMILY

KINGDOM OF FYNN

BETROTHED

KEEPS AS A HOSTAGE

USES NELLY AS A SHIELD

BETRAYS

GORDON — BROTHERS — SCOTT — FRIENDLY

SERVES

BORGHEN

KINGDOM OF KASHUAN

DESTROYS

EMPIRE OF PALAMECIA

045

Firion

Patriot battling to
restore his homeland.

フリオニール

[Furionīru/Frioniel]

▶ Personal Data

Gender	Male
Hometown	Unknown
Dominant Hand	Right

▶ GBA Illustration

A youth who lived in the kingdom of Fynn with Leon, Maria, and Guy. He volunteers to join the rebels to take back his homeland, which was lost to the Empire's assault. His ability is soon acknowledged by the rebel leader Princess Hilda, throwing him headlong into the battle against the Empire. While he demonstrates abilities that impress even the adults around him, his inexperience shines through in certain situations, such as falling for the charms of a beautiful woman.

Memorable **Quotes**

▶ FIRION

"Your Highness, please allow us to join the rebel forces!"

—In the town of Altair, when volunteering to join the rebels.

Hilda harbors Firion after his defeat at the hands of marauding Black Knights. Perhaps his desire to join the rebels represented a departure from his former, less capable self as he set out on a new path.

"Hey, but it's free! Miss, we'd like to take up your offer."

—In the town of Paloom, regarding the ship to Deist upon hearing that Leila is ready to set sail.

Firion agrees to Leila's offer despite the wariness Maria feels about a story that seems too good to be true. A heart devoid of doubt is one of his greatest strengths, but perhaps he's just taken in by the promise of "free."

"Now, let's go. This is going to be the real beginning!"

—After seeing off his comrades during the finale.

Although the Empire has fallen and Fynn Castle has been restored, the final battle is just one step on the road to world peace. Firion sees Paul and Leila back to where they need to go, and resolves to embark on another journey to secure peace for all lands.

Firion: I'm fine, Maria. You alright too, Guy?
But wait... Where's Leonhart?
Guy: Princess of Fynn save us.
But...Leonhart's not here.

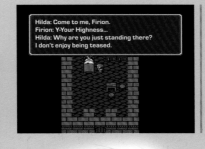

Hilda: Come to me, Firion.
Firion: Y-Your Highness...
Hilda: Why are you just standing there? I don't enjoy being teased.

Swallowing the Royal Bait

Completely fooled by a shape-shifting monster posing as Hilda, Firion gulps in response to her unexpected invitation. He gets on the bed as she requests, unwittingly putting himself in a life-threatening situation.

▶ FIRION

Memorable **Scenes**

Firion: Leonhart! When the time is right...we'll be waiting.

Waking in an Unknown Place

Having sustained a fatal wound at the hands of Black Knights, Firion is taken to Altair and saved from imminent death. While happy to hear Maria and Guy are safe, Leon is nowhere to be found . . .

Farewell, Leon

Firion and his comrades have returned peace to the world, but Leon regrets the actions he took in the course of events. As the man leaves his sister and friends behind, Firion sees him off, with the hope that they might meet again one day.

Wishing for peaceful days.
Kindhearted girl devoted to family.

Maria マリア

[Maria]

▶ Personal Data

Gender	Female
Hometown	Fynn
Dominant Hand	Right

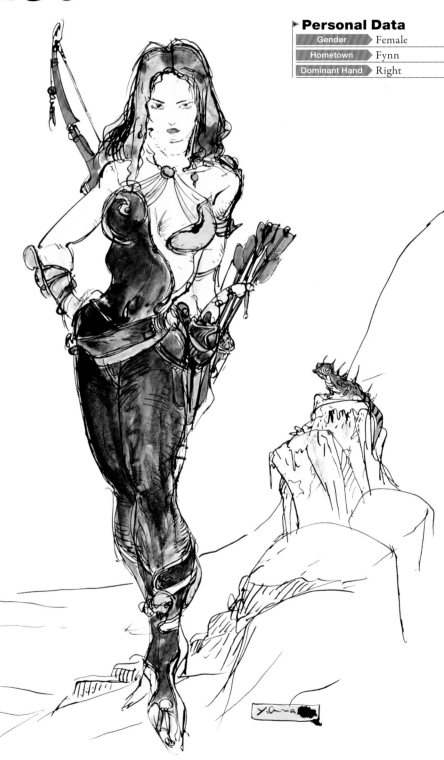

▶ GBA Illustration

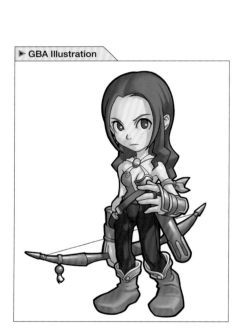

A young girl who speaks her mind, Maria grew up with Firion and Guy, sharing a bond as close as siblings. She and the others join up with the rebel forces after losing their home in the Imperial assault. Maria is anxious to learn the whereabouts of her brother Leon, from whom she was separated during their escape. When she learns that her brother has joined the Empire and has become its Dark Knight, she grows desperate to persuade him to renounce his new allegiances. Watching over and over as her comrades lose their lives cuts Maria to the core, and she desperately hopes for an end to the tragedy of war.

Behind the giant's rough exterior
lies a heart filled with compassion.

Guy ガイ

[Gai/Guy]

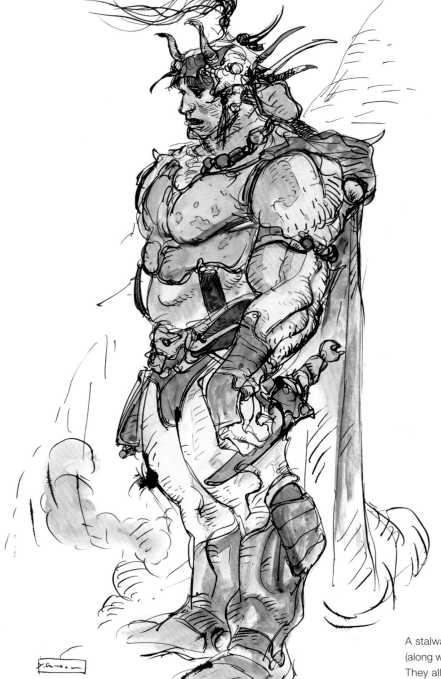

▶ GBA Illustration

A stalwart man raised by wolves as a baby, Guy
(along with Firion) was taken in by Maria's parents.
They all lived together until the Empire attacked
their land and drove them to join the rebels in
Altair. Guy's grim appearance belies a gentle
disposition, and he can understand the language
of animals. However, Guy is poor at communicating
with his fellow humans, and prefers to speak as
few words as possible.

The solitary knight of darkness
seeking the power of an Imperial general.

Leon

レオンハルト

[Reonharuto/Leonhart]

Maria's true brother, raised together with Firion and Guy. Leon is separated from his comrades while escaping their homeland and these traumatic events seem to prove his own helplessness, causing him to adopt the mantra "power is everything." He serves the hated Empire of Palamecia as their Dark Knight, contributing to the construction of war projects including the Dreadnought. Leon attempts to succeed Emperor Mateus after the ruler's demise, but the emperor's surprise return forces him to abandon those aspirations. His sister Maria is able to persuade him to join the rebels.

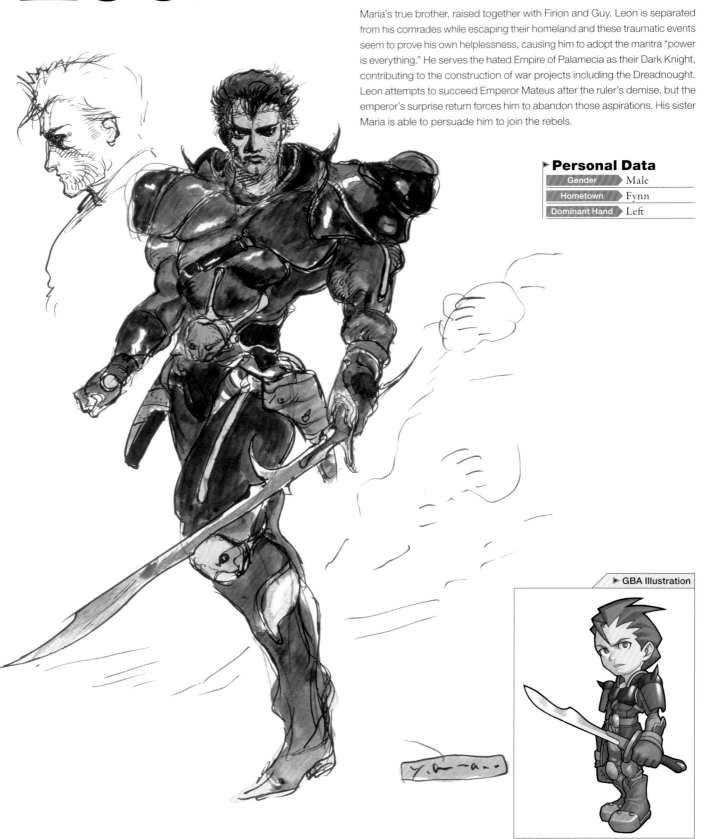

▶ **Personal Data**

Gender	Male
Hometown	Fynn
Dominant Hand	Left

▶ GBA Illustration

Memorable **Quotes**

▶ MARIA

"No, please stop this! Why do you have to cross your sword against your friend?"

—In Palamecia Castle, when facing her brother Leon, who stands before them as the Dark Knight.

Without hesitation, the girl leaps to intervene in the standoff between brother and friend. Maria believes in Leon, despite his association with the enemy, for he is her true brother. She urgently attempts to persuade him.

"Josef, Minwu, Cid, and now Ricard . . . They're all dead. I can't take this anymore!"

—In Fynn Castle, remembering those who have fallen in battle.

Maria screams in grief at the memory of the comrades they have lost, who sacrificed their lives to open a path for our heroes. As she expresses her pain, Maria resolves to prevent further tragedy at all costs.

▶ GUY

"You coming with us. We want you come."

—In the Snow Cave, to Josef while he holds back a massive boulder.

Guy worries for Josef, who protects his comrades from a trap sprung by the defeated Borghen. He resists leaving Josef behind until the last moment, despite the danger to himself. Here, the gentle giant demonstrates his true character.

▶ LEON

"I knew you'd come, Firion. You think you can defeat me?"

—In Palamecia Castle, confronting Firion's party.

The new emperor casts a bold declaration at the former friends who now stand before him. His demeanor still suggests a high regard for Firion's strength, as he notes his enemy's skill on his way to the throne.

"Let me ask you one thing: What conquers the world? The answer is power. I am the emperor now, and I will not let go of it!"

—In Palamecia Castle, responding to his sister's plea.

Leon's attachment to power manifests clearly in his words. Having endured the shame of serving the enemy, Leon finally reigns over all of existence. From his perspective, the idea of parting with such power is inconceivable.

Dropping a Bombshell

While rescuing Hilda is their top priority, Firion's party also attempts to blow up the enemy Dreadnought. Yet when they arrive at the engine, Maria blurts out something that suggests she's forgotten all about the princess.

Sorrowful Appeal to Kin

Knowing Leon has lost his position of power after the emperor's return, Maria entreats her brother to join them in their fight. Leon's hardened heart is moved by his sister's heartfelt plea.

▶ MARIA

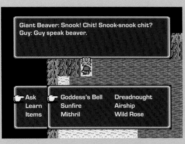

The Man Who Talks to Animals

When searching for the Goddess's Bell, Guy employs his special skill to gain crucial information from a giant beaver. He conveys the whereabouts of the bell to Firion and the others.

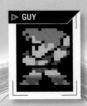
▶ GUY

Memorable **Scenes**

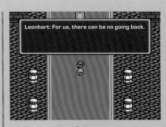

In Pursuit of Power

Leon once lamented his own powerlessness, and thus he sought overwhelming strength. While persistent in staking his claim to the throne he wrested from Emperor Mateus, there was nothing Leon could do to prevent the emperor's return from Hell itself . . .

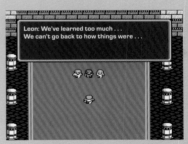

Regretting Indiscretions

Although peace has returned to the world, Leon knows that his actions as the Dark Knight aren't easily forgiven. Rebuffing his sister's attempts to stop him, he departs on his own.

▶ LEON

Minwu ミンウ

Officer of the rebel army.
The calm and collected sage.

[Min'u/Ming-Wu]

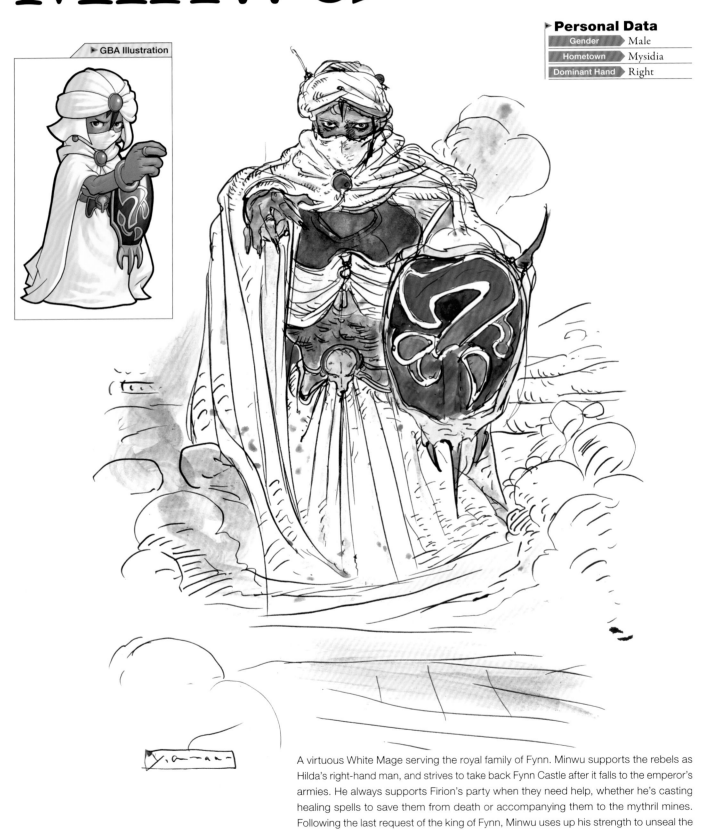

▶ GBA Illustration

▶ Personal Data

Gender	Male
Hometown	Mysidia
Dominant Hand	Right

A virtuous White Mage serving the royal family of Fynn. Minwu supports the rebels as Hilda's right-hand man, and strives to take back Fynn Castle after it falls to the emperor's armies. He always supports Firion's party when they need help, whether he's casting healing spells to save them from death or accompanying them to the mythril mines. Following the last request of the king of Fynn, Minwu uses up his strength to unseal the passage to the Ultima Tome in Mysidian Tower. The effort costs him his life.

Josef

Part rebel warrior,
part doting father.

ヨーゼフ
[Yōsefu/Josef]

▶ **Personal Data**

Gender	Male
Hometown	Fynn
Dominant Hand	Right

An agent of the rebellion who lives with his beloved daughter Nelly in the northern town of Salamand. Josef was ordered to investigate the mythril mines, but Commander Borghen of the Empire took Nelly as a hostage. Josef didn't dare resist. After Firion returns Nelly safely, Josef cooperates with them to show his thanks. He protects Firion's party from a massive boulder trap that Borghen activates inside the Snow Cave, and dies a hero's death.

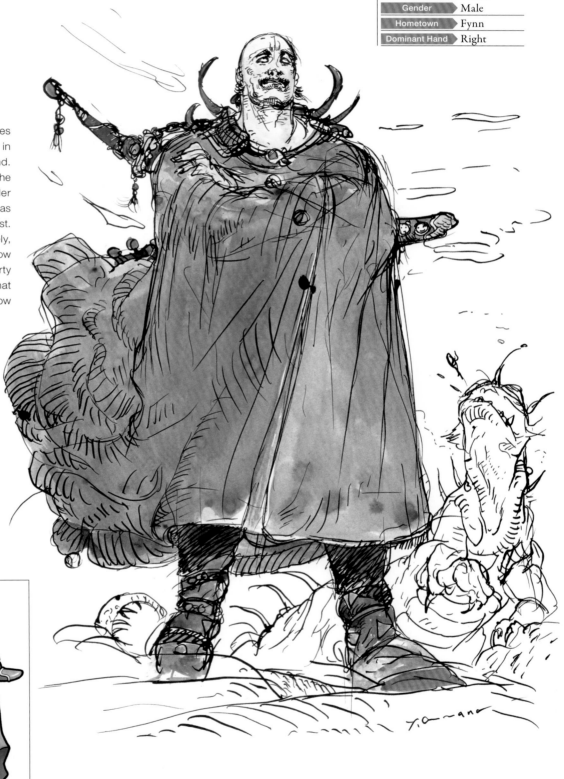

▶ GBA Illustration

The pessimistic prince
who wishes to be brave.

Gordon ゴードン

[Gōdon/Gōrdon]

▶Personal Data

Gender	Male
Hometown	Kashuan
Dominant Hand	Right

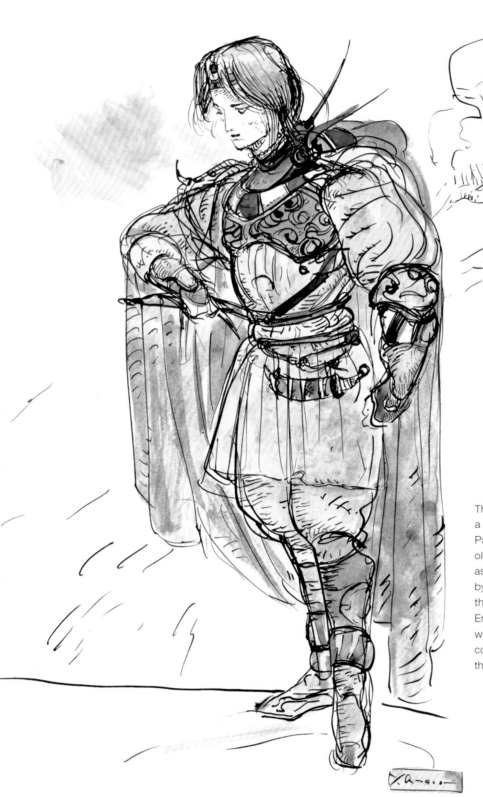

The second in line for the throne of Kashuan, a kingdom destroyed by the Empire of Palamecia. Gordon feels indebted to his older brother Scott, who resisted to the end as Gordon fearfully fled the country. Inspired by the bravery of Firion's party, Gordon throws himself into the fight against the Empire. Bit by bit, Gordon grows into a man whom the king of Fynn deems worthy of commanding the rebel army. Until the end of the war, he supports the princess Hilda.

> MINWU

Memorable Quotes

> GORDON

> JOSEF

"I see your destiny. It is intertwined with mine."

—In the town of Altair, while guiding Firion's group on their journey.

Minwu has only just met Firion and his friends, yet he seems to predict the perilous fate facing the party. Perhaps he had even foreseen his own destiny?

"All living creatures must die. It cannot be helped. But my duty is to save those who are suffering."

—In the town of Altair, upon receiving word of the king's worsening condition.

As a White Mage who has healed countless people from fatal wounds, Minwu has faced more death than most. Even so, he believes he should do everything he can to help others, and thus devotes himself to the practice of medicine.

"Thank you so much for saving my daughter! I'm so sorry."

—In Salamand, to Firion's group after they saved Nelly.

At first, Josef refuses to help the heroes out of concern for the fate of his kidnapped daughter. He returns to his open and honest nature after she is safely returned, and he apologizes to the group for his earlier coldness.

"I was so afraid Hilda would reject me that I stayed here, wasting away . . . Go on, laugh!"

—In the town of Altair, after Firion's party volunteers for the Rebel Army.

Despite wanting to support the rebels, Gordon is too depressed to take action during the early stages of the saga. He blames his own cowardice for his inaction, constantly dwelling on his worst qualities.

"This is a terrible loss, but we must go on. Now, let's go. We have duties to fulfill!"

—In the town of Altair, after the King of Fynn draws his final breath.

Stouthearted encouragement to those lost in their sorrow over the passing of their king. Here Gordon begins to manifest a strong sense of leadership, as he grows into a capable commander of the rebel forces.

Watching Over the Youths
The mage offers advice to a group of youths who are eager to travel on a mission for the rebellion. Guiding youngsters is the duty of the elderly, no matter the era.

Eternal Rest
Minwu awaits the party at the top of Mysidian Tower, near the room where the all-powerful magic Ultima sleeps. He drains all his power to break the magic seal binding the door, and passes away knowing he has done all he could.

> MINWU

Entrusting the Future
With his bare hands, Josef halts the huge boulder sent tumbling down by Borghen's trap. Having protected the heroes to the bitter end, Josef utters the name of his beloved Nelly one last time before his strength gives out.

> JOSEF

Memorable Scenes

Despite His Courage
Gordon sneaks into Kashuan Keep to obtain an item known as Egil's Torch. Yet the keep has become a home for dangerous beasts, and their presence stops him in his tracks.

To the Trapped Princess
He heads to the Coliseum with Firion's party, where Princess Hilda is being offered as a tournament prize. Gordon does his duty and rescues the princess, but his affection for her goes much deeper than professional loyalty.

> GORDON

Leila

Leader of seafaring rogues.
The resolute pirate lass.

レイラ
[Reira/Leila]

▶ Personal Data

Gender	Female
Hometown	Unknown
Dominant Hand	Left

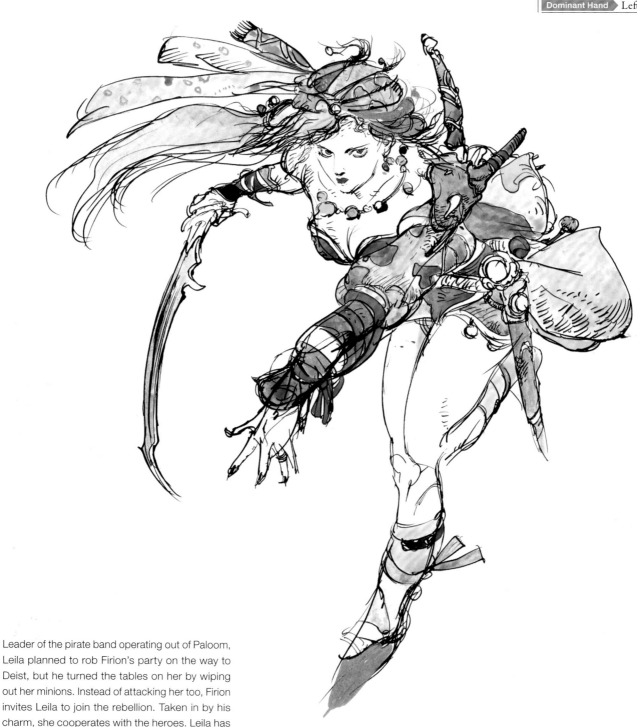

Leader of the pirate band operating out of Paloom, Leila planned to rob Firion's party on the way to Deist, but he turned the tables on her by wiping out her minions. Instead of attacking her too, Firion invites Leila to join the rebellion. Taken in by his charm, she cooperates with the heroes. Leila has a meddlesome side, and plays an active role in the rebellion. Her assistance proves essential during the plan to recapture Fynn Castle.

Ricard リチャード [Richādo/Richard]

A valiant Dragoon.
The last of his kind.

▶ *Richard Highwind* リチャード・ハイウィンド

▶ Personal Data

Gender	Male
Hometown	Deist
Dominant Hand	Right

One of the Dragoons, powerful warriors who bond with their Wyvern mounts. When the Empire destroyed his homeland of Deist, Ricard had already left for Mysidia in search of the Ultima Tome. He was the only Dragoon to survive the attack. Ricard meets Firion's party in the belly of the Leviathan. Inspired by their noble purpose, he agrees to accompany them. They destroy the emperor, but when a resurrected emperor arises from Hell, Ricard sacrifices his life to save his friends.

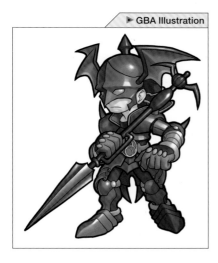

▶ GBA Illustration

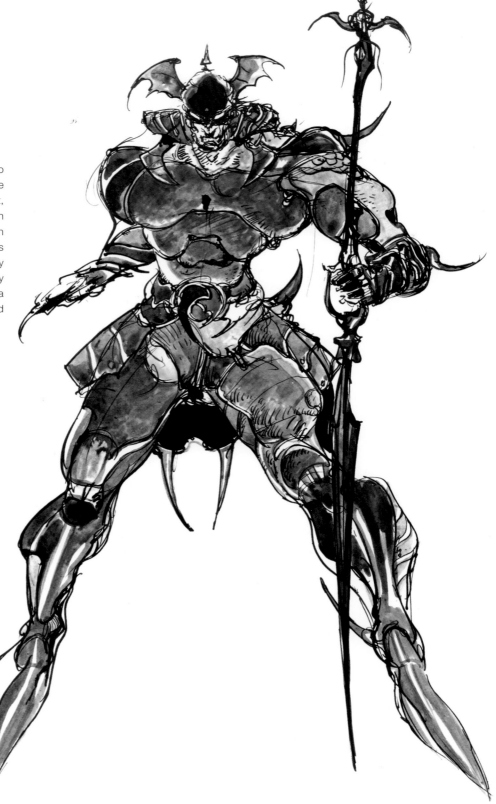

Hilda ヒルダ

Original leader of the rebellion.
Princess of Fynn.

[Hiruda/Hilda]

▶ Personal Data

Gender	Female
Hometown	Fynn

▶ GBA Illustration

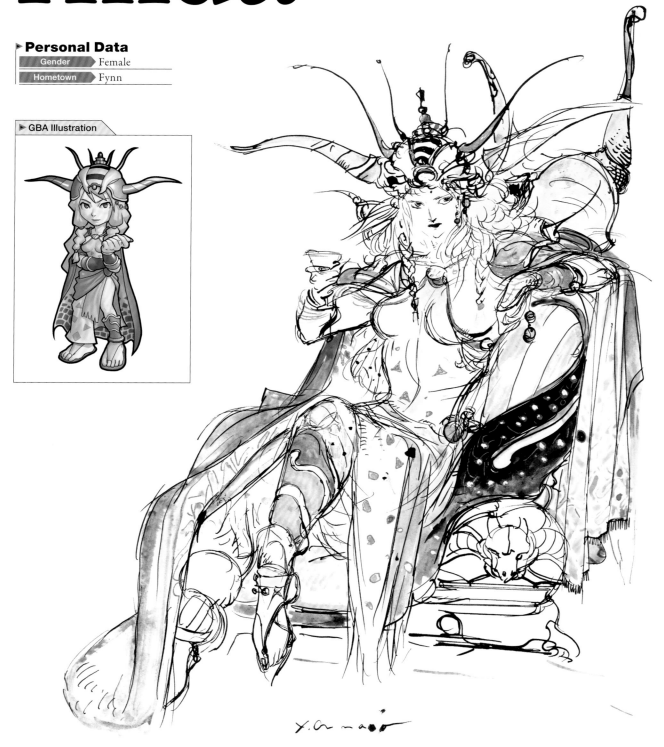

The beautiful and shrewd leader of the rebels. Hilda takes control of the war against the Empire of Palamecia after her father, the king, becomes bedridden with injury. At first she has no intention of allowing Firion's friends into the rebellion, but after seeing their skills firsthand she asks for their help in the coming fight. Despite such ordeals as becoming a captive of the Empire, having a shape-shifting monster replace her as head of the rebellion, and being offered up as a tournament prize, Hilda proudly leads her warriors through every hardship.

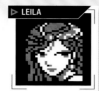

LEILA

HILDA

Memorable *Quotes*

RICARD

"Buddy, we'll go anywhere in this world with you!"
—On the pirate ship, when Firion invites her to join him.

Treating a group of rogues as equals, and not blaming them for their trickery—this was the first time Leila had ever encountered anyone with Firion's soft touch. Leila's subsequent devotion to Firion's cause demonstrates just how much that early encounter changed her life.

"Hey, stay sharp. Women can do scary things sometimes!"
—In the town of Ardea, to Firion, who was deceived by the Lamia Queen.

Firion barely survives his encounter with the monster disguised as Princess Hilda. First Leila, then the Lamia Queen . . . Leila's statement "Women can do scary things" seemed justified, given the level of deceit he had encountered so far.

"I am going to defeat the emperor now. When I come back, will you let me be your father?"
—In Castle Deist, after introducing himself to Elina's son.

Ricard held a vague affection for Elina, wife of his late friend Phillip. What Ricard said to the woman's son seemed to indicate his intention to tell Elina of his true feelings for her, after peace had returned to the world.

"Nonsense. You would only waste your lives in the war. You must go home at once."
—In the town of Altair, when stopping the heroes from joining the Rebel Army.

Her words may seem cold at first, but Hilda puts the safety of her people above all else. "I must admonish these children who would wage war without considering the consequences." Such careful consideration for others is one of her best qualities as a leader.

"Don't worry, I'm the real Hilda."
—In the Rebel Camp, when Firion asks about "Wild Rose."

The princess says this to a wary Firion, setting him at ease after his disturbing encounter with her impostor. The implication here is that Hilda is now fully aware of how Firion was deceived.

We're Pirates
Feigning kindness, Leila's crew allows Firion and friends to board their ship. Once out to sea, they'll rob them of everything they own. That's the plan, anyway . . .

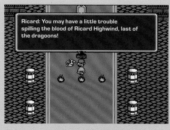

Self-Sacrifice for Friends
Ricard challenges the revived emperor, hoping to buy the other heroes enough time to escape. Confident that his comrades have escaped on the Wyvern, the last Dragoon lays down his life.

Regretful Admonishment
"Josef wouldn't have died if I hadn't sent you after the Goddess's Bell." Sometimes, Hilda regrets the outcomes of her orders. Upon seeing Gordon, who had vanished during a critical time, the emotionally drained princess displays an uncharacteristic degree of exasperation.

By the Pirate's Code
The world is at peace. The time has come to say goodbye to Firion. "I'll be lookin' forward to seein' you again!" . . . Could those words conceal a deeper meaning?

LEILA

RICARD

Memorable *Scenes*

Homeland Returned
Fynn Castle is finally liberated through the hard work of the heroes. Hilda expresses her thanks to these brave and remarkable youths.

HILDA

The Emperor

Overwhelming magical power.
Tyrant seeking world domination.

皇帝 [Koutei/Emperor]

▶ Personal Data

Gender	Male
Hometown	Palamecia

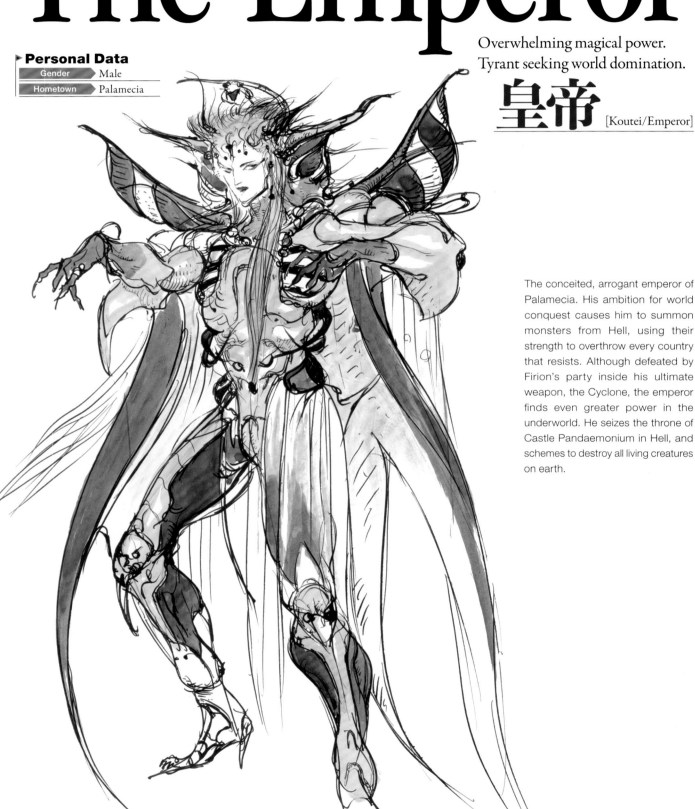

The conceited, arrogant emperor of Palamecia. His ambition for world conquest causes him to summon monsters from Hell, using their strength to overthrow every country that resists. Although defeated by Firion's party inside his ultimate weapon, the Cyclone, the emperor finds even greater power in the underworld. He seizes the throne of Castle Pandaemonium in Hell, and schemes to destroy all living creatures on earth.

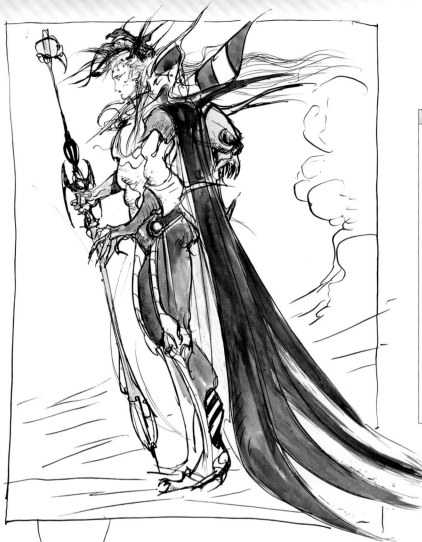

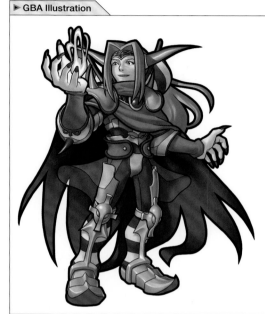

▶ GBA Illustration

Memorable Quotes

▶ EMPEROR MATEUS

"You? The emperor?
Ha! You do not know
that you only deserve
to work in the shadows
of the real emperor!"

—In Palamecia Castle, upon returning from Hell and
appearing before Leon.

The new self-proclaimed emperor Leon has been cast aside. Emperor
Mateus's prideful words betray his twisted personality, and his inability
to share his power with any challengers.

"B-but why . . . Why can't I defeat . . . you . . . ?
Who . . . are . . . y-you . . . ? Rrrraaaaagh!"

—In Pandaemonium, when defeated by the heroes.

Despite brimming with confidence in light of his newfound powers,
the resurrected emperor once again tastes defeat. Never expecting
any outcome other than complete victory, the emperor disappears
from this world, his thoughts consumed with shock and rage.

A Princess, the Prize

The grand opening of a tournament
in which the kidnapped princess
will become the grand prize. The
emperor succeeds in capturing the
rebel heroes, who easily fell for
the bait.

Emperor: Here is your reward. A reward
befitting rebels, Firion!

▶ EMPEROR MATEUS

Memorable Scenes

Emperor: The empire? Ha! I've no need for such
trifles now. All the world shall fall by my hand and
the powers I gained in Hell. And your blood will be
the first to spill!

Reign of Infernal Strength

Emperor Mateus returns, with de-
monic abilities and a hunger for
global destruction. He plans to
start with Firion and Leon.

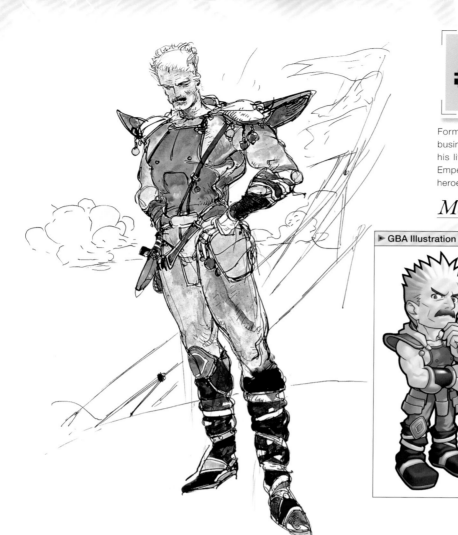

Cid

シド [Shido/Cid]

Former White Knight of Fynn, now operating an airship transport business based in Poft. He is obsessed with airships and has devoted his life to understanding the technology. Cid is gravely injured by Emperor Mateus's Cyclone, but he entrusts his beloved airship to the heroes before he passes.

Memorable **Quote**

▶ GBA Illustration

"Now, listen, I'll let you use her until I get better. Got that? Take good care of her . . ."

—In the town of Fynn, giving away the airship to Firion's group on his deathbed.

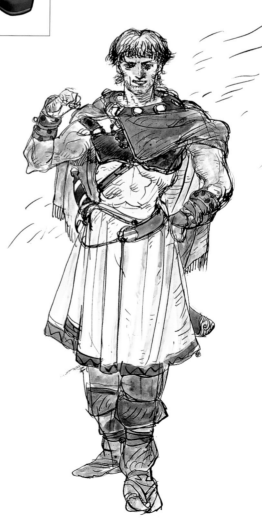

Paul

ポール [Pōru/Paul]

A boastful thief assisting the rebellion. Paul has infiltrated even the supposedly impregnable Palamecia Castle, and will brag about it endlessly. A sociable fellow, Paul forms a bond with Firion during their shared adventures.

Memorable **Quote**

"So there's my thanks for saving me from the mines! You'd better get moving!"

—In the Coliseum, showing up to save Firion's imprisoned party.

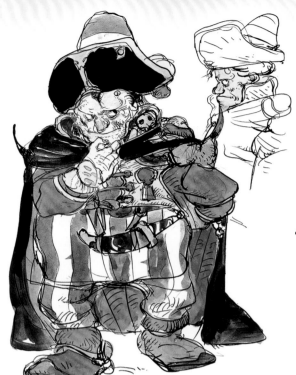

Borghen
ボーゲン [Bōgen/Borgen]

Former count of Fynn, who betrayed his country to become a captain in the Empire of Palamecia. Borghen doesn't care for anything other than his own ambitions. His blusterous arrogance makes him deeply unpopular among his troops. He assumes control of the Dreadnought construction project from the Dark Knight, but foolishly lets Firion and his friends sneak in right under his nose. Borghen is blind to his own incompetence, and he meets a fitting end when he attacks the heroes in the Snow Cave.

Memorable **Quote**

"Damn you! You've ruined me! The emperor will not tolerate failure. I can't go back now. Well, if I'm going down, you're coming with me!"

—In the Snow Cave, when lunging at the rebel party.

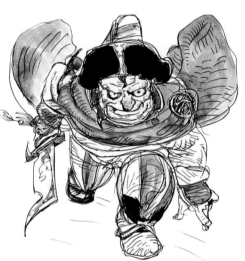

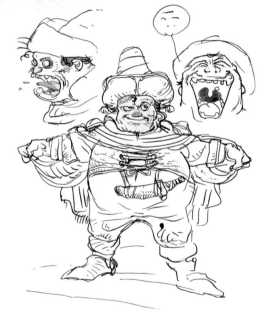

Scott
スコット [Sukotto/Scott]

The prince of Kashuan and Princess Hilda's betrothed. Scott is fatally wounded in the battle against the Empire, and takes shelter in the town of Fynn. In Fynn, Scott is discovered by Firion's group. With his final words, Scott gives them a message to relay to Hilda and his brother Gordon, as well as his favorite ring.

Memorable **Quote**

"Oh, how tired I am . . . Please let me rest now."

—In the town of Fynn, after giving his last words and a ring to the party.

▶ GBA Illustration

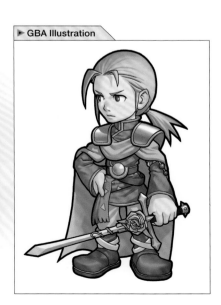

WORLD

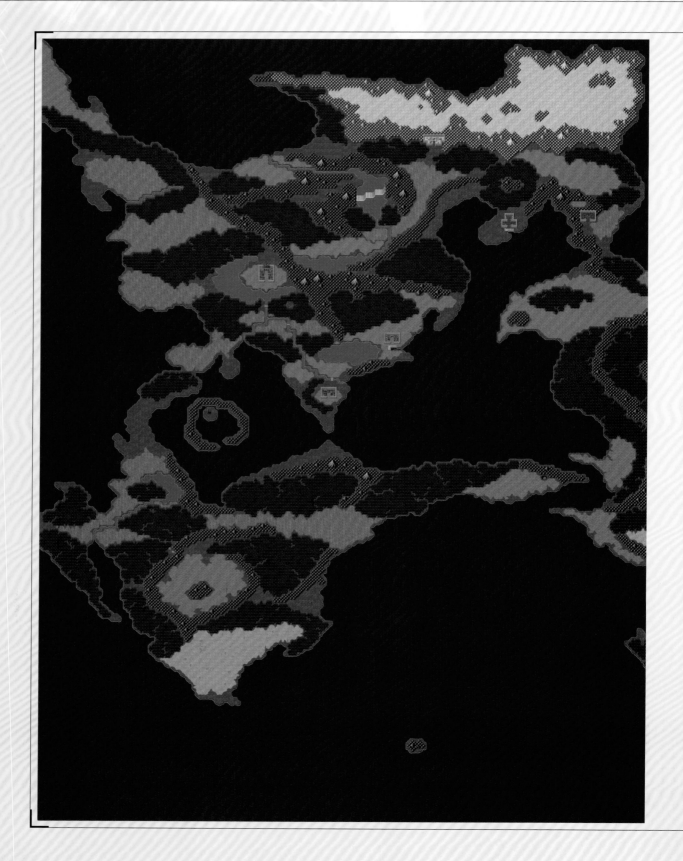

This tale takes place on a single, massive continent. The continent is divided to the north, east, and west, but the landmasses are connected enough to allow our heroes to traverse most of it on foot. The world is green and lush, with deep snowfields and vast deserts.

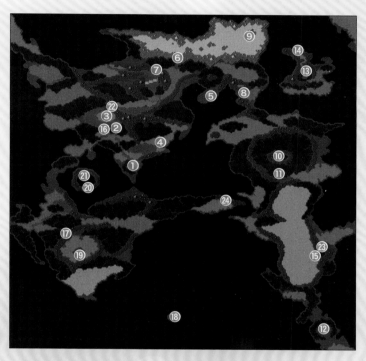

1 Altair
2 Gatrea
3 Fynn
4 Paloom
5 Poft
6 Salamand
7 Semitt Falls
8 Bafsk
9 Snow Cave
10 Kashuan Keep
11 Chocobo Forest
12 Dreadnought
13 Castle Deist
14 Deist Cavern
15 Coliseum
16 Rebel Camp
17 Mysidia
18 Southern Islands
19 Cave of Mysidia
20 Leviathan
21 Mysidian Tower
22 Cyclone
23 Palamecia Castle/Pandaemonium
24 Jade Passage

MONSTERS

Goblin
ゴブリンt [Goburin]

Leg Eater
レッグイーター [Regguītā]

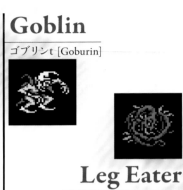

Captain
キャプテン [Kyaputen]

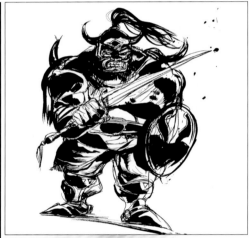

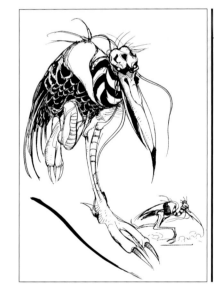

Sprinter
スプリンター [Supurintā]

Zombie
ゾンビ [Zonbi]

Land Turtle
ランドタートル [Randotātoru]

Memorable Feature

Swap, the Giant-Killer
The captains roaming Fynn are incredibly strong in the early stages of the game. By using Swap when Minwu is near death, you can switch his hit points—or lack thereof—with that of the enemy, letting you scrape by with a victory.

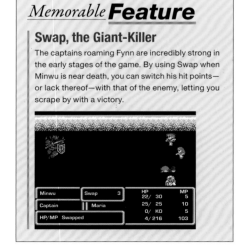

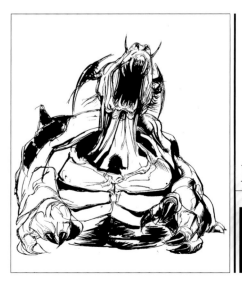

Dead Head

デッドヘッド [Deddoheddo]

Icicle

アイシクル [Aishikuru]

Snowman
スノーマン [Sunōman]

Shadow
シャドウ [Shadō]

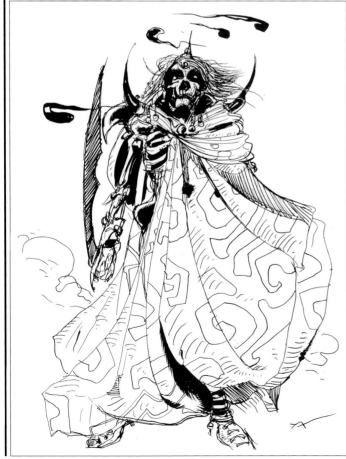

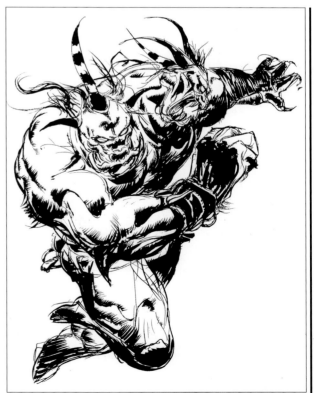

Dual Heads

デュアルヘッド [De~yuaruheddo]

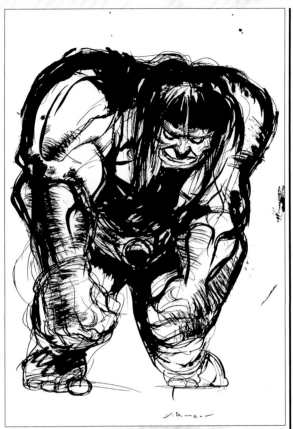

Wererat
ウェアラット [U~earatto]

Ogre
オーガ [Ōga]

Red Soul
レッドソウル [Reddosouru]

Werepanther
ウェアパンサー [U~eapansā]
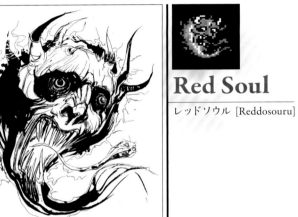

Magician
マジシャン [Majishan]

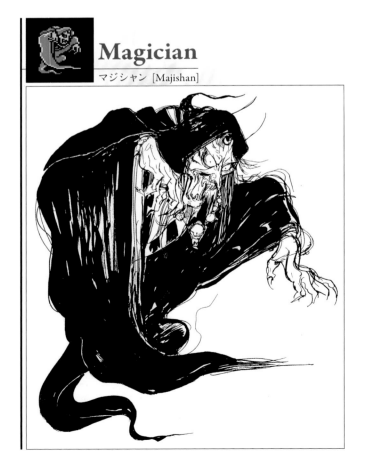

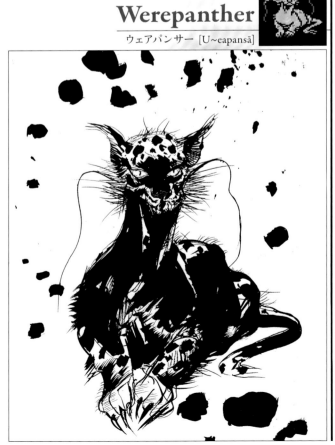

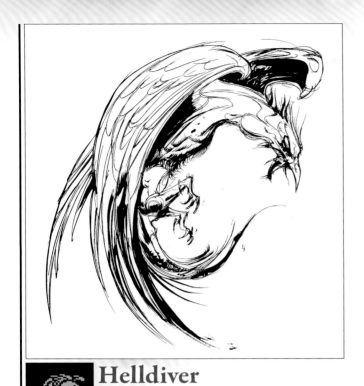

Helldiver
ダイブイーグル [Daibuīguru]

Hill Gigas
ヒルギガース [Hirugigāsu]

Pirate
かいぞく [Kaizoku]

Sea Snake
シースネイク [Shīsuneiku]

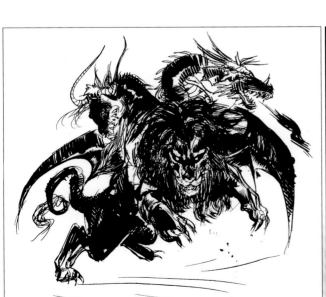

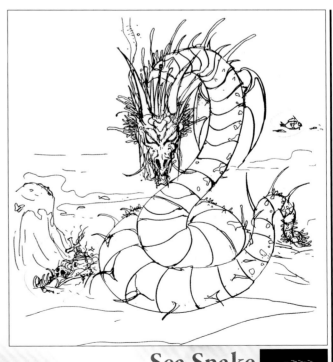

Chimera キマイラ [Kimaira]

Antlion
ありじごく [Arijigoku]

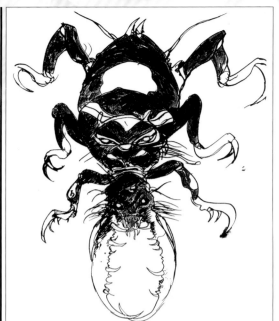

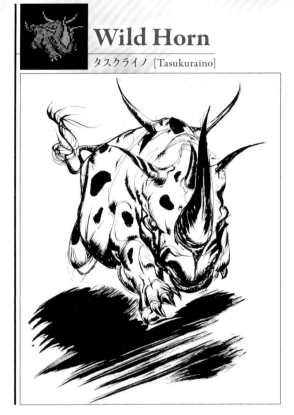

Wild Horn
タスクライノ [Tasukuraino]

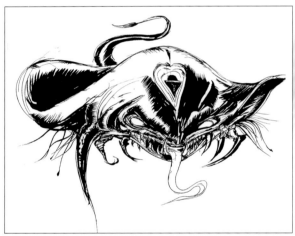

Land Ray
ランドレイ [Randorei]

Behemoth
ベヒーモス [Behīmosu]

Poison Toad
ポイズントード [Poizuntōdo]

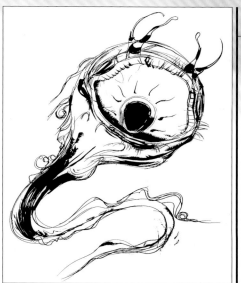

Parasite

パラサイト [Parasaito]

Brain

ブレイン [Burein]

Gottos

ゴートス [Gōtosu]

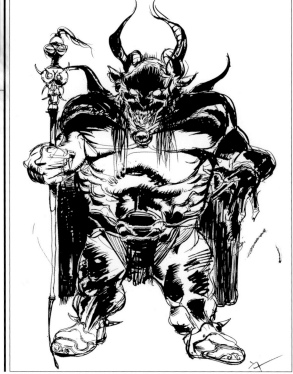

Bomb
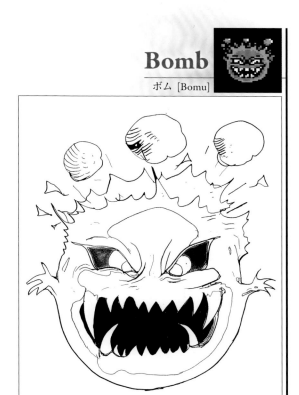
ボム [Bomu]

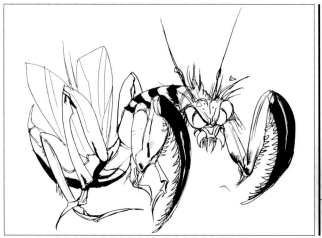

Killer Mantis

キラーマンティス [Kirāmantisu]

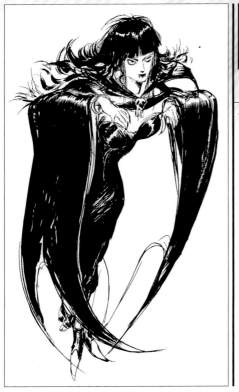

Vampire Girl

バンパイアガール [Banpaiagāru]

Red Mousse

レッドマシュマロ [Reddomashumaro]

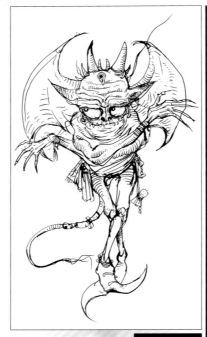

Imp

インプ [Inpu]

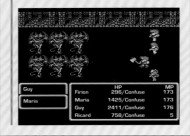

Memorable **Feature**

Muddle 16 Nightmare

Imps usually appear in groups, and use Muddle 16 on your entire party. It has a high rate of success and confuses targets—forcing party members to beat each other to death.

Guy				
Maria		HP		MP
	Firion	296/Confuse		173
	Maria	1425/Confuse		173
	Guy	2411/Confuse		176
	Ricard	758/Confuse		5

Malboro

モルボル [Moruboru]

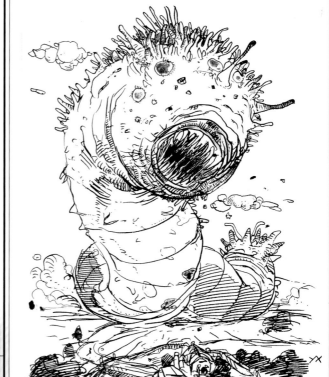

Roundworm

ラウンドウォーム [Raundou~ōmu]

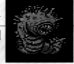

White Dragon
ホワイトドラゴン [Howaitodoragon]

Devil's Bloom
あくまのはな [Akuma no Hana]

Salamander
サラマンダー [Saramandā]

Wood Golem
ウッドゴーレム [Uddogōremu]

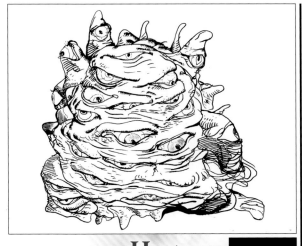

Hecteyes
ヘクトアイズ [Hekutoaizu]

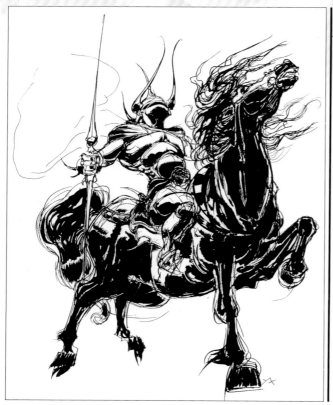

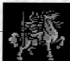
Black Knight
くろきし [Kurokishi]

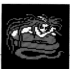
Lamia Queen
ラミアクィーン [Ramiaku~în]

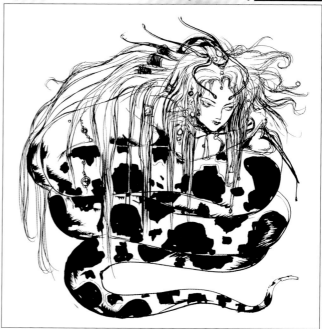

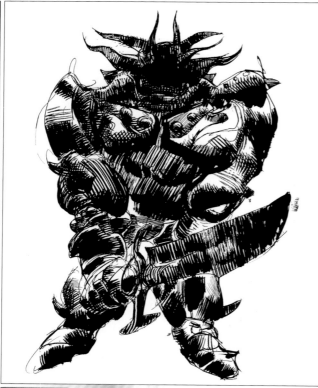

Iron Giant

テツキョジン [Tetsukyojin]

Beelzebub
ベルゼブル [Beruzeburu]

Memorable **Feature**

A Rare Treat

The Lamia Queen that the player fights as a boss midway through the game appears in the final dungeon as a regular foe. She drops an assortment of valuable items. If you are lucky enough to get the ribbon, you will find subsequent battles to be much easier.

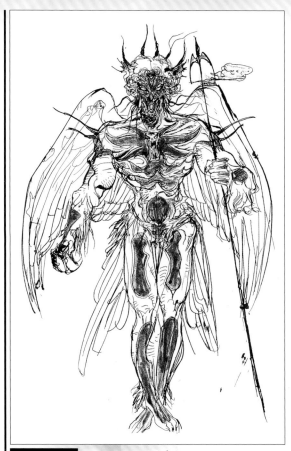

Astaroth
アスタロート [Asutarōto]

Memorable Feature

Blood Sword Beatdown

The final form of the emperor boasts incredibly enhanced stats, making it a foe worthy of an end boss. In addition to a high magic defense, the emperor is almost invulnerable to ordinary weapons—but the Blood Sword is far from ordinary. With its accuracy and the high percentage of maximum hit points it removes with every hit, the Blood Sword is the best tool for defeating the emperor of Hell.

		HP	MP
Firion	11 Hits	2116/ 2116	258
Emperor	6892	2351/ 2351	314
Critical Hit!		2417/ 3132	266
		2058/ 2058	37

Emperor (Final Boss)
こうてい（2回目）[Kōtei (2-kai-me)]

EXTRA CONTENT

WORLD PLANNING

Publicity World Map

A world map illustration made for *Final Fantasy II* publicity. The upper ring contains the entire world map. Zoomed-in portions are explored in the larger circles below. All maps are drawn as azimuthal projections.

World Map Configuration Plan

Configuration plans for the world map, towns, and dungeons. Town locations on the world map and peeks inside the dungeons are written here. The hierarchy chart written in the Area Floor Count Configuration Plan displays the number of floors for each area.

▶Early Development World Map

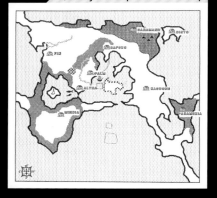

▶ Area Floor Count Configuration Plan

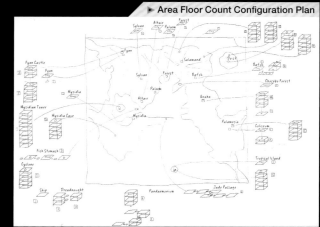

▶Dungeon Configuration

Mt. Salamand	①Rugged walls	②Valley	③Rope bridge
Bafsk Cave	①Stone wall dungeon	②	
Salamand Cave	①Limestone cave	②Flooding	
Kashuan	①Destroyed castle		
Dreadnought			
Deist Cave	①Rugged walls	②Grass	③Small spring in lowest level
Southern Cave	①Vine walls	②Grass	③Water ④Grass ceiling
Coliseum	One monster		
Fynn Castle			
Fynn Underground	①Castle wall dungeon	②Flooding on lowest level	
Mysidia Cave	①Many fenced-in areas	②Grass	③Water
	→ Open on top		
Fish Stomach	①Appears next to the anus in the large intestines		
Mysidian Tower	1F/2F		
	3F	Lava/lava waterfall	Boss
	4F		
	5F	Ice damage floor/ice walls	Boss
	6F		
	7F	Thunder	Boss
	8F		
	9F		
	10F		Crystal
Cyclone	Ice damage	1F-5F in the cyclone	
		6F-7F castle above the cyclone	Emperor
Palamecia Castle	Fall from 7F to 1F, choose floor		
Jade [Passage]	①Limestone cave ②Water ③Grass ④Waterfall ⑤Valley		
Pandaemonium	Corridors of many different levels		

SQUARE

SPRITE MATERIALS

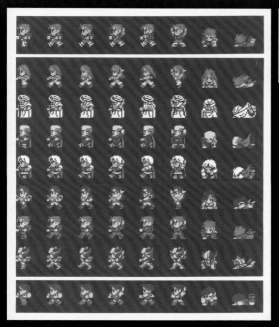

Battle Sprites

Each sprite is composed of six blocks in a 3x2 formation, as indicated in the specs below. Identical blocks are used for parts that have the same numbers on the spec sheet. For example, the "rest" sprite on the far left and the "run" sprite next to it only need to change the bottom two sets of blocks between them.

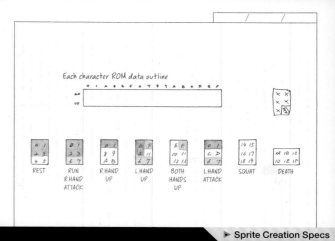

► Sprite Creation Specs

Field Sprites

Character and vehicle sprites as displayed in the field. These use the same four patterns seen in *Final Fantasy I* (seen on page 28). Some of these are not seen in-game, such as the sideways sprites for Emperor Mateus.

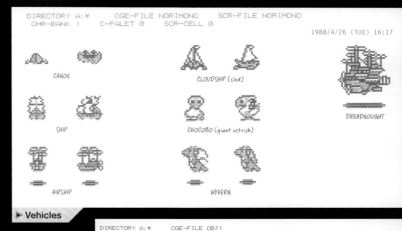

► Vehicles

► Sprite Data

Monster Sprites

Documents about monsters that appear in battle. The Monster Size List shows the sizes for different monsters, and the Monster List features the name, characteristics, and size of the representative monster for creatures of the same shape. There was a battle planned with Leon at this stage in development.

Leg Eater　Vampire Thorn

Hornet　Queen Bee

Snowman　Sasquatch

Icicle　Stalactite　Stalagmite

Astaroth

Emperor

▶ Monster Size List

SQUARE

▶ Monster List

File Name = 'FF2¥MONSTER.FF2'　Tue Apr 12 15:04:18 1988

1. Goblin (S) : A small comrade of the ogres, less than 1.5m in size. Likes dark places like subterranean caves.
2. Dive Eagle (S) : A bird that dives to pluck up prey in the water's surface. Sometimes attacks men on boats.
3. Vampire Thorn (S) : A bloodsucking vine. It mixes in with normal thorns, and once it latches onto prey, it doesn't let go.
4. Soul (S) : They say these dully glowing orbs are the souls of the dead, but no one knows for sure. Erratic and unpredictable, some attack those who walk away, while others heal the wounded.
5. Parasite (S) : A parasitic organism that attaches to a person's chest and sucks out their magic ability. It looks like a stretched-out will-o'-the-wisp.
6. Skull (S) : These often appear at night or in dark places. It uses magic to suck up the energy of living creatures.
7. Doppleganger (S) : A beast composed of a chest only. It clings to other creatures.
8. Hornet (S) : A massive hornet that possesses deadly poison and highly developed mandibles.
9. Slime (S) : A slimy, amoeba-like monster.
10. Killer Fish (S) : A small and vicious fish that attacks in schools.
11. Bomb (S) : A round, balloon-like monster. It self-destructs upon death, damaging those around it.
12. Ruster (S) : A bug-like monster. Touching it makes metal rust.
13. High Guard (M) : The emperor's guard, an elite unit chosen from among the Imperial soldiers. Wears brilliant armor.
14. Wizard (M) : The emperor's mages. Its mind is lost in its power, and it wields the darkest of magics.
15. Ghost (M) : The ghost of a human that bore a grudge while living. Its thirst for revenge is directed at all living things. It shows mercy to none, not even its former family and friends.
16. Vampire (M) : Many vampires are seduced by the lure of power, only to have their spirits drained away.
17. Buccaneer (M) : A pirate that willingly works for the empire. Their vicious behavior is detested by their fellow swashbucklers.
18. Icicle (M) : A creature that pretends to be an icicle, attacking those who pass beneath it.
19. Zombie (M) : A revived corpse with an abnormal attachment to life. Its soul is warped, perhaps out of sadness for the life it left behind.
20. Snowman (M) : Not an actual snowman, but a furry ape man that has become adapted to the ice and snow. They love the piping-hot flesh of the living.
21. Imp (M) : A tiny demon that whispers evil things in people's ears to corrupt them. Though they are relatively weak demons, they can be confounding enemies in battle.
22. Borghen (M) : Borghen.
23. Leon (M) : Leon.
24. Emperor (M) : The emperor.
25. Ogre (L) : A humanoid over three meters in height, and far more primitive than the average human.
26. Land Ray (L) : A ray-like creature that hides in the sand, attacking without warning.
27. Wild Horn (L) : A rhino with a massive horn, which can devastate foes with its violent charge.

28. Malboro (L) : A giant anemone that lures prey with the unusual movement of its tentacles. Many of them live on the shore.
29. Gottos (L) : A humanoid monster with goat horns atop its head.
30. Lamia (L) : A monster that is half woman and half snake. It can transform into a human to fool people into dropping their guards.
31. Gigantoad (L) : A poisonous toad that gouges its victims to inflict a poisonous attack.
32. Adamantoise (L) : A type of tortoise, named for its hard shell. It has a vicious personality, but its shell fetches a high price. Countless people have suffered severe injuries trying to claim one.
33. Killer Mantis (L) : A massive mantis that attacks humans and animals with its sharp mandibles.
34. Death Rider (L) : A knight from the infernal realm of Hell. It rides atop a hellish steed and never dismounts from its demonic partner.
35. Basilisk (L) : A chameleon-like monster that turns anyone it looks at into stone.
36. Antlion (L) : A huge antlion that dwells in the desert and can inflict paralysis on the unwary.
37. Hecteyes (L) : An amoeba covered with countless eyes.
38. Dual Heads (L) : A two-headed giant. It is powerful, but disagreements between its two heads often result in a confused state.
39. Death Flower (L) : A gorgeous, sweet flower that is actually a man-eating predator.
40. Worm (L) : A thin, earthworm-like beast. Many live in deserts, others in water, and still others in the passage to the underworld.
41. Sprinter (L) : A bird with withered wings. It uses two long legs to run with incredible speed.
42. Coeurl (L) : A wild animal resembling a leopard. It has two long feelers that can cause paralysis with a single touch.
43. Chimera (L) : A monster with the body of a lion, the wings of a dragon, the tail of a goat, and three heads belonging to each creature.
44. Sea Dragon (L) : An aquatic dragon shaped like a sea serpent.
45. Gigas (XL) : An ogre more than six meters tall. Gigas belong to a race far wiser than the average human.
46. Golem (XL) : A giant crafted from magic. Its power is overwhelming, and magic performs poorly when deployed against it.
47. Dragon (BOSS) : A powerful monster with wings, sharp claws, and deadly fangs, though its most fearsome weapon is the fire or ice it can spew from its mouth.
48. Behemoth (BOSS) : An enormous, four-legged beast with a majestic, fluttering mane. Its limbs are tough, and the tip of its thick tail is covered in spikes.
49. Tiamat (BOSS) : This evil, five-headed dragon king is said to be the incarnation of a malevolent god.
50. Iron Warrior (BOSS) : A legendary giant warrior. One strike from its sword can demolish a mountain.
51. Beelzebub (BOSS) : A demon from Pandaemonium, shaped like a giant fly.
52. Astaroth (BOSS) : A demon from Pandaemonium, shaped like an angel.
53. Emperor (KING) : The emperor of the Palamecian Empire, who is transformed into a demon after he becomes the Lord of Hell.

Monster Color Assignments

As with *Final Fantasy I* (page 30), three to six colors can be used for enemies onscreen at one time. "Boss" and "king" size monsters appear by themselves, so they get more colors.

MONSTER COLOR

#	Monster				
01	Leg Eater / Queen Bee	16	27	2B	1D
02	Vampire Thorn / Hornet	1B	2B	16	1E
03	Snowman	31	30	23	1F
04	Sasquatch	17	36	19	20
05	Icicle / Sprinter	22	31	30	21
06	Stalactite / Ogre / Dual Heads	18	28	22	54
07	Stalagmite / Land Turtle / Ogre Mage / Dual Deads	18	2C	1C	23
08	Phorusracos / Adamantoise / Ogre Chief	19	29	27	58
09	Wererat	00	10	16	25
0A	Stunner / Revenant / Specter / Chimera	18	28	33	26
0B	Zombie	18	2c	16	27
28	Eyemoeba	19	29	12	41
29	Hecteyes	1C	2C	24	42
2A	Land Worm	0C	1C	2A	43
2B	Sand Worm	17	28	1C	44
2C	Green Slime	19	2A	30	45
2D	Yellow Jelly / Yellow Soul	27	37	30	46
2E	Red Marshmallow / Red Soul	16	26	30	47
2F	Black Flan / Imperial Shadow	0C	1C	37	48
30	Green Soul	19	2A	30	45
31	Vampire Girl / Mantis Devil / Black Knight / Stone Golem	1C	2C	16	49
32	Vampire Lady / Mantis King	19	29	25	4E
33	Emperor	13	28	37	4A
34	Killer Mantis	17	27	30	3B
35	Guard / Wood Golem	07	17	28	4B
44	Behemoth	0C	1C	16	51
		0C	1C	37	52
45	King Behemoth	18	28	1B	53
		18	28	22	54
46	White Dragon	22	3C	25	55
		22	3C	30	56
47	Green Dragon	19	29	16	57
		19	29	27	58
48	Blue Dragon	11	21	25	59
		11	21	37	5A
49	Red Dragon	16	26	22	5B
		16	26	3A	5C
4A	Iron Giant	1C	2C	27	5D
		1C	26	3A	5E
4B	Tiamat	17	27	2C	5F
		17	27	2A	75
4C	Beelzebub	13	23	37	76
		13	23	16	77
4D	Astaroth	19	38	30	78
		19	38	27	79
4E	Emperor	18	28	23	7A
		18	28	16	7B

Battle Background Sprites

Background sprites as displayed in the upper part of the screen in battle. Various patterns have been prepared to suit the terrain. There's even a background for the inside of Leviathan's stomach.

▶ Plains

▶ Forest

▶ Marsh

▶ Snowfield

▶ Desert

▶ Sea

▶ Semitt Falls, etc.

▶ Snow Cave, etc.

▶ Kashuan Keep, etc.

▶ Dreadnought

▶ Southern Islands

▶ Leviathan's Stomach

▶ Mysidian Tower

▶ Cyclone

▶ Pandaemonium

▶ Pandaemonium (Final Floor)

SCENARIO PLANNING

Scenario Outline

A document explaining the new elements of this title. All of these were implemented in the final game. In addition to the Word Memory and proficiency systems, the document describes the constant cycling of playable characters.

– – – Final Fantasy 2 – – –

2MROM
+ 64K CHR-RAM
+ 64K RAM (battery backup)

☆ An RPG adding improvements to the systems from *Final Fantasy*, as well as developing a new story.

☆ Screen composition is the same as the previous game, with the following differences:
1 . Talking mode
When talking with people in towns, you can select and learn specific words from their messages to remember. Players can then ask the acquired words to other people.
2 . RPG growth system
Characters do not get stronger with experience, but through weapon proficiency and magic progression. For example, max HP increases the more enemy attacks you receive, and spells strengthen in power the more you use them.
Thus, player actions give rise to different types of character growth.
3 . Party members
You start the game with four characters, and the party composition changes as the story progresses.
Players take control of nine characters in total, including the protagonist.
4 . Battle formations
In the previous game, the order of the four characters changed how damage was taken, but now each character can be put in either the front or the back row. Only front row characters can deal damage with weapons, and back row characters will not make attacks. Magic can be cast on all enemies or allies.
These parameters will create more realistic and strategic battle scenes.

– – – Main characters – – – ★ Protagonist and comrades (have face pictures)
☆ Other characters (don't join the party)

★ Firion (temporary name)
The main character . . . birthplace unknown, picked up by Leon's parents and raised together with Leon and Maria. Firion's parents were killed in the fight against the Empire. The three characters join the rebels to take their revenge.

★ Leon (temporary name)
The rival. He is captured by the Empire in the first battle, and brainwashed to become the captain of the Dark Knights. Leon appears before the protagonist early in their journey, but they don't learn his identity until later. After the emperor's death, Leon is put on the throne as the second emperor. When the emperor becomes the dark Demon King, Leon returns to normal, and rejoins the protagonist to defeat the Demon King.

★ Maria (temporary name)
Leon's sister. Maria treats Firion like a brother. She loses both her parents and Leon, and is only able to rely on Firion for support. It pains her to learn that her brother is the Dark Knight, but she steels herself and continues her battle against the Empire.

★ Guy (temporary name)
Guy was raised by monsters as a child, which left him with poor speaking skills and made him a target for bullies. Only Firion stood up for him. Guy became unwaveringly loyal to Firion, and grew into a powerful ally.

Those are the four characters you begin with (players choose their names).
(You play as Firion, Maria, and Guy the whole time.)

★ Leila
A female pirate captain who is a bit of a punk and a tomboy. She falls for Firion, but remains a wild woman who loves booze.

★ Gordon
Formerly a prince of the kingdom of Kashuan, Gordon saw his realm annihilated in an Imperial attack, leaving him as the sole survivor. He tries desperately to recover his brother Lysander's fiancée Cynthia, but she doesn't initially respond to his efforts. Over time, Gordon becomes a reliable ally by working with the protagonists.

★ Josef
A blacksmith who lived quietly in the mountains until the Empire kidnapped his daughter. The protagonists rescue the girl, gaining Josef's loyalty. He is very knowledgeable about minerals and helps the party search for the legendary metal mythril. Soon after, Josef sacrifices himself to save the party.

★ Minwu
A White Mage from Mysidia. Minwu possesses great magic power, but his ultimate magic is sealed and cannot be used. He is loyal to the king of Fynn, and is a close adviser to Princess Cynthia. In the beginning, he moves with the protagonists, but he leaves the party when the king's condition worsens. After the king dies, Minwu goes to Mysidia Tower to unlock the ultimate magic, in accordance with the king's final wishes. His whereabouts are unknown, but eventually he reappears in the tower with the protagonists.

★ Dragoon
The last of the legendary Dragon Knights. Once they protected the world, but the Empire's attacks have annihilated all Dragoons but one. Together with his Wyvern partner, the last Dragoon demonstrates great combat skills, but he loses his life at the hand of the revived emperor.

Main Character List

Profiles of the main characters. "Dragoon" under the main characters refers to Ricard, and "Cynthia" in the secondary characters becomes Hilda in the actual game.

– – Other characters – –

☆ Cynthia
The princess of Fynn. Strong-willed, wise, and beautiful, but not the type to ever get too friendly. The so-called "class rep" type and this world's Joan of Arc. She is the commander of the rebellion, but still holds sadness inside of her. Cynthia has lost not only both of her parents in the fight against the Empire, but also Lysander, her fiancé and the prince of the neighboring kingdom of Grahn. That is why she cannot forgive Gordon, the brother of Lysander and the only survivor of the previous skirmish. Eventually Cynthia is touched by Gordon's resolve, and grows to love him.

☆ Cid
An airship captain who takes a neutral stance, siding with either the Empire or the rebels as long as he gets paid. Cid lets the protagonists ride aboard his airship on multiple occasions, and over time he grows affectionate toward them. He perishes in one of the Empire's attacks, but gives the party his airship as his dying wish.

☆ Paul
A thief turned merchant who joins the rebels, Paul is good with his hands and specializes in jailbreaks. He is especially good at running away. Paul is a city slicker who possesses a kind disposition.

☆ Borghen
An oafish commander within the military hierarchy of the Empire. Borghen always seems to come out at the bottom of events, and he is no match for the Empire's elite Dark Knight brigade.

☆ Emperor
The root of all evil in this world. The emperor is a terrible person who controls monsters from the demon world, which he uses to expand his Empire to achieve world domination. After the emperor is killed by the protagonists he becomes the Dark Emperor, obtaining incredible power and resurrecting himself from the depths of Hell.

Story Progression Outline

The main story beats are written here. These developments made it into the final game with few alterations, but some parts are different, notably making your favorite character your comrade in the beginning and the monsters that raised Guy making an appearance.

FINAL FANTASY II STORY PROGRESSION OUTLINE

1) After the battle scene at the start: Protagonist wakes up, reunites with comrades.
 Cynthia's introduction.

2) Altair: Important people there. Of two of them, one becomes a comrade . . .
 Gordon, Minwu, Hilda, Cid, Josef, Paul, Princess Cynthia.
 Ask princess to join the fight, but are rejected due to their youth.
 The princess can use magic if she has the crest of Fynn. The princess wants to use White Magic to save
 her father the king.

3) Meet the rebels under Fynn Castle. (Get the Fynn Crest deep in the underground dungeon.) . . . Show the rebel
 seal at a bar to open the door to the underground.

4) Show the Fynn Crest to the princess, she recognizes the protagonists as warriors. Get a canoe from the royal
 treasury. King of Fynn rests due to illness. Princess cries where no one can see her.

 You hear from the princess . . . The Empire is building a massive warship.
 You can make weapons and armor with mythril from Salamand.
5) Use the canoe to go to Paloom, pay money to ride a ship. Go to Poft . . . put on a disguise, go to Bafsk.

6) Bafsk: When the Dark Knight is there, no one will talk to you. Can't get close to the Dreadnought.

7) Salamand: Save Josef's daughter, earn Josef's trust, get mythril.
 There was the rebels under Fynn Castle. . . . Show the ore mine across the marsh with slaves, but it is currently inaccessible.

8) Cid's Port: Pay money to ride the airship.

9) Bafsk: The Dark Knight switches with Borghen.
 Borghen's an idiot. Get help from the townsfolk to go underground and into the Dreadnought. Head into
 the bowels of the Dreadnought and destroy it.
 Leon appears right before you destroy it. Warp to the World Map (where the Dreadnought takes off).
 At the same time, Leon is yelled at by Borghen. "This is your last chance . . . go to Salamand. Get
 information in Salamand . . . there's a key to Kashuan."

10) Salamand: Borghen is there.
 Josef guides you to the mine when you tell him about the key to Kashuan. You free the slaves, and Josef
 dies.
 Connected to ancient ruins via a tunnel. Get the key to Kashuan.
 Borghen fails again.

11) Kashuan: Use the key to get ___.

12) The princess is captured in Bafsk, along with the airship.
 She panicked at the king's worsening condition, boarded the airship, and was caught along with the
 ship before the protagonists' eyes.

13) Fynn Castle: You rescue the princess and get back the airship!
 Maybe Leon is the fourth member?
 Dreadnought is destroyed.

14) King's death in Altair: Last words with Minwu and the protagonists.
 Gives an item to Minwu, tells him to unseal the ultimate magic.
 Tells the protagonists to go to Deist and search for the Dragoon.
 The princess doesn't seem to be sad?

15) Ride a pirate ship from Altair: The pirate Leila reveals her true colors en route. Eventually becomes an ally.
 You can control the ship yourself!

16) Deist: The Wyvern appears.
 Talk about the Wyvern egg. There are no more Dragoons.

17) Returning to Altair, the princess is acting strange. Very bewitching (she tries to
 seduce you . . . oh my!).

18) Palamecia Arena: The princess is offered as a prize. The princess in Altair is a monster!

19) To the arena: Discovered by the Empire and locked up. Saved by Paul, you escape
 together with the princess.

 The princess learns of her father's death . . . and is paralyzed?!

20) The rebels make a camp next to Fynn. Soon they can take back Fynn Castle.
 Go to the castle with the princess, and defeat Borghen.
 You retake Fynn Castle!

 Minwu hasn't returned from Mysidia . . . the protagonists go to Mysidia.

21) Boat is swallowed by a massive fish on the way to Mysidia (appears if you have an item).
 There's a town inside . . . the people in town all have items. People who try to
 undo the seal . . . a Dragoon is there, too. Afterward, a Wyvern appears and
 both join your party. You escape from the giant fish.

22) Unlock the ultimate magic in Mysidia . . . where is Minwu???

23) When returning from Mysidia, everything but Fynn is in flames . . . the rebels
 congregate at Fynn.

 Cid gives his airship to the protagonists with his dying breath.

24) The Palamecia Empire comes to Fynn Castle. You defeat the emperor.

25) During the celebration, a message comes . . . Leon has taken over as emperor of
 Palamecia.

26) Guy's parent monster: At first it thinks you're from the Empire, but it calms down upon
 seeing Guy and guides you through caves to Castle Palamecia.
 Cave to Palamecia.

27) Confront Leon in Palamecia. Just then . . .

28) The emperor revives, and Leon regains his senses.
 Pandaemonium floats up.
 The emperor is revived from Hell. The Dragoon tries to distract the emperor . . .
 "Go, run." The Wyvern carries the party off and dies in Fynn.

29) Confront the emperor . . . four of you, together with Leon.

30) The end . . .

Opening Storyboards

Storyboards of the event that occurs after Firion wakes up in Altair following his defeat by the Black Knights. Effects and dialogue are simplified in the final product. Hilda leaves the room with Minwu, leaving Firion to wake up alone.

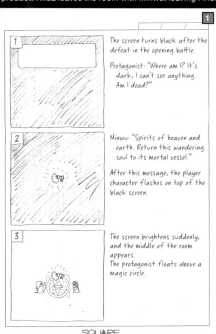

1

1 The screen turns black after the defeat in the opening battle.

Protagonist: "Where am I? It's dark, I can't see anything. Am I dead?"

2 Minwu: "Spirits of heaven and earth. Return this wandering soul to its mortal vessel."

After this message, the player character flashes on top of the black screen.

3 The screen brightens suddenly, and the middle of the room appears.
The protagonist floats above a magic circle.

SQUARE

2

4 The flashing protagonist slows down into the center of the magic circle and the flashing stops.

5 Minwu walks over to Hilda.

Minwu: "His consciousness has returned. He should awaken before long."

Hilda: "You must be tired. Please go and rest."

6 Minwu turns away from Hilda and descends the stairs.

SQUARE

3

7 Hilda: "You're okay now. Your wounds have been healed. Now then, awaken."

8 The protagonist stands up. They press the A button to talk to Hilda.
Hilda: "Your friends are waiting below. Please show them that you are all right."

9 Hilda descends the stairs.

SQUARE

Early Plot

A draft of the scenario written during development. Details of the plot and the order of events are arranged here. The final story was based off of this document.

File Name = 'C:STORY¥STORY.DOC' Fri Mar 11 10:55:06 1988

********** INTRODUCTION **********

Firion never knew his mother or father, but was raised by Leon's parents. The two of them got along like brothers and grew up together.

The Empire formed during their adolescence, but that passionate pair wouldn't sit back and do nothing. They invited their friends Guy and Maria to travel on a journey to take down the Empire.

In their youth, they knew nothing of war. What's more, the opponent they faced was the evil Borghen, the self-proclaimed "right hand of the emperor." He attacked the children without mercy.

Firion fell unconscious, and was on the brink of life and death. When he awoke, he first thought that he had passed on, for before his eyes stood a beautiful woman.

"You're all right now. We have healed your wounds. Now awaken."

When he wakes, he feels no pain. The wounds he received are healed. He realizes that another person is there besides the woman: a Mysidian White Mage, who must have healed Firion's wounds. Having confirmed his well-being, the mage leaves the room without a sound.

"Now then, go home."

With those words, the woman also departs. Firion is the only one left in the room.

He hears a disturbance outside. Slowly, Firion stands up and peeks through the door. Dozens of men and women stand talking, and one of them turns to look at him.

"Firion!"

It's Maria, and Guy is with her.

"You're alive!"

The two of them had barely escaped with their lives. Firion asks about Leon, but the two shake their heads. Guy says,

"I saw them take Leon."

The three of them hope he is still alive, even if it means he is in chains.

"Attention! Her highness, Princess Hilda of Fynn!"

In response to this declaration, even Firion stands at attention without knowing why. The door inside opens and a woman appears adorned in armor. It is the same woman who talked to him before! Without concern for his surprise, the woman speaks.

"I'm very happy that you would all stand against the Empire. Once, this continent had seven prosperous countries. But because they would not work together, they were conquered by a single land.

"The first was Fynn, my homeland. The holy knights fought valiantly against the monster hordes, but they were overwhelmed. They were defeated and torn to pieces.

"Deist's Dragoons have been wiped out.

"In Kashuan, many brave warriors died to protect their people.

"The magicians of Mysidia ran away without fighting. Altair and Salamand fell with hardly a fight.

"Now everyone lives like slaves, but we still hope to overthrow the Empire's rule. This feeling will surely sustain us.

"I hope you all fight brilliantly as freedom fighters, and I hope that you may live through this conflict."

Hilda turns to leave, and many people follow.

"C'mon, let's go too!"

Rebel Base (Altair)
Port (Paloom)
East Islands
Deist Cavern

********** THE DRAGOON **********

Firion's party hears a rumor that one of Deist's Dragoons still lives, and goes between Altair and Paloom to gather information. They are tasked by Princess Hilda with finding the last survivor.

They meet a Wyvern, but they cannot understand what it says, and neither can Hilda. They have to go to Deist to learn about Wyverns, and so they head off.

The Dragoon's cave is enveloped in darkness. Faint cries can be heard here and there, of people lost in their sadness. One child proclaims, "I'll become a Dragoon for sure!" His mother panics and looks around to see if they were heard by the soldiers.

Finally the party gathers information: the Dragoons all have pendants, and a secret room exists inside the Dragoon's cave.

In the Wyvern cave, the party finds a Dragoon's corpse. After saying a prayer, they take his pendant and go to visit the Wyvern. When wearing the pendant, they can understand its language.

"My name is Opal. At least that's what you humans call me.

"The Wyverns have not been wiped out. Our eggs are somewhere in the East Islands.

"Only those that lay eggs that year know where the eggs are. This is the greatest secret of the Wyverns. I must find out where they are and protect them.

"For my fellow Wyverns, and for the world, please give me your help."

Firion gladly concedes to this request, and heads to the Wyvern cave with Opal.

A woman who saw Opal at the Dragoon cave says, "Emerald? Emerald! You're okay . . . Oh, you're not Emerald . . ."

It's a hint that the eggs are in the Wyvern cave. Looking at the Dragoon's body, Opal sheds a tear.

They find a mural depicting the location of the eggs in a hidden room. After memorizing the location, Firion destroys the mural.

On the way back, the party encounters someone unexpected: their friend Leon. But he is no longer his old self.

"Leon!"

"I'm glad to see you all alive. My life was saved by my masters in the Empire. Leave that pendant and Wyvern, and go. I will spare your lives. You are my friends, after all."

"And what do you plan to do with him?"

"Him? Oh, the Wyvern. That has nothing to do with you."

"We can't let you do this. The Wyvern is our friend."

"In that case, I can't let you leave. Get them!"

The party defeats Leon.

"We'll meet again sometime, Firion."

He leaves with those parting words.

The East Islands float to the east of the continent. They go to Paloom to board a ship. There they meet Leila, a captain who lets them ride in her ship. In truth she's a pirate, but she does not reveal this.

They arrive at the island and find a shrine at the entrance to the dragon valley, where the party is asked three questions. They get through unharmed and enter the valley, where they find many eggs. Some have already hatched, and several babies are crawling around.

There is a mountain of treasure in the adjoining cave.

"I'll stay here and look after the young ones. Thank you so much. Please take this treasure as a sign of our thanks."

The opening, including part of the story about the Wyvern egg. The Wyvern appears in the final game in Deist, but during early development it showed up in Altair and went by the name of Opal. Opal the Wyvern was planned to reunite with Leon while searching Deist.

********** THE SHIP **********

On the way back from the island, Leila shows her true colors.

"Give us everything you got, if you value your lives!"

But the pirates can't beat this group.

"Dammit! If you're gonna kill us, then do it, already!"

"You seem a bit more ladylike now."

Leila blushes when Firion says this.

That night, the sea suddenly turns violent.

"It's the Leviathan!" the pirates are all shouting.

"The Leviathan?"

Leila answers Firion's question.

"It's a massive sea monster. There's always a storm when it appears. They say it's been around even longer than Kashuan. Now get into the cabin and don't move. We'll drive it off."

"Let us help somehow."

Leila thinks for a moment, and says,

"In that case, man the helm! You look like you've got the muscle for it."

He runs to the stern and takes the wheel.

The next morning, Firion looks out at the unnaturally calm sea, and thinks on all of the wonders of the world.

********** TRAVEL COMPANIONS **********

Firion meets all kinds of people. I will introduce some of his traveling companions here.

Cid. Captain of the airship *Enterprise*. The man is a friend to the rich, and treats the poor with disdain. As long as you have the money, he'll take you to the most dangerous places on his airship. Cid's connection to the rebellion is just business. He looks down on Firion, who is passionate about combat, but his attitude slowly changes as the battle continues.

Paul. Head of a thieves' guild in Lamballe, where he gathers information from all over the world. Like Cid, all he cares about is money. Still, he interacts with Firion like a parent would with a son.

Minwu. A mage of Mysidia who brings Firion back from the brink of death after the first battle. A powerful magician who seems to know the future, but he doesn't like hurting the living and never wields spells that can do so. He offers Firion the same warning time and again: "Going down the path of carnage makes you like the emperor! I see a bit of him in you!"

Gordon. Prince of Kashuan, whose older brother was betrothed to Hilda. When his people stood and fought, he ran away in fear and was the only survivor. Now he lives the life of a drunken lush out of shame. He cannot even look Hilda in the eye. When invited to join Firion, he says,

"Really? You'd let a useless piece of trash like me join you?"

As the adventure progresses, Gordon's lost confidence returns. Eventually he regains Hilda's trust, and works together with her to restore the world.

Hilda. Crown princess of Fynn, and a brave Holy Knight who became leader of the rebellion. She feels a deep hate in her heart for the Empire that harmed her father, mother, brother, and fiancé. She treats Firion with kindness from the start. Even though he misinterprets said kindness, she never thinks of him as anything more than a good friend. At first she despises Gordon, but his bravery and resilience eventually move her heart.

Aile. A gypsy fortuneteller who travels the land. You can visit her when you don't know what to do and she will put you on the right path. Her true identity is that of the former queen of Palamecia, and the emperor's mother.

********** MYTHRIL **********

Firion's adventure with the Wyvern ends, and they return to the rebel base at Altair. The treasure they brought back from the Wyvern's cave is a great boon to the rebellion. But there's still a problem: they are lacking in weapons and armor.

Having heard of the elusive metal mythril, they bring that information to Hilda.

"I've also heard of mythril. The man to talk to about it, Josef, was dispatched to Salamand, but we haven't heard anything from him since then."

"There are all sorts of mines in Salamand. It's a very important region, and it seems the Empire is keeping a close eye on it, too."

"We should try getting in touch with Josef," says Firion.

They arrive in Salamand and find Josef, but he doesn't trust them. Even when they show him the seal they got from Princess Hilda, he still doubts them.

"I'll believe you, if you attack the Empire's lookout post in the ore mines."

Firion's party has no choice but to go in and defeat the enemies. They find a captured girl inside, and bring her back to Josef's place.

"Papa!"

"Oh, Nelly! I'm so glad you're safe!"

The girl dives into Josef's arms.

"I'm sorry. I knew I could trust you all . . . It's just that my daughter was taken hostage and I didn't know what to do. I'm so grateful . . . thank you.

"I've looked into the mythril for you. Apparently there's an abandoned mine full of it."

They go to the mine, but when they bring back a promising piece of metal, Josef says,

"Sorry, but that's not mythril. Looks like I should've gone with you."

The party bring Josef with them this time, finally getting their hands on some mythril.

However, someone blocks their path on the way out. Leon.

"We meet again. How about it, won't you come and serve the emperor? If you do, we won't have to cross swords like this. We're best friends, aren't we?"

"What are you saying? Wake up already! Did you forget our pledge to defeat the emperor and be free again?"

"I said it. And what protects freedom? Strength, that's what. Strength is what guarantees personal freedom. The Empire is giving me that strength. You'll agree once you see His Majesty's power, Firion."

"I don't care how strong the emperor is, I'll beat him! If you plan to get in my way for the sake of the Empire, I won't regret it if I have to take you down myself! Bring it, Leon!"

Firion casts aside his feelings for his brother. Leon flees again, and the party returns safely to Salamand.

"Now then, I'll make a bunch of weapons for you from this mythril."

Josef returns to his blacksmith profession. Soon, excellent mythril weapons and armor start making their way into the rebel forces.

This includes details from Leila's attack to the party's acquisition of mythril, and introduces the important secondary characters. The section about getting mythril immediately after searching Deist is particularly notable. The character Aile did not appear in the game. She was to be a fortuneteller, and the mother of Emperor Mateus.

********** CASTLE OF TRAPS **********

The rebels step up their activities and attack Imperial troops here and there. Still, neither side is willing to set foot in Kashuan Keep. That ancient castle is littered with traps, and those who enter do not make it out alive.

Gordon, prince of Kashuan, relies on his memory to draw a simple map. You enter the castle with him, making your way deeper while dodging traps. "We can't go any further than this. Even I don't know what's beyond here."

Gordon's voice is a bit uneasy.

(We don't actually know what's beyond there ourselves.)

Firion brings back treasure and (something important) from Kashuan Keep. He finally gets a chance to meet the emperor.

The winner of the tournament held in Palamecia will receive a symbol of victory from the emperor himself.

"This has to be a trap."

Everyone tries to stop Firion, but he says, "This is my chance to meet the emperor directly. I want to see him with my own eyes. Don't worry, I won't do anything stupid. This isn't an enemy I can defeat on my own." Cid delivers the party to Palamecia on his airship. Cid says, "You're a strange guy. I'll wait three days, if you're not back by then, I'm leaving."

********** THE COLISEUM **********

When they get to the arena, Firion is asked his name by the soldiers.

"It's Colm."

He gives a fake name, hands over his equipment, and enters the arena.

A giant dinosaur enters into the arena. Participants have to defeat this beast with nothing but a single sword. Brave men dive in one after another, but they can't stand up to this dinosaur.

"Next, the brave Colm!"

Finally it's his turn. Far from being worn down, the beast has gone on a rampage. Firion has closely watched the battles up to now and knows that the most dreadful of the dinosaur's attacks is its tail strike. He has surmised that he can beat it if he can beat that attack.

Firion keeps his guard up, and when the dinosaur swings its tail, Firion dodges and stabs the creature. Eventually, the seemingly immortal dinosaur falls to the ground.

Firion climbs the stairs amid applause. Ahead of him, the emperor sits on a magnificent throne.

"I extol your peerless strength . . . Do you think you can kill me with that sword, Firion?"

Firion is shocked to have his identity revealed, and takes the emperor up on his challenge. He swings his sword, but it stops a hair from his enemy. The emperor smirks, raises his hand, and blasts Firion with tremendous force. Soldiers surround Firion and take him to jail.

In jail, Firion's mind and body are assaulted by pain. Thinking he might rot away in this cell, he bursts into tears.

When he comes back to his senses, Firion scours the walls for a way to escape. He hears a soft noise in a crack in the wall. The noise gets bigger, and soon the wall begins to crumble. Firion backs away.

The thief Paul pops out from the other side.

"I went to visit the stadium, and what did I see but you getting captured. Jeez, what a reckless guy you are. Here, drink this medicine."

Drinking the medicine replenishes Firion's stamina.

"Right, now let's get out of here. Oops, almost forgot."

Paul takes out some chalk and writes "The emperor is a piece of @#$!" on the jail wall.

They get back Firion's equipment on the way out, picking up an amazing sword as well.

********** THE SPY **********

A little while after Firion returns, he is ambushed by rebel forces. Everyone thinks that there's a spy among them, and they suspect Firion.

"He only came back because he made a deal with the emperor!"

"He grew up with Leon!"

The boy takes a stand to clear himself of these suspicions.

********** LIBERATING SLAVES **********

Borghen is using slaves from Salamand to speed up the pace of his mining operation.

The rebel war council decides to free the slaves.

The plan succeeds, but Josef loses his life.

The mine starts to shake, and the whole thing starts to come down. A boulder large enough to block their way out falls, and Josef catches it with his body.

"Go on through, quick!"

They escape one after another.

"I'm glad I met you. Please . . . take care . . . of Nelly . . ."

Josef is crushed by the boulder.

********** THE DREADNOUGHT **********

Hilda is on Cid's airship when it is captured by the Empire's Dreadnought. Firion infiltrates the airship docked at Fynn in order to rescue the two of them.

They go around the ship and rescue Cid.

"Hilda was taken by Borghen."

They destroy the ship's engine, and escape on the *Enterprise*.

"Damn, the engine won't start."

The engine turns over in the nick of time. They destroy the wall and fly off, and the Dreadnought goes up in a massive explosion behind them.

********** HUMAN CHESS **********

They seek out and enter Borghen's estate. Borghen is waiting for them.

"I thought you'd come here. Now then, into this room."

When they enter the adjacent room, the floor is laid out like a chessboard. Hilda is surrounded by monsters.

"Whoa there, don't be hasty now. I just want you to play a game of chess with me. If you win, I'll give back the princess.

"The rules are simple: You will have a real fight when you land on the same space as an enemy."

Firion's team takes up their position. Borghen has a lot of pieces on his side, but you only have four. And who is standing in the queen's spot but Hilda, with a glassy look in her eyes!

********** THE EMPEROR'S DEFEAT **********

The emperor comes to the frontlines, all the way to Fynn Castle. Gordon makes a suggestion.

"I'll command our forces to divert the enemy. You enter the castle and defeat the emperor."

Firion's party makes a suicide run into the castle and defeats the emperor in an amazing come-from-behind victory.

A celebration begins, and everyone is in great spirits. But then, a notice arrives.

Leon has decided to continue the battle as the emperor's heir.

********** THE EMPEROR'S RETURN **********

Firion heads to Castle Palamecia to settle things with Leon once and for all. There, a predestined battle begins, but a black fog-like wraith suddenly appears amid lightning and earthquakes.

"Mu-hahaha! Long time no see, Leon."

It is the unmistakable voice of the emperor.

"I died, and went to Hell. There I received the ultimate power, and was resurrected. Behold my power!"

The quakes grow even stronger, and next to Castle Palamecia a terrifying fortress juts from the earth.

"I will kill all living things, and destroy the world! Haha, bah-haha, ahhh-hahahaaa!"

The emperor disappears, and a bizarre silence remains.

"This is a nightmare. The emperor has returned as a demon."

Leon mutters to himself.

"Well, Leon, did you see that? The emperor has returned. Do you plan on turning into that, too?"

Leon ponders Firion's words.

"I can't fight with you all, not now."

"That's not true. Things have changed," says Guy.

"That's right, Leon. Besides, we're friends, aren't we?" cries Maria.

Leon sheathes his sword.

"And what about you, Firion?"

"Goes without saying, doesn't it?"

The two shake hands.

********** THE FINAL BATTLE **********

The emperor has returned as a demon to threaten the world. Knowing this, Minwu agrees to unseal the mage tower.

Leon joins you as an ally, and with the ultimate magic in hand you defeat the emperor once and for all.

********** OTHER **********

@ The story of Hilda rethinking how she feels about Gordon.

@ The story of Aile and the emperor (mother and son).

@ The fate of Leon and Firion.

@ Putting Guy and Maria into the story. Guy is a cool-headed magician. Maria is a lively archer.

Each scene focusing on the conflict against the Empire and Emperor Mateus, like the Coliseum and Palamecia Castle. Certain scenes got cut from the final game, such as Firion accused of being a spy, and a human chess game played with Borghen. At this point in development, Guy was proficient at magic and had a cool personality.

Pandaemonium Escape Storyboards

Storyboards for the escape from Pandaemonium after the emperor's defeat. Opal the Wyvern appears as the keep crumbles, exchanging comical banter with Firion as they fly into the sky.

1

Pandaemonium top floor

The emperor is beaten.
Emperor: "Firion, I'll make you my companion, too."

A shrill sound rings out.

Protagonist: "Wow, what a show."
"But what should we do? The door is closed . . ."

Sprite when falling

BGM plays when it falls

The Wyvern suddenly flies in out of nowhere . . .
Opal's come to the rescue!

Protagonist: "Hey, Opal! You all right?"
Opal: "Now's not the time to be so nonchalant!"

SQUARE

2

Opal: "Now then, get on my back quickly."
Protagonist: "Your scales are as hard as ever."
Opal: "Quiet. Shut your mouth and hold on tight."

Opal: "Wahooooooo!"

Protagonist: "That was a close one."

Opal: "You'd better be grateful."
Protagonist: "Ah, whoops. One of your scales came off."

SQUARE

PROTOTYPE PLANNING

Several sets of planning materials made early in development. These can be considered *Final Fantasy II* prototypes, since they date from before the story was finalized. These are full of ideas that never saw the light of day.

********** STORY **********

Basil the 2nd, king of Altair, has three sons: the eldest Philip, the second child Richard, and the youngest Roger.

The king is wondering who to make his successor. In the natural course of things, Philip would be the next king, but he dotes on Roger the most. Knowing the king's plight, the court splits into two factions. If the prince they back becomes king, their positions will vastly improve.

Following the laws of royal succession, Philip has the advantage. What's more, he is a knight of superior valor, standing out from the many generals of the kingdom.

Roger's greatest ally is the king himself, but many unsavory types gather at his side to concoct their schemes.

The middle child Richard has no desires of his own and gives up, becoming a frontier commander to escape this conflict.

The neighboring Empire wasn't going to let this opportunity pass them by. Minister Heinrich from the kingdom of Elude heard that this was a good chance to expand their power into Altair. Under the right circumstances, they could even move their armies . . .

Some observed this human strife with glee, namely the monsters in the wild wastes on the other side of the Wall Mountains.

They had been chased into the wastes by humans, but they sometimes snuck into Altair and Elude to cause trouble. Centuries ago the human heroes Firion and Aile vanquished the monsters, and they have not had a proper invasion since.

Then, someone appears to unite the scattered monsters: Dole, daughter of the evil dragon Gawain, who was killed by Firion in the previous battle. She burns with a thirst for revenge against humanity. But her wounds from the previous battle are deep; even with the combined power of all monsters, a frontal assault would be difficult. But with this internal strife, she found one who would cooperate with monsters . . .

[Scenario Ending Conditions]
1 : The monster faction is defeated (Dole dies).
2 : The human faction is defeated (both countries are destroyed).

The ending changes depending on the situation when you finish.
(Ex.) Whether any of the princes still live.
How far the monsters have conquered.
Your status (title, wealth, etc.).

[Development]
1 : Player actions will affect good/evil and fame parameters.
2 : Player conditions will affect the people (monsters) that become allies.
3 : Events will occur on the timeline conforming to conditions.
4 : Allies will move differently depending on their degree of trust.

[Characters]

Basil the 2nd	:	King of Altair. Indecisive due to old age.
Marguerite	:	Basil's first wife who birthed three princes. Dying of illness.
Elizabeth	:	The present queen. Saddened by the conflict of her stepchildren.
Philip	:	First prince. Insists he is the successor by law.
Richard	:	Second prince. Joins hands with Heinrich to vie secretly for the throne.
Roger	:	Third prince. Tempted by schemers and believes in meritocracy.
Waylan	:	Statesman of Altair and mage. Part of Roger's faction.
Hasim	:	Statesman of Altair and monk. Part of Philip's faction.
Margus	:	Imperial knight captain and loyal subordinate to Basil.
Heinrich	:	Elude's commander. He's trying to use Richard.
Joan	:	Heinrich's daughter and Philip's fiancée.
Jamil	:	Roger's attendant. Schemes to make a deal with monsters.
Mueller	:	Richard's subordinate who hates Heinrich.
Botam	:	Destructionism high priest working with Heinrich.
Monk	:	Blind female monk (Grue). Expounds on the dangers of evil.
Leon	:	Part of Bamberg and a famous knight.
Paul	:	Leader of Altair's thieves' guild. Information broker.
Kesey	:	An odd magic user.
Hilda	:	Female knight. Her mother was taken by monsters, so she hates them.
Josef	:	A brazen strongman, but friendly.
Leila	:	Female thief. Only cares about money.
Knave	:	Priest of destructionism.
Gordon	:	A cruel bounty hunter.
Minwu	:	Man aiming to be the ultimate mage.
Rigel	:	Cold-hearted Dark Knight.
Firion	:	Legendary hero. Gave his life to defeat Gawain.
Aile	:	Was a powerful female mage. After Firion's death, her whereabouts are unknown.
Gawain	:	An evil dragon. Gawain's bloodline is being killed off.
Dole	:	Gawain's daughter. She survives and holds a grudge against humans.
Seager	:	Dole's son.

Plot Summary and Characters

Explanations of the story and its characters. The plot revolves around a battle for succession in the kingdom of Altair. Aside from character names, this version shares almost no similarities with the final game. Thematic elements such as the passage of time, how story progression varies depending on conduct, the dragon parents Gawain and Dole, and more also eventually made it into Square's *Romancing SaGa* series.

ITEM

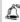 MIRROR
Joshua is trapped inside. Use in front of a mirror in a certain castle.

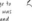 CLOAK
Wearing this lets you cross the thunder plateau without taking damage.

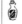 BELL
A bell cursed by a White Mage to keep monsters away. The bell was taken from the town church and hidden somewhere, allowing monsters to invade the town and make the townsfolk their servants.

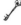 SCARF
Embroidered with the royal family crest. Lets you enter the castle.

RED WINE
Pour this on a certain thorn to make a legendary purple rose bloom.

 CHAIN KEY
You must use this to undo the lock on a magic chain in order to rescue the king.

 LEATHER ENVELOPE
Roast this in holy flame to make a spell appear on it.

CHESS PIECE
The swordswoman princess of a certain castle casts magic on monsters, turning them into chess pieces.

 BLACK ARROWHEAD
Proof of a certain person's strategy.

 MASK
Held by Cynthia. Use this in a dark dungeon to let you see the unseen.

 BLACK CANDLE

 BLOOD
If you investigate the large sculpture in front of the wall, it moves and leads to a tough battle. But if you use the Naga's blood without checking it out, the sculpture destroys the wall and reveals a hidden passage. Can be obtained by defeating a dark lord.

SQUARE

Key Item Ideas

Proposals for items that move the story along. Names, illustrations, and effects are written here. The bell and mask remain in the game in shape only, and their roles have changed completely.

Various Species

Descriptions of the species appearing in the prototype. You can see a moogle-like creature called a "Kryon." The Kryon graphic was altered and used for the Giant Beaver, while the Cinidician graphics were used for the natives of the Southern Islands.

► Species Settings

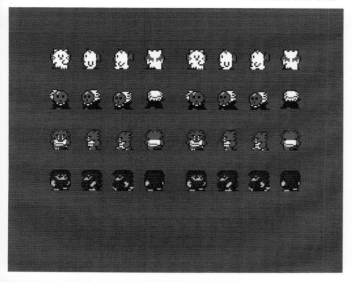

DIRECTORY A:¥ CGE-FILE 11-4-B SCR-FILE 11-.
 CHR-BANK 3 C-PALET 0 SCR-CELL 0
 1987/12/18 (FRI) 14:52

► Species Sprites

KRYONS — A bipedal bat-like creature with white fur. Lives in cold, icy areas. They are nomads that move in groups known as milds.
Once every three years, a group of Kryons go out to the edge of the ice lands for trade, marriage, and fishing. This land is a holy land. They obey their leader, and go to warm lands during the winter. Exchange pelts.

RYUUBINES — Sometimes trade with humans. Hate werewolves. Have an abundance of metal weapons (silver lances, silver swords, silver arrows, etc.). Each elder has their own faction. They're nomads who build log cabins wherever they are. The cabins are built with a large bonfire in the center.

CINIDICIANS — They live under a city lost in a desert. They have bone-white hair and wear colorful masks based on birds and animals. They have infrared vision. Cinidicians have forgotten that the rest of the world exists.

SHALGAGS — Have brown hair and beards and move between the trees. If one is killed in the forest, it becomes a cursed wasteland for seven years.

✳ Note: talking to creatures other than humans requires a ring imbued with knowledge (the Ring of Intellect). The ring will interpret for you.

You can ask about information unknown to humans, and make exchanges for hard-to-get items.

SQUARE

Event and Gimmick Ideas

Various ideas about in-game events and gimmicks. Several ideas include how they should appear in-game. The previously mentioned species and key items are included among these ideas.

Push A button. Corpse sprite character.
The fallen man stands up with vigor, and undergoes a startling transformation before your eyes.

His face warps, his skin turns black and wrinkled, and rots until nothing but bones are left.

His eyes burn red, and long fangs jut from his mouth. A zombie?

BATTLE

Push A button
A/The sprite character's corpse

The forest of thorns damages with every step, but there's a legend that purple roses once bloomed here. Thorns where these have bloomed are said to "return light to those without light."

You enter the mirror which contains a dungeon, but the inside is pure white. You can't tell where the walls are.

Color the whole thing white with BG palette 012. 3 is the mirror palette.

But if you use the black candle here, you can see the walls and floor made in the mirror.

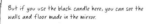

SQUARE

SQUARE

FINAL FANTASY II
MEMORIES

Firion: Where am I? Leonhart! Maria! Guy! Where are you?

An overwhelming difference in strength . . .
Comrades trounced by Black Knights.
—IN THE OPENING

Testing out learned words and asking people about "Wild Rose."
—IN ALTAIR

Tobul: What could you want with me? I'm just an old man...

Ask
Learn
Items

Wild Rose

Rebel curs!

Suddenly calling out to Imperial soldiers only to be assaulted by captains.
—IN FYNN

Cycling confirm and cancel, or attacking allies to increase ally proficiency.
—IN BATTLE

Firion 2 Hits HP 50/ 74 MP 5
46/ 55 13
Guy 27 Damage 78/108 5

You found a chocobo!

Ask
Learn
Items

The first hidden path in the *Final Fantasy* series. Time to rub up against suspicious walls from now on . . .
—IN FYNN

Finding a chocobo in the deep woods south of Kashuan Keep.
—IN CHOCOBO FOREST

Finally obtaining the all-powerful Ultima, its strength almost incalculable.
—IN MYSIDIAN TOWER

The new menace even more dangerous than the Dreadnought. Emperor Mateus assaults city after city with the Cyclone.
—NEAR FYNN CASTLE

Josef, Minwu, then Ricard . . .
So many lives sacrificed in battle . . .
—IN PALAMECIA CASTLE

Defend yourself, or your party faces annihilation. Petrify and Death afflictions everywhere.
—IN THE JADE PASSAGE

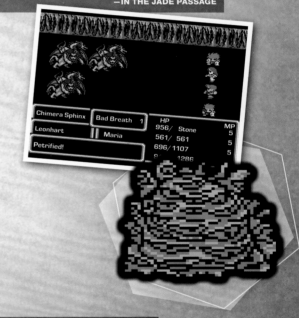

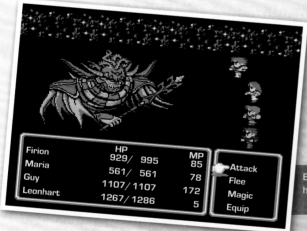

Emperor Mateus returns from Hell. Send him back where he came from!
—IN PANDAEMONIUM

DS/Smartphone/PSP Version

FINAL FANTASY III
ファイナルファンタジーⅢ

Expanded tactics with the job system

The most prominent feature of *Final Fantasy III* is the job change system, allowing players to progress through their adventure while swapping character abilities to suit the situation. The youths chosen by the crystals as the Warriors of the Light join the battle between light and darkness for the fate of the world. From the DS remake onward, the four protagonists are given names, personal histories, and other traits.

Famicom	Nintendo DS	Nintendo DS (Console Bundle)	Nintendo DS (Ultimate Hits)
Final Fantasy III	**Final Fantasy III**	**Final Fantasy III Crystal Edition**	**Final Fantasy III**
Launch Date ● April 27, 1990	JP Launch Date ● August 24, 2006 NA Launch Date ● November 14, 2006	Launch Date ● August 24, 2006	Launch Date ● October 23, 2008

Wii/Wii U (Virtual Console)	iPod touch/iPhone	iPad	Android
Final Fantasy III (Famicom Version)	**Final Fantasy III**	**Final Fantasy III for iPad**	**Final Fantasy III**
Launch Date ● July 21, 2009	Launch Date ● March 24, 2011	Launch Date ● April 21, 2011	Launch Date ● March 1, 2012

PlayStation Portable	PlayStation Portable/ PlayStation Vita (Digital Download)	PlayStation Portable (Limited Edition)
Final Fantasy III	**Final Fantasy III** (PlayStation Portable Version)	**Final Fantasy 25th Anniversary Ultimate Box**
JP Launch Date ● September 20, 2012 NA Launch Date ● September 25, 2012	JP Launch Date ● September 20, 2012 NA Launch Date ● September 25, 2012	Launch Date ● December 18, 2012 ✢ Square Enix e-Store Limited Edition

ART

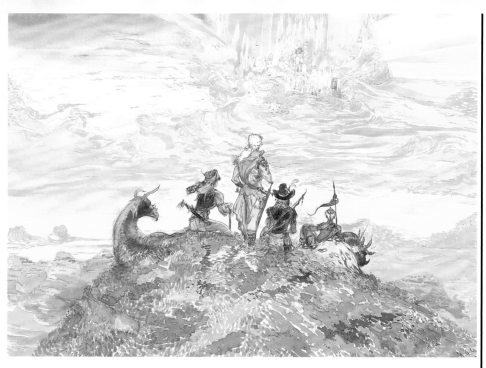

Illusory Castle

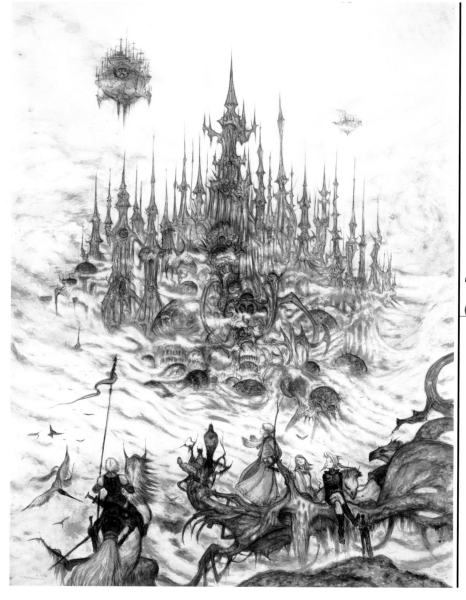

The Crystal Tower
(DS package illustration)

Comrades

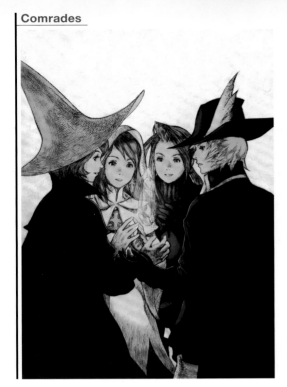

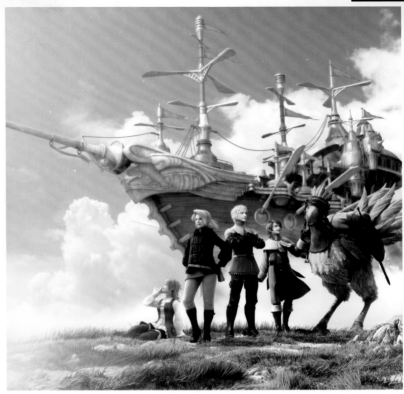

**Comrades
(PSP package illustration)**

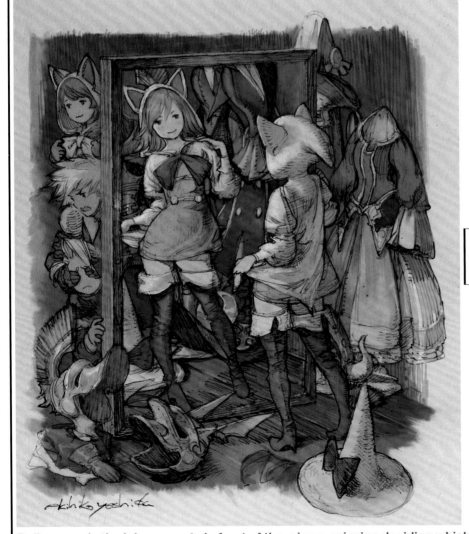

The theme of this illustration was chosen in a campaign carried out in conjunction with the PSP release, and drawn by Akihiko Yoshida, character designer for the remake. Users participated in the campaign online and offered ideas and votes via Twitter.

Refia spreads the job garments in front of the mirror, enjoying deciding which one to wear

Arc	Run Away	HP
	Arc	100/ 167
Escape attempt failed!		89/ 161
		124/ 150
		65/ 157

Ahh...the power of darkness is a thing of beauty, a black tapestry of chaos!

Cough ...Please!
You must bring me to the Temple of Water!

A hearty helping of thanks upon you!
We thought we were done for!

FINAL FANTASY III
STORY

I am Ragnarok, the Demonblade.
Let us test your strength and see if you are worthy!

Oh, my, did I sleep well...
Parrot! On my shoulder, now!

Hah hah hah...
This is the world of darkness...you cannot defeat me with only the power of light!

In a world of light protected by the four crystals, humans once stood at the pinnacle of prosperity, building an advanced civilization of floating continents. But the ancients overused the power of the light, triggering a terrible calamity. The power of the light ran wild, flooding the world and shattering the natural balance between light and dark. The Cloud of Darkness was summoned to return the world to nothingness. Faced with imminent doom, the crystals selected warriors from the worlds of both light and darkness.

Warriors of the Light and Warriors of Darkness fended off the Cloud of Darkness and returned stability to the world.

A thousand years passed . . . and danger returned to the world that had emerged in the ruins of the old one. An earthquake shook every region, causing the light of the crystals to go out. Monsters with the power of darkness started rampaging throughout the land. The Wind Crystal entombed within the earth used what little power remained, entrusting hope to the Warriors of the Light—hope that may yet save the world from ruin. These warriors are four youths from the remote village of Ur.

FINAL FANTASY III
STORY AND CHARACTERS
CHARACTERS

‡ Images are from the PSP version
REMAKE Characters or relationships only appear in the remake

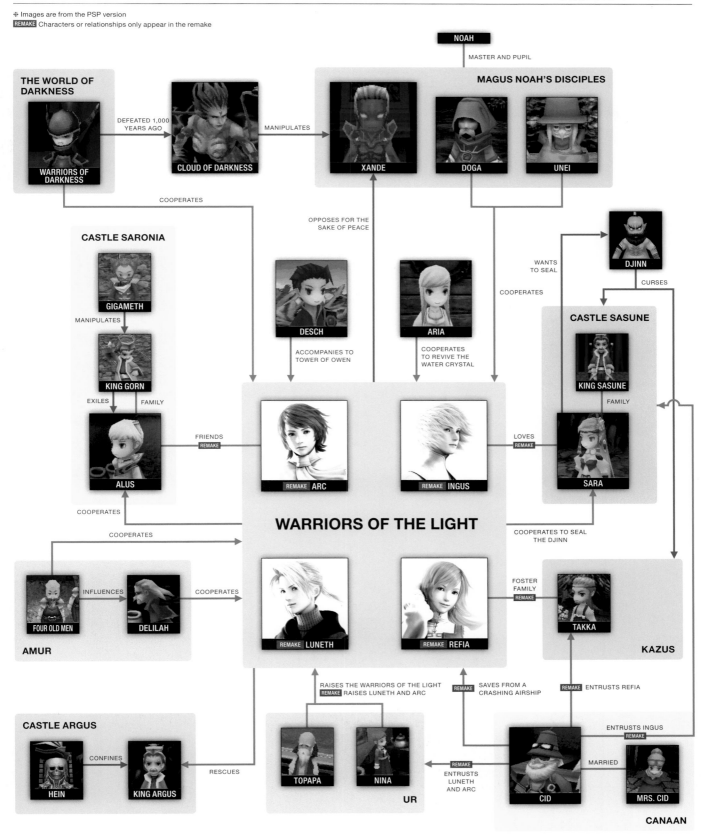

NOAH

MASTER AND PUPIL

THE WORLD OF DARKNESS

WARRIORS OF DARKNESS — *DEFEATED 1,000 YEARS AGO* → **CLOUD OF DARKNESS** — *MANIPULATES* →

MAGUS NOAH'S DISCIPLES

XANDE **DOGA** **UNEI**

COOPERATES

OPPOSES FOR THE SAKE OF PEACE

CASTLE SARONIA

GIGAMETH
MANIPULATES
KING GORN
EXILES *FAMILY*
ALUS

COOPERATES

DESCH
ACCOMPANIES TO TOWER OF OWEN

ARIA
COOPERATES TO REVIVE THE WATER CRYSTAL

WANTS TO SEAL

DJINN
CURSES

COOPERATES

CASTLE SASUNE

KING SASUNE
FAMILY
SARA

FRIENDS REMAKE → **ARC** **INGUS** *LOVES* REMAKE →

WARRIORS OF THE LIGHT

COOPERATES

COOPERATES

FOUR OLD MEN *INFLUENCES* → **DELILAH** *COOPERATES* →

AMUR

LUNETH REMAKE **REFIA** REMAKE

FOSTER FAMILY REMAKE → **TAKKA**

KAZUS

COOPERATES TO SEAL THE DJINN

CASTLE ARGUS

HEIN *CONFINES* → **KING ARGUS**
RESCUES

RAISES THE WARRIORS OF THE LIGHT
REMAKE *RAISES LUNETH AND ARC*

TOPAPA **NINA**

UR

REMAKE *SAVES FROM A CRASHING AIRSHIP*

REMAKE *ENTRUSTS REFIA*

ENTRUSTS INGUS REMAKE

REMAKE *ENTRUSTS LUNETH AND ARC*

CID *MARRIED* **MRS. CID**

CANAAN

093

Warriors of the Light

Youths chosen by the crystals
to save a world on the brink of destruction.

光の戦士たち

[Hikari no Senshi-tachi]

Four orphans raised in the remote town of Ur by Elder Topapa, having survived an ordeal in the Altar Cave during a test of courage, are tasked by the elemental crystals with saving the world. Traveling from land to land, they learn that the wizard Xande means to incite a flood of darkness to destroy the world, and they struggle to halt his ambitions. Propped up by friends they have made along their journey, the Warriors of the Light bravely oppose Master Xande.

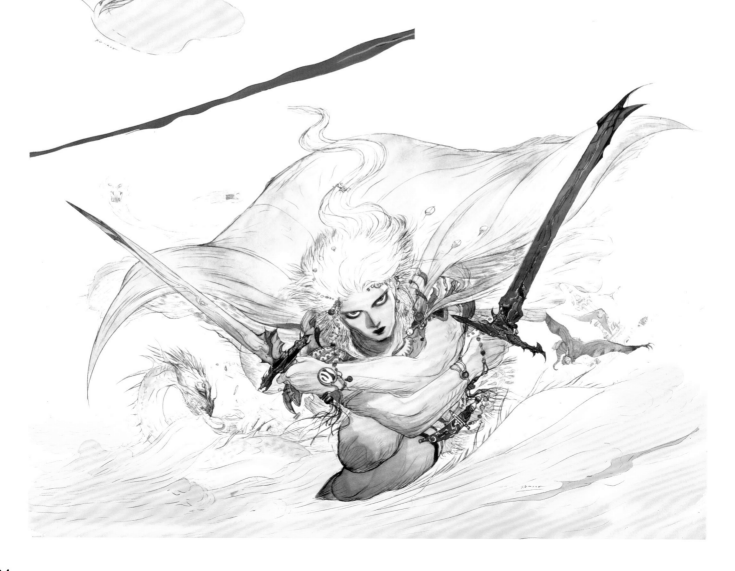

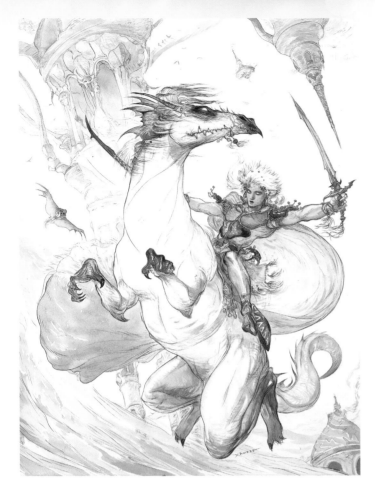

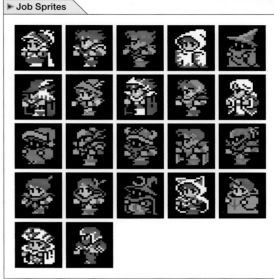

First row: Onion Knight, Warrior, Monk, White Mage, Black Mage
Second row: Red Mage, Ranger, Knight, Thief, Scholar
Third row: Geomancer, Dragoon, Viking, Black Belt, Dark Knight
Fourth row: Evoker, Bard, Magus, Devout, Summoner
Fifth row: Sage, Ninja

Memorable Quotes

▶ WARRIORS OF THE LIGHT

"How do you like it?"

—Playing the piano at the inn in Ur.

By playing the piano at the inn, you can hear some funny reactions from customers. Will the youths be showered in praise, or suffer a torrent of unrelenting booing?

"Let's sleep in the princess's bed!"

—In Castle Sasune, taking a nap in Princess Sara's bed.

Be it a royal bedchamber or a maiden's bunk, the warriors will sleep wherever they can. Just another reminder that these youths are utterly fearless.

"Topapa, Mom . . . We . . . we did it!"

—Returning to Ur during the finale.

Their battles now behind them, the warriors return to their hometown of Ur on the frontier. Their confidence shines through as the young adventurers spin tales of their exploits to their foster parents, Topapa and Nina.

Whose Fault Was the Fall?

After falling into a pit, the four youths wander into the Altar Cave. They run into some monsters and try to blame their problems on each other.

The Sorcerer's Trial

In order to obtain the Eureka and Syrcus Keys, the Warriors of the Light must defeat Doga and Unei . . . The young warriors try their best to avoid fighting their benefactors, but in the end . . .

▶ WARRIORS OF THE LIGHT

Bonds Breaking the Dragon's Curse

The Warriors of the Light are paralyzed by the curse of the five wyrms. Finally, five brave souls who bonded with the youths on their journey save them from their predicament.

Memorable Scenes

Luneth

Stouthearted youth
chosen by the crystal.

ルーネス
[Rūnesu/Luneth]

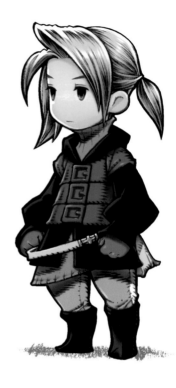

▶ **Personal Data**

Gender	Male
Light	Courage

▶ **Full Body**

A cheerful boy raised by adoptive parents alongside his childhood friend Arc. Originally from the surface world, Luneth was saved from the crash that killed his parents by the airship engineer Cid, and was left in the care of Topapa, village elder of Ur. Chosen by the elemental crystal inside the Altar Cave, Luneth embarks on a journey of unknown dangers and gradually grows to understand his responsibility as a Warrior of the Light. Luneth wants to bring peace to the world to honor the priestess Aria, who dies protecting him.

JOB APPEARANCES

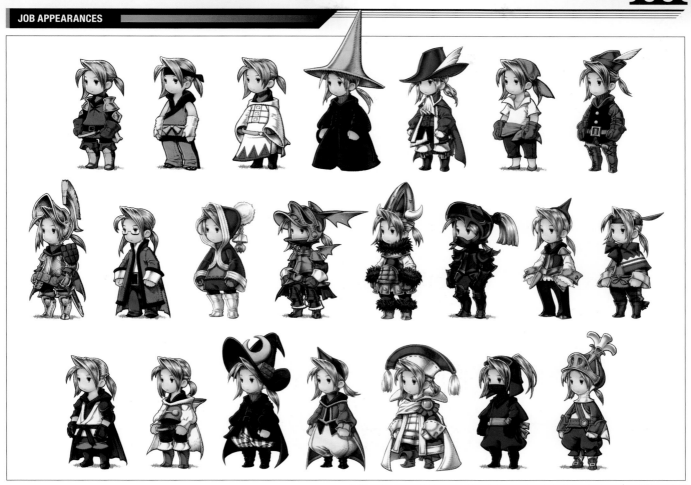

First row: Warrior, Monk, White Mage, Black Mage, Red Mage, Thief, Ranger
Second row: Knight, Scholar, Geomancer, Dragoon, Viking, Dark Knight, Evoker, Bard
Third row: Black Belt, Devout, Magus, Summoner, Sage, Ninja, Onion Knight

Memorable **Quotes**

▷ LUNETH

"... It's weird. I feel as if we've done this before."

—In Nelv Valley, destroying the massive boulder and disembarking from the damaged airship.

Cid protected the four warriors a decade ago, when his airship crashed on the Floating Continent and killed all other passengers. The youths remember almost nothing about their ordeal, but fragments of their pasts come back to them after they destroy the boulder in Nelv Valley.

"We won't let you! Not if we have anything to say about it!"

—Confronting the Cloud of Darkness in the World of Darkness.

Luneth shows a rare moment of anger before the Cloud of Darkness, an entity that wishes to return the world to nothingness. Continuing the fight to honor the memories of the late Aria, Doga, and Unei, the boy seethes with his hunger for victory.

Luneth
Wait...you're an orphan, too?

▷ LUNETH

Aria
N-no... It's too late...for me.
You...you must go.

Their Hidden Connection

Luneth is astonished to find that Refia and Ingus are orphans, just like himself and Arc. He wonders if there is some larger meaning behind their similar backgrounds.

Memorable **Scenes**

A Priestess's Hope

Aria dies protecting Luneth, struck by a cursed arrow launched by Kraken, an agent of Master Xande. Luneth will never forget the woman who wished for world peace with her final breath.

Remake "Warriors of the Light"

Arc

Brave bookworm,
sensitive to the needs of others.

アルクゥ

[Aruku~u/Arc]

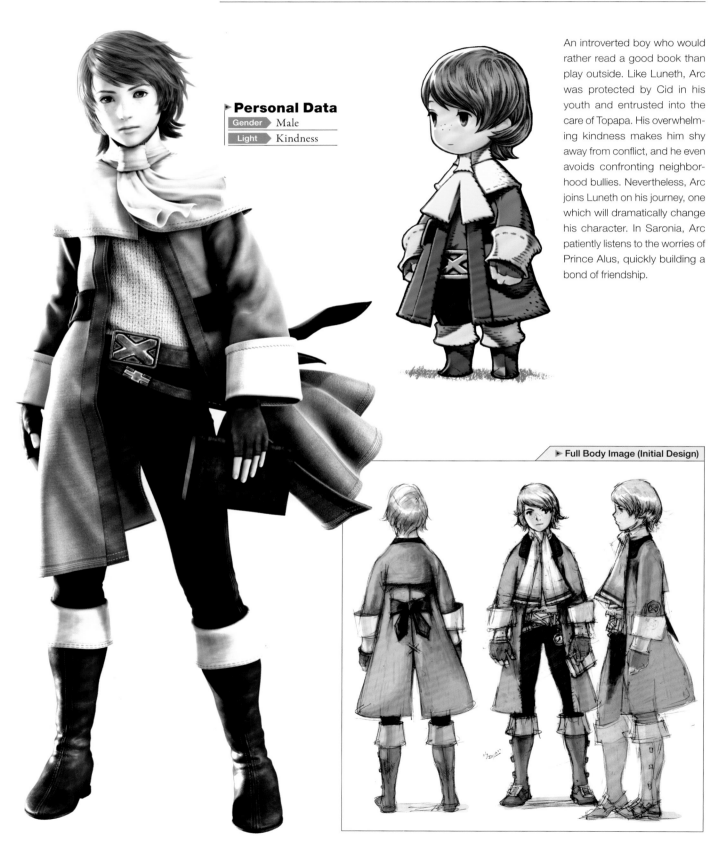

Personal Data

Gender	Male
Light	Kindness

An introverted boy who would rather read a good book than play outside. Like Luneth, Arc was protected by Cid in his youth and entrusted into the care of Topapa. His overwhelming kindness makes him shy away from conflict, and he even avoids confronting neighborhood bullies. Nevertheless, Arc joins Luneth on his journey, one which will dramatically change his character. In Saronia, Arc patiently listens to the worries of Prince Alus, quickly building a bond of friendship.

▶ Full Body Image (Initial Design)

JOB APPEARANCES

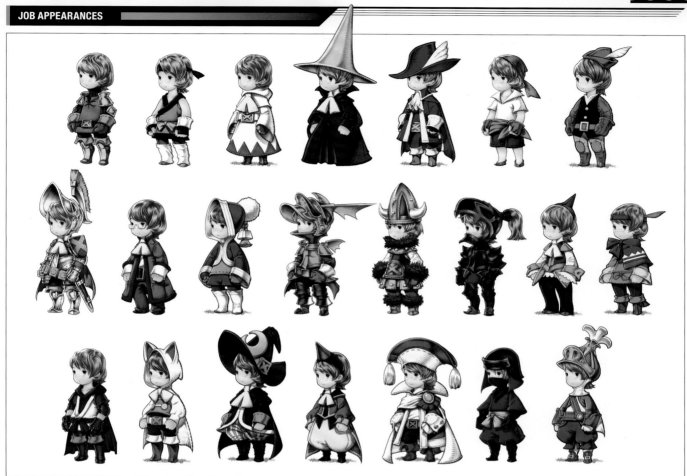

First row: Warrior, Monk, White Mage, Black Mage, Red Mage, Thief, Ranger
Second row: Knight, Scholar, Geomancer, Dragoon, Viking, Dark Knight, Evoker, Bard
Third row: Black Belt, Devout, Magus, Summoner, Sage, Ninja, Onion Knight

Memorable **Quotes**

▶ ARC

"But I can't ask for Luneth's help . . .
I'll show them!"

—In Ur, deciding to ascertain the truth of
the ghostly disturbance.

Though the village children called him a weakling, Arc doesn't intend to stay passive forever. On his own, Arc heads to Kazus to investigate rumors of ghosts. He ultimately has to rely on Luneth's help.

"H-hey! Uh . . . Stop that!"

—In Saronia, speaking out against the crowd of ruffians
surrounding Prince Alus.

When Arc sees Prince Alus helplessly encircled by thugs, he recalls events from his past. The protected becomes the protector, and Arc musters up the courage to take a stand.

Arc
So...it should be weak to the Blizzard spell, and the Antarctic Wind item.

▶ ARC

No parent would ever lose their love for their children! Your father must've had a good reason for doing this.

Memorable **Scenes**

The Walking Encyclopedia

A bookworm at heart, Arc has an endless supply of magical knowledge. Whether determining the Djinn's weak point or providing vital information when faced with a riddle, he demonstrates the value of knowledge in all sorts of situations.

Bond with the Prince

Prince Alus has become uncertain about the motivations of his parents, who are suddenly acting strange. Arc offers him some encouragement to ease his concerns.

Refia レフィア

Remake "Warriors of the Light"

Rebellious runaway tomboy bearing deep affection for her foster father.

[Refia]

►Personal Data

Gender	Female
Light	Affection

Adopted daughter of Takka, the blacksmith of the village of Kazus. Refia has a strong-willed and straightforward personality, and always says exactly what comes to mind. Her foster father wants her to become a blacksmith, but Refia is tired of her training and often runs away from home. During one such instance, the village of Kazus falls under the curse of the Djinn. Refia is spared from the curse's effects, and works with Luneth's party to free her fellow villagers. She sets off with the party as a fellow Warrior of the Light, though her rebellious streak is a big part of her motivation for tackling such a dangerous adventure.

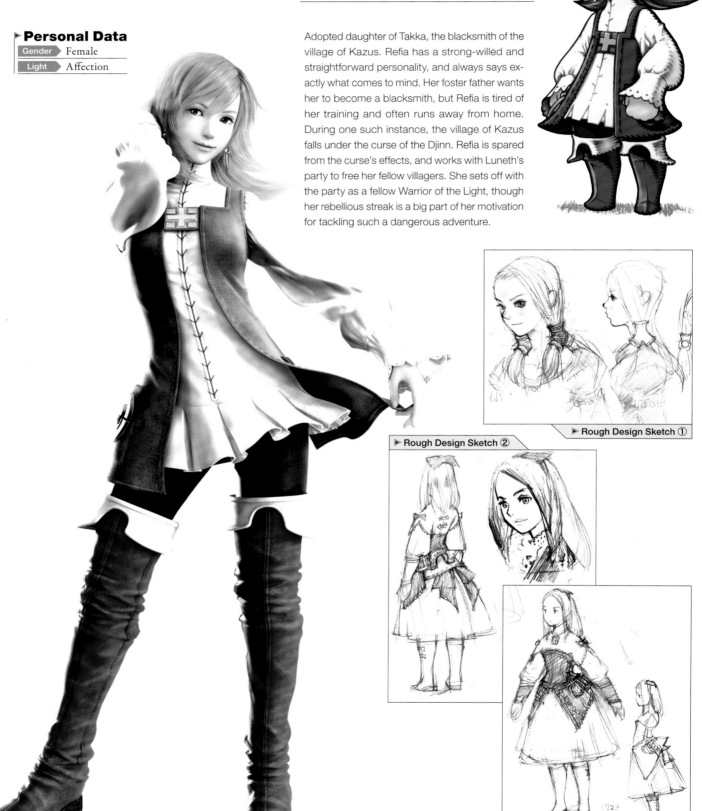

►Rough Design Sketch ①

►Rough Design Sketch ②

JOB APPEARANCES

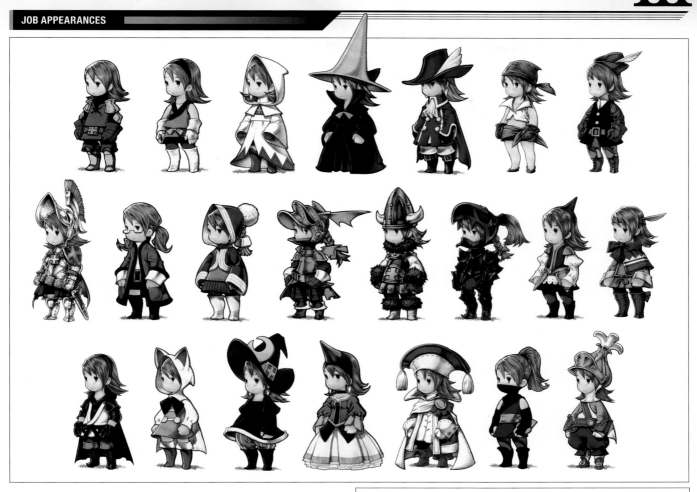

First row: Warrior, Monk, White Mage, Black Mage, Red Mage, Thief, Ranger
Second row: Knight, Scholar, Geomancer, Dragoon, Viking, Dark Knight, Evoker, Bard
Third row: Black Belt, Devout, Magus, Summoner, Sage, Ninja, Onion Knight

Memorable **Quotes**

REFIA

"We all promised the crystal we'd go on our journey. And . . . I don't want to be a smith just yet."

—On Cid's airship, when telling the others of her decision to travel with them.

Refia says goodbye to Luneth and his friends after breaking the Djinn's curse, but somehow she is the first to arrive at the airship. Though Refia fulfills her duty as a Warrior of the Light, her secondary motivation is to get some distance from her foster father.

"Oooh! So you've finally come to your senses!"

—Hearing that Desch will leave the airship at Canaan during the finale.

Refia gets excited upon hearing that Desch will return to Salina. She knows how Salina must feel, being separated from her lover for so long, and she rejoices as if she were the one receiving the good news.

Refia
I'll wait here... I don't want to see my father. At least, not yet...

Not Exactly Homesick

Her ambivalence toward the profession of blacksmith caused Refia to run away from home, which also allowed her to escape the Djinn's curse. However, her guilty conscience made it hard to go see her adoptive father Takka. She waits outside the village while Luneth's party visits.

REFIA

Memorable **Scenes**

Refia
Toads!? I hate toads! Don't turn me into one!

Not Easy Being Green

Certain parts of the Tower of Owen and the Subterranean Lake require diving underwater in order to proceed. The party can use the White Magic spell known as Toad to turn into frogs, but Refia doesn't seem too enthusiastic about the idea.

Ingus

An honest youth
with a composed outlook.

イングズ

[Inguzu/Ingus]

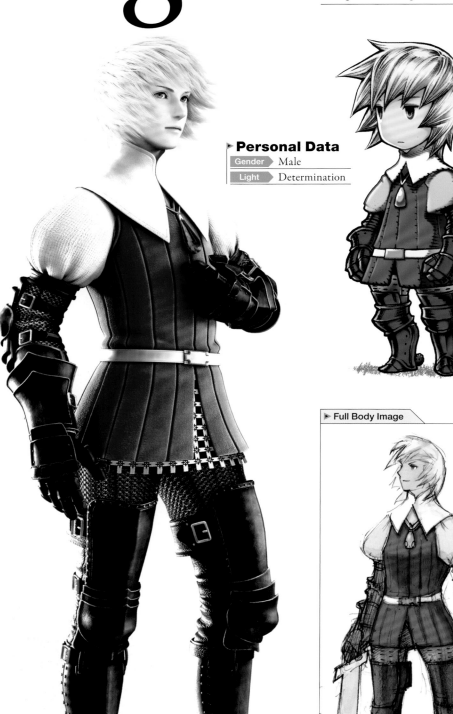

Personal Data

Gender	Male
Light	Determination

A devoted soldier who has served Castle Sasune since childhood. Ingus harbors romantic feelings for Princess Sara, but he maintains a respectful distance befitting his rank as an enlisted warrior. Because he had ventured outside the castle walls, Ingus did not fall prey to the curse of the Djinn. With help from Luneth's friends, he sets out to track down the missing princess. After defeating the Djinn, Ingus is chosen as one of the four Warriors of the Light. Keeping his feelings for Sara buried deep in his heart, he sets out to save the world.

▶ Full Body Image

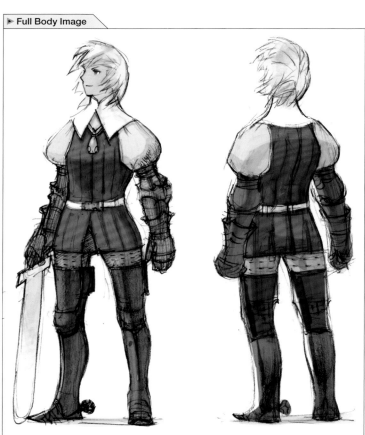

JOB APPEARANCES

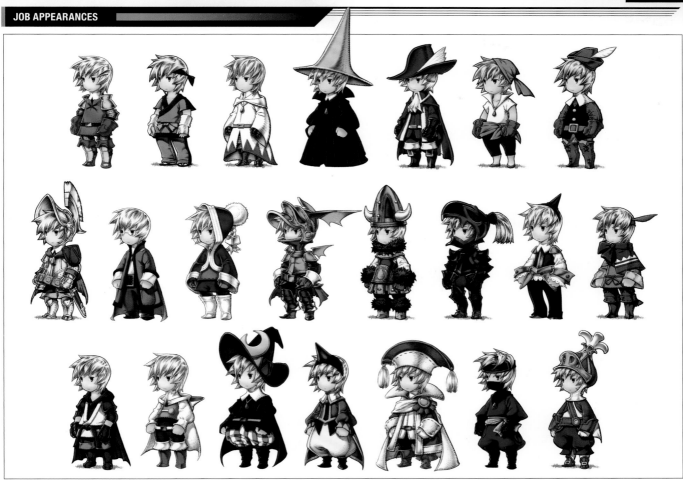

First row: Warrior, Monk, White Mage, Black Mage, Red Mage, Thief, Ranger
Second row: Knight, Scholar, Geomancer, Dragoon, Viking, Dark Knight, Evoker, Bard
Third row: Black Belt, Devout, Magus, Summoner, Sage, Ninja, Onion Knight

Memorable **Quotes**

▶ INGUS

"No, I . . . couldn't have done anything on my own."
—In the Sealed Cave, when thanked by Sara for coming to her rescue.

Princess Sara ventured to the cave, though she feared what lay within. Ingus felt embarrassed by her gratitude, and offered the excuse that he couldn't have succeeded without the help of Luneth and his friends.

"Inconceivable . . ."
—Upon seeing the Four Old Men in Amur.

Seeing the ridiculous posturing of the old men claiming to be the four legendary heroes, Ingus can no longer hold his tongue. Did it take rowdy old-timers to finally crack Ingus's perfect composure?

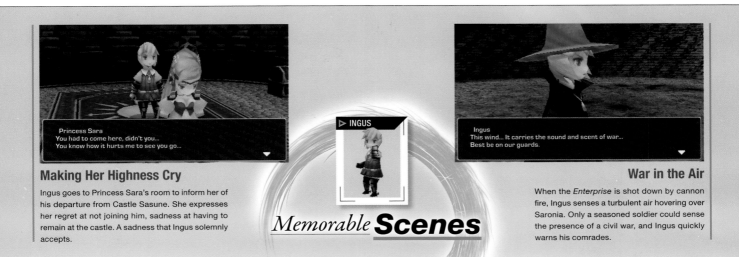

Princess Sara
You had to come here, didn't you...
You know how it hurts me to see you go...

Making Her Highness Cry

Ingus goes to Princess Sara's room to inform her of his departure from Castle Sasune. She expresses her regret at not joining him, sadness at having to remain at the castle. A sadness that Ingus solemnly accepts.

▶ INGUS
Memorable **Scenes**

Ingus
This wind... It carries the sound and scent of war...
Best be on our guards.

War in the Air

When the *Enterprise* is shot down by cannon fire, Ingus senses a turbulent air hovering over Saronia. Only a seasoned soldier could sense the presence of a civil war, and Ingus quickly warns his comrades.

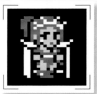

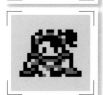

Sara (Sara Altney) サラ [Sara]

▶ Personal Data

| Gender | Female | Age | 21 |

Strong-hearted princess of Sasune, who always follows through on her decisions. On her own, Sara ventures to the Sealed Cave to seal in the Djinn and free her people. She succeeds with the help of the Warriors of the Light, and awaits the heroes within her castle.

Memorable **Quote**

"Men are so obtuse . . . Must I say it plainly?
I want to stay with you a bit longer. There!"

—Conveying her feelings before the Warriors of the Light during the finale.

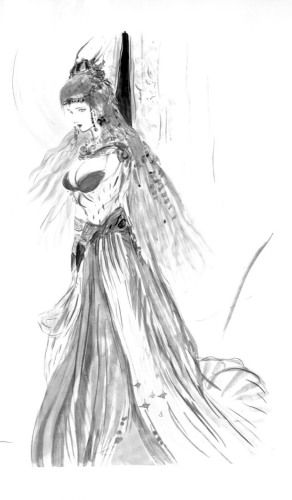

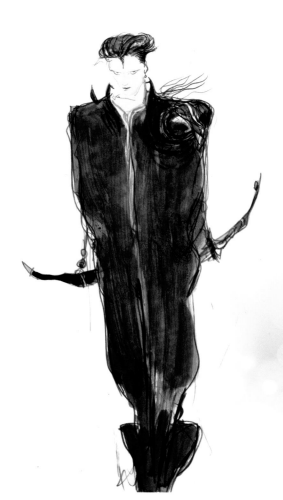

Memorable **Quote**

"You did it! The ship is ours! Now I can pick up beauties all over the . . . H-hey, I'm just kidding!"

—Obtaining the *Enterprise* from Vikings' Cove.

Desch

デッシュ [Desshu/Desch]

▶ Personal Data

| Gender | Male | Age | Unknown |

Last of the Ancients, who suffers from amnesia due to his centuries-long slumber. As the guardian of the tower built by his father, Desch risked his life to restore the reactor inside the Tower of Owen and prevent the collapse of the Floating Continent. You can see one of Desch's unused early designs below.

▶ Unused Design

Cid (Cid Haze)

シド [Shido/Cid]

▶ Personal Data

| Gender | Male | Age | 64 |

An airship engineer from Canaan. On a visit to Kazus, Cid is struck by the Djinn's curse. He asks the Warriors of the Light to help him. Cid later uses the Wheel of Time to convert the pirate ship *Enterprise* into an airship, allowing the party to continue their quest.

Memorable Quote

"I used to work for King Argus. I made airships using the Wheel of Time. I'm famous, I tell ya! Ah ha ha ha!"

—In Canaan, after remodeling the *Enterprise*.

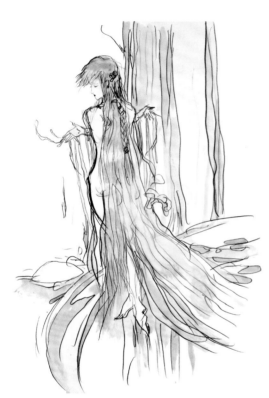

Aria (Aria Benett)

エリア [Eria/Aria]

▶ Personal Data

| Gender | Female | Age | 15 |

Priestess of the Temple of Water. She asked for the warriors' cooperation in restoring the submerged world. Although light is restored to the Water Crystal, Aria is struck down by Master Xande's assassin Kraken while protecting the youths.

Memorable Quote

"N-no . . . It's too late . . . for me. You . . . you must go. Promise me . . . Promise me you will banish the darkness, and restore peace to the world . . ."

—After falling to the Kraken's cursed arrow in the Cave of Tides.

Alus (Alus Restor)

アルス [Arusu/Alus]

▶ Personal Data

| Gender | Male | Age | 10 |

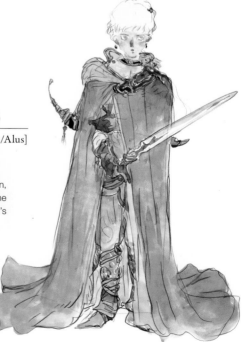

The kingdom of Saronia's young prince. Alus is driven from his castle by his father, King Gorn, who has been acting strangely. He is saved from a gang of scoundrels by the Warriors of the Light. With their help, Alus takes down Garuda, the true mastermind behind the kingdom's recent strife. Obeying his father's dying request, he ascends to the throne of Saronia.

Memorable Quote

"I can't help but wonder . . . what has happened to my father? Do you think . . . he doesn't love me anymore?"

—In Castle Saronia, revealing his worries to the warriors before retiring.

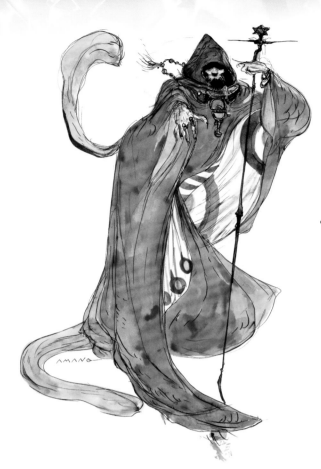

 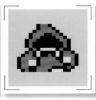

Doga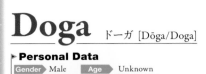

▶ Personal Data

| Gender | Male | Age | Unknown |

One of Magus Noah's disciples, now living in seclusion. He inherited the power of magic from his teacher. Lamenting the crimes committed by his fellow student Xande, Doga guides the Warriors of the Light on their path. He risks everything to craft the key to the forbidden land of Eureka, and entrusts its treasures to the heroes.

Memorable **Quote**

"Only five souls who possess hearts of pure light may break the curse of the five wyrms . . . I will go forth and find the five! Do not lose hope!"

—Saving the heroes under the wyrms' curse in the Crystal Tower.

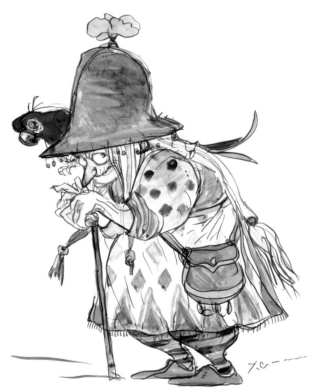

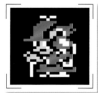

Unei

▶ Personal Data

| Gender | Female | Age | Unknown |

Another of Magus Noah's disciples, Unei is an old woman who watches over the dream world she inherited from her master. After waking from a long sleep, Unei lends her power to the young warriors trying to stop Xande's ambitions. The image to the left is a young Unei, who was set to appear early in development.

Memorable **Quote**

"But don't worry. Even if our bodies are lost, our souls will still remain . . . Now, take this!"

—In Doga's Grotto, when challenging the Warriors of the Light to combat in order to make the Eureka and Syrcus Keys.

▶ Unused Design

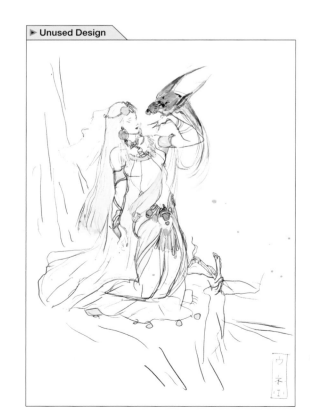

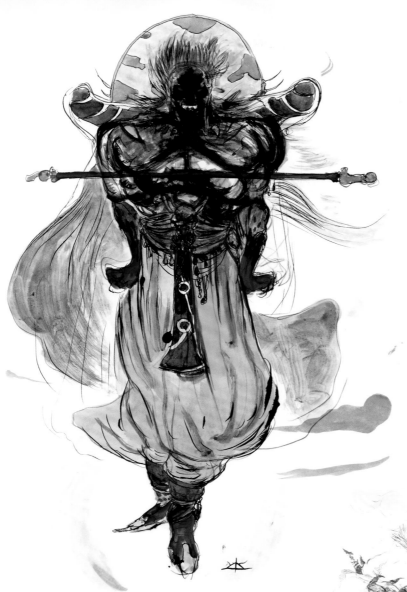

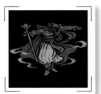

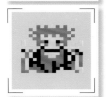

Xande
ザンデ [Zande/Xande]

▶ Personal Data

| Gender | Male | Age | Unknown |

A mage scheming to flood the world with the power of darkness. Xande fails to discover the true value of the gift of mortality, given to him by his teacher Noah. Alienated by his master's actions, he becomes estranged from his fellow disciples. Xande perverts the power of the Earth Crystal to cause a devastating earthquake, sinking the four elemental crystals beneath the world's surface and sealing off the power of the light.

Memorable **Quote**

"I admire your persistence . . . But you are too late.
The darkness draws ever so close, and is almost upon
this world! Hah hah hah! Die!"

—Awaiting the Warriors of the Light in the Crystal Tower.

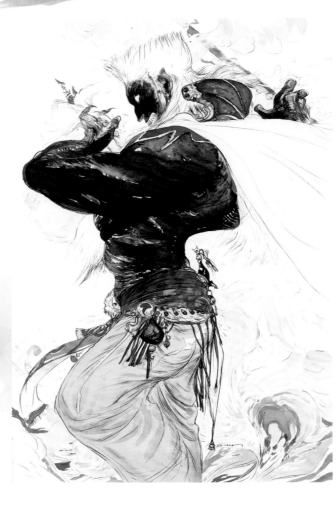

WORLD

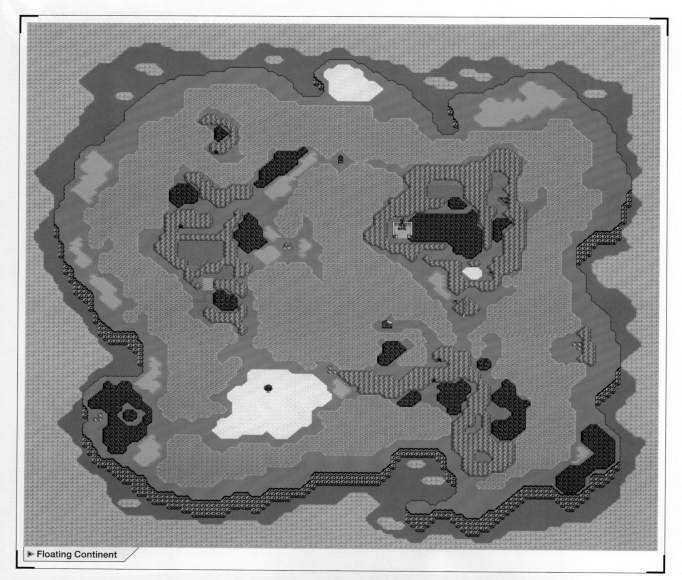

▶ Floating Continent

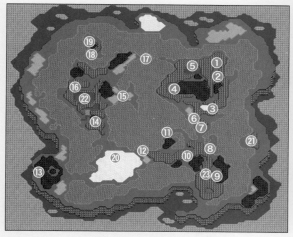

① Altar Cave
② Ur
③ Kazus
④ Castle Sasune
⑤ Sealed Cave
⑥ Canaan
⑦ Mountain Road (✳ 1)
⑧ Healing Copse
⑨ Tozus
⑩ Vikings' Cove
⑪ Temple of Nepto (✳ 2)
⑫ Tokkul
⑬ Village of the Ancients
⑭ Living Forest (✳ 3)
⑮ Castle Argus

⑯ Gulgan Gulch
⑰ Tower of Owen
⑱ Dwarven Hollows
⑲ Molten Cave
⑳ Castle Hein
㉑ Gysahl
㉒ Lake Dohr
㉓ Bahamut's Lair

✳ 1 "Dragon's Peak" in the remake
✳ 2 "Nepto Temple" in the remake
✳ 3 "Living Woods" in the remake

The story starts off on the Floating Continent, but it is soon revealed that the continent is just an island floating above a vast Surface World. The heroes arrive on the surface world, but discover that the realm has lost the power of the Water Crystal. Most of the world is completely submerged, save for a small area surrounding the Temple of Water.

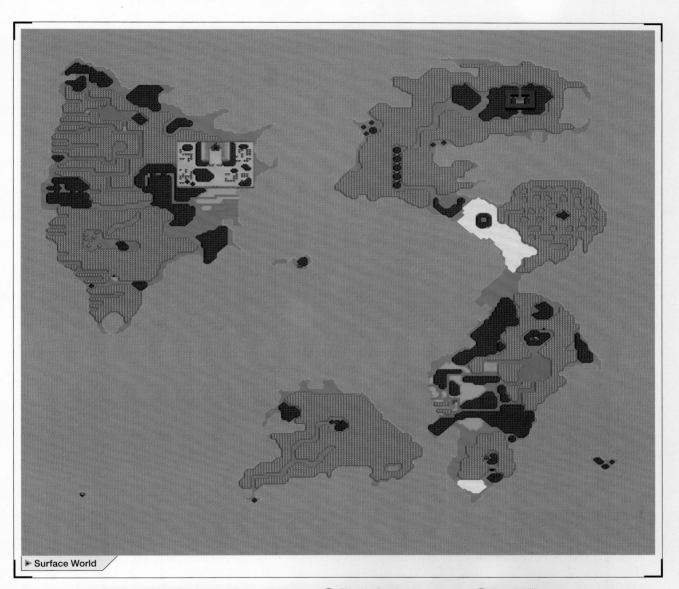

▶ Surface World

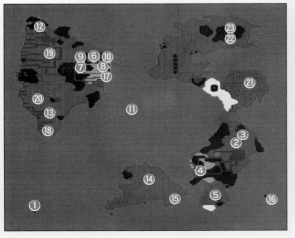

❶ Floating Continent
❷ Temple of Water
❸ Cave of Tides
❹ Amur
❺ Goldor Manor
❻ Castle Saronia
❼ Saronia 1 (✳ 4)
❽ Saronia 2 (✳ 5)
❾ Saronia 3 (✳ 6)
❿ Saronia 4 (✳ 7)
⓫ Duster
⓬ Replito
⓭ Unei's Shrine
⓮ Doga's Manor/
Cave of the Circle

⓯ Doga's Village
⓰ Sunken Cave
⓱ Underground Maze of Saronia (✳ 8)
⓲ Temple of Time
⓳ Ancient Ruins
⓴ Falgabard
㉑ Cave of Shadows
㉒ Ancients' Labyrinth
㉓ Crystal Tower/Forbidden Land Eureka/
World of Darkness

✳ 4 "Southwestern Saronia" in the remake
✳ 5 "Southeastern Saronia" in the remake
✳ 6 "Northwestern Saronia" in the remake
✳ 7 "Northeastern Saronia" in the remake
✳ 8 "Saronia Catacombs" in the remake

MONSTERS

Djinn

ジン [Jin]

Land Turtle

ランドタートル [Randotātoru]

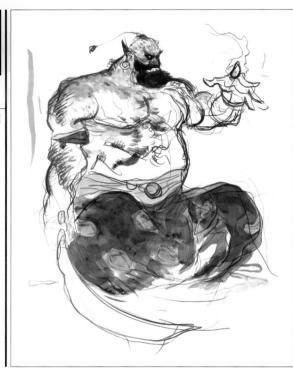

Giant Rat

おおネズミ [Ōnezumi]

Gutsco

とうぞくグツコー [Tōzoku Gutsukō]

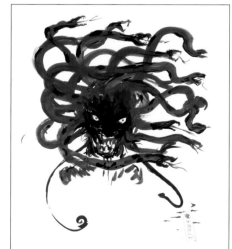

Medusa

メデューサ [Mede~yūsa]

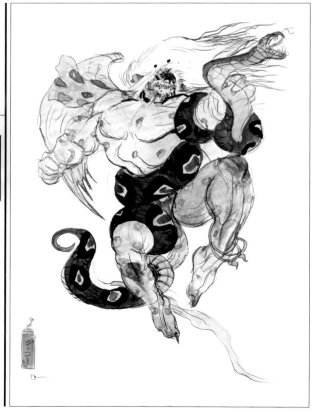

Hein

まどうしハイン [Ma-dōshi Hain]

Salamander

サラマンダー [Saramandā]

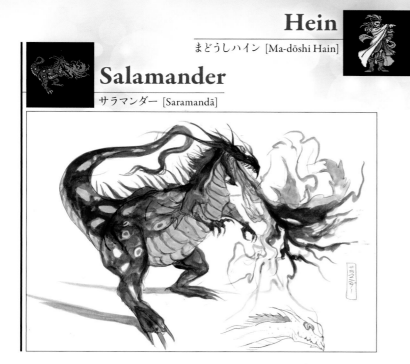

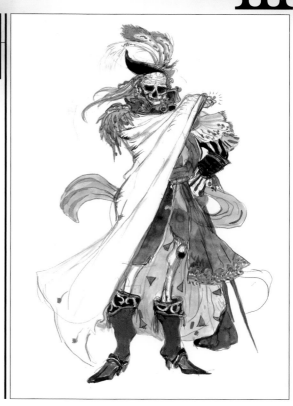

Kraken

クラーケン [Kurāken]

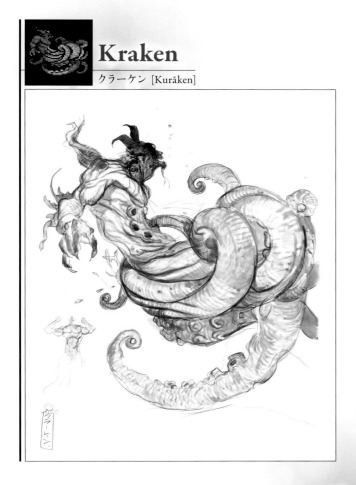

Memorable Feature

Brains over Brawn

Hein uses Barrier Shift to fundamentally shift his quality of elemental weakness, allowing him to absorb the damage inflicted by any other type of elemental attack. Players should fight by paying attention to Hein's weakness. You might think you can just use attacks, but Hein has high evasion. Relying on Knight or Monk classes will result in a string of missed attacks and an unnecessarily drawn-out battle.

		HP	
Luneth	Miss!	485/	485
Hein		Arc 479/	479
		Refia 267/	413
		Ingus 477/	477

Gold Knight

ゴールドナイト [Gōrudonaito]

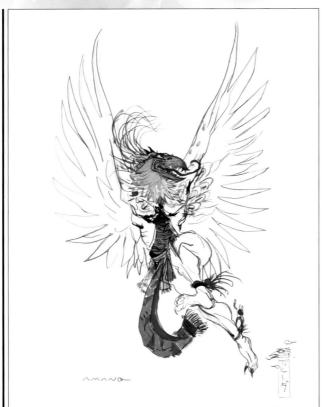

Garuda

ガルーダ [Garūda]

Memorable **Feature**

Riding the Lightning

Garuda uses Lightning at almost every turn, deploying a powerful attack that hits all party members at once. There's no way to win if you endure these attacks head on, but if you heed the legends of Saronia and change your job class to Dragoon, you can avoid the Lightning attacks with Jump and battle your way to victory.

Doga

ドーガ [Dōga]

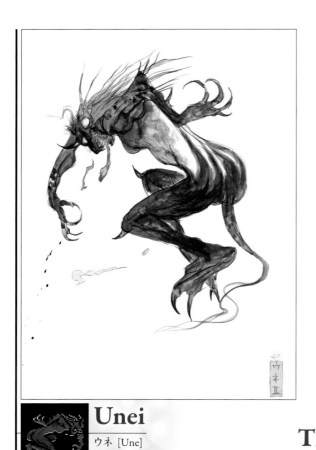

Unei
ウネ [Une]

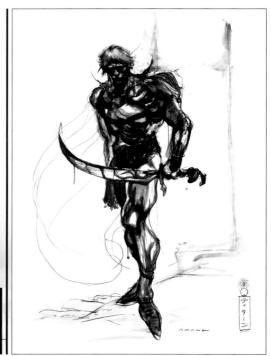

Titan

ティターン [Titān]

Kunoichi
くのいち [Kunoichi]

Ninja
ニンジャ [Ninja]

General
ジェネラル [Jeneraru]

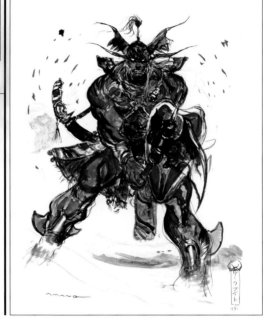

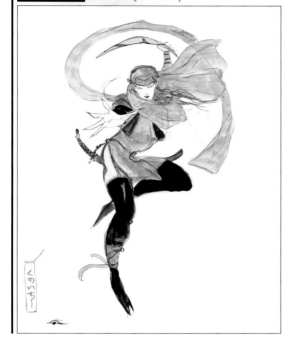

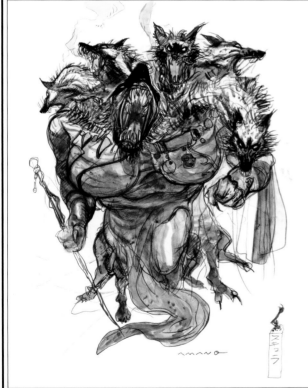

Scylla
スキュラ [Sukyura]

Glasya Labolas
グラシャラボラス [Gurasharaborasu]

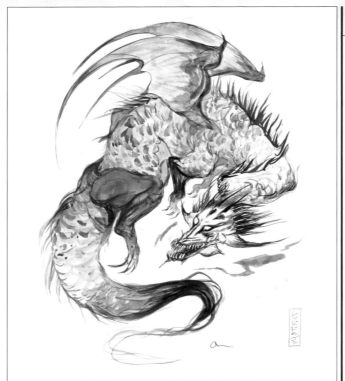

Red Dragon

レッドドラゴン [Reddodoragon]

Cerberus
ケルベロス [Keruberosu]

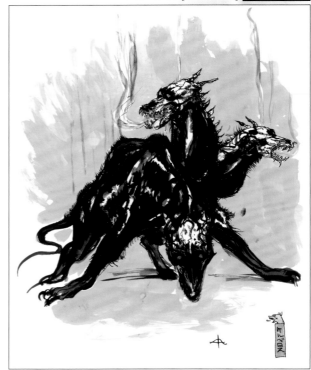

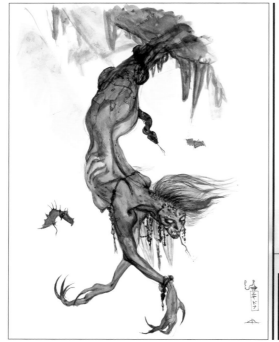

Echidna
エキドナ [Ekidona]

Memorable **Feature**

The Sudden Terror of Meteor

Ahriman unleashes Meteor on the very first turn of battle, dealing devastating damage to the entire party. Ahriman's other attacks aren't nearly as powerful, but after a few turns it will be ready to use Meteor again. Players must keep a close eye on the hit points of everyone in their party.

Ahriman	◎ Meteor	HP
All	Arc	0000/0000
	Rafia	0000/0000
	Ingus	2222/2227

Ahriman
アーリマン [Āriman]

Two-Headed Dragon
2ヘッドドラゴン [2 Heddodoragon]

Memorable **Feature**

Abnormal Strength

The Two-Headed Dragon only uses normal attacks, but the damage packed into each blow is considerable. Any party member in the front row will fall when suffering a single blow, so players must get into a cycle of losing and reviving their comrades as the fight drags on.

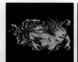

Cloud of Darkness
くらやみのくも [Kurayami no Kumo]

Memorable **Feature**

With the Aid of Darkness

Until the player gains the help of the four Warriors of Darkness, no attack will succeed against the Cloud of Darkness. Entering the World of Darkness without this knowledge, and jumping right into the final fight, will send the player back to the base of the Crystal Tower.

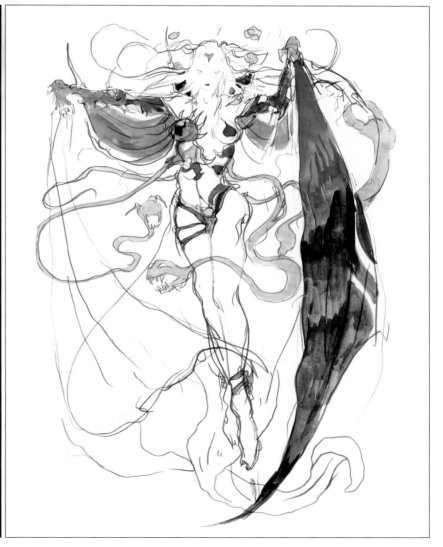

DEVELOPMENT STAFF MONSTER DESIGNS

Some *Final Fantasy III* monster designs were not drawn by Yoshitaka Amano, but by the development staff. The designs conceptualized by both parties have been reproduced in-game in sprite form.

Griffon

グリフォン [Gurifon]

Helldiver

ダイブイーグル [Daibuīguru]

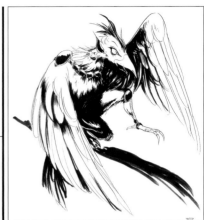

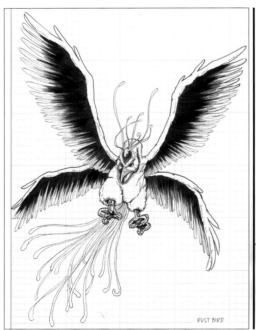

Leprechaun

レプラホーン [Repurahōn]

An imp encountered in the Tozus Tunnel. Its in-game appearance is identical to the design image here, but its weapon was switched from a bow and arrow to a spear.

Rust Bird

ラストバード [Rasutobādo]

Petit プティ [Puti]

A monster with oversized ears and a tail that resembles an adorable puppy. Two illustrations were created, and the rightmost depiction was selected for the in-game design.

Roper

ローパー [Rōpā]

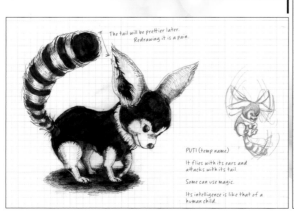

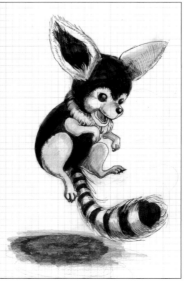

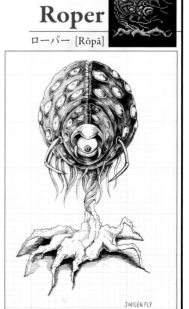

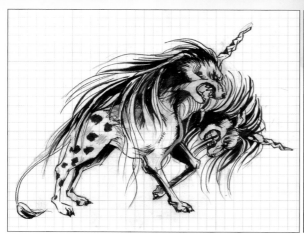

Twin Heads
ツインヘッド [Tsuinheddo]

Cockatrice
コッカトリス [Kokkatorisu]

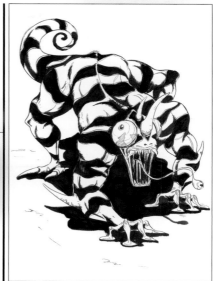

Seahorse
シーホース [Shīhōsu]

COIZED SEAHORSE

Charybdis
カリュブディス [Karyubudisu]

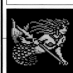

Mermaid
マーメイド [Māmeido]

Pterodactyl
プテラノゴン [Puteranogon]

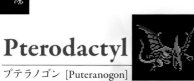

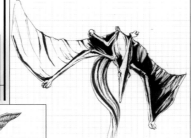

PTERODACTYL (temp name)

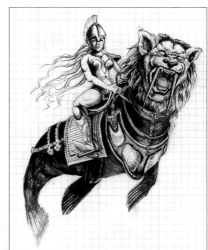

Sea Lion シーライオン [Shīraion]

An aquatic creature with the body of a sea lion and the head of a land-dwelling lion. During an early phase of development, the design team played around with the idea that sea lions could be ridden like horses.

117

FINAL FANTASY

ULTIMANIA ARCHIVE VOLUME 1

EXTRA CONTENT

SUMMONS

Summon magic falls into three categories: Black Magic, White Magic, or a mix of the two. The effect of each summon changes depending on the color that appears. Each set of sprites (starting from the left) are White, Black, and combined.

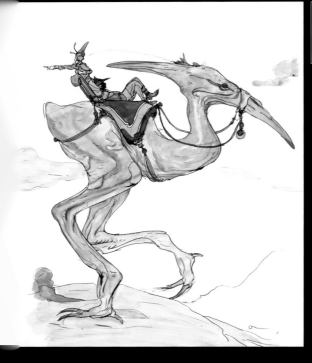

Chocobo

A speedy land-dwelling bird tha the Escape summon is cast. T chocobo's plumage for the com ended up being the closest in Yoshitaka Amano's original cor

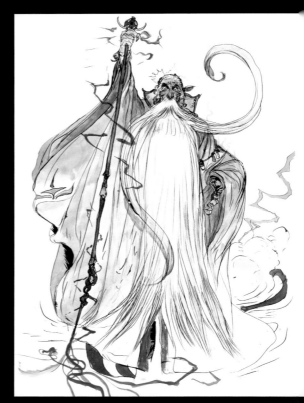

Ramuh

A wielder of thunde when called by the S Not only does Ram Lightning, but his W paralyze all enemies

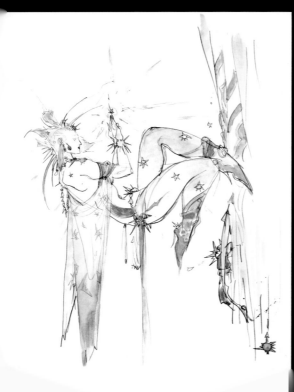

Shiva

The ice queen who appears wh Icen summon. Shiva's Black elemental attribute, and even c enemies who are strong agains

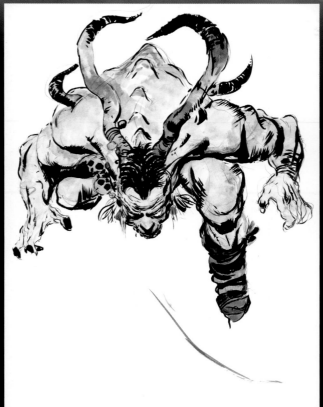

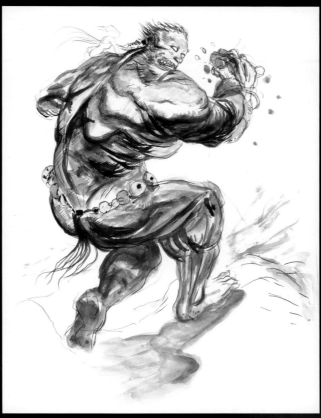

Ifrit

A fire Djinn who appears when spurred to action by the Heatra summon. In contrast to its violent appearance, Ifrit's White effect will restore hit points to friendly allies.

Titan

A giant who appears during the Hyper summon. Each of its Black, White, and combined versions will do substantial damage to enemies. The sprite for Titan has longer hair than in the original picture.

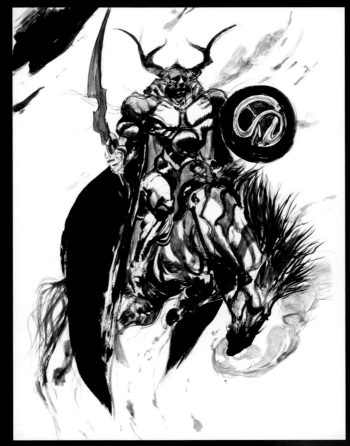

Odin

The legendary warrior who appears as a result of the Catastro summon. Not only does Odin attack enemies with his sword, but his White effect casts Reflect on all allies—bouncing magic back at its casters.

Memorable **Feature**

The Joy of Bisection

Odin is famous for his combined effect, Zantetsuken. Not only can the ability wipe out all opponents with a single gesture, but the image of enemies cleaved in twain caused quite a stir at the time.

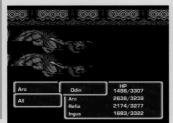

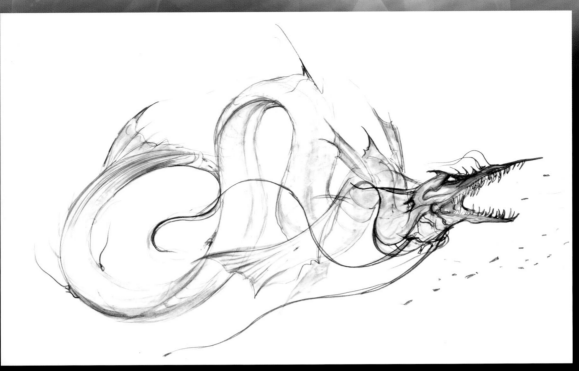

Leviathan

The master of Lake Dohr, Leviathan can be called forth using the Leviath summon. The original picture shows the full length of Leviathan's body, but the in-game sprite curls that body back onto itself.

Memorable **Location**

Shadows beneath the Surface

A shadow drifts on the surface of the lake lying south of Gulgan Gulch on the Floating Continent. The first time you visit this area, you cannot approach it. Its true nature remains a mystery. After obtaining the airship *Invincible* and fighting Leviathan in the Lake Dohr dungeon, players will discover that the shadow has disappeared. It was the Leviathan all along.

Bahamut

The King of Dragons appears during the Bahamut summon. Its enemy sprite was created based on the picture to the right, which is also the graphic that is used during the creature's summon.

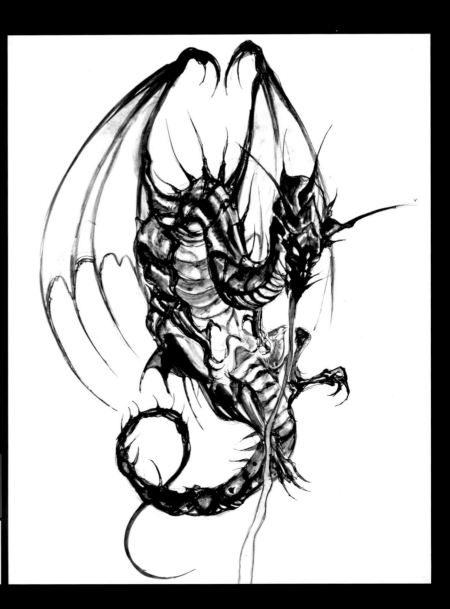

OTHER ILLUSTRATIONS

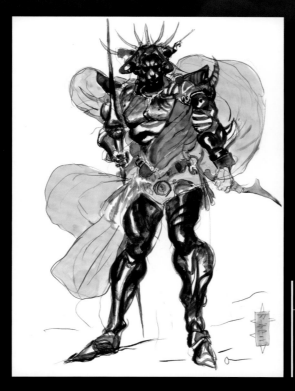

Guardian (Unused)

The original picture for Guardian, an unused summon monster (see "Monster List" on page 127). Although a monster with the name of Guardian appears in the Forbidden Land of Eureka, this version of Guardian resembles the form of a Glasya Labolas (seen on page 113).

REMAKE LOGO ILLUSTRATIONS

New illustrations drawn for the background of the DS remake's title logo. These artworks reproduce the illustration that appeared on the game's original packaging. Minor differences exist in each version, such as the loincloth, the shoulder pads, and the fluttering of the hair. After coloring, the version in the upper left was used as the official artwork.

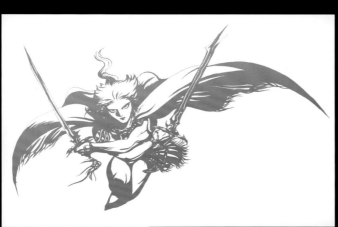

► Design Used in Final Logo

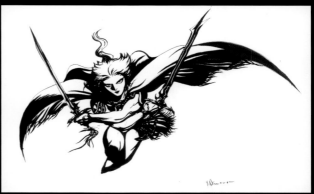

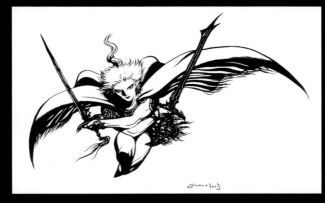

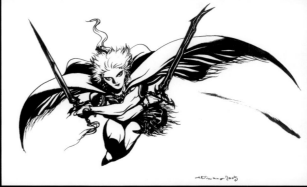

SPRITE MATERIALS

Early Development Job Concepts

Sprites made for the rough sketches of each job. Several jobs do not appear in-game, and some jobs have different names or designs in the final product. One notable design is the initial Dark Knight sprite, which resembles the Blue Mage from *Final Fantasy V*. Other surprising ideas included petrified characters turning into *Mannekin Pis* statues.

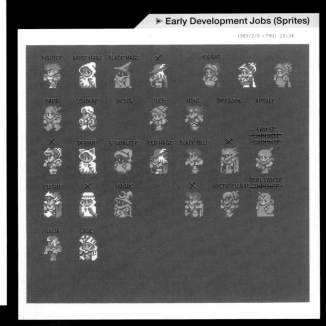

► Early Development Jobs (Rough Sketches)

► Early Development Jobs (Sprites)

Sprite Creation Rough Sketches

Rough sketches used to develop sprites. Drawing poses on graph paper allowed the development team to estimate sprite layouts.

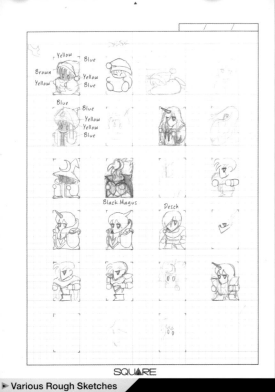

► Various Rough Sketches

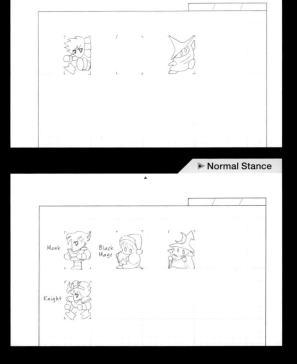

► Damage Recoil

► Normal Stance

Battle Sprites

Job character design lead Koichi Ishii refers to these job sprites as a compilation of his own original designs. Eager to create pose variations for each job, Koichi Ishii crafted every sprite individually. Whether it's damage or knockout sprites, it's easy to see the small differences in poses for each job.

ONION KNIGHT

WARRIOR

MONK

WHITE MAGE

BLACK MAGE

RED MAGE

RANGER

KNIGHT

THIEF

SCHOLAR

GEOMANCER

DRAGOON

DRAGOON JUMP

VIKING

BLACK BELT

DARK KNIGHT

EVOKER

BARD

MAGUS

DEVOUT

SUMMONER

SAGE

NINJA

Field Sprites

Sprites for characters in the field. Koichi Ishii's battle sprites (seen on page 123) are made using six 8x8–pixel blocks, but these field sprites can only occupy four blocks total. This makes them slightly harder to create.

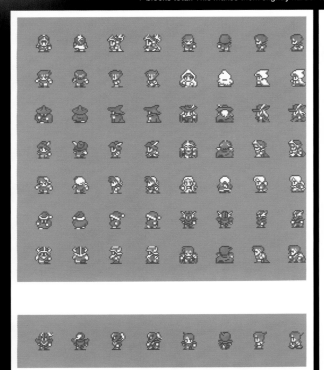

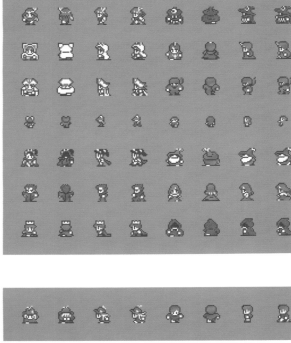

▶ Jobs and Local Folks

▶ Vehicles

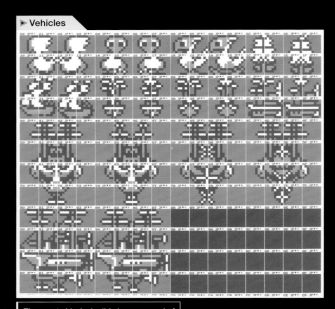

The great ship *Invincible* is composed of sixteen blocks, four times more than any character. Each direction has two sets of sprites so that the propellers can be shown in motion—a choice that seemed a bit extravagant for its time.

▶ Sheep

DIRECTORY A:＼ CGE-FILE HITUGI OBJ-FILE
CHR-BANK 1 C-PALET Ø

0 1

SCENARIO PLANNING

Early Development World Map

An incomplete version of the world map. At the time, the Viking ship was known as the *Nautilus*, and the entrance to the Forbidden Land of Eureka lay in a different location than the Crystal Tower.

► Surface World (Flooded)

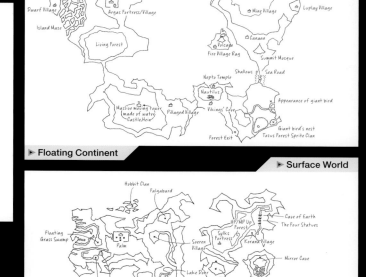

► Floating Continent

► Surface World

Early Plot for Altar Cave Event

Text explaining the event flow of the first dungeon, along with its map. The text differs slightly in the final game, but the flow is mostly unchanged. The dungeon composition is completely different, though the elements of the healing spring and the two single-use magic items remain.

■ WIND CAVERN

The youths had just intended to look around, for a bit of fun.
They enter the cave created when the Wind Crystal sank into the earth.
As they walk, messages display automatically (to explain the situation).
You start from the center of B3. Monsters are imps that you can destroy as knights. You find the Wind Crystal and receive your first job changes.
--> Warrior/White Mage/Black Mage/Red Mage
Escape using the magic circle next to the crystal.

● Ouch!
Dang, we fell into a pit!
Hey, are you okay?
Yeah, somehow . . .
● Hey, is it okay for us to come to a place like this?
What are you saying? You're the one that said it was okay.
If you have time to argue, then look for an exit. This place is creeping me out.
Man, I want to go home. We shouldn't have come poking our noses around here.
● Hey, I thought we were gonna die back there.
What was that monster just now?
It was a scary one.
Jeez. . . .

● (Wind Crystal) It's the Wind Crystal . . . it's glowing white . . .

Opening
As the Wind Crystal speaks, the opening starts . . .

FINAL FANTASY III
by SQUARE
Staff Name--

Someone caused a massive earthquake, intending to plunge this world into darkness. The four crystals of Fire, Earth, Water, and Wind were buried deep underground and the world was thrown out of balance. Monsters roamed the land, and people began to think the world was coming to an end. But in that moment, four youths received a revelation--they were the final light of hope . . .

I see, so you are the chosen ones, are you?
Hey! The crystal just spoke!
They don't seem up to the task. Could this really be them?

All of you were chosen. You must obtain the power to drive off the darkness threatening this world--the power of the ancient heroes. Use this to restore the light. This is all I can do for you now. Some sort of power is restraining me.
Now then, warriors, take the power of the ancient heroes!
Find the other three crystals, and use their powers to destroy the darkness!

● Job Change Message

► Story Plot

► Dungeon Composition Images

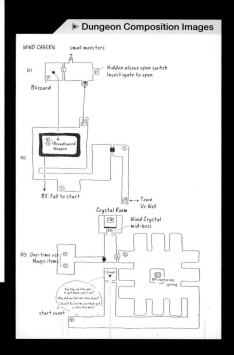

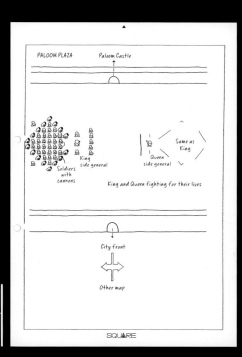

Early Castle Saronia Map Images

An image of the map, when Saronia was provisionally named "Paloom." The opposing armed forces staring each other down appeared in the game very close to this developmental form. During development the left side was meant to represent the king's forces, while the right side stood for the armies of the queen.

MISCELLANEOUS DEVELOPMENT

Early Battle Screen Images

Images of the battle screen. Hill Gigas, Ogre, and Roundworm sprites from *Final Fantasy II* were used here as placeholder assets. The topmost character represents a warrior-like job class which ultimately went unused (seen on page 122).

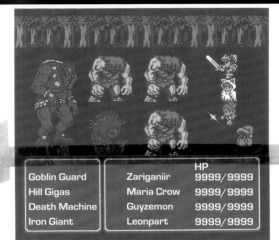

Event Effect Specifications

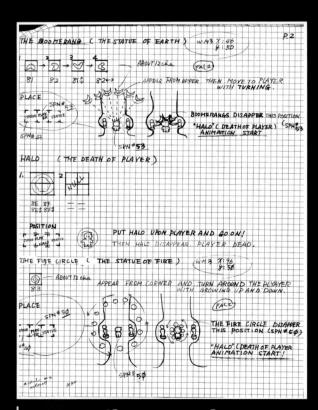

English specifications, made to convey the images to lead programmer Nasir Gebelli. This document details what happens when you approach the Statues of the Quest without the four Elemental Fangs. "The Boomerang" are the objects that fly toward the player who doesn't have the Fang of Earth in hand, and "The Fire Circle" describes the vortex of flames that surrounds them should they not possess the Fang of Fire.

Magic Effect Sketches

Images of offensive magic spell effects. The effects for Holy and Flare changed significantly in the final game. The text "silver whirlpool" next to Meteor represents the effect used during summon magic.

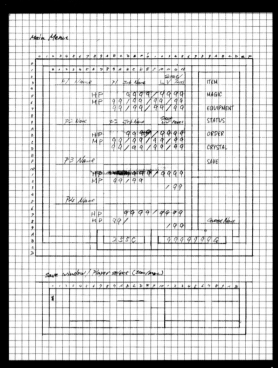

Menu Screen Blueprints

Drafts of the menu screen. The data that would be displayed was decided well in advance, as well as the data's positioning on the screen. The "Crystal" command would become "Job" in the final version, but everything else was faithfully reproduced in-game.

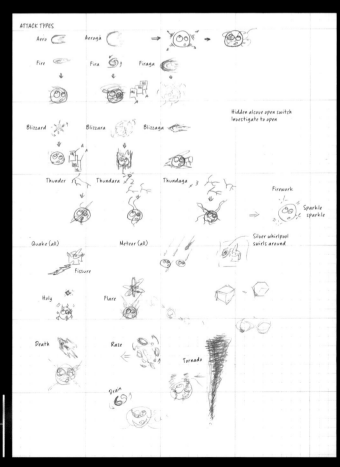

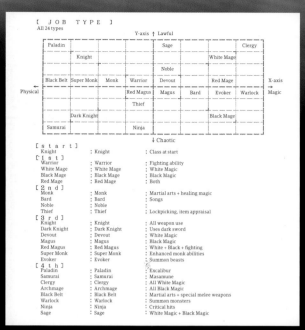

[JOB TYPE]
All 24 types

Y-axis ↑ Lawful

				Sage			Clergy
Paladin							
	Knight					White Mage	
				Noble			
Black Belt	Super Monk	Monk	Warrior	Devout		Red Mage	
			Red Magus	Magus	Bard	Evoker	Warlock
			Thief				
	Dark Knight					Black Mage	
Samurai			Ninja				

← Physical Magic →

← X-axis

↓ Chaotic

[s t a r t]
Knight : Knight : Class at start

[1 s t]
Warrior : Warrior : Fighting ability
White Mage : White Mage : White Magic
Black Mage : Black Mage : Black Magic
Red Mage : Red Mage : Both

[2 n d]
Monk : Monk : Martial arts + healing magic
Bard : Bard : Songs
Noble : Noble :
Thief : Thief : Lockpicking, item appraisal

[3 r d]
Knight : Knight : All weapon use
Dark Knight : Dark Knight : Uses dark sword
Devout : Devout : White Magic
Magus : Magus : Black Magic
Red Magus : Red Magus : White + Black + fighting
Super Monk : Super Monk : Enhanced monk abilities
Evoker : Evoker : Summon beasts

[4 t h]
Paladin : Paladin : Excalibur
Samurai : Samurai : Masamune
Clergy : Clergy : All White Magic
Archmage : Archmage : All Black Magic
Black Belt : Black Belt : Martial arts + special melee weapons
Warlock : Warlock : Summon monsters
Ninja : Ninja : Critical hits
Sage : Sage : White Magic + Black Magic

Early Development Job List

A chart showing the early job list, with "physical↔magic" on the horizontal axis and "lawful↔chaotic" on the vertical axis. While this does not appear onscreen, the specifications in this chart all appear in the final game. Capacity points are needed to change jobs, corresponding to the units of distance between current and new jobs as seen on the chart.

◆ Weapon equipment
● Attack Numbers
• Barehanded, two-handed
 $Atck_num = 1 + [(Rlev+Llev)/32 + Job_Lev/16 + DEX/32]$
• One-handed, equipped hand (H = R or L)
 $Atck_num = 1 + [Hlev/32 + Job_Lev/16 + DEX/32]$
• Bow and arrow, sling (special case)
 $Atck_num = 1 + [Alev/16 + Job_Lev/16 + DEX/32]$;Alev: Bow hand

Two-handed equipment weight, including shields: $W = (R+L)$ wep_weight
Equipment weight obstacle: $Miss_num = W/5 - STR/12$
 if $Miss_num > 0$ then $Atck_num = Atck_num - Miss_num$

◇ Accuracy ; (max100)
• Barehanded, two-handed
 $Hit\% = DEX/4 + (Rlev+Llev) /8 + (R+L)wep_hit\% /4$
• One-handed, equipped hand (H = R or L)
 $Hit\% = DEX/4 + Hlev/4 + wep_hit\% /2$
• Bow and arrow, sling (special case)
 $Hit\% = DEX/4 + Blev/4 + bow_hit\% /2$;Blev: Bow hand

◇ Damage
• Barehanded, two-handed
 $Damg_max = [STR/2 + Rwep_dmg/2 + Lwep_dmg/2] / 2$
 Exception: Barehanded for monk type
 $Damg_max = STR + Rwep_dmg/2 + Lwep_dmg/2$
• One-handed, equipped hand (H = R or L)
 $Damg_max = STR/2 + Hwep_damg$
• Bow and arrow, sling (special case)
 $Damg_max = STR/2 + arrow_dmg + bow_dmg/2$

◇ Additional weapon effects
 Optn = R_wep_Optn OR L_wep_Optn ; determine shield and exclude

◆ Armor equipment H:head ; B:body, A:arms , S:shield
◇ Evasion number
 $Def_num = DEX/16 + S_num(0/1/2) - total_weight/16$;(min0)
◇ Evasion rate
 $Def_\% = DEX/4 + H_evde_\% + B_evde_\% + A_evde_\% + S_evde_\%(R, L)$
◇ Defense
 $Absb = VIT/2 + H_Absb + B_Absb + A_Absb + S_Absb(R,L)$
◇ Magic evasion number
 $Mgc_Def_num = DEX/32 + (IQ + MIND)/32 - total_weight/16$;(min0)
◇ Magic evasion rate
 $Mgc_Def_\% = (IQ + MIND)/4$
◇ Magic defense
 $Mgc_Absb = H_M_Absb + B_M_Absb + A_M_Absb + S_M_Absb$
◇ Special defense
 anti_Optn = H_anti_Optn OR B_anti_Optn OR A_anti_Optn OR S_anti_Optn
◇ Elemental defense
 anti_type = H_anti_type OR B_anti_type OR A_anti_type OR S_anti_type
◇ Weakness
 weak_type = [(anti_type/2) AND $28] OR [(anti_type*2) AND $50]
 (b6<->b5 , b4<->b3) (see table below)

```
b7   b6   b5   b4   b3   b2   b1   b0   [type]
+- - + - - + - - + - - + - - + - - + - - + - - +
Ghost Stone Earth Flame Cold Thunder Poison Heal
+- - + - - + - - + - - + - - + - - + - - + - - +
        1 Weak
      Weak 1
              1 Weak
      Weak 1
+- - + - - + - - + - - + - - + - - + - - + - - +
```

Defense	Weakness	Element→Weakness
Petrify Attack	Weak to Earthquake	$40 -> $20
Earthquake Attack	Weak to Petrify	$20 -> $40
Flame Attack	Weak to Cold	$08 -> $04
Cold Attack	Weak to Flame	$04 -> $08

Battle Formulas

Documentation of internal calculations for battles. Hit counts, accuracy, damage output, and more are determined according to these formulas.

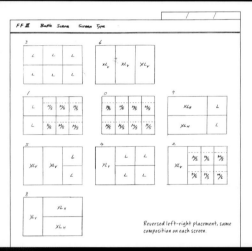

FF III Battle Scene Screen Type

Reversed left-right placement, same composition on each screen.

Monster Appearance Patterns

Monster placement patterns in battle. There are five monster sizes in all—S, M, L, XLV, and XLH—and their onscreen positions are determined by the sizes of the other enemies that appear on the screen.

Monster List

A portion of the monster list developed during the planning stages. The amount of unused settings is fascinating, including the reference to the Guardian as "King of Lake Dohr," and to Xande as "A cold and beautiful woman." At this point, the Cloud of Darkness was known as "Darkening Cloud," much like the nickname for Famfrit, a similarly themed monster from *Final Fantasy XII*. In the Red Dragon section, it is clear that they were originally intended to play the roles of the five wyrms.

File Name = 'MONSTER.MOS' Mon Apr 10 16:19:08 1989 Page = 001/018

FF3 Monster List

● Has a picture specially drawn by Square graphics
□ Monster introduced in *FF2* (no reference pictures this time)
▲ Has a picture for publication
(no mark) Has no reference picture
A Outsourced to Yoshitaka Amano

S size 16------------------------------

□ 1S Goblin (Knocker, Red Cap)
A well-known imp (with no horn, despite being in the ogre clan).
It is not at all strong, attacking with arrows and spears.
Smaller than the average man.

□ 2S Killer Bee (Hornet)
Large for an insect, but small for a monster.
It possesses a long stinger, poisoning those it stabs.
About the size of a fist.

● 3S Firebird (Ice Bird)
A large hawk wrapped in flames. It has a bit of equipment, but nothing you could call armor. Attacks with its bill, its talons, and fire magic.

File Name = 'MONSTER.MOS' Mon Apr 10 16:19:08 1989 Page = 016/018

They attack using magic.

A 12B Guardian
A summon monster called from the Feymarch through an Evoker's summon magic. A massive warrior encased in magic armor.
King of Lake Dohr, like a slimmed-down version of Daimajin.

A 13B Red Dragon (Triple Dragon)
A massive dragon several times bigger than Bahamut.
Guards the door to Xande's room in the Crystal Tower.
There are seven in all, and attack all at once.

A 14B Xande <160>
Perhaps the strongest magic user in the world, who learned from the same teacher as Master Doga. Used the power of the Earth Crystal to throw the world into chaos.
A cold and beautiful woman.
Uses the four Dark Crystals of the other dimension (corresponding to the Wind, Fire, Water, and Earth crystals) to create the ultimate monster in an attempt to destroy the world.

A 15B Darkening Cloud <192>
The strongest monster in *FF3*, the ultimate enemy created by Xande through the boundless power of the four Dark Crystals. Looks like a woman trying to emerge from a mass of spiritual energy. Its entire form is lead colored, and because it is incomplete, only its top half has formed. A peerless beauty.

200 types total

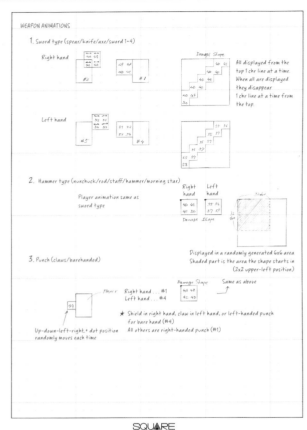

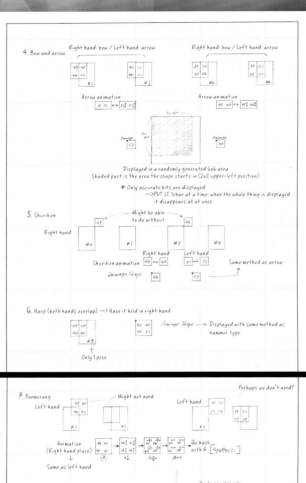

SQUARE

Weapon Animation Specifications

Specification documents related to effects associated with weapon attacks. The details for each weapon are broken down pixel by pixel.

Koichi Ishii Illustration

Some cute character illustrations for jobs, by Koichi Ishii. Many of the illustrations that appeared in magazines and strategy guides at the time of the game's release were drawn by the development staff, beginning with Koichi Ishii.

⊹ Onion Knight

⊹ Congratulations

Background Music and Effect List

A partial list of the background music and sound effects used in the game. "Itoh plays 'Für Elise'" refers to sound effect director Hiroyuki Itoh's attempt to play the famous Beethoven song, mistakes and all.

music.new P_1

Song Names

00	0: Usual opening ====================================	01
01	1: Crystal Cave ====================================	02
02	2: Area Theme ====================================	03
03	3: Harp ====================================	04
04	4: Village/town/castle after problem resolution========	05
05	5: Town of Amur ====================================	06
06	6: Victory Fanfare ==================================	07
07	7: Chocobo Theme ==================================	08
08	8: Old Man's Theme ================================	09
09	9: Chopper 1, 2, 3 ================================	0A
0A	10: Dwarf Village ================================	0B
0B	11: Village/town/castle with a problem =============	0C
0C	12: Living Forest ================================	0D
0D	13: Panic short music==============================	0E
0E	14: Underwater Shrine =============================	0F
0F	15: Simple City ==================================	10
10	16: Sasazaki City ================================	11
11	17: Some city (TBD) ==============================	12
12	18: Game Over ====================================	13
13	19: FF Theme ====================================	14
14	20: Going Underwater =============================	15
15	21: Nepto's Shrine ===============================	16
16	22: Fanfare 1====================================	17
17	23: Fanfare 2 ===================================	18
18	24: Dungeon ====================================	1D
19	25: World Map 1, 3 ===============================	1E
1A	26: Ur or Canaan (Miho) ==========================	1F
1B	27: Battle 1 ====================================	20
1C	28: Mountain Road ================================	21
1D	29: Enterprise===================================	22
1E	30: Xande Battle=================================	cut.
1F	31: Dreadnought==================================	23
20	32: Tower of Owen ================================	24
21	33: Crystal Tower ================================	25
22	34: Unei's Cave, Doga's Shrine (Nariken's favorite song) ====	26
23	35: Eureka ====================================	27
24	36: Big Boss Battle ===============================	28
25	37: Into Darkness ================================	29
26	38: Mid-Boss Battle ===============================	2A
27	39: Adding comrades ==============================	2C
28	40: Dangerous short music ==========================	2D
29	41: Saronia ====================================	2E
2A	42: World Map 2 ==================================	2F
2B	43: Fall into a pit (SM) ============================	30
2C	44: Big chopper rises from the water (SM) ==============	31
2D	45: Chopper 3 sound at Saronia ======================	32
2E	46: Giant bird's nest==============================	cut.
2F	47: Applause (SM) ================================	33
30	48: Booing (SM) ==================================	34
31	49: Go to giant bird sky ==========================	35
32	50: Crystal Room ================================	36
33	51: Ending 2 ====================================	37
34	31: Hein's castle ================================	38

music.new P_2

35	53: Chocobo Forest================================	39
36	54: The Flea Waltz ==============================	3A
37	55: Ending 3 ==================================	3B
38	56: Ending 1 (close to Miho) ======================	3C
39	57: Dangerous short music 2 =======================	3D
3A	58: Dangerous short music 3 =======================	3E
3B	59: Dangerous short music 4 (up-tempo of 3) ==========	3F
3C	60: Itoh plays "Für Elise" =========================	40
3D		
3E	: Music restart===============================	7E
3F	: Music stop=================================	7F

Above are the current changes.
The following are new entries. Be nice to them.

00	Inn Bed Music ================================	(SM)
19	Fat Chocobo Theme ============================	(To be looped.)
1A	Amur Town Dance =============================	(No loop, ends.)
1B	Unei's Radio Exercise ==========================	(same)
1C	Dancer's Dance ===============================	(same)
70	Special: #37 ending 2 =========================	FADE IN & OUT

☆ Sound Effects

00[80]	0: Cannon
01[81]	1: Bio
02[82]	2: Blizzard
03[83]	3: Door
04[84]	4: Wave (on the ocean)
05[85]	5: Menu select
06[86]	6: Beep
07[87]	7: Split
08[88]	8: Dorian
09[89]	9: Healing
0A[8A]	10: Punch
0B[8B]	11: Harp Attack
0C[8C]	12: Throwing ring into a spring
0D[8D]	13: We Kill
0E[8E]	14: Floating Continent
0F[8F]	15: Menace
10[90]	16: Tackle (chopper 1)
11[91]	17: Death Magic
12[92]	18: Lock sound
13[93]	19: Screen change (main->sub)
14[94]	20: Screen change (sub->main)
15[95]	21: Screen change (to battle)
16[96]	22: Walking while poisoned
17[97]	23: Leader change
18[98]	24: Cursor movement sound
19[99]	25: Barrier Magic
1A[9A]	26: Breakga Magic
1B[9B]	27: Break Magic

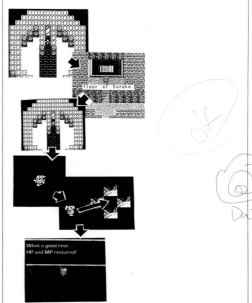

When using magic "Desion"(Warp 1floor) at the entrance floor of Eureka, when returning from Eureka,it is a black world with blue squares on right, and that square recovers HP/MP to Max.
"Desion" again and get back to the entrance of Eureka.

floor of Eureka

What a good rest...
HP and MP restored!

SQUARE

Debug Report

A report detailing an exploit in which using Warp to return to the first floor on the way back to the Crystal Tower from Eureka would send the player to a mysterious inn. Though this was understood during development, the big "OK" indicates that there was no objection to leaving it in the game.

OCT- 3-90 WED 20:24 NASIR GEBELLI

NAS

To : Mr. TANAKA

I'll send you the updated version of FF2 and FF3. Although it's not the final version, but it should be sufficient for testing.
The special alpha table(ce,th,..) location is at the end of program in the last BANK, before BATTLE-ROT.

NAS.

Nasir Gebelli Fax

Part of a fax sent from Nasir Gebelli to game system design lead Hiromichi Tanaka. Mr. Gebelli's signature adorns the bottom right of the fax.

REMAKE ILLUSTRATION ORIGINALS

Original pictures for each job, drawn by Akihiko Yoshida, the character designer for the 3D remake. Some of the jobs underwent even further redesigns down the road.

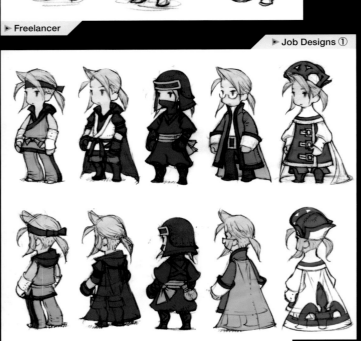

▶ Freelancer

▶ Job Designs ①

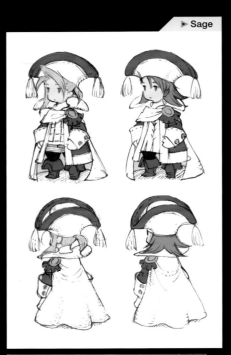

▶ Sage

The Sage design in the illustration to the left is merely a draft. Comparing this to the illustration above, it is clear how many changes were made to the final design. Several other details differ from the final game, including Luneth's hair being tucked into the hood of his ninja outfit and the chest ribbon on Refia's Black Mage outfit appearing as red instead of light blue.

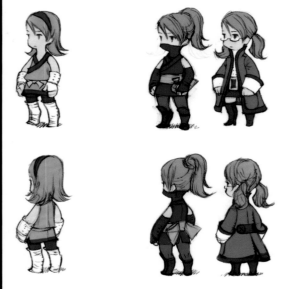

✥ Left to right: Monk, Black Belt, Ninja, Scholar, early Sage design

▶ Job Designs ②

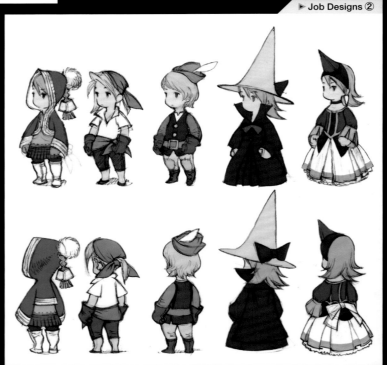

✥ Left to right: Geomancer, Thief, Ranger, Black Mage, Summoner

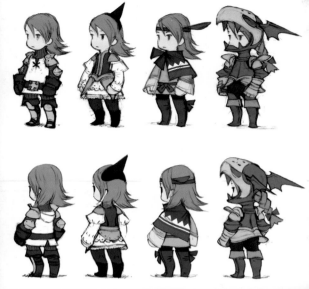

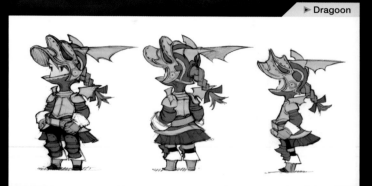

▶ Dragoon

The coloring for the Warrior and Onion Knight jobs as seen here is significantly different from that in the final game. The Dragoon's helmet and armor design also changed greatly from the left illustration, transforming into a version resembling the illustration above. In the final version, the ribbon and loincloth colors changed to light blue.

▶ Job Designs ③ ⁂ Left to right: Warrior, Evoker, Bard, early Dragoon design

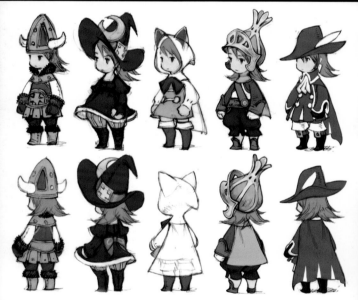

▶ Dark Knight

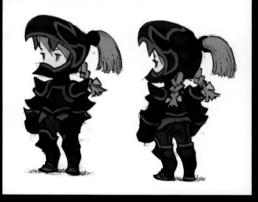

⁂ Left to right: Viking, Magus, Devout, Onion Knight, Red Mage ▶ Job Designs ④

▶ Princess Sara

This design remained faithful to Yoshitaka Amano's work, as seen when comparing it to the illustration on page 104. One thing that stands out is the decorations on either side of Sara's head.

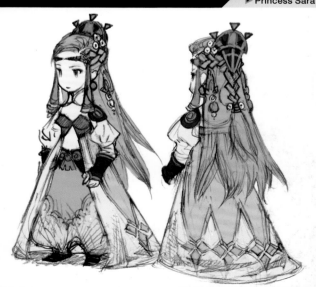

REMAKE MOVIE MATERIALS

Illustration materials used to create the remake movie. Castle Sasune and the Crystal Dome appear
very close to their final forms seen in the actual movie.

► Castle Sasune

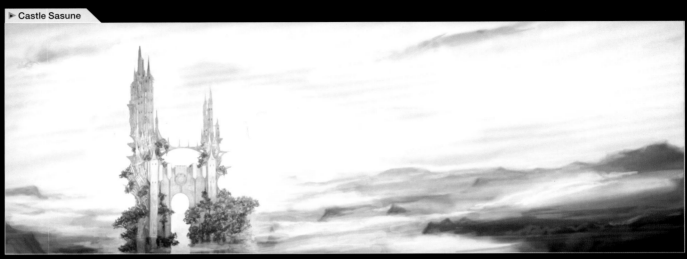

► Crystal Dome

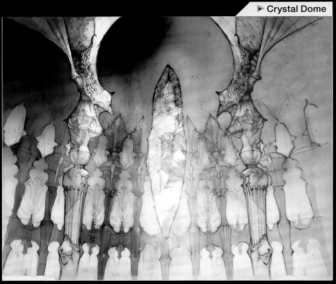

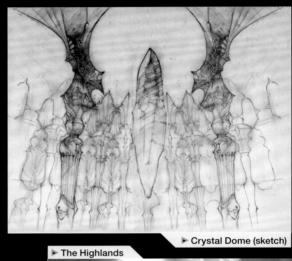

► Crystal Dome (sketch)

► The Highlands

► Village of the Ancients

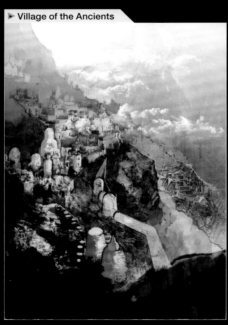

► The Airship

► Crystal Tower

FINAL FANTASY III
MEMORIES

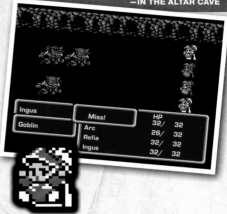

The first job received: the Onion Knight. Its ultimate potential was largely unknown.
—IN THE ALTAR CAVE

The joy of riding an airship shortly into the game, only for it to ultimately be destroyed.
—IN NELV VALLEY

Taking on the Nepto Dragon out of foolish bravery, and facing the dire consequences of one's actions . . .
—NEAR NEPTO TEMPLE

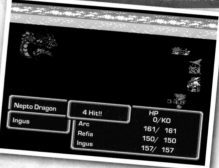

Leaving the Floating Continent and seeing a vast ocean stretching out ahead. Having to fly around and search for land.
—ON THE SURFACE WORLD

From frogs to tiny people, changing one's shape with magic allows the traversal of dungeons.
—IN THE SUBTERRANEAN LAKE

Walking between the stone statues without the four Elemental Fangs? Game over for the Warriors of the Light.
—NEAR THE CRYSTAL TOWER

The more they're cut, the more there are. Tough battles against splitting monsters.
—IN THE ANCIENT RUINS

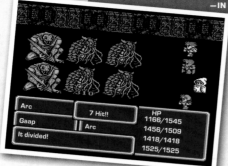

Arc
Gaap
It divided!

7 Hit!!
Arc

HP
1166/1545
1456/1509
1418/1418
1525/1525

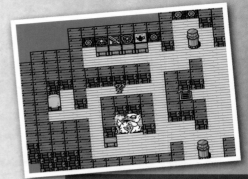

The top-of-the-line airship *Invincible* is packed with all the amenities. Despite these luxuries, the *Nautilus*'s speed is nothing to sneeze at.
—ON THE *INVINCIBLE*

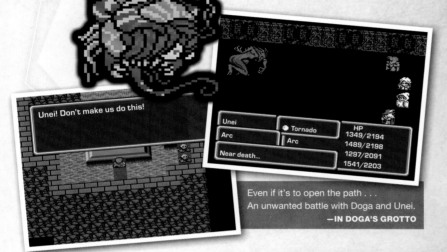

Unei! Don't make us do this!

Unei
Arc
Near death...

Tornado
Arc

HP
1349/2194
1489/2198
1297/2091
1541/2203

Even if it's to open the path . . .
An unwanted battle with Doga and Unei.
—IN DOGA'S GROTTO

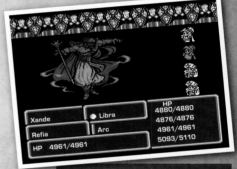

Xande
Refia
HP 4961/4961

Libra
Arc

HP
4880/4880
4876/4876
4961/4961
5093/5110

Xande uses Libra at regular intervals. Better safe than sorry?
—AT THE CRYSTAL TOWER

The Crystal Tower, and the World of Darkness . . .
A long, grueling trek without save points.
—IN THE WORLD OF DARKNESS

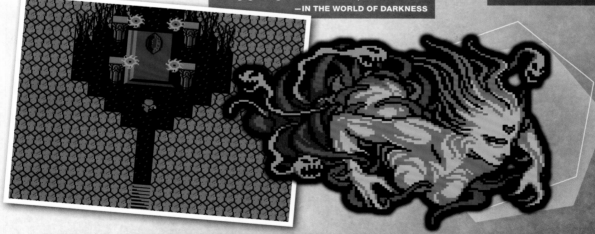

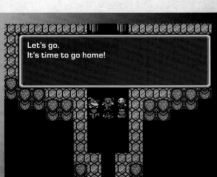

Let's go.
It's time to go home!

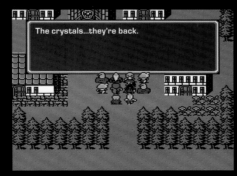

The crystals...they're back.

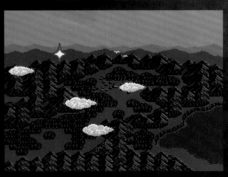

ファイナルファンタジーIV
FINAL FANTASY IV ®

Easy Type Version

WSC Version

GBA Version
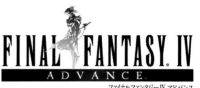

DS Version
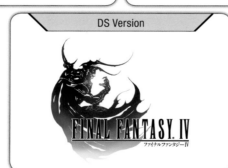

PS/Mobile Version
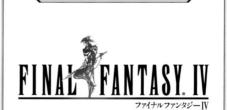

Incredible storytelling combined with the first use of the real-time ATB (Active Time Battle) system

The fourth *Final Fantasy* game made its way to the Super Famicom and Super Nintendo Entertainment System as *Final Fantasy II*, bringing next-generation music and graphics to the ongoing series. A deep human drama focuses on the growth of Cecil, a man with the blood of the Lunarians, and introduces the Active Time Battle system. A direct sequel set decades after the events of *FFIV* was released in 2008, called *Final Fantasy IV: The After Years*.

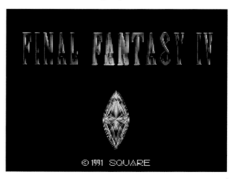

Super Famicom	Super Famicom/SNES	PlayStation	PlayStation	PlayStation (Limited Edition)
Final Fantasy IV	**Final Fantasy IV Easy Type**	**Final Fantasy IV**	**Final Fantasy Collection**	**Final Fantasy Collection Anniversary Package**
Launch Date ● July 19, 1991	JP Launch Date ● October 29, 1991 NA Launch Date ● November 23, 1991 ✻ NA version released as *Final Fantasy II*	JP Launch Date ● March 21, 1997 NA Launch Date ● June 29, 2001 ✻ JP version convenience store exclusive	Launch Date ● March 11, 1999	Launch Date ● March 11, 1999

WonderSwan Color	Game Boy Advance	Game Boy Advance (Console Bundle)	Nintendo DS	Wii/Wii U (Virtual Console)
Final Fantasy IV	**Final Fantasy IV Advance**	**Final Fantasy IV Advance** Yoshitaka Amano Design GB Micro Final Fantasy Model Bundle Set	**Final Fantasy IV**	**Final Fantasy IV** (Super Famicom/SNES Version)
Launch Date ● March 28, 2002	JP Launch Date ● December 15, 2005 NA Launch Date ● December 12, 2005	Launch Date ● December 15, 2005	JP Launch Date ● December 20, 2007 NA Launch Date ● July 22, 2008	JP Launch Date ● August 4, 2009 NA Launch Date ● March 8, 2010

i-mode	EZweb Mobile Phone Service	Yahoo! Mobile	Nintendo DS (Ultimate Hits)	PlayStation Portable
Final Fantasy IV	**Final Fantasy IV**	**Final Fantasy IV**	**Final Fantasy IV**	**Final Fantasy IV Complete Collection**
Launch Date ● October 5, 2009	Launch Date ● December 10, 2009	Launch Date ● January 13, 2010	Launch Date ● March 4, 2010	JP Launch Date ● March 24, 2011 NA Launch Date ● April 19, 2011

PlayStation Portable (Limited Edition)	PlayStation Portable/PlayStation Vita (Digital Download)	PlayStation 3/PlayStation Portable/PlayStation Vita (PS one Classics)	PlayStation Portable (Ultimate Hits)	PlayStation (Limited Edition)
Final Fantasy IV Complete Collection Ultimate Pack	**Final Fantasy IV Complete Collection** (PlayStation Portable Version)	**Final Fantasy IV** (PlayStation Version)	**Final Fantasy IV Complete Collection**	**Final Fantasy 25th Anniversary Ultimate Box**
Launch Date ● March 24, 2011 ✻ Square Enix e-Store exclusive	Launch Date ● March 24, 2011	Launch Date ● June 27, 2012 ✻ Available on PS Vita from August 28, 2012	Launch Date ● July 5, 2012	Launch Date ● December 18, 2012 ✻ Square Enix e-Store Limited Edition

ART

The Darkness and the Light
Cecil

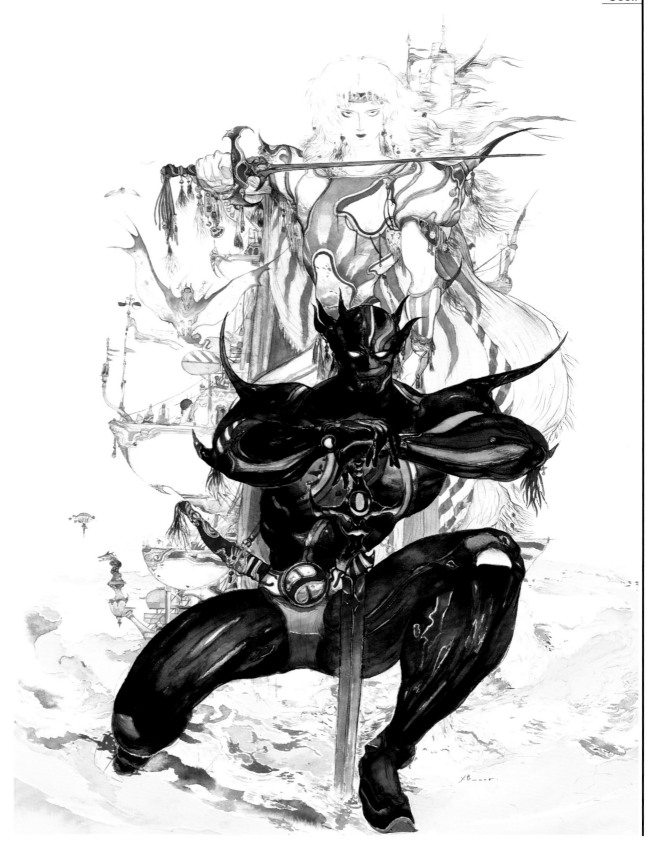

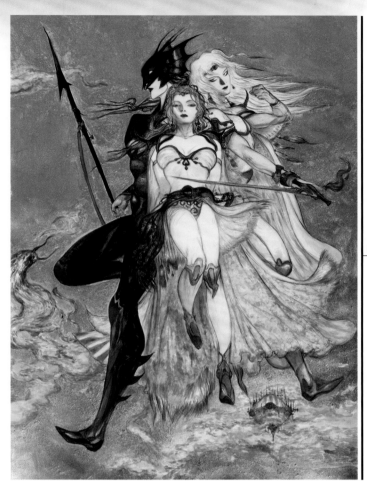

Cecil, Rosa, and Kain

Comrades
(DS package illustration)

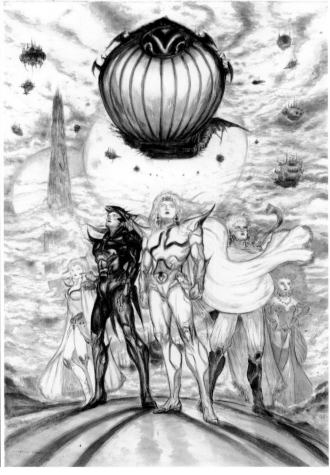

If the Crystals know,
they share no answers—
only their pure and silent light.

Why, Kain!?

Dragoon

Cecil HP
 328/ 328

Stay back. This is a fight for me and me alone.
My atonement for all the sins I've wrought—
my test.

FINAL FANTASY IV
STORY

Caught you, black chocobo!

Meteo

Golbez

Tellah HP
 416/ 416

We will guide you to the core.

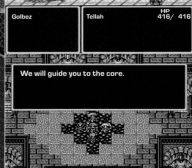

Long ago, a mysterious race of Lunarians abandoned their doomed home world, arriving on what they called the Blue Planet. Most of them wanted to blend in among the denizens of this world, yet one, Zemus, advocated taking the Blue Planet by force. Zemus's brethren disagreed, and sealed him away. The others then fell into a long sleep on the newly constructed Red Moon, and awaited the day when the natives of the Blue Planet would evolve to their level. This is how the Blue Planet came to have two moons.

Many centuries passed, and the people of the Blue Planet eventually learned to build flying airships. This development, however, provided the wings upon which a new war would fly. The kingdom of Baron formed an airship squadron to attack its neighbors, and began stealing the crystals that conferred blessings upon the world. Behind the sudden aggression was Zemus, whose malice had only deepened during his confinement. His wicked campaign tore apart two brothers who inherited the blood of the Lunarians: the elder, Golbez, who sought the crystals under Zemus's command, and the younger, Cecil, whose noble heart drove him to protect the crystals. From on high, the distant moon watched over their fraternal conflict . . .

CHARACTERS

FINAL FANTASY IV
ファイナルファンタジーIV

✣ Images are from the DS version
✣1 DS version-exclusive character

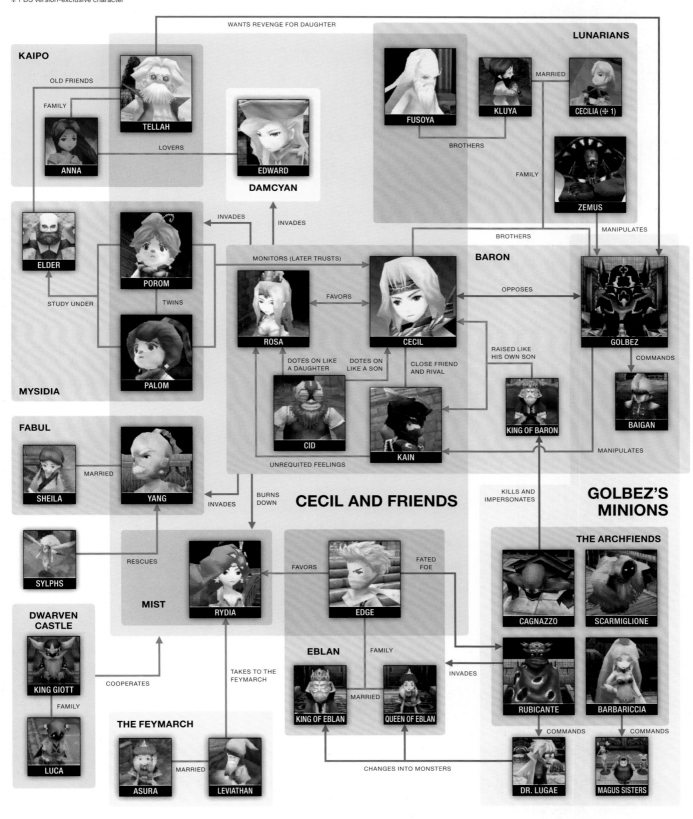

KAIPO

WANTS REVENGE FOR DAUGHTER

LUNARIANS

OLD FRIENDS

FAMILY

TELLAH

ANNA

LOVERS

EDWARD

DAMCYAN

FUSOYA

KLUYA

MARRIED

CECILIA (✣1)

BROTHERS

FAMILY

ZEMUS

MANIPULATES

ELDER

POROM

INVADES

INVADES

MONITORS (LATER TRUSTS)

BARON

BROTHERS

STUDY UNDER

TWINS

ROSA

FAVORS

CECIL

OPPOSES

GOLBEZ

PALOM

DOTES ON LIKE A DAUGHTER

DOTES ON LIKE A SON

CLOSE FRIEND AND RIVAL

RAISED LIKE HIS OWN SON

COMMANDS

MYSIDIA

CID

KAIN

KING OF BARON

BAIGAN

FABUL

UNREQUITED FEELINGS

MANIPULATES

SHEILA

MARRIED

YANG

INVADES

BURNS DOWN

CECIL AND FRIENDS

KILLS AND IMPERSONATES

GOLBEZ'S MINIONS

SYLPHS

RESCUES

MIST

RYDIA

FAVORS

EDGE

FATED FOE

THE ARCHFIENDS

DWARVEN CASTLE

CAGNAZZO

SCARMIGLIONE

EBLAN

FAMILY

KING GIOTT

COOPERATES

TAKES TO THE FEYMARCH

INVADES

FAMILY

KING OF EBLAN

MARRIED

QUEEN OF EBLAN

RUBICANTE

BARBARICCIA

LUCA

THE FEYMARCH

COMMANDS

COMMANDS

ASURA

MARRIED

LEVIATHAN

CHANGES INTO MONSTERS

DR. LUGAE

MAGUS SISTERS

Cecil

Compassionate knight
troubled by his way of life.

セシル
[Seshiru/Cecil]

▶ *Cecil Harvey* セシル・ハーヴィ

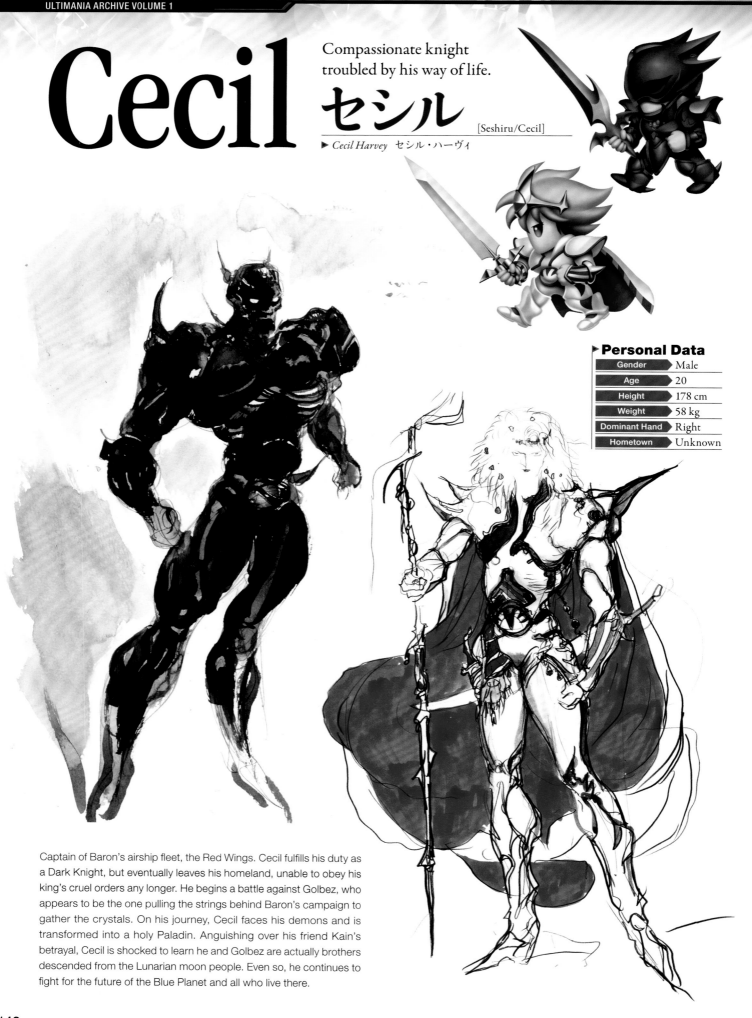

▶ Personal Data

Gender	Male
Age	20
Height	178 cm
Weight	58 kg
Dominant Hand	Right
Hometown	Unknown

Captain of Baron's airship fleet, the Red Wings. Cecil fulfills his duty as a Dark Knight, but eventually leaves his homeland, unable to obey his king's cruel orders any longer. He begins a battle against Golbez, who appears to be the one pulling the strings behind Baron's campaign to gather the crystals. On his journey, Cecil faces his demons and is transformed into a holy Paladin. Anguishing over his friend Kain's betrayal, Cecil is shocked to learn he and Golbez are actually brothers descended from the Lunarian moon people. Even so, he continues to fight for the future of the Blue Planet and all who live there.

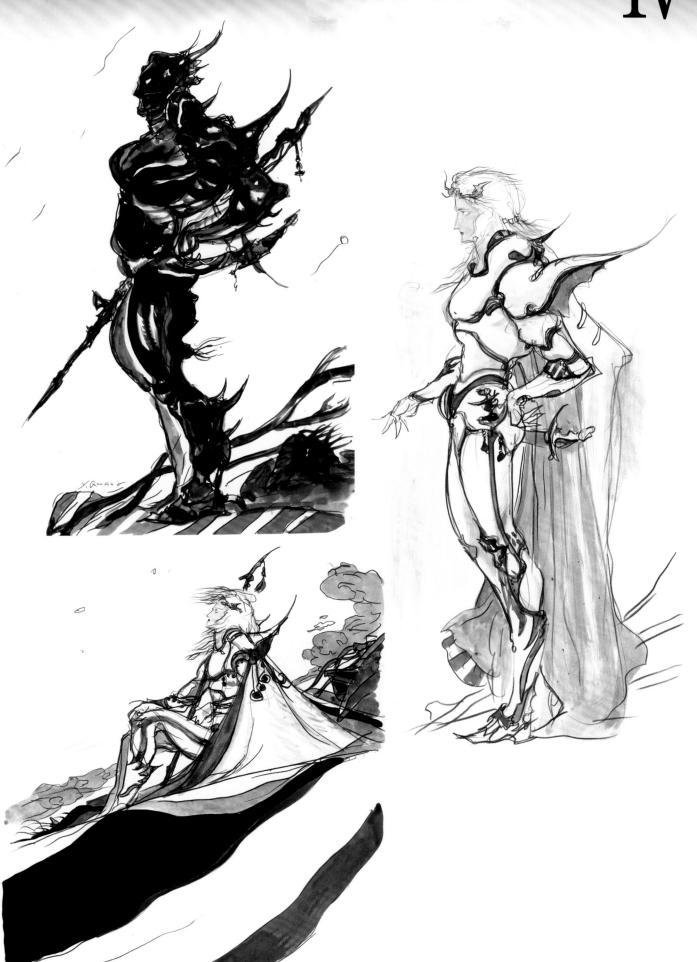

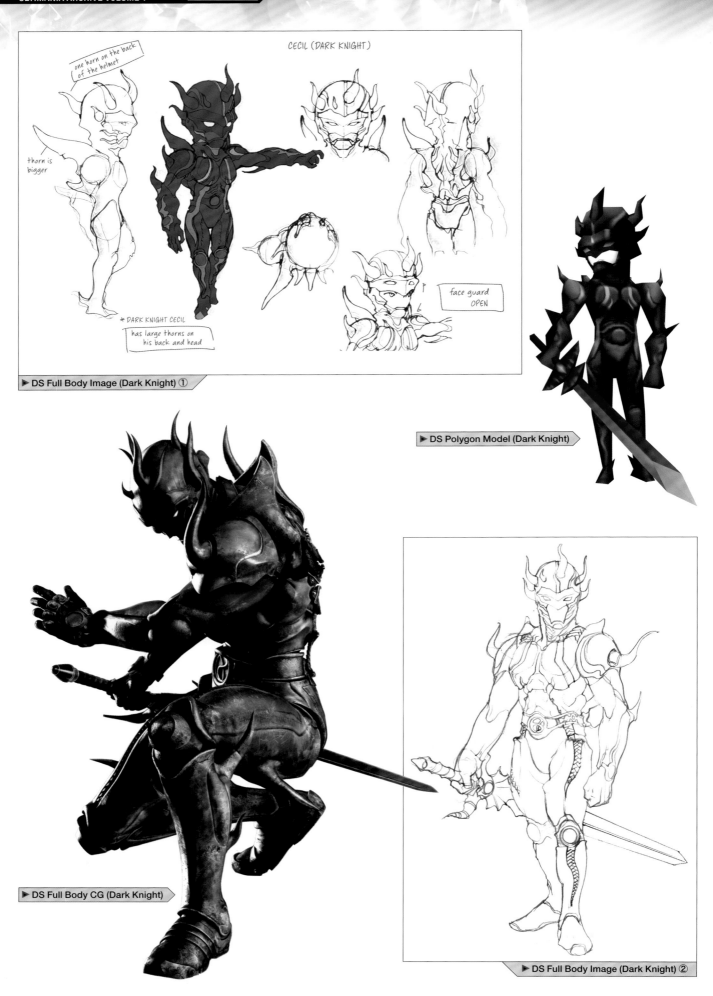

one horn on the back of the helmet

thorn is bigger

CECIL (DARK KNIGHT)

* DARK KNIGHT CECIL has large thorns on his back and head

face guard OPEN

▶ DS Full Body Image (Dark Knight) ①

▶ DS Polygon Model (Dark Knight)

▶ DS Full Body CG (Dark Knight)

▶ DS Full Body Image (Dark Knight) ②

▶ DS Full Body CG (Paladin)

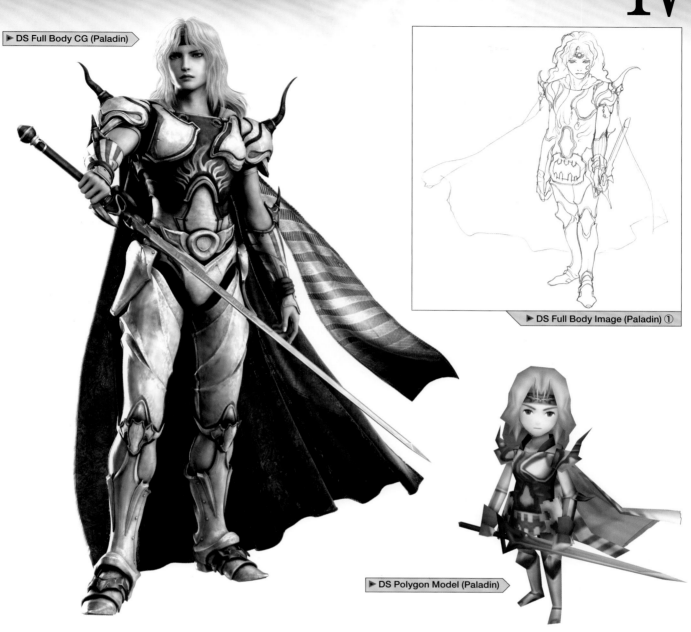

▶ DS Full Body Image (Paladin) ①

▶ DS Polygon Model (Paladin)

▶ DS Full Body Image (Paladin) ②

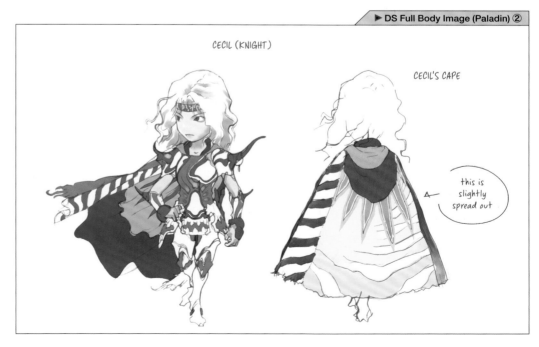

CECIL (KNIGHT)

CECIL'S CAPE

this is slightly spread out

Memorable Quotes

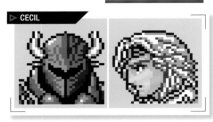

> CECIL

"I'm a coward. A coward who cannot even defy orders he knows he ought not follow."

—In Baron Castle, deriding himself for lacking the commitment to disobey the inhuman commands of his king.

Cecil mocks his perceived weakness when speaking with his beloved, Rosa. Despite his long service to the king, Cecil is ashamed of performing actions he considers reprehensible. Conflicted in his emotions, he erects a wall between him and the woman he loves.

"You'll help us fight Golbez, won't you? We could use your help now more than ever."

—After Kain comes back to his senses in the Tower of Zot.

Kain, who had hounded Cecil while under Golbez's diabolical mental control, is welcomed back as a friend. This action demonstrates Cecil's kindness and his unshakable faith in his comrade.

"Zeromus . . . This is the end for you—not us!"

—In the Lunar Subterrane, before the final battle with Zeromus.

The party is overwhelmed by Zeromus, a spirit of hatred that seeks to erase everything. With the crystals from his brother Golbez and the hopes of so many resting on his shoulders, Cecil challenges the evil apparition to a showdown.

"But why? WHY!!!"

—In Mist, while watching the village burning around him as a result of the destructive Carnelian Signet.

Under the guise of delivering an important item to the village of Mist, the king of Baron sought to exterminate the powerful summoners who lived there. Upon realizing that he was an unwitting participant in unleashing this tragedy, Cecil screams in rage.

"Stay back. This is a fight for me and me alone."

—On Mount Ordeals, when stopping his comrades from leaping to his aid.

Cecil does not waver when confronted with another version of himself, recognizing it as a symbol from his past that he must overcome. He stops his friends from joining the fight, knowing he must pass this trial using only his own strength.

"Farewell . . . my brother."

—Saying goodbye to Golbez during the finale.

Cecil is troubled after learning that his foe Golbez was actually his brother. And yet, when Golbez faces dire straits in the final battle, he calls out to Cecil as one brother to another. Cecil returns the sentiment when Golbez sets out on his own, bidding a fond farewell to the brother he barely knew.

Memorable Scenes

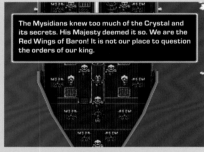

Captain of the Red Wings

Stealing the crystal from the town of Mysidia is an unpleasant mission for the aviators of the Red Wings. Despite feeling the same reluctance as his subordinates, Cecil reminds them that orders from His Majesty are absolute.

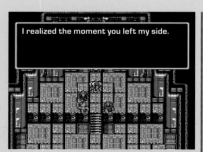

Feelings for Rosa

Rosa is narrowly saved from the Tower of Zot. Cecil realized just how important Rosa was to him during her absence, and warmly embraces her for the whole world to see.

Alone in the Frontier

On the way from Fabul to Baron, Cecil's ship falls under attack by the Leviathan. Launched onto the shore, Cecil calls out for his comrades, but no one answers his cries . . .

> CECIL

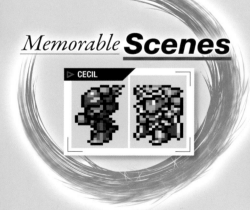

The Enemy's Identity

Within the Giant of Babil, Cecil discovers that Golbez is his older brother. Shocked by the revelation, Cecil cannot find the words to communicate with Golbez, who is now rushing into certain doom to atone for his sins . . .

Reconciling the Past

Confronting the Dark Knight that represents his former self, Cecil wisely sheathes his blade. Instead of severing ties with his past by force, Cecil conquers it with his heart. By doing so, he is infused with holy power and becomes a Paladin.

The prideful Dragoon,
unable to show his true feelings.

Kain カイン

[Cain]

▶ *Kain Highwind* カイン・ハイウインド

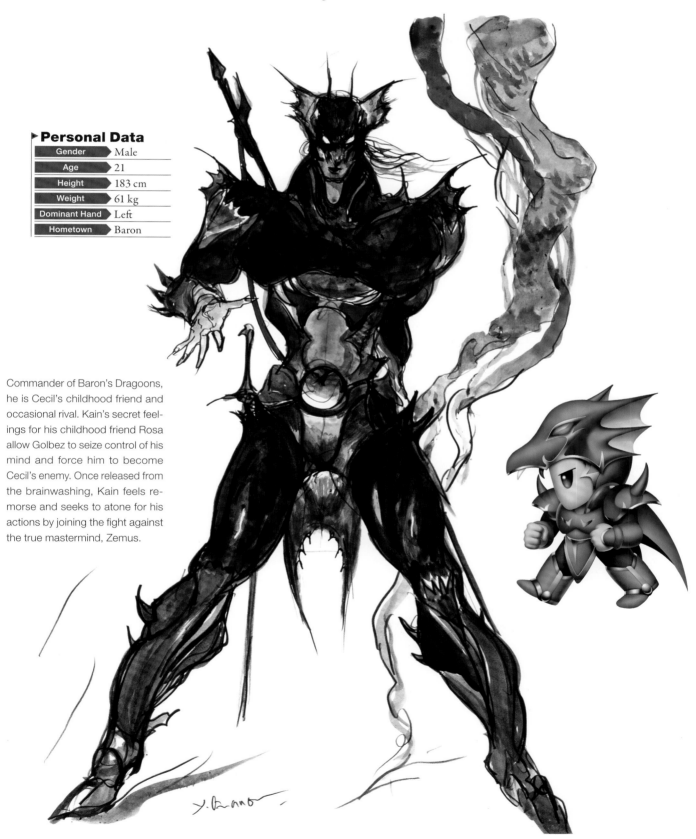

▶ Personal Data

Gender	Male
Age	21
Height	183 cm
Weight	61 kg
Dominant Hand	Left
Hometown	Baron

Commander of Baron's Dragoons, he is Cecil's childhood friend and occasional rival. Kain's secret feelings for his childhood friend Rosa allow Golbez to seize control of his mind and force him to become Cecil's enemy. Once released from the brainwashing, Kain feels remorse and seeks to atone for his actions by joining the fight against the true mastermind, Zemus.

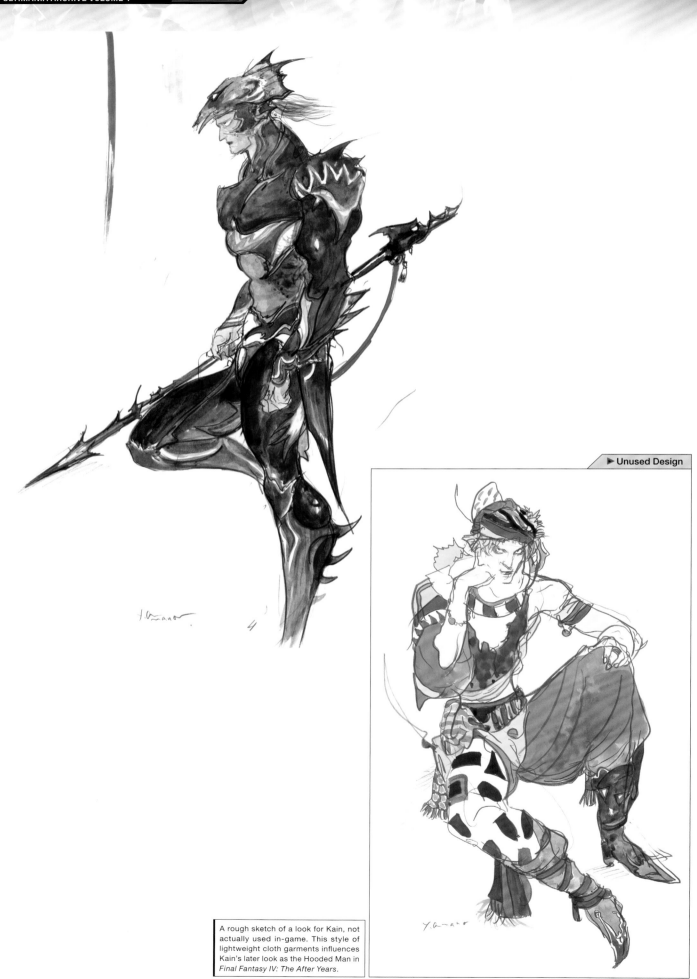

▶ Unused Design

A rough sketch of a look for Kain, not actually used in-game. This style of lightweight cloth garments influences Kain's later look as the Hooded Man in *Final Fantasy IV: The After Years*.

▶ DS Full Body CG

▶ DS Full Body Image

▶ DS Polygon Model

▶ DS Full Body Image (Early Proposal)

Memorable Quotes

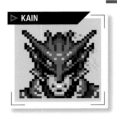

> KAIN

"Urgh . . .
Don't . . .
look at me!"

—In Fabul Castle, when being scolded by Rosa
as she rushes in.

Kain defeats Cecil while under Golbez's spell, but upon seeing Rosa he begins to falter. His unwillingness to reveal his betrayal of his best friend to Rosa reveals the true feelings in his heart.

"I am more than Cecil will ever be. You'll see that soon enough."

—To the captured Rosa in the Tower of Zot.

Thinking that Rosa has chosen Cecil, Kain hides the inferiority he feels when compared to his friend. His resentment toward Cecil is laid bare when he falls to the enemy's mental manipulations.

"Forgive me, Rosa. Not all of what I did was because of Golbez's spell. I just wanted to keep you . . . to keep you by my side."

—In the Tower of Zot, speaking truthfully to
the rescued Rosa after returning to his senses.

Freed from Golbez's spell, Kain confesses his love for the woman he tried to keep by his side. The timing of his confession is heartbreaking, occurring right after Cecil and Rosa finally hold each other in their arms.

"If that should happen, kill me without a second thought."

—Aboard the Lunar Whale, to Edge, who suspects
that Kain will be brainwashed again.

More than anyone, Kain understands how serious it would be were he to betray Cecil a second time. He doesn't shy away from Edge's verbal attack, replying with a grim resolve that reveals the depth of his commitment.

"It's all right. I . . . I'm back in control of myself."

—Under the sway of Golbez, before betraying
Cecil again in the Sealed Cave.

Even under Golbez's control, Kain remains convinced of his own sanity. Yet in contrast to his words, Kain steals the recently acquired crystal from Cecil and runs off.

"I owe His Majesty much, but not so much I'd soil the Dragoons' name in his."

—In Mist, expressing his desire to leave Baron
with Cecil.

Kain pretends he wants to kill Rydia in order to draw out Cecil's true feelings. More important than Kain's allegiance to his king is the path he believes in above all else—the life of a Dragoon.

Take the Fight to the Skies

As a Dragoon, Kain uses the high-flying Jump command. He declares that Barbariccia, the Empress of the Winds, is "not the only one who can ride the wind," and leaps boldly into the skies.

A Heart Restored

With Golbez freed from Zemus's control, the spell over Kain is shattered. Kain apologizes to Cecil's party for his actions, and vows to exact vengeance on Zemus for all he has done.

Setting Out from Baron Castle

Because he stood up for Cecil when his friend doubted the intentions of the king of Baron, Kain is sent alongside Cecil to handle the mission to Mist Village. Sharing a bond of trust, the two old friends depart from Baron Castle.

Memorable Scenes

> KAIN

Kain: A duel, Cecil!
Cecil: What do you mean?

Fight with a Friend

After separating from Cecil in the village of Mist, Kain arrives in the crystal room of Fabul Castle alone. The next time he meets Cecil, Kain points his lance threateningly at the friend who seems overjoyed to see him . . .

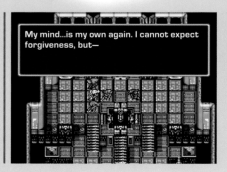

My mind...is my own again. I cannot expect forgiveness, but—

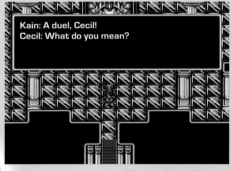

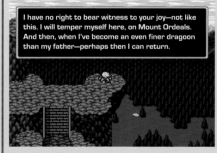

I have no right to bear witness to your joy—not like this. I will temper myself here, on Mount Ordeals. And then, when I've become an even finer dragoon than my father—perhaps then I can return.

Oath at Mount Ordeals

Having protected their beloved Blue Planet from the evil of Zemus, the comrades go back to their homes. But Kain does not return to the land of Baron . . . Instead, he decides to train on Mount Ordeals, working toward the day when he can wholeheartedly celebrate the union of Cecil and Rosa.

Peerless beauty,
braving dangers for love.

Rosa ローザ

[Rōza/Rosa]

▶ *Rosa Farrell* ローザ・ファレル

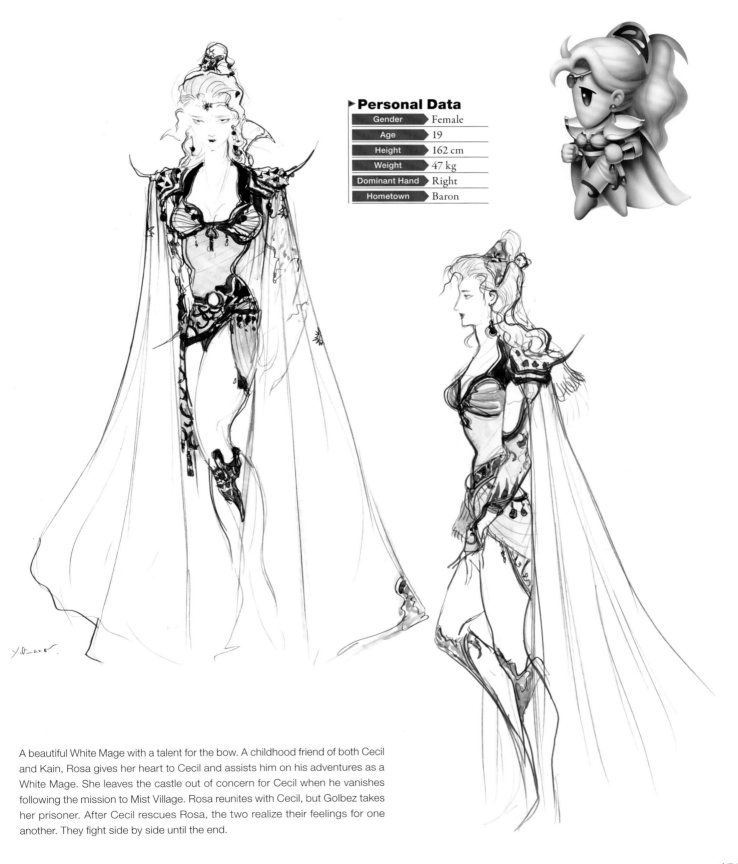

Personal Data

Gender	Female
Age	19
Height	162 cm
Weight	47 kg
Dominant Hand	Right
Hometown	Baron

A beautiful White Mage with a talent for the bow. A childhood friend of both Cecil and Kain, Rosa gives her heart to Cecil and assists him on his adventures as a White Mage. She leaves the castle out of concern for Cecil when he vanishes following the mission to Mist Village. Rosa reunites with Cecil, but Golbez takes her prisoner. After Cecil rescues Rosa, the two realize their feelings for one another. They fight side by side until the end.

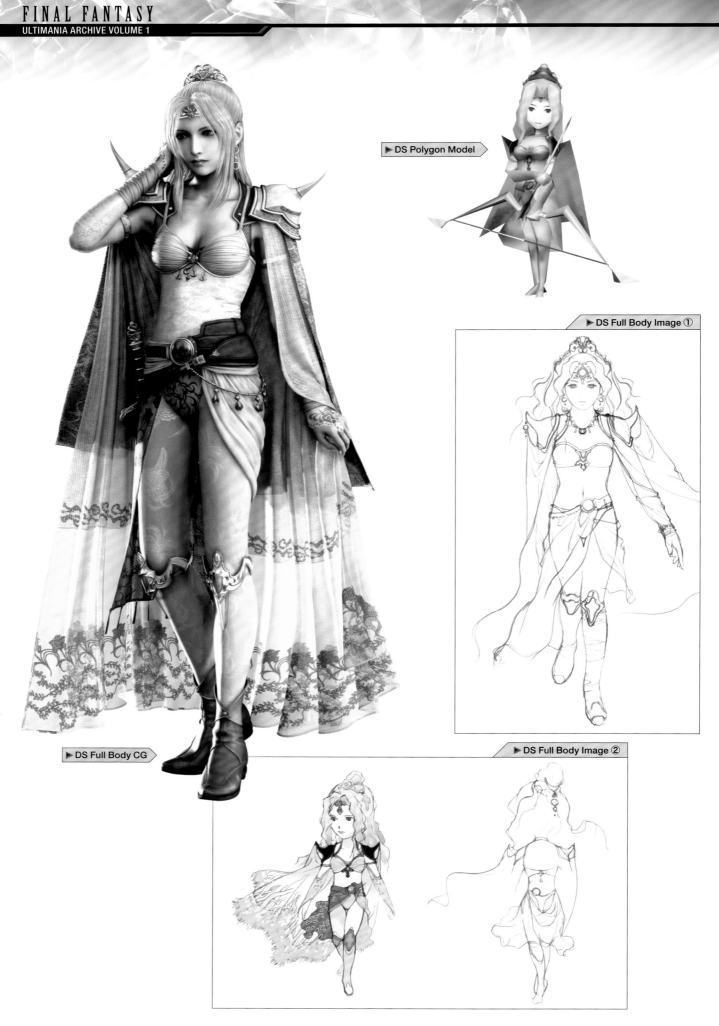

▶ DS Polygon Model

▶ DS Full Body Image ①

▶ DS Full Body CG

▶ DS Full Body Image ②

Rydia リディア

An honest maiden,
wise to the value of the heart.

[Ridia/Rydia]

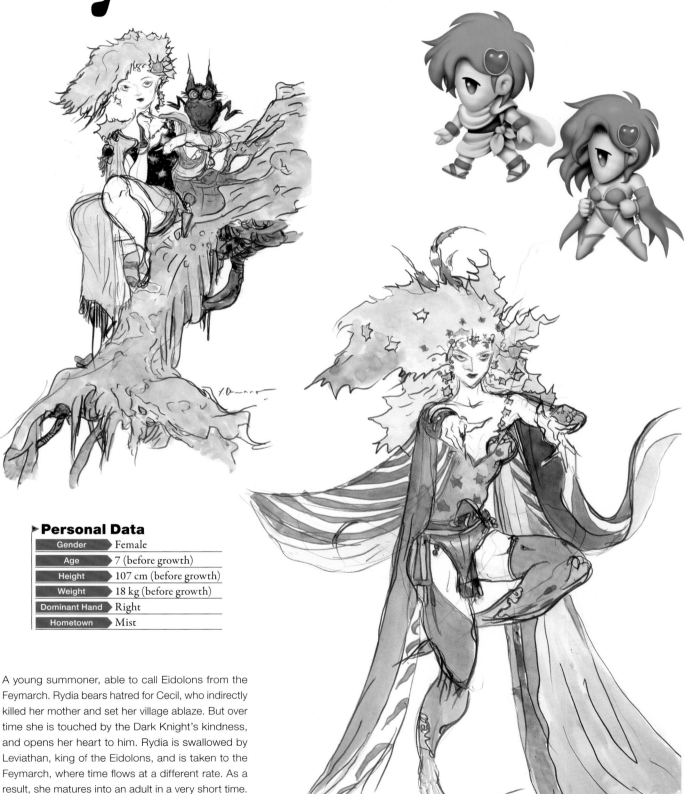

▶Personal Data

Gender	Female
Age	7 (before growth)
Height	107 cm (before growth)
Weight	18 kg (before growth)
Dominant Hand	Right
Hometown	Mist

A young summoner, able to call Eidolons from the Feymarch. Rydia bears hatred for Cecil, who indirectly killed her mother and set her village ablaze. But over time she is touched by the Dark Knight's kindness, and opens her heart to him. Rydia is swallowed by Leviathan, king of the Eidolons, and is taken to the Feymarch, where time flows at a different rate. As a result, she matures into an adult in a very short time. Rydia rushes back to aid Cecil's party when Golbez attacks them, rejoining their quest for the crystals.

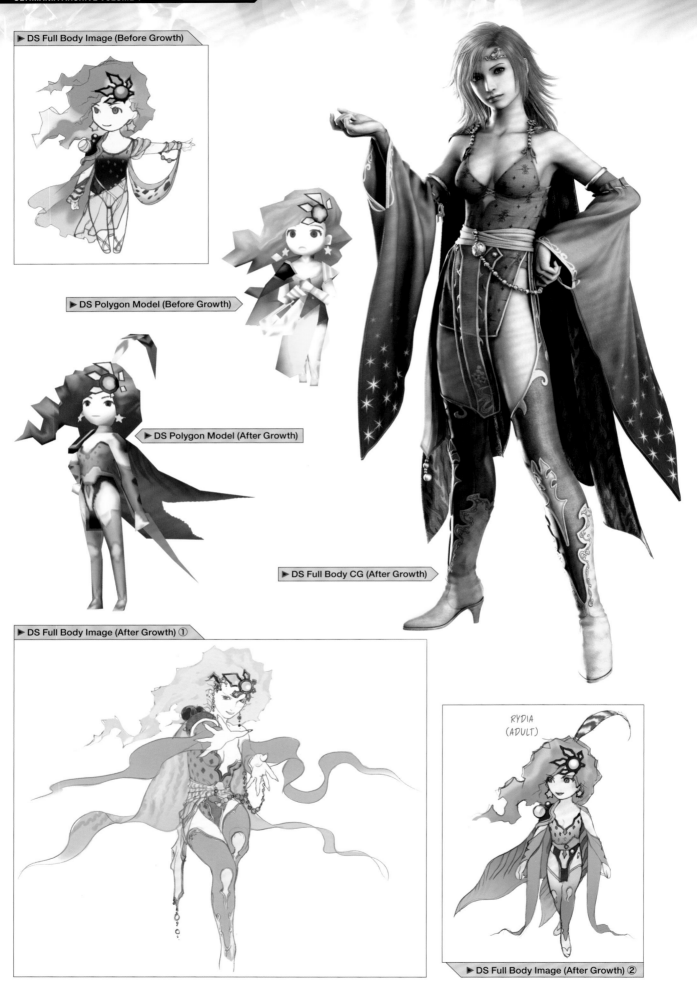

▶ DS Full Body Image (Before Growth)

▶ DS Polygon Model (Before Growth)

▶ DS Polygon Model (After Growth)

▶ DS Full Body CG (After Growth)

▶ DS Full Body Image (After Growth) ①

RYDIA (ADULT)

▶ DS Full Body Image (After Growth) ②

Memorable **Quotes**

 ▷ ROSA

 ▷ RYDIA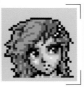

"Cecil! I'll visit you in your tower later."

—In Baron Castle, when worried about Cecil, who has come back from his mission.

As soon as she sees Cecil returning to the castle, Rosa rushes to see him. Her words are bold for a girl her age, but they express her frustration with his despondent attitude.

"Coward. You're a man, aren't you? A grown man! Stop crying. I have."

—In Damcyan Castle, scolding the heartbroken Edward after he loses his love, Anna.

Rydia struggles to overcome the sadness of her mother's death and the destruction of her village. Recognizing her own grief in Edward's pitiful appearance, she coldly berates him.

"I knew you'd come for me."

—In the Tower of Zot, when she is saved by Cecil in the nick of time.

Rosa has suffered during her imprisonment by Golbez. She endured her ordeal because she never lost faith that Cecil would come to her rescue.

"...Uhhn...Cecil... Please, Cecil... Be alive!"

—In the oasis village Kaipo, while suffering from desert fever.

Upon hearing that Cecil perished in the village of Mist, she flees the castle. Having taken ill, she calls out Cecil's name in her fever-ridden daze.

"Enough! I can't watch another person go off to die."

—In the Cave of Eblan, appealing to Edge, who keeps pushing himself even on the verge of death.

After both Yang and Cid sacrifice themselves, Rydia can no longer contain herself when she sees Edge's reckless attitude. Rydia has lost people close to her, including her mother and Tellah, so she cannot sit by and watch anyone else throw their life away.

"All that matters is what's inside us. Isn't that right, Cecil?"

—Muttering during the finale about Cecil, who has gone off to a distant land.

When asked by an Eidolon child why she is different from their kind, Rydia answers, "There's no difference between humans and Eidolons." From meeting Cecil, she understands that it's what's on the inside, not the outside, that truly matters.

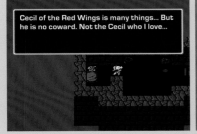
Cecil of the Red Wings is many things... But he is no coward. Not the Cecil who I love...

Late-Night Meeting

Rosa secretly enters Cecil's room in the dead of night. Having heard Cecil beat himself up over his inability to disobey the king's orders, Rosa reveals her true feelings, hoping to shake him out of his funk.

Summon of Wrath and Sorrow

Frightened by the approach of Cecil and Kain, Rydia is unable to control her power and summons the mighty Eidolon called Titan. The entire village is rocked by a major earthquake.

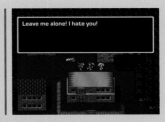
Leave me alone! I hate you!

To Assist Cecil

Rosa begs Cecil to let her join him on the journey to Fabul, pointing out that her White Mage abilities will prove useful. Her unwillingness to part from Cecil after their reunion is enough to spur Rosa into action.

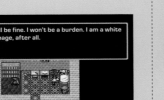
I'll be fine. I won't be a burden. I am a white mage, after all.

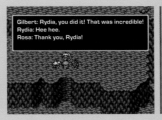
Gilbert: Rydia, you did it! That was incredible!
Rydia: Hee hee.
Rosa: Thank you, Rydia!

Conquering Fear of Fire

Having watched her hometown go up in flames, the traumatized Rydia is unable to use the most basic of Black Magic spells, Fire. With Rosa's encouragement, Rydia uses Fire to melt the ice blocking the mountain road on Mt. Hobs.

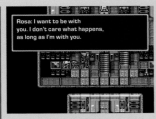
Rosa: I want to be with you. I don't care what happens, as long as I'm with you.

With the One She Loves

Out of concern for her safety, Cecil orders Rosa to leave the *Lunar Whale* before the final battle. Rosa sneaks back onboard with Rydia, and the two remain with Cecil's party until the bitter end.

 ▷ ROSA

▷ RYDIA

Memorable **Scenes**

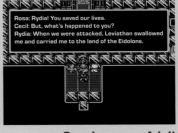
Rosa: Rydia! You saved our lives.
Cecil: But, what's happened to you?
Rydia: When we were attacked, Leviathan swallowed me and carried me to the land of the Eidolons.

Reunion as an Adult

In a form unrecognizable to Cecil's party, Rydia saves them from their harrowing battle with Golbez. Her maturation while living in the Feymarch has given her the appearance of an adult, but Rydia's pure heart is unchanged.

The sage who sacrifices all to avenge his daughter.

Tellah テラ

[Tera/Tella]

An old man who lived in the oasis town of Kaipo with his daughter, Anna. When Anna eloped with Prince Edward, he pursued the couple to Damcyan Castle. Anna was killed during an attack by the armies of Baron, and Tellah vowed revenge against Golbez and the Red Wings under his command. Tellah climbs Mount Ordeals to obtain the power to defeat his foe, mastering Meteor, the sealed magic of legend. When Tellah confronts Golbez in the Tower of Zot, he expends his life force to cast Meteor, perishing soon after.

▶ Personal Data

Gender	Male
Age	60
Height	177 cm
Weight	48 kg
Dominant Hand	Right
Hometown	Mysidia

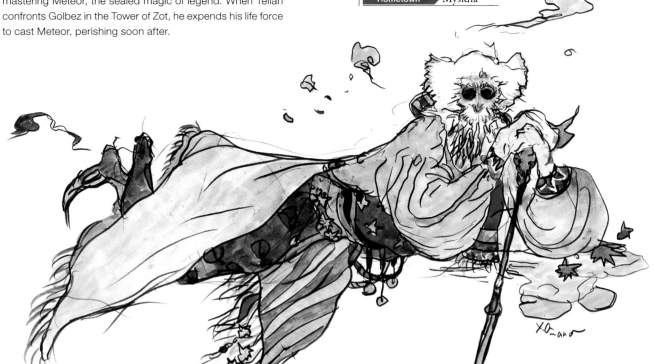

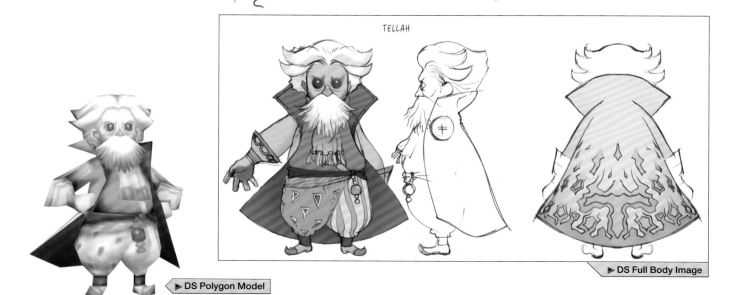

TELLAH

▶ DS Polygon Model

▶ DS Full Body Image

Edward

The sensitive prince
gaining courage on his journey.

ギルバート
[Girubāto/Gilbart]

▶ *Edward Chris Von Muir* ギルバート・クリス・フォン・ミューア

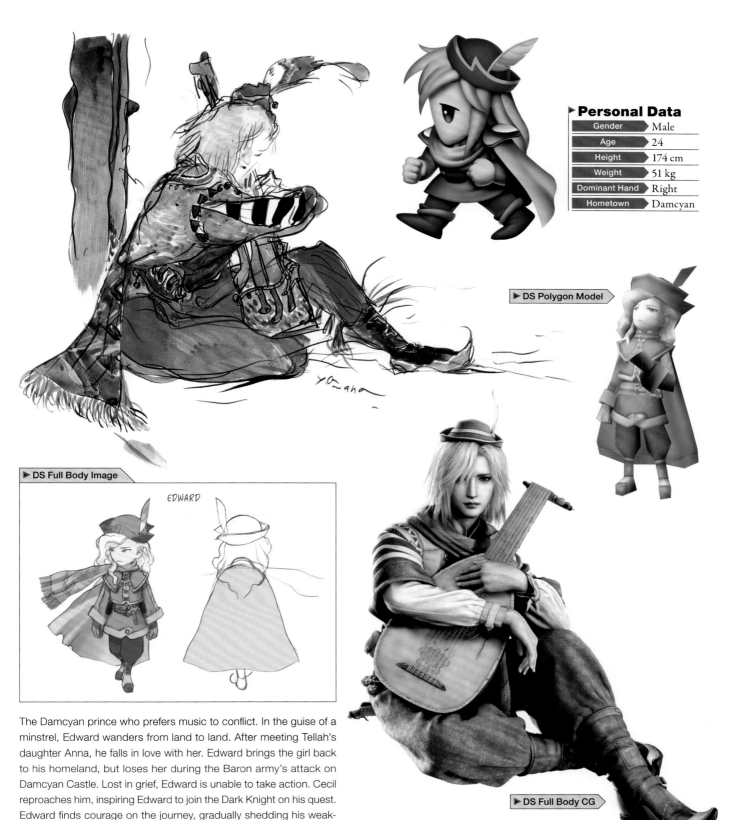

▶ **Personal Data**

Gender	Male
Age	24
Height	174 cm
Weight	51 kg
Dominant Hand	Right
Hometown	Damcyan

▶ DS Polygon Model

▶ DS Full Body Image

EDWARD

▶ DS Full Body CG

The Damcyan prince who prefers music to conflict. In the guise of a minstrel, Edward wanders from land to land. After meeting Tellah's daughter Anna, he falls in love with her. Edward brings the girl back to his homeland, but loses her during the Baron army's attack on Damcyan Castle. Lost in grief, Edward is unable to take action. Cecil reproaches him, inspiring Edward to join the Dark Knight on his quest. Edward finds courage on the journey, gradually shedding his weaknesses and becoming a man unafraid to save his comrades.

Memorable **Quotes**

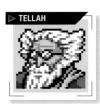

> TELLAH

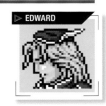

> EDWARD

"You-you're that bard! You're the one responsible for this!"

—In Damcyan Castle, blowing his top at Edward, who appears beside the fallen Anna.

When he remembers his daughter, Tellah's blood boils and he loses all perspective of his surroundings. In Edward, Tellah sees only the "evil" that spirited his daughter away. He assaults the bard, despite Edward's passivity.

"You're right. I'm nothing but a coward, just as you say. That's why I'm just going to stay at Anna's side. It doesn't matter anymore . . . Nothing does!"

—In Damcyan Castle, when called a coward by Rydia.

Having been reprimanded by the girl, he becomes defiant in his remorse, losing himself in his grief. Unable to stand by and watch this pathetic display, Cecil gives Edward a good whack.

"So be it! Let my life fuel the spell that ends his!"

—In the Tower of Zot, when resolving to end his life to cast Meteor.

Tellah squares off against Golbez, ready to sacrifice himself to defeat his daughter's murderer. Tellah has dreamed of this moment since the day he lost his beloved Anna.

"Fools . . . if any of us had to die, it ought to have been me."

—In Baron Castle, upon seeing Palom and Porom turned to stone to stop the walls from closing in.

Tellah cannot deal with the thought of two promising mages volunteering to sacrifice their lives. Despite his own determination to end his life, the regret he feels from witnessing their deaths is too much for the old man to bear.

"Anna, my love. I . . . I will try. But, what would you have me do?"

—In the oasis town Kaipo, when inspired by Anna's soul.

With Anna's encouragement Edward attempts to stand once more, but the gentle bard cannot understand what it means to have true courage. From this point on, Edward will learn bravery in small but meaningful steps.

"I am the only one . . . the only one who can save them!"

—Playing his lyre to save Cecil's party from danger in Troia Castle.

Edward rouses his weakened body and takes up his lyre, saving Cecil's party from the power of the Dark Elf. To rescue his comrades far away, Edward musters an inner valor all his own.

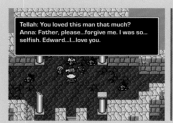

Farewell to a Beloved Daughter

Anna apologizes to Tellah, who never accepted her love for Edward. Tellah's hatred toward the man he blames for his daughter's death shatters his composure, causing him to shake off Cecil and leave the place.

Light from Dark Magic

Thanks to the effects of the light bestowed upon the Paladin Cecil, he remembers several magic spells once thought forgotten to him. In addition, he learns the sealed spell Meteor, which completes his preparations for facing Golbez.

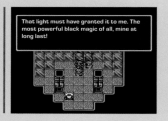

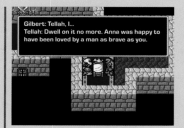

Reconciling with His Daughter's Beloved

Tellah views Edward as the reason his daughter is dead, and cannot bring himself to accept him. He is forced to acknowledge Edward's bravery after the bard breaks the Dark Elf's magnetic field, and his resentment disappears.

Shock from an Unexpected Attack

They go to the Antlion's Den in pursuit of the Sand Pearl. Thinking the monster is docile, Edward lets his guard down. He cries out in shock when it attacks.

Encouraged by Anna's Soul

Playing his lyre by the lakeshore in Kaipo during the middle of the night, Edward is attacked by a Sahagin. Anna's soul appears before Edward to encourage him.

> TELLAH

> EDWARD

Memorable **Scenes**

The Sound of Saving Cecil

Cecil cannot fight, due to the magnetism at the Dark Elf's disposal. Edward senses the danger, and uses the Whisperweed to play a song that undoes the evil elf.

Level-headed monk
with an indomitable will.

Yang

ヤン
[Yan/Yang]

▶ *Yang Fang Leiden* ヤン・ファン・ライデン

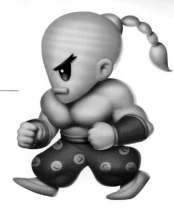

▶ Personal Data

Gender	Male
Age	35
Height	182 cm
Weight	76 kg
Dominant Hand	Ambidextrous
Hometown	Fabul

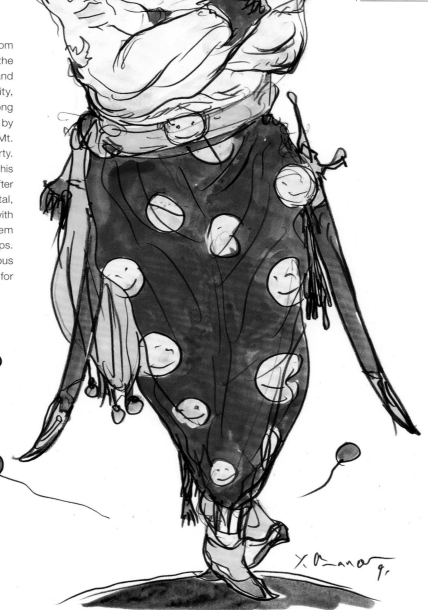

A monk and squadron leader from the kingdom of Fabul. He is the strongest monk in his nation and possesses a polite personality, making him quite popular among his people. Yang is attacked by monsters while training on Mt. Hobs and is saved by Cecil's party. He joins them after learning that his country's crystal is in danger. After the battle for the Wind Crystal, Yang continues to adventure with Cecil's party and helps them overcome innumerable hardships. Yang's personality is both serious and strict, but he is no match for his short-tempered wife.

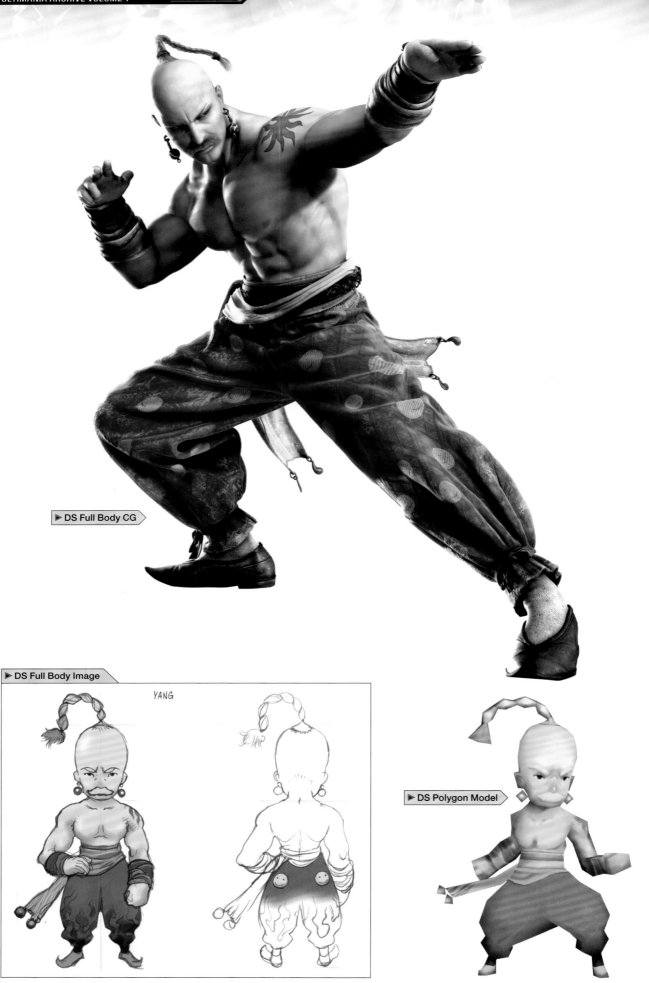

▶ DS Full Body CG

▶ DS Full Body Image

YANG

▶ DS Polygon Model

Palom & Porom

Dauntless twins.
Prodigious mages in the making.

パロム＆ポロム

[Paromu & Poromu/Palom & Porom]

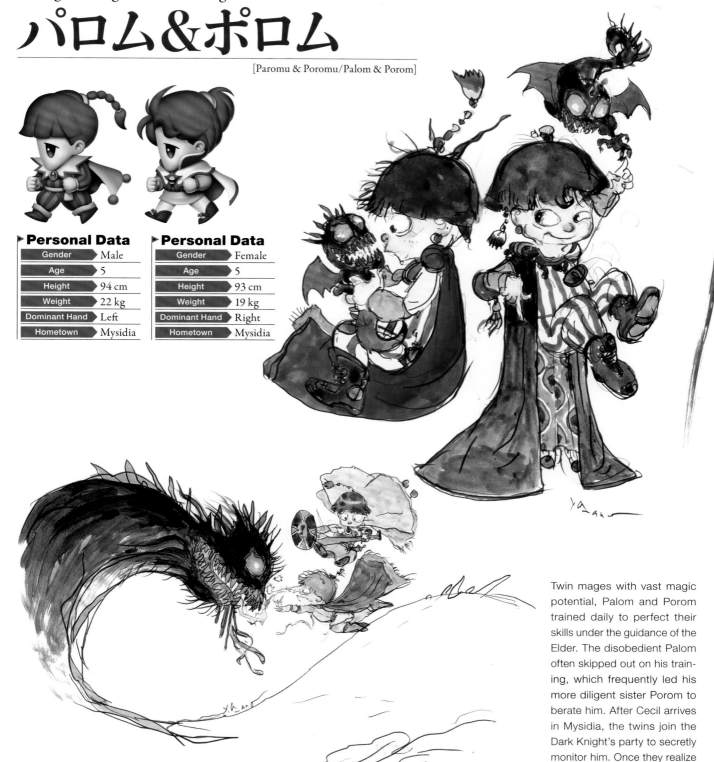

▶ Personal Data

Gender	Male
Age	5
Height	94 cm
Weight	22 kg
Dominant Hand	Left
Hometown	Mysidia

▶ Personal Data

Gender	Female
Age	5
Height	93 cm
Weight	19 kg
Dominant Hand	Right
Hometown	Mysidia

Twin mages with vast magic potential, Palom and Porom trained daily to perfect their skills under the guidance of the Elder. The disobedient Palom often skipped out on his training, which frequently led his more diligent sister Porom to berate him. After Cecil arrives in Mysidia, the twins join the Dark Knight's party to secretly monitor him. Once they realize Cecil's trustworthiness, they join him in his fight.

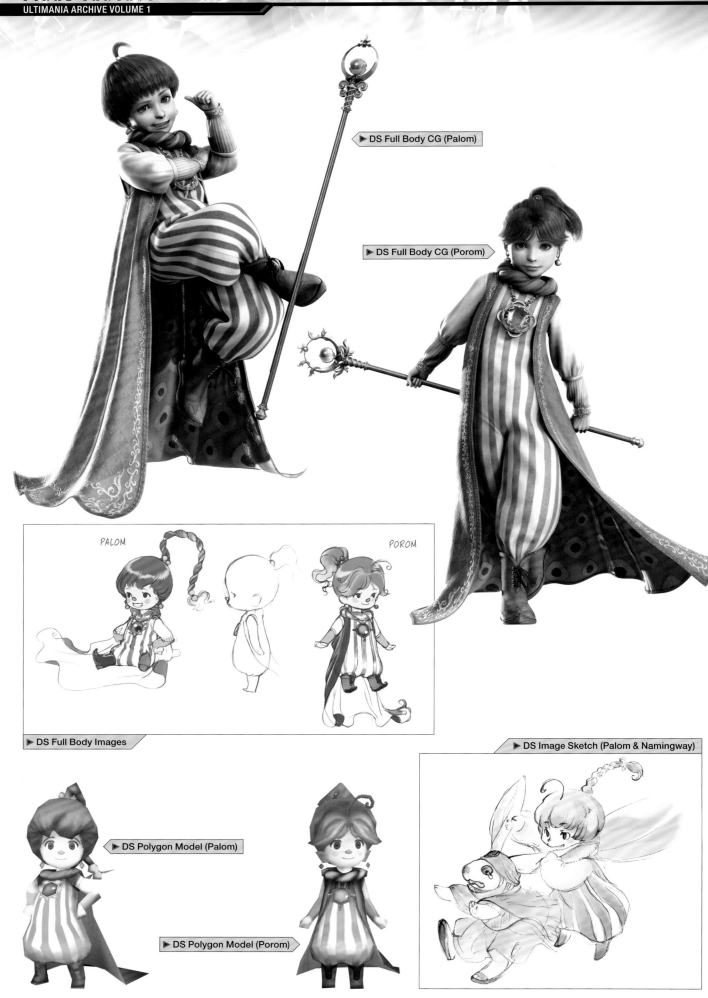

▶ DS Full Body CG (Palom)

▶ DS Full Body CG (Porom)

PALOM

POROM

▶ DS Full Body Images

▶ DS Image Sketch (Palom & Namingway)

▶ DS Polygon Model (Palom)

▶ DS Polygon Model (Porom)

Memorable **Quotes**

> ▷ YANG

"Uhh . . . is it time for training already? Let me sleep a little longer . . ."

—In the Sylph Cave, after being hit on the head by Sheila's frying pan.

Putting his life on the line to stop the cannons in the Tower of Babil, Yang suffers injuries that put him into a coma. He is nursed back to health by the fairy-like Sylphs, and a loving blow with a frying pan from his wife brings him to consciousness. Yang drowsily slurs his words, and gives a smile only offered to family.

"I see. Then I will most humbly accept whatever help you are willing to provide."

—On Mt. Hobs, upon hearing from Cecil's party that Fabul is in danger.

After learning that Golbez is invading Fabul while the city is short on defenses, he grasps the truth of the situation. He hears the group's reasons for fighting Golbez, and thanks them for their offer to help.

"It has been an honor fighting with you."

—Saying goodbye to their friends at the Tower of Babil.

As he prepares to stop the Tower of Babil cannons, Yang expresses his pride in having fought with the party for so long. A man of action, he packs his feelings toward his comrades into few words.

> ▷ PALOM & POROM

"Blizzard! And that, my friends, is how it's done!"

—Palom, on Mount Ordeals, bragging after extinguishing the flames blocking their path onward.

Palom uses ice magic—his forte—at the entrance to Mount Ordeals. Porom scolds him for his arrogance, but Palom doesn't care. He boasts that his actions will go down in the annals of history.

"You would expect him to try a little harder to fool us, wouldn't you?"

—Porom, sensing a "monster's stench" from Captain Baigan in Baron Castle.

Cecil asks for help from Baigan, captain of the Imperial guard, but Palom and Porom are quick to view him with suspicion. The two mages are highly sensitive to the presence of monsters, and easily anticipate their enemy's trick.

"Cecil . . . We'll miss you!" "It was almost like we'd gained an older brother."

—Palom and Porom, preparing to hold back the walls in Baron Castle.

At first the twins distrusted the man who had attacked Mysidia. But after fighting with Cecil, they grew to idolize him like a brother, vowing to do anything to protect him.

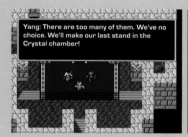

Defense of Fabul

With Cecil and Edward's help, he intercepts the Baron forces seeking to steal the Wind Crystal. Unfortunately they are slowly driven back by the enemy onslaught, and have no choice but to retreat to the crystal room.

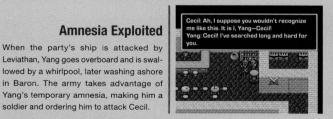

Amnesia Exploited

When the party's ship is attacked by Leviathan, Yang goes overboard and is swallowed by a whirlpool, later washing ashore in Baron. The army takes advantage of Yang's temporary amnesia, making him a soldier and ordering him to attack Cecil.

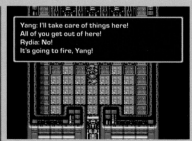

In the Service of Life

Having honed his spirit through his training as a monk, Yang is prepared to surrender his life when the time comes. He sacrifices himself at the Tower of Babil to stop the out-of-control cannons.

The Genius Mage Twins!

The twins accompany Cecil to Mount Ordeals at the command of the Elder. Porom politely introduces herself, but Palom can't hide his cheeky attitude.

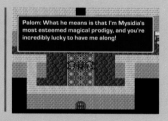

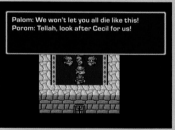

Joined in Purpose to Protect Their Friend

The walls close in on our heroes as Cagnazzo springs his trap, threatening to end their journey once and for all. To stop the walls, Palom and Porom turn themselves to stone.

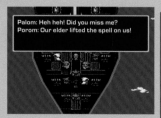

Saved by the Elder

Since the two mages turned to stone of their own volition, neither Gold Needles nor Esuna could heal them. Yet they are later restored by the Elder of Mysidia, and they rush off to help Cecil's party inside the Giant of Babil.

> ▷ YANG

> ▷ PALOM & POROM

Memorable **Scenes**

Cid

Stubborn airship engineer overflowing with kindness.

シド
[Shido/Cid]

▶ *Cid Pollendina* シド・ポレンディーナ

▶ Personal Data

Gender	Male
Age	54
Height	159 cm
Weight	67 kg
Dominant Hand	Right
Hometown	Baron

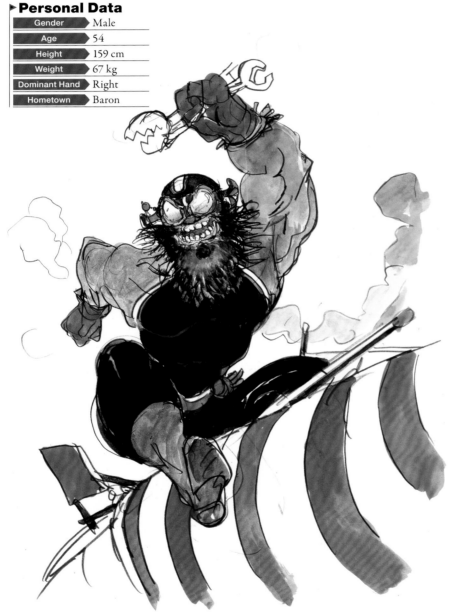

▶ DS Polygon Model

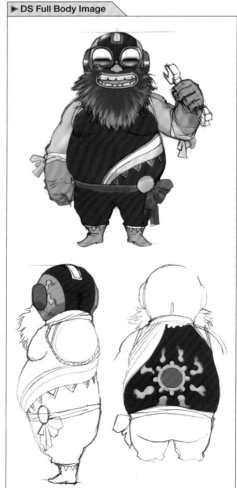

▶ DS Full Body Image

An engineer in Baron who knows more about building airships than anyone. Cid is the chief mechanic for the airships used by the Baron Red Wings, and is idolized by his apprentices. He treats Cecil like his own flesh and blood, having taken an interest in the boy since Cecil's childhood. After Cecil becomes a Paladin and returns to Baron Castle, he reunites with Cid. The two of them leave together on the airship *Enterprise*. Although Cid largely stays away from the front lines, he aids the party by making improvements to the airship.

Edge

Reckless ninja.
Self-involved prince.

エッジ
[Ejji/Edge]

▶ *Edge Geraldine* エドワード・ジェラルダイン

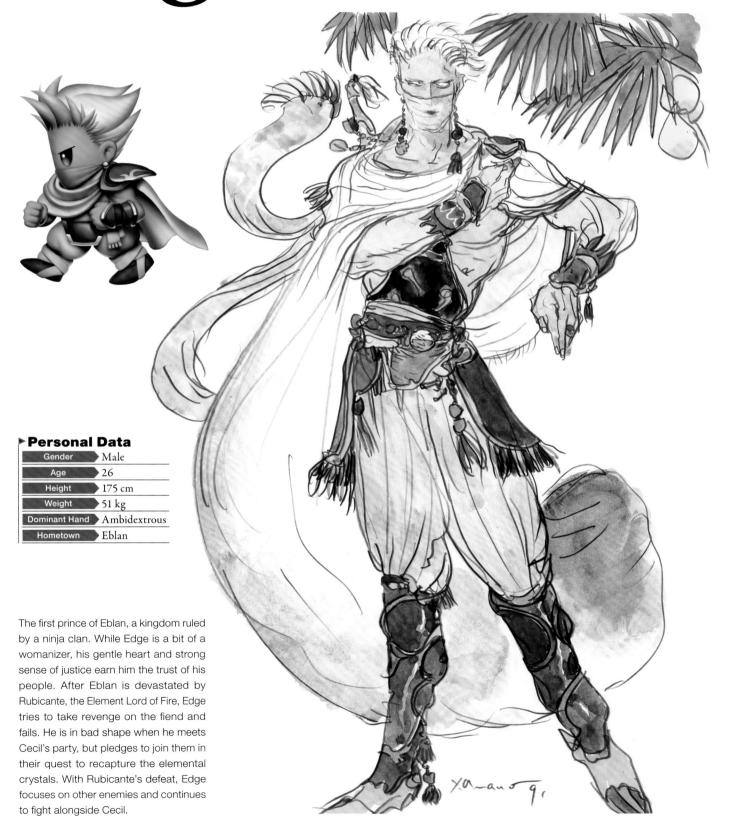

▶ Personal Data

Gender	Male
Age	26
Height	175 cm
Weight	51 kg
Dominant Hand	Ambidextrous
Hometown	Eblan

The first prince of Eblan, a kingdom ruled by a ninja clan. While Edge is a bit of a womanizer, his gentle heart and strong sense of justice earn him the trust of his people. After Eblan is devastated by Rubicante, the Element Lord of Fire, Edge tries to take revenge on the fiend and fails. He is in bad shape when he meets Cecil's party, but pledges to join them in their quest to recapture the elemental crystals. With Rubicante's defeat, Edge focuses on other enemies and continues to fight alongside Cecil.

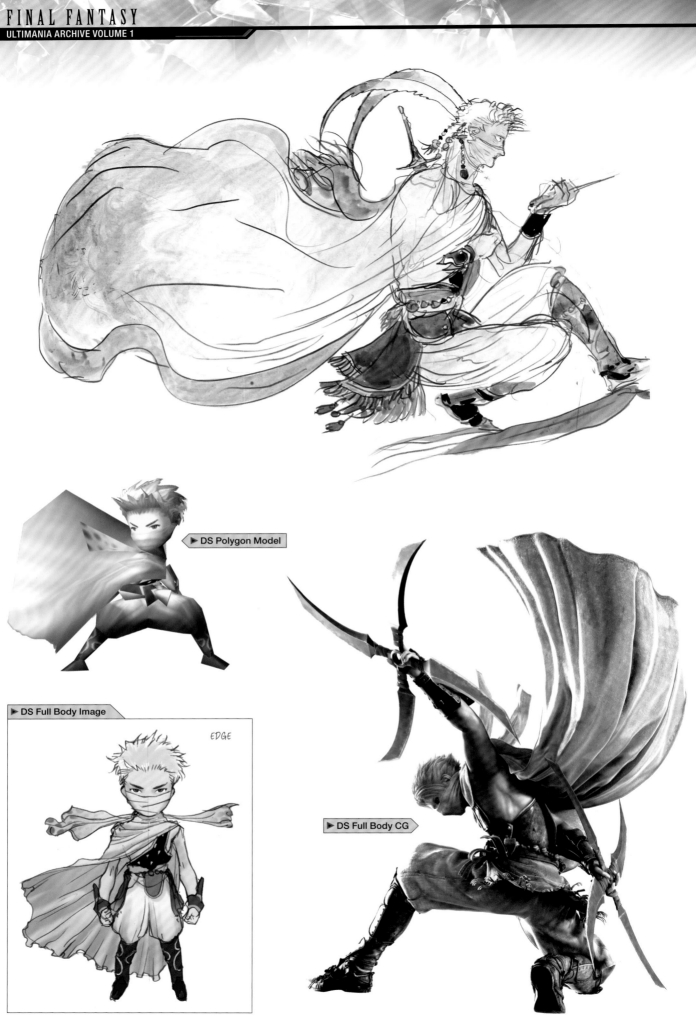

▶ DS Polygon Model

▶ DS Full Body Image

EDGE

▶ DS Full Body CG

Memorable **Quotes**

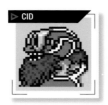
▷ CID

▷ EDGE

"Oh, don't you go falling in love with me too now, Rosa!"

—In the Dwarven Castle, cracking a joke to a worried Rosa.

Cid deflects Rosa's worries with a joke when he ventures alone to the surface to repair the airship. Cid's concern for Rosa's feelings shows the regard he holds for the woman he treats like his own daughter.

"Heh . . . Don't mistake me for some pampered prince. The Eblanese royal family is heir to the secrets of the ninja masters of old."

—In the Cave of Eblan, putting up a front about his beaten-up appearance.

Though Edge is on death's door after his defeat at Rubicante's hand, he puts up a confident front. Edge has always been a bit of a braggart, but the genuine pride he feels for his ninja heritage helps back up his bold words.

"I was hoping I'd get to see your kids someday, but someone's got to keep Yang company."

—In the Underworld, telling Cecil's party about plugging the hole with a bomb.

Cid takes a page from Yang's playbook, preparing to sacrifice himself for the party much as the monk did when stopping the Tower of Babil cannons. Although he genuinely means to end his life, he does not wish to make the moment into a tragic spectacle.

"Hey! Who you calling an old man?!"

—In the Underworld, when Rydia teases him with an unwelcome nickname.

Cid still considers himself youthful and active, and hates when he is treated like an old fogey. Perhaps Cid's indignation in this moment leads Rydia to avoid similar language when they meet again inside the Dwarven Castle.

"You think our rage is . . . a weakness? Then let me show you how wrong you are!"

—Enraged by the appearance of Rubicante at the Tower of Babil.

After watching his parents become beasts, forced to sacrifice their own lives, Edge feels grief and rage on an immeasurable scale. Hearing Rubicante call humankind a "slave to their emotions," Edge lets his anger push his hidden ninja abilities to the surface.

"But, Rydia . . . There's not a girl in this world that will ever come close to you."

—Thinking during the finale about Rydia, who had returned to the Feymarch.

Edge won't let his responsibilities to the kingdom of Eblan keep him from chasing the ladies, but the lovely summoner who cried on his behalf now occupies most of the space in his heart. Although no relationship resulted during his adventure, Edge isn't the type to give up on romance so easily.

Grumpy Old Men

Cid: Who's this testy old-timer think he is?
Tellah: One might ask the same of you!
Cid: Me? You're calling me old?

Though he is only six years Tellah's junior, Cid still considers himself a spring chicken—and doesn't hesitate to make that opinion clear. The two may quarrel from time to time, but their stubborn personalities and their devotion to their children prove that they have more in common than they realize.

Mano a Mano against His Country's Foe

Edge recklessly challenges the fiend who destroyed the kingdom of Eblan to single combat, winner take all. Badly burned by Rubicante's hellfire, the flame-wielding ninja finds himself beaten at his own game.

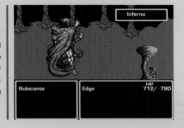
Inferno / Rubicante / Edge HP 712/ 790

The Airship's Pain Is the Engineer's Pain

After arriving in the Underworld, the party finds itself caught up in a battle between the Red Wings of Baron and the dwarven army. The airship, which Cid treats like his own child, breaks through the bombardment of cannon fire.

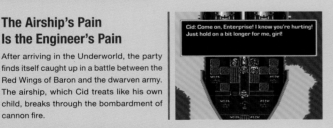
Cid: Come on, Enterprise! I know you're hurting! Just hold on a bit longer for me, girl!

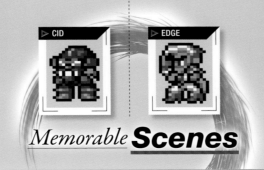
We must depart now . . .

King of Eblan / Queen of Eblan
Cecil 1386/ 1412
Rosa 1003/ 1003
Kain 1299/ 1299
Rydia 648/ 648
Edge 711/ 790

Farewell to His Parents

Edge is attacked by his parents after they are transformed into monsters, forcing him to face the king and queen in a battle he never wanted to fight. In the end, Edge's parents regain their sanity and say goodbye to their son before destroying themselves forever.

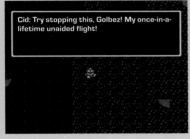
Cid: Try stopping this, Golbez! My once-in-a-lifetime unaided flight!

Once in a Lifetime

To stop the relentless airships pursuing them, Cid plans to dive-bomb the hole that connects the Overworld with the Underworld. He bets it all to fight back against Golbez, the man who stole the Red Wings from him.

▷ CID

▷ EDGE

Memorable **Scenes**

Edge: This beauty? Not a chance! All right, then...we'll call her the Falcon!

Falcon, Full Speed Ahead!

In the Tower of Babil, Edge eagerly claims the new, state-of-the-art enemy airship for himself. He dubs it the *Falcon*, and takes off with the air of a captain.

The gentle wise man
protecting the Lunarians.

Fusoya フースーヤ
[Fūsūya/Fusuya]

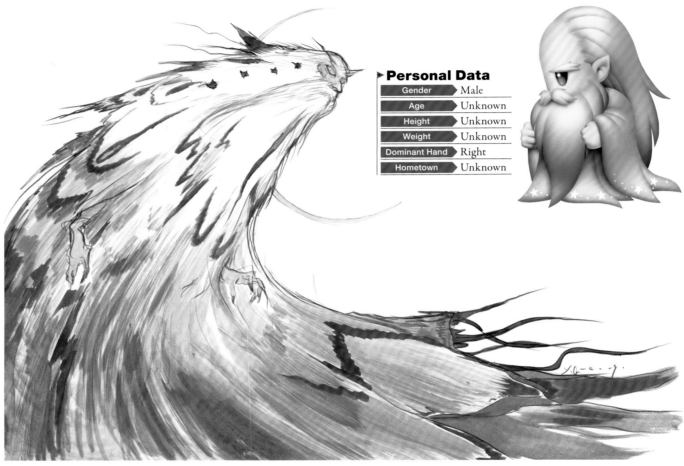

▶ Personal Data

Gender	Male
Age	Unknown
Height	Unknown
Weight	Unknown
Dominant Hand	Right
Hometown	Unknown

▶ DS Polygon Model

▶ DS Full Body Image

FUSOYA

A Lunarian, and the brother of Cecil's father, Kluya. After sealing away the evil Lunarian known as Zemus many centuries ago, Fusoya has watched over his kin as they slumbered and awaited the evolution of the Blue Planet's natives. Fusoya learns that Zemus aims to scorch the Blue Planet using the Giant of Babil, and he cooperates with Cecil when the warriors arrive on the moon. When Fusoya enters the Giant of Babil to destroy it, he frees Golbez from Zemus's brainwashing. This allows him to spill the secret behind the births of both Golbez and Cecil.

Golbez

A man of Lunarian blood
ensnared by evil.

ゴルベーザ
[Gorubēza/Golbeza]

Personal Data

Gender	Male
Age	30
Height	Unknown
Weight	Unknown
Dominant Hand	Left
Hometown	Unknown

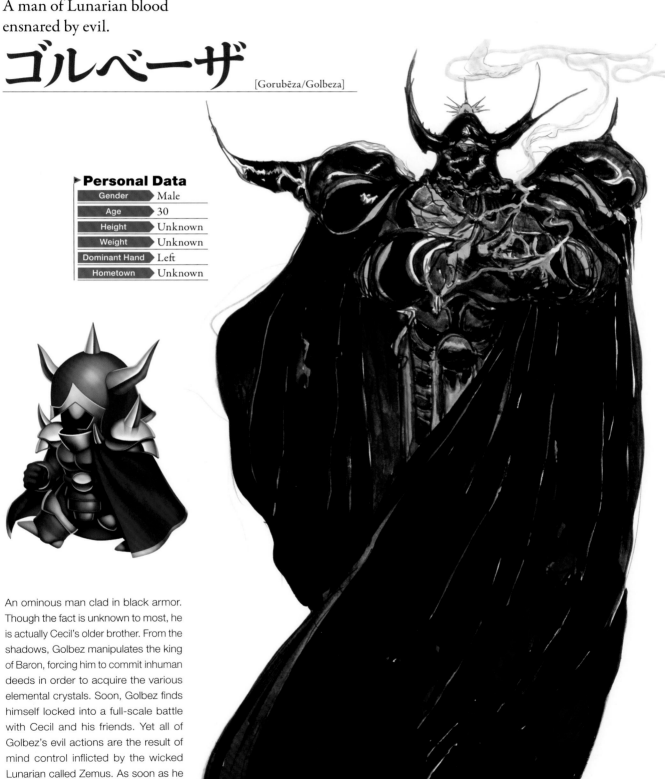

An ominous man clad in black armor. Though the fact is unknown to most, he is actually Cecil's older brother. From the shadows, Golbez manipulates the king of Baron, forcing him to commit inhuman deeds in order to acquire the various elemental crystals. Soon, Golbez finds himself locked into a full-scale battle with Cecil and his friends. Yet all of Golbez's evil actions are the result of mind control inflicted by the wicked Lunarian called Zemus. As soon as he is free of this brainwashing, Golbez goes to the moon with his uncle Fusoya to challenge the true mastermind.

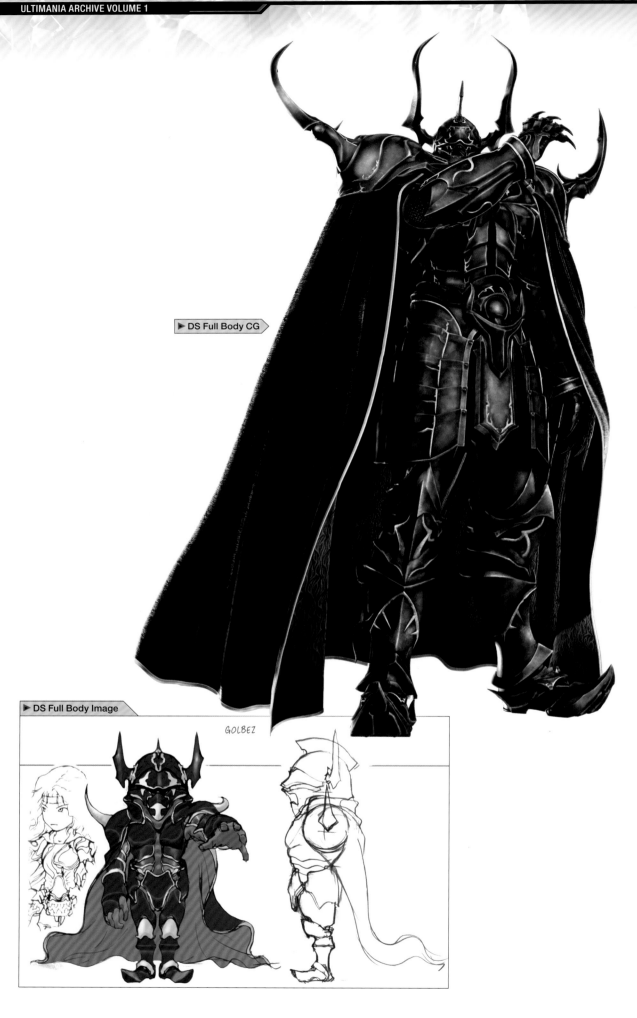

▶ DS Full Body CG

▶ DS Full Body Image

GOLBEZ

Memorable Quotes

FUSOYA

GOLBEZ

"You were being manipulated by the all-powerful Zemus. Your Lunarian blood rendered you an easy target for his curse, and bound your thoughts to his. To think Kluya's sons would be made to fight one another . . ."

—In the Giant of Babil, when Golbez's brainwashing is lifted.

Fusoya cannot overlook the fighting between Cecil and Golbez, who are the living mementos of his brother Kluya. He explains the truth to them as an uncle should. Fusoya risks his life to restore Golbez's mind, sensing the regret of a saddened brother.

"What a waste. Such incredible power, and all of it warped to evil ends."

—Working with Golbez to defeat Zemus in the Lunar Subterrane.

While Fusoya does not agree with Zemus's ideology, he does respect the talent of his fellow Lunarian. This has given him complex feelings about Zemus, the man who would betray his own people.

"Thank you . . . Cecil!"

—During the finale, when saying farewell to Cecil, who called him "brother."

Golbez knows he cannot expect forgiveness for his actions against Cecil, and doesn't feel that he has a right to be considered a brother. When Cecil refers to him as such during their parting moments, it fills the remorseful warrior with joy. Golbez expresses his gratitude to his brother, knowing the two must part ways again.

"Why? Why was I so consumed by hate?"

—In the Giant of Babil, regaining his sanity with Fusoya's help.

Fusoya uses his power to free Golbez, who is able to look back on his brainwashed actions with deep regret. Golbez admits that he was so easily controlled by hatred because of the evil in his own heart, and is ashamed at this realization of his sins.

"You underestimate the strength of my abilities. I had but slackened your friend's leash, waiting for the proper moment to pull it taut."

—In the Sealed Cave, reassuming control of Kain and forcing him to steal the crystal.

Golbez puts Kain back under his thrall when Cecil's group succeeds in obtaining the final crystal. The impeccable timing—showing his hand after letting them go free—demonstrates Golbez's abilities as a master tactician.

"So, you are Cecil. Allow me to give you something—a gift, to remember our meeting by."

—Confronting Cecil when he arrives to steal the crystal at Fabul Castle.

Golbez meets Cecil following his victory over Kain, and commemorates the occasion with a special greeting. When Yang and Edward try to intervene, Golbez denounces them as worms. He escapes with both Rosa and the crystal, establishing himself as the biggest antagonist standing in the party's way.

Light Extinguishing the Dark

When Fusoya stops the Giant of Babil, Golbez appears in a rage. The wise man senses this is the child of his brother, Kluya. He devotes himself to breaking Zemus's hold on Golbez, knowing that Golbez has forgotten his true lineage.

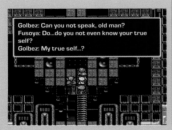

Journey to the Moon

Cecil and the warriors from the Blue Planet defeat Zeromus, the corrupt manifestation of Zemus's residual will. Fusoya had been waiting for the day when the people of the Blue Planet had evolved enough to meet the Lunarians. This incident proved the moment is much closer than he realized, and Fusoya enters a deep slumber.

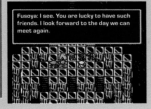

A Bewildering Truth

Before Golbez could finish Cecil off in the Tower of Zot, he began shaking violently as if unconsciously expressing their fraternal bond. That fact, combined with his serious wounds, is enough for Golbez to forfeit the fight and flee to fight another day.

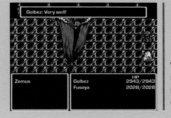

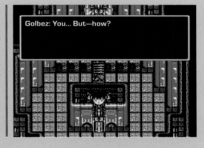

Joining Forces

Fusoya and Golbez unite, driving Zemus into a corner. At his uncle's behest, Golbez pours all of his power into the devastating incantation known as Meteor.

Light for His Brother

He tries to use a crystal to reveal Zeromus's true form, but the artifact will not shine for those who have walked the path of darkness. On his last legs, Golbez hands the crystal to his brother, who has walked the path of the light, entrusting Cecil with the fate of the world.

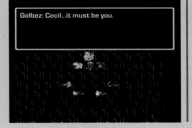

FUSOYA GOLBEZ

Memorable Scenes

Scarmiglione

スカルミリョーネ [Sukarumiryōne]

The Blight Despot, one of the four Elemental Lords serving Golbez. Scarmiglione was sent to assassinate Cecil after the warrior arrived at Mount Ordeals to become a Paladin. Scarmiglione reveals his true form after his first defeat and attacks Cecil's party a second time.

Memorable **Quote**

"Impressssive . . . But my true s-s-strength lies in death! And now, you shall join me in it!"

—A backhanded attack after a defeat at the hands of Cecil's party on Mount Ordeals.

Memorable **Scene**

A Blighted Back Attack

The second battle with Scarmiglione is a surprise attack from the rear. He claims he will use this underhanded strike to "smite their ruin on the mountainside," but the only thing remaining after the fight is the fiend's death knell echoing off the mountain stones.

Cagnazzo

カイナッツォ [Kainattsu~o]

One of Golbez's Four Fiends: the Archfiend of Water, also known as the Drowned King. After killing the king of Baron, Cagnazzo takes his place and assumes control of the entire nation. He reveals himself to Cecil upon the warrior's return to his homeland, only to be defeated. With the last of his power, Cagnazzo seals the party in a passage and pushes the walls in to crush them.

Memorable **Quote**

"The Drowned King, Cagnazzo, deposed! But the wicked are not wont to fall alone. In life, I was terrible—in death, steeped in terror greater still. Drink long and deep of it ere you die! I'll save a briny pit for you in Hell."

—In Baron Castle, trying to bring Cecil's party down with him.

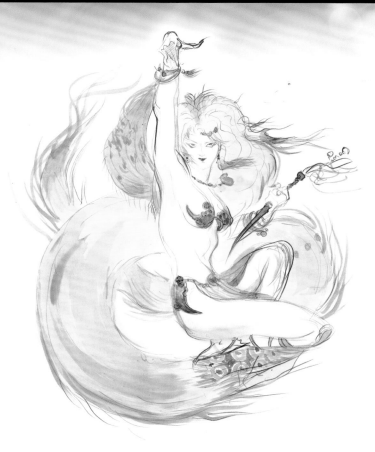

Barbariccia バルバリシア [Barubarishia]

The Empress of the Winds, and the Archfiend that controls the Tower of Zot. Barbariccia effortlessly wields the power of wind, and specializes in midair combat. She entraps the group and goes on the attack, but her wind barrier is shattered by Kain's Jump ability. In the end, Barbariccia destroys the Tower of Zot in the hope of trapping Cecil's group forever.

Memorable **Quotes**

"Hahahaha! It seems Master Golbez has underestimated you."

—In the Tower of Zot, demonstrating her hatred for Cecil and his friends.

"And you've grown arrogant as well, I see! I should have killed you and Rosa both when I first had the chance."

—In the Tower of Zot, verbally abusing Kain, who has allied himself with Cecil.

Rubicante ルビカンテ [Rubikante]

The Autarch of Flame, and an Archfiend clad in a crimson mantle. Rubicante boasts the greatest ability of all the Archfiends, and faces his foes with a surprising degree of respect and honor. He is especially hated by Edge, due to his role in devastating the kingdom of Eblan.

Memorable **Quotes**

"Pitiful. Allow me to show you real flame!"

—Shrugging off Edge's Flame Ninjutsu in the Cave of Eblan.

"Come, I will heal your wounds. Face me at full strength!"

—In the Tower of Babil, healing the full party before they do battle with him.

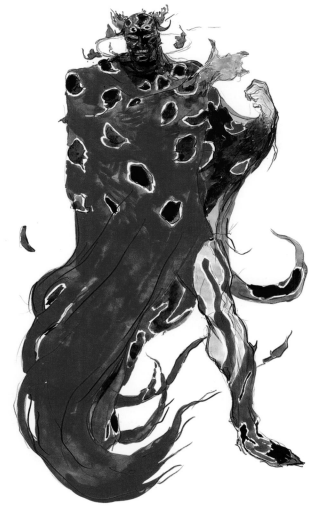

Memorable **Scene**

More Powerful Than One?

All of the defeated Fiends are revived by Zemus's hands, reappearing before the party. Rubicante boasts that the Archfiends learned the "power of many" from their previous battles, and now plan to put it into practice. Despite this, they fight one after the other rather than truly collaborating, leading to their downfall once more.

Rubicante: How I yearned for this! When last we met, you taught me a great truth: that many are more powerful than one.

ファイナルファンタジーIV
FINAL FANTASY IV WORLD

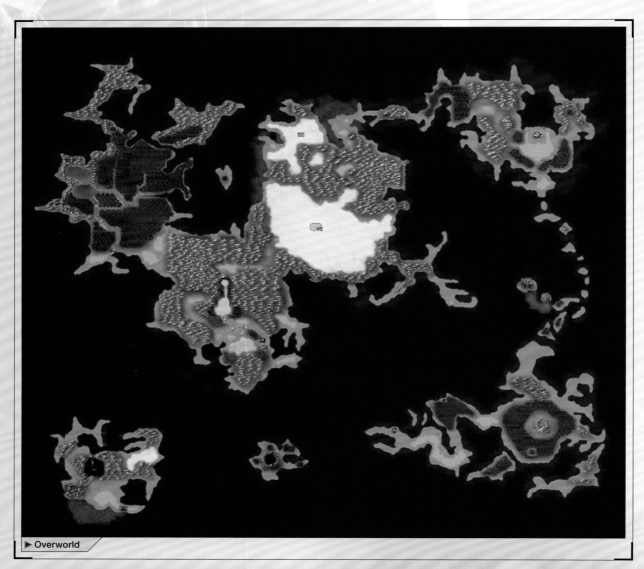

▶ Overworld

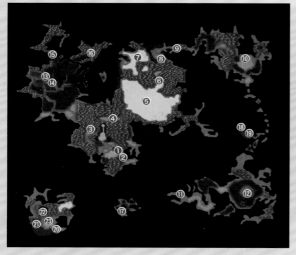

❶ Baron Castle

❷ Baron/Old Waterway

❸ Mist Cave (✻1)

❹ Mist

❺ Kaipo (✻2)

❻ Underground Waterway

❼ Damcyan Castle

❽ Antlion's Den (✻3)

❾ Mt. Hobs (✻4)

❿ Fabul Castle

⓫ Mysidia

⓬ Mount Ordeals

⓭ Troia Castle/Tower of Zot

⓮ Troia

⓯ Chocobo Village

⓰ Lodestone Cavern

⓱ Agart (✻5)

⓲ Mythril

⓳ Adamant Isle Grotto (✻6)

⓴ Eblan Castle

㉑ Cave of Eblan (✻7)

㉒ Tower of Babil (Overworld)

㉓ Giant of Babil

✻1 Also known as "Misty Cave"
✻2 Also known as "Kaipo, Oasis of the Desert"
✻3 Also known as "Antlion Cave"
✻4 Also known as "Mount Hobs"
✻5 Also known as "Village of Agart"
✻6 Also known as "Adamant Cave"
✻7 Also known as "Cave of Eblana"

The world is split into three areas: the Overworld and its blue oceans; the Underworld and its scorching lava flows; and the barren surface of the Moon. The Tower of Babil stretches from the Underworld to the Overworld, and part of the tower can be viewed from both worlds. The land surrounding Mysidia is notable for its dragon-like contours.

► Underworld

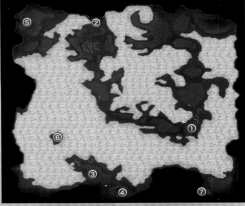

1 Dwarven Castle (✣ 8)
2 Tower of Babil (Underworld)
3 Sealed Cave
4 Tomra (✣ 9)
5 Sylph Cave
6 Passage of the Eidolons/the Feymarch
7 Kokkol's Forge

✣ 8 Also known as "Dwarf Castle"
✣ 9 Also known as "Village of Tomera"

► The Moon

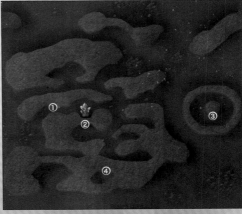

1 Lunar Tunnel
2 Crystal Palace/Lunar Subterrane
3 Lair of the Father
4 Hummingway Home

MONSTERS

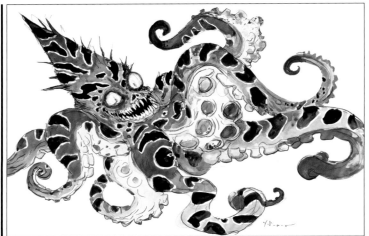

Octomammoth

オクトマンモス [Okutomanmosu]

Antlion

アントリオン [Antorion]

Leshy

レーシイ [Rēshii]

Mom Bomb

マザーボム [Mazābomu]

Zu
ズー [Zū]

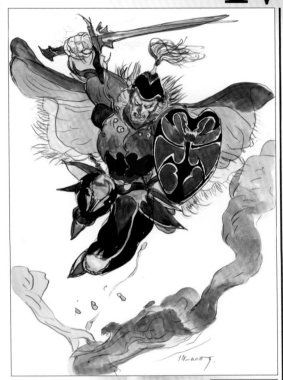

Baron Guardsman
バロン近衛兵 [Baron Kin'eihei]

Baigan
ベイガン [Beigan]

Evil Doll
マリオネイター [Marioneitā]

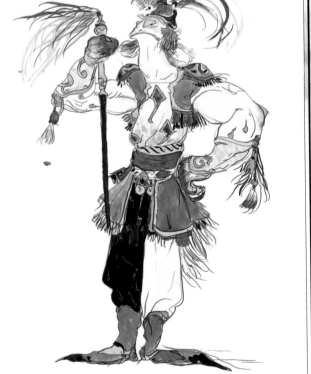

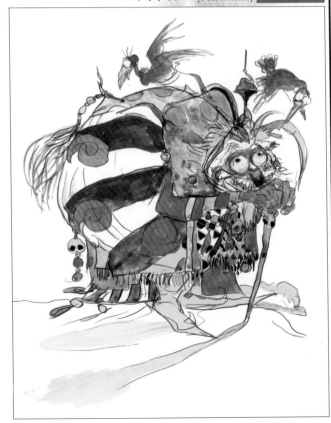

Memorable **Scene**

Captain Baigan Joins Your Party?!

During the course of the story, Cecil returns to Baron Castle and makes an ally of Imperial Captain Baigan. The party is already at its five-person limit when you meet Baigan. As you consider which party member to remove, Palom and Porom realize that Baigan is a monster in disguise, leading to a battle.

Cecil: What is it?
Palom: Something stinks.
Porom: I smell it, too...a monster's stench.

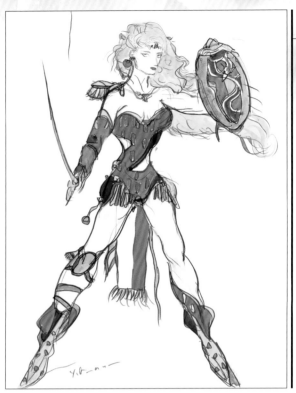

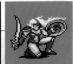

Soldieress
レディガーダー [Redigādā]

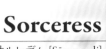 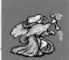

Sorceress
ソーサルレディ [Sōsaruredi]

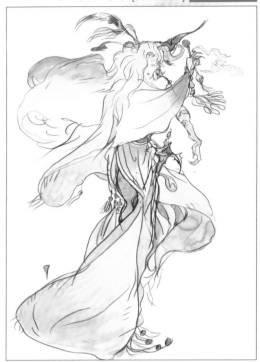

Magus Sisters
(Sandy, Cindy, Mindy)

メーガス三姉妹（ドグ、マグ、ラグ）
[Mēgasu Sanshimai (Dogu, Magu, Ragu)]

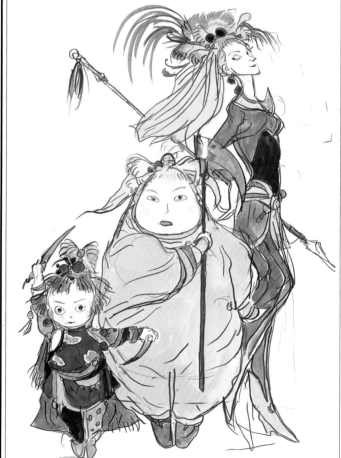

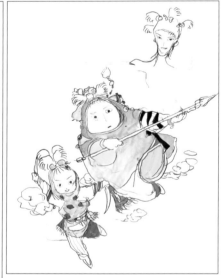

Memorable **Feature**

The Original Delta Attack

After Sandy casts Reflect on Cindy, Mindy casts offensive magic onto the eldest sister. The siblings shout "Delta Attack!" as the spell is reflected. Following this appearance, some fans began referring to the technique of using allies to reflect magic as a Delta Attack. Later games included attacks using the same name, but none of them revolved around reflecting magic.

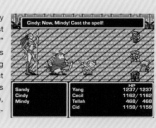

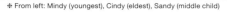
✧ From left: Mindy (youngest), Cindy (eldest), Sandy (middle child)

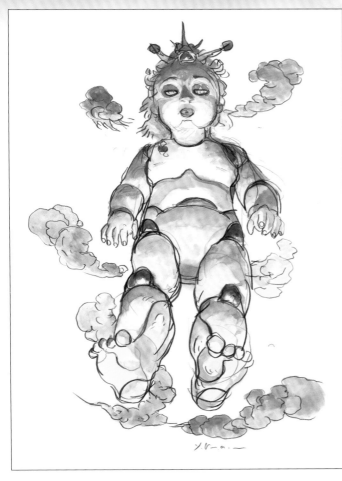

Calcabrina
カルコブリーナ [Karukoburīna]

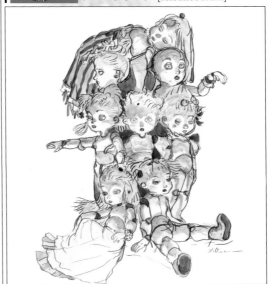

Memorable **Feature**

Puppets in a Pinch

When the battle begins, there are three Calcas and three Brinas. After either group is wiped out, the remaining puppets fuse together to form Calcabrina. Calcabrina is a tough enemy, and will split back into six puppets if it is not defeated quickly enough. Players who defeat all of the Calcas and Brinas at the same time will never have to face them in their fused form.

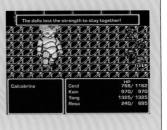

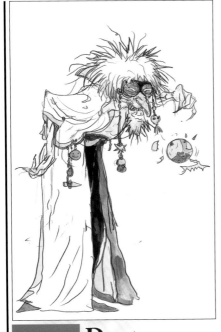

Doctor (Lugae)
博士 (ルゲイエ) [Hakase (Rugeie)]

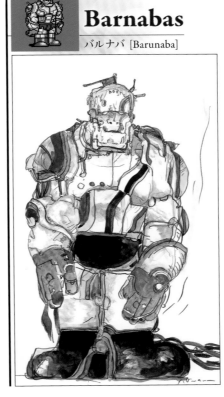

Barnabas
バルナバ [Barunaba]

Dr. Lugae
(Transformed)

ルゲイエ [Rugeie]

Green Dragon
グリーンドラゴン [Gurīndoragon]

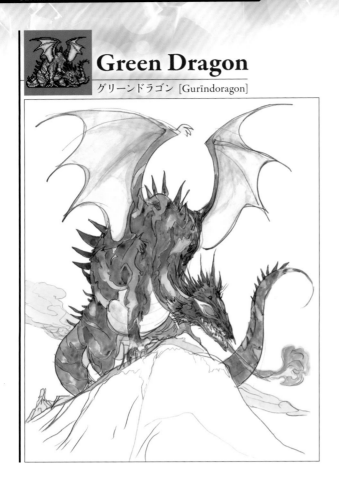

Arachne
アルケニー [Arukenī]

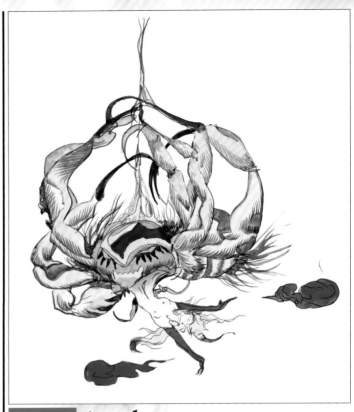

Queen of Eblan
エブラーナ王妃 [Eburāna-ōhi]

King of Eblan
エブラーナ王 [Eburāna-ō]

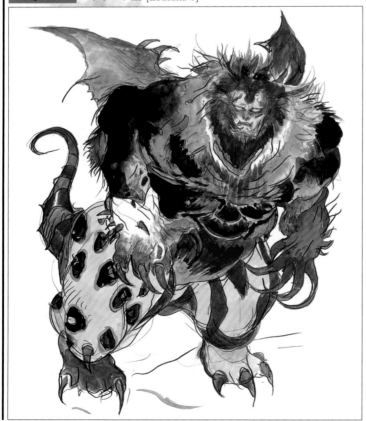

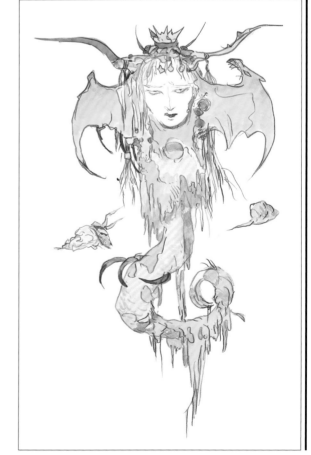

Trap Door

アサルトドアー [Asarutodoā]

Demon Wall

デモンズウォール [Demonzuu~ōru]

Memorable Feature

The Ever-Encroaching Enemy

During the battle, the Demon Wall inches ever closer to the party. If it reaches the front, it will use Crush to instantly kill each party member one by one, dooming many unfortunate players.

Armor Construct

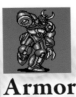

巨人兵 [Kyojinhei]

Bone Dragon

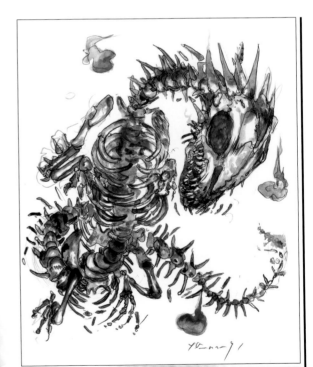

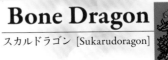

スカルドラゴン [Sukarudoragon]

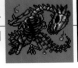

181

Red Dragon
レッドドラゴン [Reddodoragon]

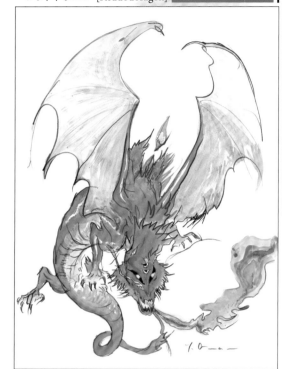
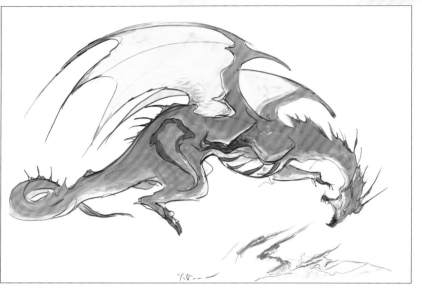

Deathmask
フェイズ [Feizu]

White Dragon 白竜 [Hakuryū]

Shadow Dragon
黒竜 [Kokuryū]

Memorable **Feature**

Malignant Magic, the Face of Fear

Deathmask is memorable not only for its grotesque appearance, but for its peculiar attack pattern. It casts Reflect on itself and the party members, then casts attacks like Flare and Holy on itself and Curaga onto enemies, causing the effects to reverse. This demon also drops the ultimate defensive headgear, Glass Mask.

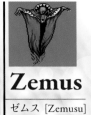

Zemus

ゼムス [Zemusu]

Memorable Feature

Stealing Dark Matter

The item Dark Matter can be stolen from Zeromus in the final battle. Even so, the item cannot be used effectively in battle, and after defeating Zeromus the game ends without allowing the player to save. There is a very low chance of a successful steal in the first place, so getting one's hands on Dark Matter is cause for celebration despite its questionable utility.

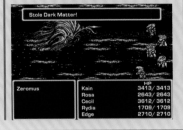

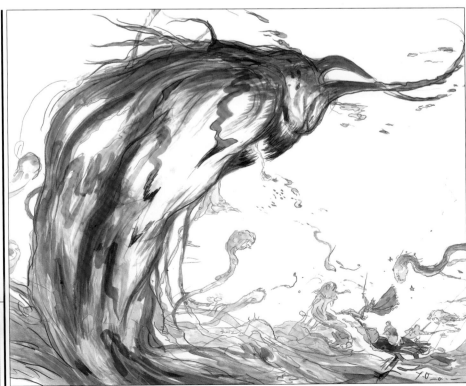

Zeromus

ゼロムス [Zeromusu]

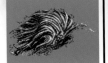

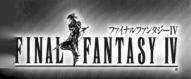

EXTRA CONTENT

| EIDOLONS

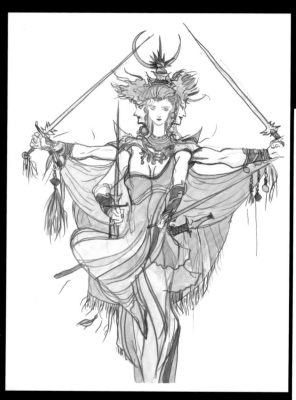

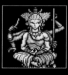

Asura

Co-ruler of the Feymarch with her husband Leviathan. She sports six arms and three heads, all with different expressions. In accordance with the rules of the Feymarch, she only lends her power to those who possess the strength to best her.

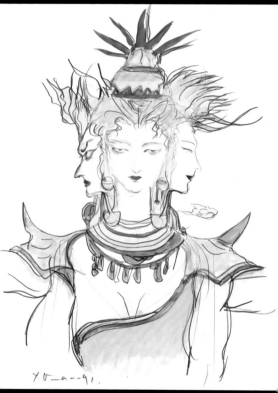

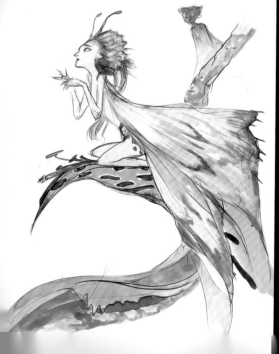

Memorable **Feature**

Luck Be an Eidolon

The three-headed Asura has three different effects when summoned, and can activate Protect, Curaga, or Raise. All three are useful in battle but are unleashed at random, forcing the player to rely on luck in the hope that they receive the desired effect at the right time.

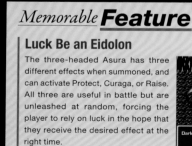

Sylphs

Fairies with the power of wind. Sylphs are cowardly and don't trust humans, but are kind beings at heart. Three Sylphs appear during their summon, attacking enemies and healing allies.

DS Eidolon Set Images

New Eidolon set images were created for the DS remake. The Whyt seen in the bottom right was added exclusively to the DS version, as a special larval form of Eidolon that can be raised by the player.

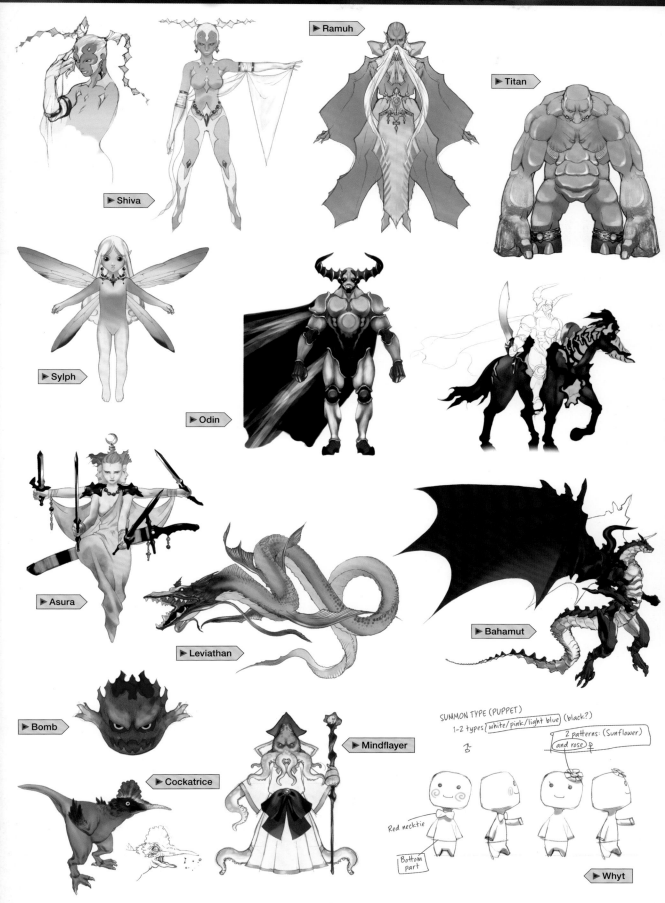

▶ Ramuh

▶ Titan

▶ Shiva

▶ Sylph

▶ Odin

▶ Asura

▶ Leviathan

▶ Bahamut

▶ Bomb

▶ Mindflayer

▶ Cockatrice

SUMMON TYPE (PUPPET)
1-2 types (white/pink/light blue) (black?)

2 patterns: (Sunflower) and rose

Red necktie

Bottom part

▶ Whyt

VEHICLES

Hovercraft

A propeller-driven hovercraft from the nation of Damcyan. It floats slightly above the ground, making it able to travel over deserts or cross shallow water with ease.

The Airship

A ship that allows the player to fly freely through the skies. This illustration was drawn early in development, with three other designs appearing in the actual game.

Lunar Whale

A legendary vehicle resurrected from the bay of Mysidia. Unlike other airships only capable of aerial movement, the *Lunar Whale* can also fly through space. The sight of its raised tail fan was faithfully re-created in-game.

Giant of Babil

A massive human-shaped weapon originating from the Moon and sent to raze the Blue Planet. The Giant of Babil begins its rampage the moment it emerges from the Tower of Babil's interdimensional elevator. Of these two illustrations from Yoshitaka Amano, the one on the left bears a closer resemblance to the final form of the Giant of Babil.

GAME BOY MICRO FACEPLATE ILLUSTRATIONS

Designs for the Game Boy Micro faceplate included in the console bundle (seen on page 137). Of these designs, the top left illustration became the final faceplate. The ones on the right were used for the game packaging.

CHARACTER ILLUSTRATIONS

Kazuko Shibuya Character Illustrations

Various characters drawn by character designer Kazuko Shibuya. The Black Mage and chocobo illustrations on the packaging were based off of these sketches.

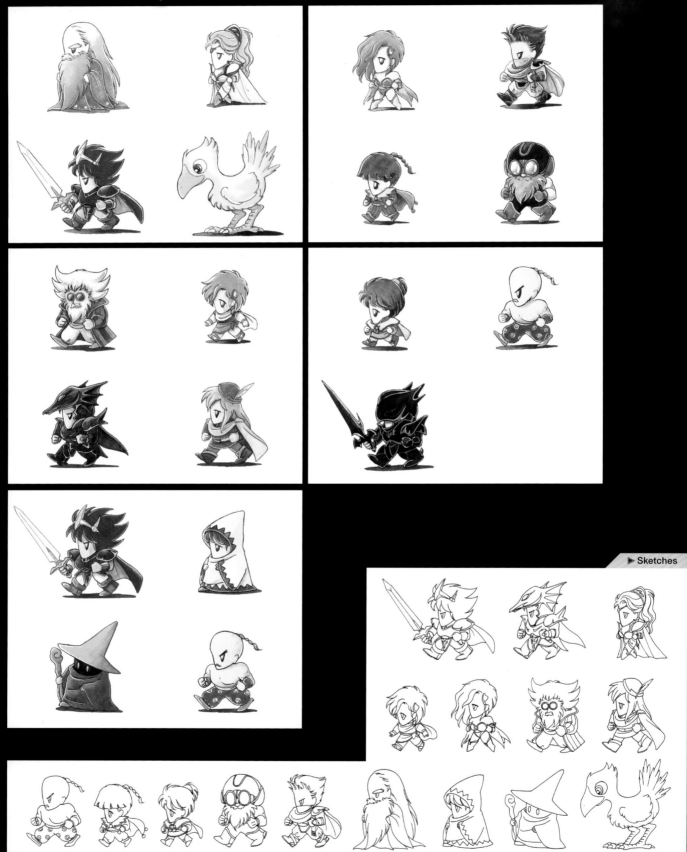

▶ Sketches

MISCELLANEOUS DEVELOPMENT

Takashi Tokita Rough Sketches for Sprite Work

Sketches drawn for character sprites and more. In-battle character sprites are sketches designed with consideration for the typical 3x2 block format, and include a variety of options including defense poses and victory poses.

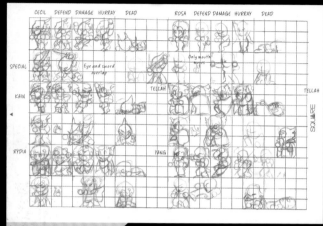

▶ Characters in Battle

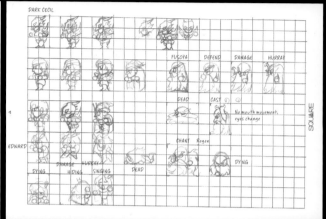

▶ Eidolons, etc.

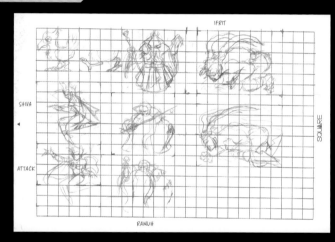

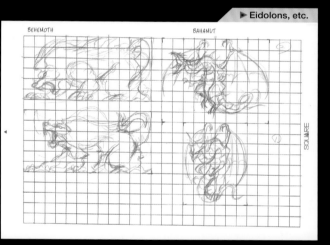

Screen Configuration Plan

Various screens planned during development. Window positions and display elements changed over time, so the final product proved to be quite different.

▶ Loading Screen

▶ Shop Screen

▶ Configuration Screen

DESIGN DOCUMENTATION

Documents written to describe game content. These include concepts and characters appearing in *Final Fantasy IV*, as well as detailed explanations of systems with actual screenshots.

[1]

Nintendo Super Famicom Game Software

Final Fantasy 4

Game Design Document

[2]

Title: Final Fantasy 4

Platform: Super Famicom

Genre: Command-type RPG

Specs: 8MB ROM, battery backup included

Target:

In addition to the obvious user base from those who played *Final Fantasy* on the Famicom, we are considering the first product for our company to release on the new Super Famicom, and plan to appeal to both new users and beginners.

In terms of age range, previous games were focused on "junior high school age." With this in mind, we plan to expand the range so that even elementary school students can understand it, and give it a depth that can even draw in adults.

[3]

Concept

1. We will put a greater emphasis on story than traditional role-playing games (hereafter referred to as RPGs), and offer a presentation that makes players feel like a movie protagonist.
Stress is on world composition, and providing ample content befitting the large card size (8MB), so we aim to include high-tempo events.

2. Looking back on traditional battle systems, we will introduce the ATB system (see subsequent documents).

3. Expanding the traditional 4-person party to 5 members greatly increases the amount of character variation.

4. We will include a Config function that lets players adjust input controls, music output, command window color, and more at their discretion.

5. Config will include a function allowing battle commands traditionally handled by a single player to be split between two players.
We will add a 2-player mode that lets each character be controlled by the first or second player.

6. We will enhance the graphic presentation using the rotation and zoom functionality of the Super Famicom.

7. We will enhance the sound using functions of the Super Famicom.

Please refer to the subsequent game summary for details on these 7 items.

[4]

Game Outline

1. Scenario

Kingdoms

Baron

The country with the strongest military. They have their Imperial guard, their army, their navy, and their airship brigade, the Red Wings. The protagonist Cecil, Rosa, Kain, and Cid are all Baron citizens.

Damcyan

Mercantile city of the desert. It holds the Fire Crystal, so it becomes a sacrifice under an assault by Baron's Red Wings.

Fabul

A religious state that trains monks. Protects the Wind Crystal.

Mysidia

A country known as the land of mages. Once on friendly terms with Baron, it became the first casualty of the war due to its harboring of the Wind Crystal.

Troia

A city of water and forests containing the Earth Crystal. Led by the eight female Epopts.

Main Characters

1. Dark Knight Cecil

The game's protagonist. He works as a Dark Knight, acting as commander of Baron's airship brigade, the Red Wings. The king he respects seeks the crystals to ensure his country's prosperity, and orders Cecil to obtain them. Doubting his orders, Cecil leaves Baron and is set on a path of destiny. As a Dark Knight, his armor itself is a product of evil. Its ominous helm covers his face, so his true appearance is unknown. Only the glitter of his eyes can be seen. Twenty years old.

2. Paladin Cecil

Cecil climbs Mt. Ordeals, receiving divine blessing and converting the negative energy of a Dark Knight into a holy power. His appearance changes as he overflows with a luminescent "life force." His armor even turns a radiant white. Because his true identity is the hybrid offspring between his human mother and his Lunarian father Kluya, his hair and eye color emit a mysterious beauty.

3. Dragoon Kain

[5]

Cecil's rival and best friend. A spear wielder inheriting the blood of Dragoons.
This clan is said to have battled from atop Wyverns, and specialize in agile midair combat. This man has a unique existence in Baron, which forces most of its soldiers to become Dark Knights.
A prideful knight, at once both cool and compassionate. He is secretly in love with the White Mage Rosa, Cecil's lover. As a result of letting Cecil escape, he is used by Golbez, the man that has already taken over Baron.
21 years old.

4. White Mage Rosa

The heroine of this tale. Cecil's lover, and a beautiful White Mage outstanding in the kingdom of Baron. She pursues Cecil when he flees Baron, and ends up joining him. Modest but strong, the epitome of feminine beauty.
19 years old.

5. Summoner Rydia (child)

Daughter to the summoner of the Mist Dragon Eidolon, who Cecil defeated on orders of the king of Baron. This defeat ended up killing Rydia's mother, but she comes to adore Cecil after he protects her from Baron's pursuers.
Although a child, she inherits her mother's proficiency at summoning and Black Magic, and wields it to aid Cecil in his journey.
Her pure and innocent countenance hides an incredible talent.
While riding a ship, she is swallowed up by the Lord of All Waters, Leviathan.
7 years old.

6. Summoner Rydia (adult)

Being swallowed by Leviathan was a sign that he found her worthy as a summoner. The world of Eidolons exists at a different speed from the real world, so she grew into an adult during her time in the Feymarch. Her innocence has not changed from childhood.
She appears to be 20 years old.

7. Sage Tellah

A famous elder mage who joins Cecil's party to defeat his daughter's killer, Golbez. Once powerful magic was all he desired, but he cannot recall spells the way he used to in his old age.
He appears unfriendly, but is actually of noble character. Even so, he gets emotional when his only daughter Anna is involved.
60 years old.

8. Bard Edward

An aristocrat who hates his nobility, instead traveling the land as a bard.
He has long hair, a feathered cap, a short cape, and a harp.
He falls for Tellah's daughter Anna, falling into despair after her death at Golbez's hands. His bravery returns to him in subsequent battles, and he risks his own life to save Rosa's.
A handsome youth steeped in sorrow.
24 years old.

9. Monk Yang

Golbez wiped out all of the monks of the kingdom of Fabul.

[6]

The lone survivor.
He was saved by Cecil and becomes his comrade. Though taciturn like a monk should be, his tempered body houses a tenacious spirit. He has a cute side, and is no match for his traditional wife. Thirty-five years old.

10. Mage Disciples Palom and Porom

Despite being five years old, these twins train to become great mages under the elder of Mysidia, a town known as the mecca of magic. They join Cecil—who had once attacked Mysidia—in order to watch him. Palom is a cheeky brat, while Porom is serious and precocious.

11. Airship Engineer Cid

Baron's airship engineer. He is a stubborn artisan, but is charming and loves children. Cid was tough in his youth, and age has done little to sap his strength. He uses tools to fight monsters. He also claims that physics starts with the body. Fifty-four years old.

12. Eblan Prince Edge

The young prince of Eblan, who hides his kind personality behind a quick mouth. He inherits the secret ninja ways of the royal family, and demonstrates outstanding martial talent. A funny, confident hero whose passion often leads to recklessness. He challenges the Archfiend of Fire, Rubicante, who destroyed Eblan—only to fail miserably. Joins Cecil's party. Twenty-six years old.

13. Lunar Elder Fusoya

Brother to Cecil's father, Kluya. An elder of the Lunarian clan that fled to Earth when their planet—formerly located between Mars and Jupiter—exploded. He saw inhabitants of Earth in the early stages of their evolution, and used his remaining power to create an artificial moon where his people could remain in suspended animation . . . but then the rogue Lunarian Zemus launched his plans to conquer Earth. Fusoya joins Cecil's party to stop Zemus. An old man with mysterious pupils.

14. Golbez

A mysterious man wrapped in eerie armor and a cape, who pursues the crystals using his black airship. Golbez possesses powerful magic. He uses the military forces of Baron to help gather the crystals. In truth Golbez is Kluya's first son, making him Cecil's older brother. Thirty years old.

15. Archfiend of Fire, Rubicante

The leader of the Four Fiends, wrapped in a cloak of flame. He is an honorable warrior who shows proper etiquette toward his foes, but he despises the weaknesses of humanity. Golbez gives him the power to command monsters.

16. Archfiend of Earth, Scarmiglione

Controls the undead. A mysterious Archfiend who always hides food on his person.

[7]

Only the glitter in its eyes contains a hint of vitality.
His true body is the pathetic form of a rotting corpse supplemented by dead animal flesh. Mammoth tusks push out from both sides, forming what look like massive claws.

17. The Archfiend of Water, Cagnazzo

Controls aquatic monsters. He disguises himself as the king of Baron, but is actually a lizard man clad in a turtle's carapace. The cruelest and most vulgar of the Archfiends.

18. The Archfiend of Wind, Barbariccia

The only female Archfiend, commanding other female monsters. A peerless beauty, her lovely countenance is like a rose hiding thorns. She uses her hair to whip up tornado-force winds.

19. Zemus

An evil Lunarian. Space spreads out from within his mantle, where stars twinkle and glow. He has no hair, and maintains an androgynous, nun-like appearance.

Vehicles

1. Chocobo

The adorable, ostrich-like animal famous throughout the *FF* series. Can only travel across land and rivers.

2. Hovercraft

Edward's ship. It can only run on land, but nothing can follow it across the desert. A vessel that can move over shallows and transport five to six people.

3. Airship *Enterprise*

The airship built by Cid, said to be the best in the world. It has separate propellers for hovering and propulsion. It was made for battle, and Cid ensured its main battery can be fired remotely. Later, it is remodeled so it can lower the hovercraft using a hook shaped like a hawk's talon.

4. Airship *Falcon*

The enemy's state-of-the-art airship stolen by the protagonists to escape the enemy base, the Tower of Babil. Because the exit to the Overworld is sealed off, the party attaches a drill to the ship's prow to escape.

5. Giant of Babil

The Lunarian's ultimate weapon, which descends from the Moon through the Tower of Babil. A humanoid machine with four limbs, thought to be a shell. Unlike modern technology, the Giant has a more biological shape.

6. Lunar Whale

[8]

The ship that brought the Lunarian Kluya to Earth.
It is buried at the Dragon Peninsula, and rises up from within a whirlpool.
It looks more like a whale than a spaceship.
It can travel between Earth and the Moon in an instant.

Story

The kingdom of Baron boasts the strongest military. The protagonist, Dark Knight Cecil, commands the kingdom's airship brigade, the Red Wings. The king of Baron once ruled his kingdom with honor, but for some reason he now forces his subordinates to fulfill his every request.

Cecil steals one of the crystals that maintain the world's balance from Mysidia, a kingdom of mages formerly on friendly terms with Baron. While scolding his underlings for daring to doubt the king's orders, Cecil starts to question his own loyalty. He brings up his doubts to the king and has his rank stripped from him. Cecil is commanded to go to the summoner village accompanied by the Dragoon Kain, who tried to stand up for him.

The innocent summoner village is wiped out as a result of the king's evil plan, inspiring Cecil's party to abandon Baron and fight against the king's forces. Wherever Cecil goes, he is now branded as a traitor to the kingdom. Yet his comrades understand, and join him on his quest.

To defeat Golbez—a mysterious man seemingly manipulating Baron from the shadows—Cecil sheds his Dark Knight persona and becomes a holy Paladin.

He learns that there are four crystals in the Overworld and four more in the Underworld. Golbez seeks these crystals in order to destroy the world.

Despite the efforts of the heroes, all of the crystals wind up in the enemy's hands. This results in the activation of the Giant of Babil: the ultimate weapon of the Lunarian civilization intended to destroy the world. But Cecil's group get their hands on another piece of Lunarian technology, the *Lunar Whale*, and use it to attack the weapon.

After this, Golbez regains his senses. It seems he has been brainwashed by Zemus, an evil Lunarian who wishes to end civilization. Not only that, it is revealed that Cecil and Golbez are brothers, sons of a union between a human woman and a Lunarian man. Cecil is stunned to discover the nature of his relationship with his longtime foe.

The reformed Golbez tries to defeat Zemus. Cecil pursues his brother with the help of his friends. When the party reaches Zemus, they see that Golbez has already defeated him. Though the heroes rejoice, Cecil cannot speak to his brother.

At that moment, Zemus's corpse begins to wriggle, and his evil heart materializes as the wicked entity Zeromus. Unleashing its overwhelming power, Zeromus drives the party to the brink of death.

Meanwhile, on Earth, many former comrades offer their prayers for the success of the heroes. These prayers reach Cecil, who struggles to his feet. Cecil uses the crystal given to him by his brother and reveals Zeromus's true form.

Following a life-or-death battle, Zeromus disappears. Golbez says he cannot return to Earth, due to the depth of his sins. As he departs, Cecil opens his heart to his sibling for the first time.

"Farewell . . . Brother!"

[9]

2. New Battle Scene System: Active Time Battle (ATB)

ATB is a new battle format eliminating turns and using the natural flow of time.

In traditional command-based RPGs, the party inputs commands according to party order, and battle begins once all inputs are complete. With ATB, commands are input in order of character speed, and characters will begin to execute actions as soon as the player moves on to input the next command.

Of course, this system applies to monsters as well. Enemies will not wait for the player's command inputs, and will press the attack regardless. But do not think of this as a real-time strategy game. In real-time games speed is the key, but with *FFIV*'s ATB system, enemy movements and adapting to changes are the keys to victory.

In battles with special enemies, you must grasp the flow of time. For example, in battles with monsters that change shape, you cannot win by attacking again and again. Instead you must calculate the timing of your attacks in order to inflict damage. If a monster has erected a barrier you must focus on defense and powering up rather than attacking. Once the barrier goes down, take the offensive and attack all at once. You must always choose the commands that best suit the situation.

Fighting while understanding the concept of time will be to your advantage. For enemies like the Bomb that self-destructs when damaged, there is now a gap between the time it takes damage and the time it explodes. By casting magic that slows its movements, you can attack again before it explodes and defeat it without taking damage.

Let's explain how magic works. All magic will incorporate the concept of time. As such, magic is not cast immediately upon input, but only after the character has completed the incantation needed to cast it. Said time will vary depending on the magic being cast. (Incidentally, characters will display a chant animation during the casting of magic.) The magic selection includes time spells to slow enemy attack cycles (Slow), to speed up ally attack cycles (Haste), or to halt enemy movement for a set time (Stop). Even supplemental magic that only changed the number of hits in previous titles will now become useful magic under the ATB system.

When you encounter several different types of monsters, the order in which you defeat them influences the battle's difficulty. This is only possible with the ATB system. For example, say you encounter two types of monsters: Type A and Type B. Type A will cast Haste on Type B, so ignoring A will only make B stronger. Players will become desperate to defeat A. We've seen scenarios like this in other *FF* games, but things get trickier with ATB. There may be cases where players decide that defeating A will stop B from powering up, so they change up the attack pattern they've been using. In doing so, they will take an unexpected amount of damage. This is why considering attack patterns with respect to enemy combinations is a vital part of fighting under ATB.

Through ATB, you proceed by changing up your style of fighting, making it a system that rewards experimentation. This is different from the past, where relying on the strongest weapons and most powerful magic would ensure a win.

Thank you for reading our simple explanation of the Active Time Battle system.

[10]

3. Party Character Movement

As the story progresses, the flexible party shifts between 1-5 people, taken from the pool of 12 main characters. That way, battles stay fresh as the tale unfolds.

Dark Knight Cecil

Dark Knight Cecil, Dragoon Kain

Dark Knight Cecil, Summoner Rydia (young)

Dark Knight Cecil, Summoner Rydia (young), Sage Tellah

Dark Knight Cecil, Summoner Rydia (young), Prince Edward

Dark Knight Cecil, Summoner Rydia (young), Prince Edward, White Mage Rosa

Dark Knight Cecil, Summoner Rydia (young), Prince Edward, White Mage Rosa, Monk Yang

Dark Knight Cecil, Prince Edward, Monk Yang

Dark Knight Cecil

Dark Knight Cecil, Black Mage Palom, White Mage Porom

Dark Knight Cecil, Black Mage Palom, White Mage Porom, Sage Tellah

Paladin Cecil, Black Mage Palom, White Mage Porom, Sage Tellah

Paladin Cecil, Black Mage Palom, White Mage Porom, Sage Tellah, Monk Yang

Paladin Cecil, Sage Tellah, Monk Yang, Engineer Cid

Paladin Cecil, Monk Yang, Dragoon Kain, White Mage Rosa

Paladin Cecil, Monk Yang, Dragoon Kain, White Mage Rosa, Summoner Rydia (Adult)

Paladin Cecil, Dragoon Kain, White Mage Rosa, Summoner Rydia (Adult)

Paladin Cecil, Summoner Rydia (Adult), Dragoon Kain, White Mage Rosa, Ninja Edge

Paladin Cecil, Summoner Rydia (Adult), White Mage Rosa, Ninja Edge

Paladin Cecil, Summoner Rydia (Adult), White Mage Rosa, Ninja Edge, Lunarian Fusoya

Paladin Cecil, Summoner Rydia (Adult), White Mage Rosa, Ninja Edge, Dragoon Kain

11

4. Config Functions

- Battle Modes

There are two modes to give more choices to users under the new ATB system: "Wait" and "Active."

"Wait" stops time during battle while selecting magic or items.

This will aid users who are not yet accustomed to ATB.

"Active" lets time flow as normal, allowing for thrilling, up-tempo battles using the concept of time.

- Battle Speed

You can set the overall battle speed to 6 different settings. This allows for a wider ATB user base.

- Battle Message

Like above, you can set battle screen message display to 6 different speeds.

- Sound

Choose between "Stereo" or "Mono" sound.

- Controller

"Custom"

Users can change the controller button assignments to suit their play style.

"Multiplayer"

2 players can battle together (see below).

- Window Color

Set message window background colors to red, green, or blue (the default color for the series). Users can set their favorite color, or leave it as the default blue.

5. 2-Player Mode

Assigning controller input to characters in the Config function lets two players fight together on the battle screen.

Fighting alone is traditional for RPGs, but the *Final Fantasy* series and the new ATB system synergize to add the enjoyment of friends and family playing together.

12

6. Game Screen

1. World Map Foot Movement Screen

Ample use of color, creating dimensionality and world building unattainable on the Famicom. When entering battles, we will use the Super Famicom's new Mode 7 function to zoom in and surprise the user.

13

2. World Map Airship Movement Screen

Improving the movement screen for one of the *Final Fantasy* series' key selling points—the airships.

Use Mode 7 to create 3D paths. This creates a sense of realism and exhilaration.

14

3. Sub-Map 1: Village

Animations for overwritten backgrounds, such as the water's surface for flowing rivers or room decorations (clocks, candles, etc.). Promotes a lived-in feeling.

15

4. Sub-Map 2: Cave

Presentation will use calculations between BG1 and BG2 to make it look like fog is rolling through the cave.

16

5. Sub-Map 3: Mountain

The parallax between BG1 and BG2 creates a sense of distance. Moving through what was once a flat sub-map becomes exhilarating.

17

6. Menu Screen

The basic layout and control scheme will remain the same as the older games conceptually, with improvements to the overall sense of control.

Character images will be even clearer, and portrait graphics will be added.

18

7. Battle Screen

The screen considers the most iconic aspects of the series. Like the menu screen, the basic layout and control scheme will remain the same, with improvements to the sense of control.

Colors and the numbers of displayed objects are expanded, using sprites to enhance the magic animation effects that fans expect. During group attacks these will display on all enemies at once, leading to speedy, splendid ATB battles.

19

8. Sound

Music

We aim for music composition that resembles real instruments using the Super Famicom's 8 sound channels and sampling function.

This will be instrumental and avoid synthesizers, using orchestral sounds to create an atmosphere resembling theatrical music despite being a computer game while aiming for a synergistic effect with the story cutscenes.

Sound Effects

These will be conceptually similar to those of the Famicom, but we will use sampling to aim for analog special effects.

ADVERTISEMENT MATERIALS

Package Illustrations

Final character illustrations based off of Kazuko Shibuya's sketches (seen on page 188). These were used on packages, advertisements, and more.

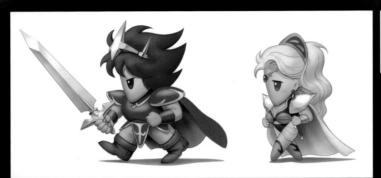

Country Crests

Crests of the countries appearing throughout the story. On the top row from the left: Baron, Damcyan, Fabul, Mysidia, and Eblan. Troia is on the bottom left. The symbol on the bottom right is that of Baron's airship brigade, the Red Wings.

Item Illustrations

Illustrations for the strategy guide, released at the same time as *Final Fantasy IV*. Included here are items that did not actually receive representation as in-game graphics.

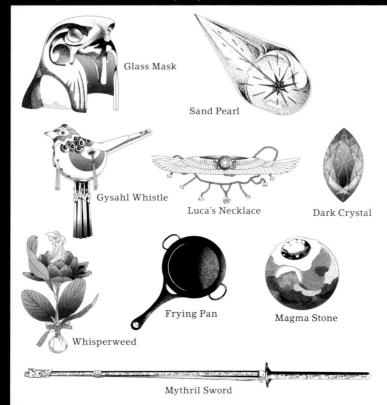
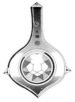 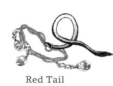 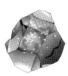
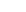

Glass Mask · Sand Pearl · Lugae's Key · Red Tail · Adamantite · Gysahl Whistle · Luca's Necklace · Dark Crystal · Cursed Ring · Giant's Gloves · Crystal Ring · Whisperweed · Frying Pan · Magma Stone · Mythril Sword · Adamant Armor · Power Sash

DS OPENING STORYBOARDS

Storyboards from Yoshinori Kanada depicting Cecil and Kain's departure from Baron Castle. This shares the same basic flow as the story, but the camera work and direction help elevate this into an impressive cinematic moment.

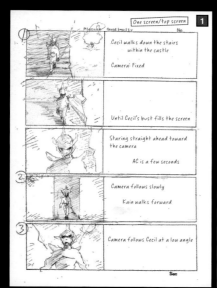

One screen/top screen

1

Cecil walks down the stairs within the castle

Camera: Fixed

Until Cecil's bust fills the screen

Staring straight ahead toward the camera

AC is a few seconds

Camera follows slowly

Kain walks forward

Camera follows Cecil at a low angle

2

Low-angle camera follow

Kain walking

Stop in front of each other, Tense expression on his face [Shadows waver slightly in torch light]
Camera rotates slightly →

Kain smiles kindly.
Kain: "You going, Cecil?"

Cecil: "I'll be counting on you, Kain."

3

Camera Kain: "Leave it to me."

Readying a spear

Cecil closes his helmet with a clang.

Gate opens with a creak

Cecil stares straight ahead

Maybe the music starts here?

Camera: Crane down

4

Pull back when the door opens

Cecil and Kain walk together toward the door.
Lots of cuts.

Camera: Crane down

The two go through the door toward the castle gate.
Soldiers see them off with respect.

5

The castle gate opens. The camera tilts slowly

The gatekeepers open the gate and you can see the pair.

Cecil and Kain walk through the castle gate.

If a few seconds is not enough, overlap into the next cut.

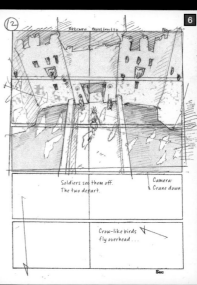

6

Soldiers see them off. The two depart.

Camera: Crane down

Crow-like birds fly overhead ...

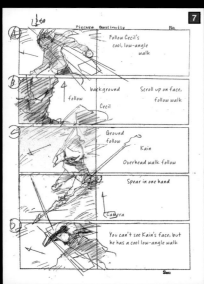

7

Follow Cecil's cool, low-angle walk

background follow
Scroll up on face, follow walk
Cecil

Ground follow
Kain
Overhead walk follow

Spear in one hand

Camera

You can't see Kain's face, but he has a cool low-angle walk

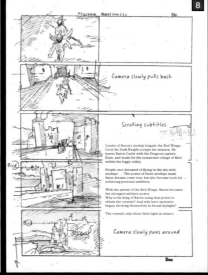

8

Camera slowly pulls back

Scrolling subtitles

Bird

Leader of Baron's airship brigade the Red Wings, Cecil the Dark Knight accepts his mission. He leaves Baron Castle with the Dragoon captain Kain, and heads for the summer village of Mist within the foggy valley.

People once dreamed of flying in the sky with airships ... The power of these airships made these dreams come true, but also become tools for achieving personal ambition.

With the advent of the Red Wings, Baron becomes the strongest military power.
Why is the king of Baron using that power to obtain the crystals? And why have monsters begun showing themselves in broad daylight?

The crystals only shine their light in silence.

Bird

Camera slowly pans around

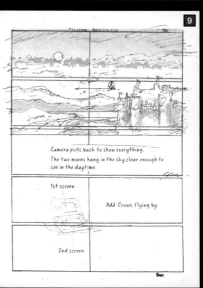

9

Camera pulls back to show everything.
The two moons hang in the sky clear enough to see in the daytime.

1st screen

Add: Crows flying by.

2nd screen

DS IMAGE ILLUSTRATIONS

Image illustrations created for the DS version. Cecil and Rosa can be seen holding each other on the terrace of the Baron Castle image. The official blog illustrations have a certain warmth not seen in other pieces.

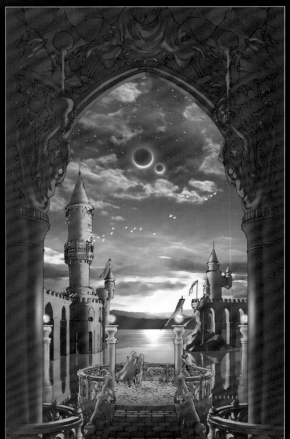

▶ Baron Castle Image

▶ Baron Castle Panorama

▶ Cecil and Kain

▶ Tower of Babil

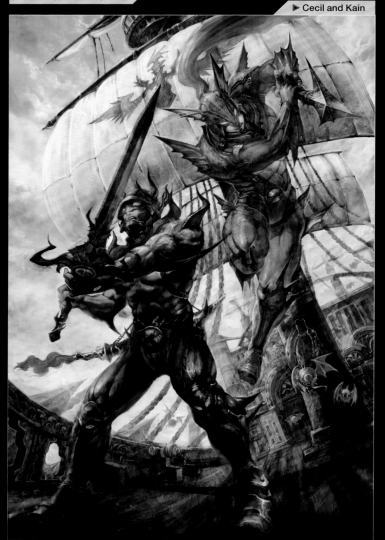

► Official Blog Illustration ①

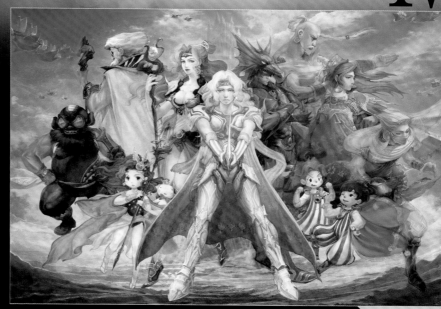

► Comrades

► The Dark Knight and the Paladin

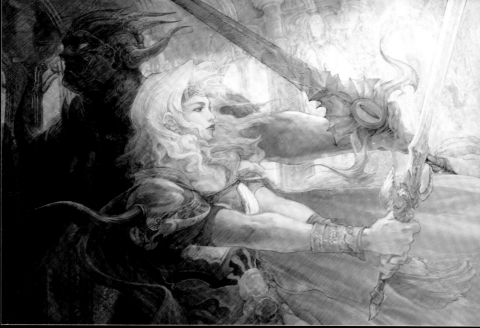

► *Lunar Whale* Image

► Official Blog Illustration ②

FINAL FANTASY IV
MEMORIES

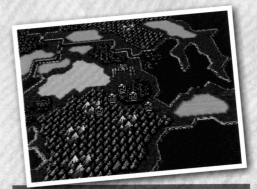

The power of the Super Famicom! The flying airship formation is enough to take the viewer's breath away.
—OPENING SEQUENCE

The new challenge of ATB (Active Time Battle): Enemies attack while you think!
—IN BARON

Kain's betrayal, and the Leviathan's attack . . . Cecil's suffering continues.
—ON THE OCEAN

Metal equipment immobilizes bodies that feel the powerful magnetism in the cave.
—IN THE LODESTONE CAVERN

Cid: The magnetic field in this cave is unbelievable! Better remove all our metal armor and weapons if we want to able to move in here.

Palom, Porom: Break!

Cagnazzo's underhanded trap. To save their friends, Palom and Porom . . .
—IN BARON CASTLE

Shocking! *FFIV* developed in an Underworld castle?!
—IN THE DEVELOPERS' OFFICE

T. Tokita has joined the party!!!

Kain's grief at missing out on healing during his signature Jump attack.
—IN BATTLE

Kain: Don't be a fool! Open the door!
Rydia: Yang!
Rosa: Please, Yang! Don't throw your life away!

Yang and Cid sacrificing themselves to help prevent the looming crisis.
—IN THE UNDERWORLD

Beating up droves of Flan Princesses to get your hands on a rare drop, the elusive Pink Tail.
—ON THE LUNAR SURFACE

Fly the *Lunar Whale* from the mouth of the dragon to the Moon. You can't help but notice a face-shaped rock . . .
—ON THE MOON

Dance with us!

Flan Princess	5		
			HP
		Cecil	3612/ 3612
		Rosa	2643/ 2643
		Kain	3413/ 3413
		Rydia	1709/ 1709
		Edge	2710/ 2710

Elder: Now is the time we pray for them. No, for the entire world!

You cannot lose! The final showdown is backed by the courage of the denizens of the Blue Planet.
—IN THE LUNAR SUBTERRANE

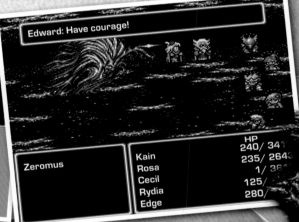

Edward: Have courage!

Zeromus		HP
	Kain	240/ 341
	Rosa	235/ 264
	Cecil	1/ 36
	Rydia	125/
	Edge	280/

Golbez: Cecil... You called me "Brother."

Guided forth anew by light made manifest
Two bound by ties of blood
By Time and Fate then wrest apart
Unto lunar light and Gaian breast

Cecil: Nothing. I just—I could have sworn I heard my brother's voice.

GBA Version

Implementing character customization for greater freedom

The fifth game in the series boasted enhanced game play while preserving the vaunted story-telling of the *Final Fantasy* franchise. Bartz and his friends adventure through three worlds to halt the ambitions of the warlock Exdeath, who seeks the power of nothingness. *Final Fantasy V* was highly praised for its introduction of Ability Points, which improved the job system and allowed players to fight with whatever abilities they preferred for their characters.

Super Famicom	PlayStation	PlayStation	PlayStation (Limited Edition)
Final Fantasy V	**Final Fantasy V**	**Final Fantasy Collection**	**Final Fantasy Collection Anniversary Package**
Launch Date ● December 6, 1992	JP Launch Date ● March 19, 1998 NA Launch Date ● September 30, 1999 ✣ JP version convenience store exclusive	Launch Date ● March 11, 1999	Launch Date ● March 11, 1999

Game Boy Advance	Wii/Wii U (Virtual Console)	PlayStation 3/ PlayStation Portable/ PlayStation Vita (PS one Classics)	PlayStation (Limited Edition)
Final Fantasy V Advance	**Final Fantasy V** (Super Famicom Version)	**Final Fantasy V** (PlayStation Version)	**Final Fantasy 25th Anniversary Ultimate Box**
JP Launch Date ● October 12, 2006 NA Launch Date ● November 22, 2006	Launch Date ● January 18, 2011	JP Launch Date ● April 6, 2011 NA Launch Date ● November 22, 2011 ✣ Available on PS Vita from August 28, 2012	Launch Date ● December 18, 2012 ✣ Square Enix e-Store Limited Edition

FINAL FANTASY V
ファイナルファンタジーV
ART

On Wings of Fate
Bartz, Krile, Lenna, and Faris

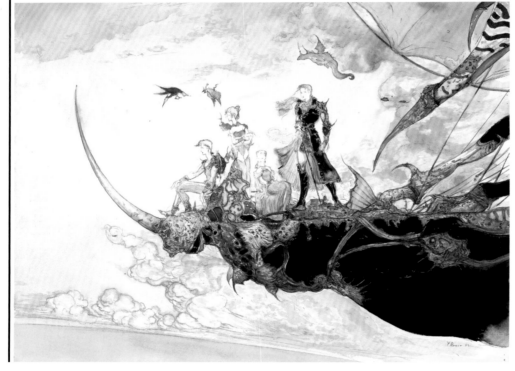

Moment of Repose
Lenna

Castle in the Clouds
Krile on the wind drake

Wrapped in Verdure

Moonlit Embrace
Bartz and Lenna

Blades of Crimson and Cerulean
Bartz and Faris

Four Warriors of Dawn

Toward the Dawn
Bartz and Lenna

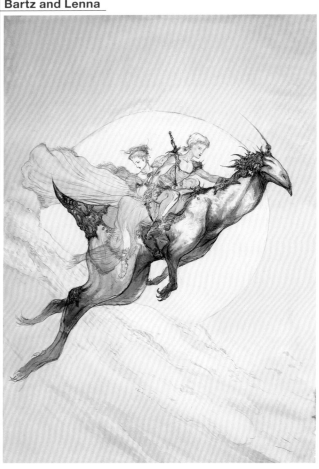

Sword and Phantom
Bartz fighting a monster

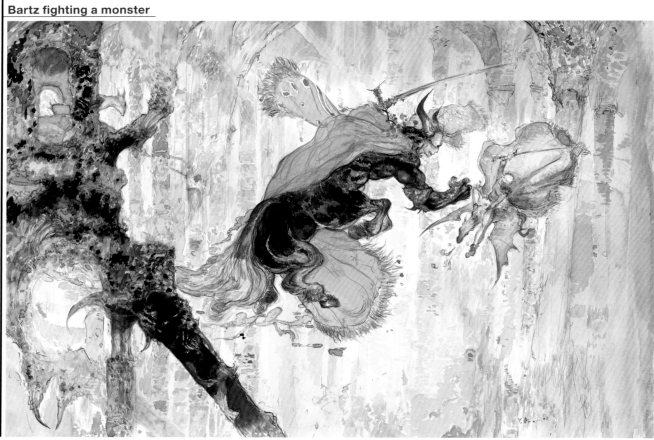

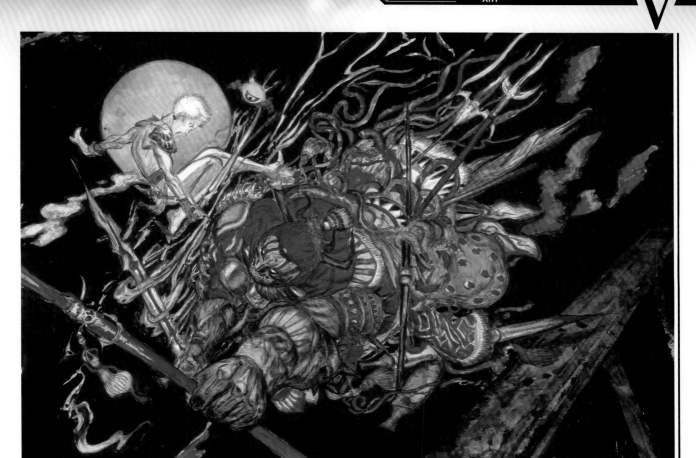

Bartz vs. Gilgamesh

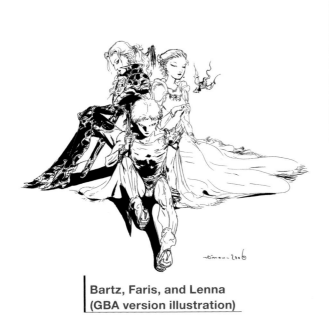

Bartz, Faris, and Lenna
(GBA version illustration)

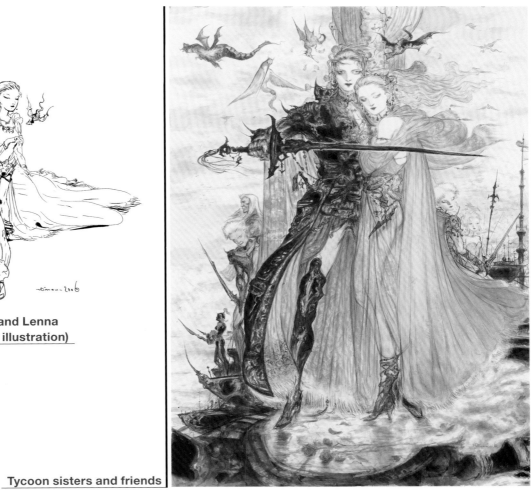

Tycoon sisters and friends

Lenna: Are these the crystals'... essences?

Faris: When I was just a lad—er, lass, a pirate band took me in. I've been one of them ever since.

Galuf: From here on, it's monsters all the way! Stay on your toes!

FINAL FANTASY V
STORY

Faris: Get up, you old bat! Quit playing around, this isn't funny!
Krile: Wake up...wake up, please!

If breaking the seals is what you seek, Approach the one you'd have and speak.

For Gilgamesh...it is morphing time!

Gilgamesh		HP
	Bartz	1222
	Lenna	2256
	Krile	905
	Faris	1900

Once Exdeath obtains the power of the Void, our new world—a world of darkness—will be born!

A thousand years in the past, four crystals were split to seal the power of the Void, splitting the world itself into two separate worlds in the process. The Void was sealed in the space between these two worlds, becoming known as the Interdimensional Rift. Though the threat was thought to have passed, many moons later the warlock Exdeath appeared and tried to channel the power of nothingness from the Void. The old Warriors of Dawn tried to defeat Exdeath, but could not succeed even after driving him into the other world. The Warriors of Dawn were forced to seal Exdeath away using the power of the crystals.

Thirty years later, those with no knowledge of Exdeath exploited the crystals to serve their own greed, which weakened the crystals' power. This allowed Exdeath to recover some of his dark powers, and he used his evil influence to manipulate others into shattering the crystals one by one. Four new Warriors of Light are chosen by the crystals, and steel themselves to prevent Exdeath's resurrection.

CHARACTERS

✤ Some images are from the GBA version

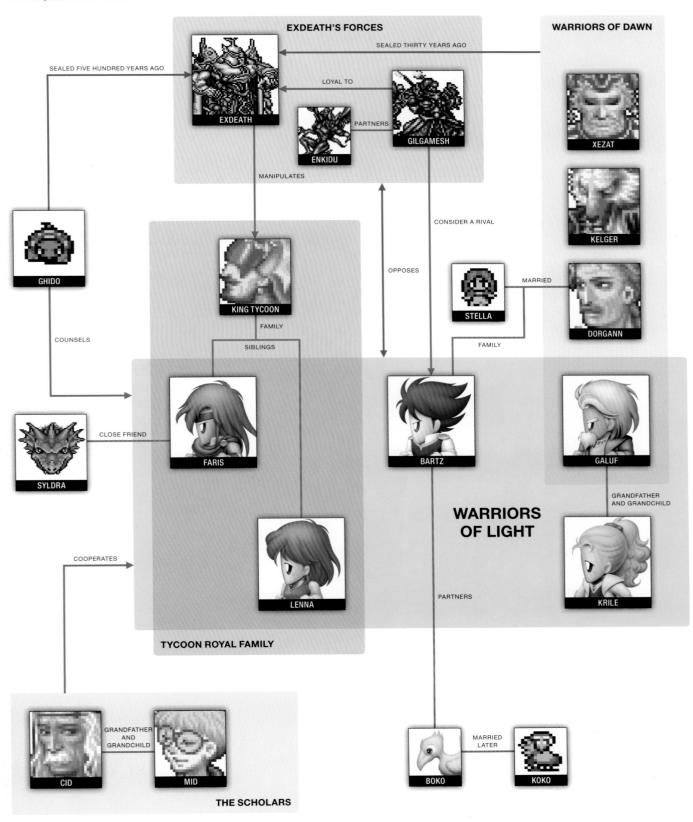

Bartz バッツ

Unfettered wayfarer following the wind.

[Battsu/Butz]

▶ *Bartz Klauser* バッツ・クラウザー

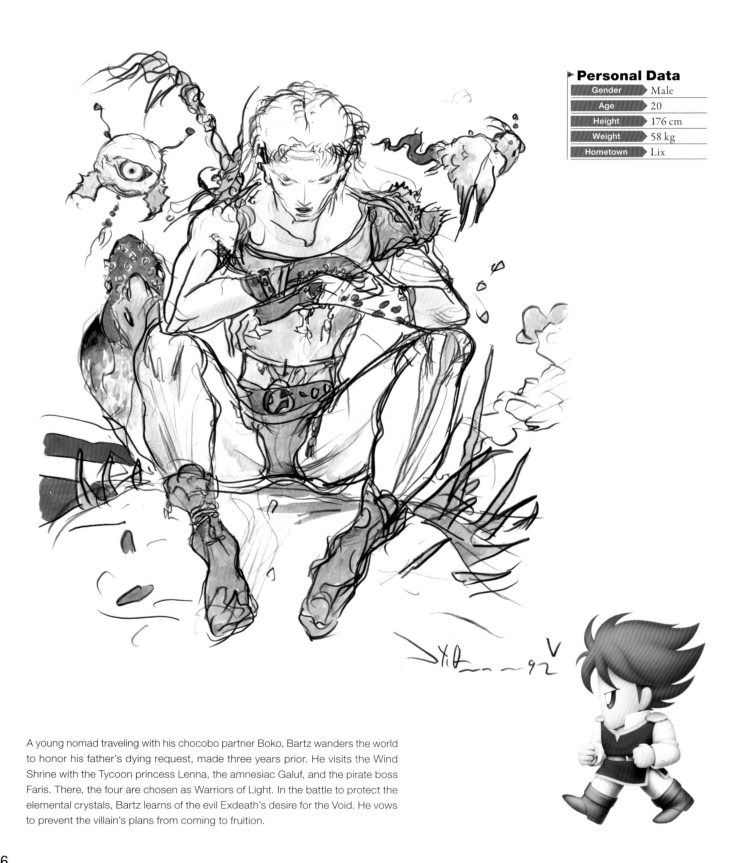

▶ Personal Data

Gender	Male
Age	20
Height	176 cm
Weight	58 kg
Hometown	Lix

A young nomad traveling with his chocobo partner Boko, Bartz wanders the world to honor his father's dying request, made three years prior. He visits the Wind Shrine with the Tycoon princess Lenna, the amnesiac Galuf, and the pirate boss Faris. There, the four are chosen as Warriors of Light. In the battle to protect the elemental crystals, Bartz learns of the evil Exdeath's desire for the Void. He vows to prevent the villain's plans from coming to fruition.

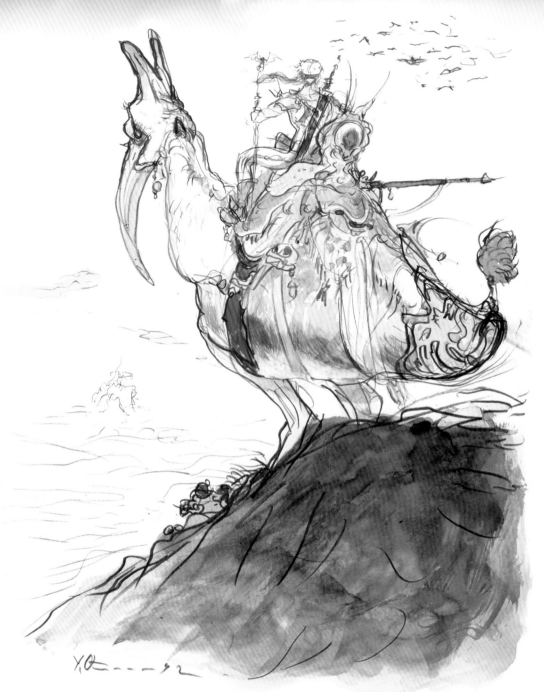

Memorable **Quotes**

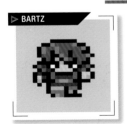

▷ BARTZ

"Be good while I'm gone, Boko!"

—**Before traveling to the other world through the warp point.**

In order to save Galuf, Bartz and his friends plan to travel to Galuf's world using the warp point caused by the convergence of meteorite power. Knowing he may never return, Bartz bids a fond farewell to his chocobo partner, Boko.

"But it's fun! Poke, poke, poke . . ."

—**In Ghido's Cave, touching the overturned Ghido.**

Bartz innocently pokes at the upside-down turtle, not realizing it is actually the sage Ghido. Despite the fact that Bartz means no harm, Galuf is mortified at his companion's behavior toward the wise teacher.

"Heh . . . No point in trying to change her . . . Faris is who she is!"

—**Morning in the Ship Graveyard, after learning that Faris is actually a woman.**

Bartz accepts the truth of Faris's identity, knowing it changes nothing about the straightforward pirate. His easy acceptance of other people is part of Bartz's natural charm.

"... Actually, I, uh, I don't really like heights ..."

—**On North Mountain, Bartz is embarrassed to admit the truth after he hesitates to ride the wind drake.**

Bartz has an intense fear of heights, brought on by an incident from his childhood where he nearly fell from a roof during a game of hide-and-seek. This uncharacteristic display of weakness from Bartz causes his comrades to erupt with laughter.

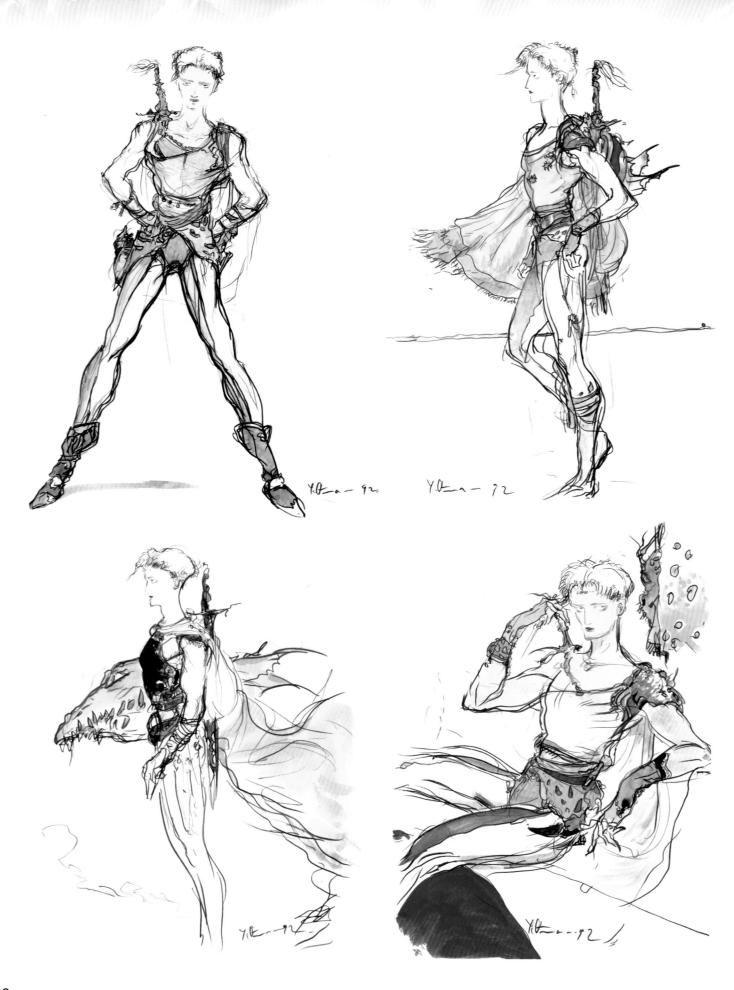

JOB APPEARANCES

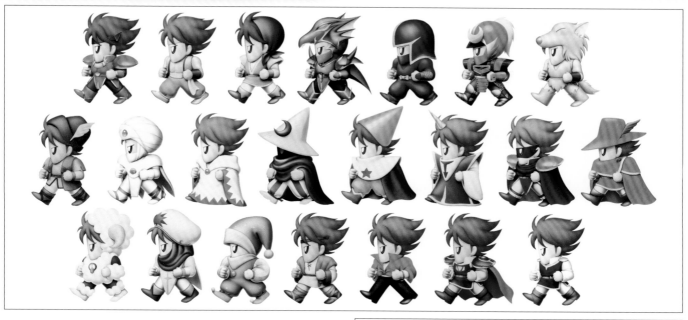

▶ Additional GBA Version Jobs ‡ Left to right: Necromancer, Oracle, Cannoneer, Gladiator

First row: Knight, Monk, Thief, Dragoon, Ninja, Samurai, Berserker
Second row: Ranger, Mystic Knight, White Mage, Black Mage, Time Mage, Summoner, Blue Mage, Red Mage
Third row: Beastmaster, Chemist, Geomancer, Bard, Dancer, Mime, Freelancer

Frustrated by a Harmless Prank?

While trying to solve the mystery of an unmoving switch inside the Catapult, Bartz follows a set of instructions, only to find a memo reading "Made you look!" at the end of his search. Realizing he has been given the runaround, the youth sighs with bitter indignation.

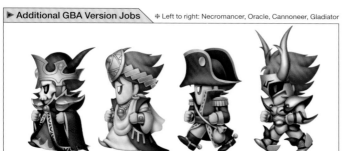

Bartz: Yeah! You know, it was my dad's dying wish that I go out and travel the world...

Bartz: Arg! That little—

Memorable Scenes

▷ BARTZ

Guided by the Wind

Bartz says goodbye to Lenna's party, only to change his mind and chase after them when he decides to join them on their journey. Although Bartz tries to act cool, Galuf suggests that he has fallen for the girl.

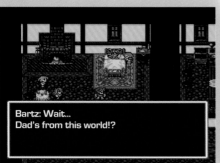

Bartz: Wait... Dad's from this world!?

Bartz: Aughhh!!!

A Father's Otherworldly Origins

Bartz's father Dorgann hailed from the same world as Galuf, and was another of the Warriors of Dawn who originally fought Exdeath. Bartz cannot conceal his shock upon learning this unexpected truth.

The Vanished Birthplace

Exdeath uses the power of the Void to attack vast regions of the world, utterly erasing Bartz's homeland of Lix from the map. Bartz loses himself in anger and sadness, allowing the airship to roam aimlessly while he cries out in grief.

Lenna レナ

Compassionate princess,
caring for all living things.

[Rena/Lenna]

▶ *Lenna Charlotte Tycoon*　レナ・シャルロット・タイクーン

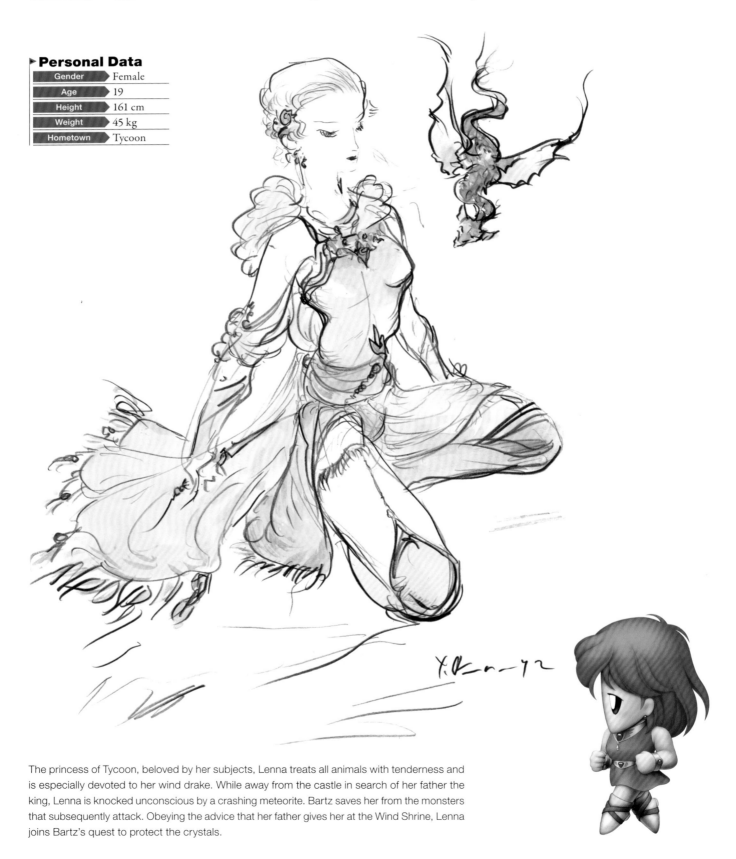

▶ Personal Data

Gender	Female
Age	19
Height	161 cm
Weight	45 kg
Hometown	Tycoon

The princess of Tycoon, beloved by her subjects, Lenna treats all animals with tenderness and is especially devoted to her wind drake. While away from the castle in search of her father the king, Lenna is knocked unconscious by a crashing meteorite. Bartz saves her from the monsters that subsequently attack. Obeying the advice that her father gives her at the Wind Shrine, Lenna joins Bartz's quest to protect the crystals.

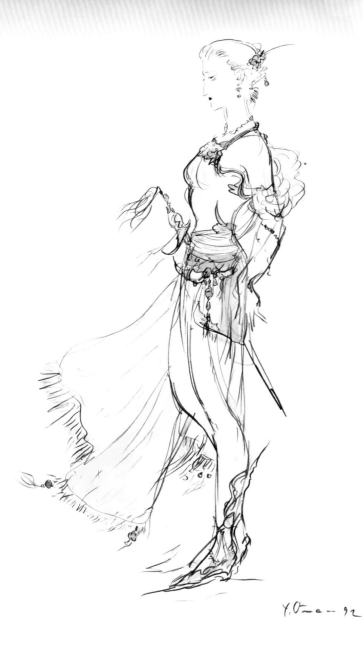

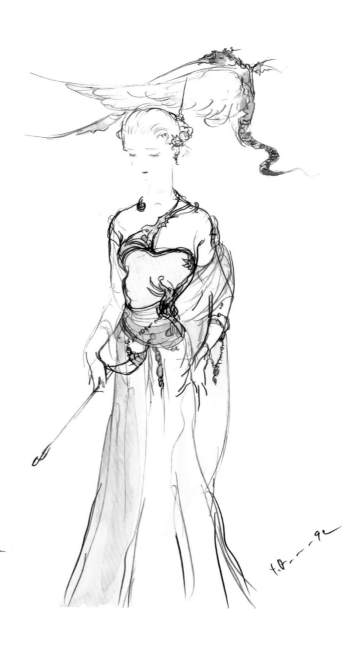

Memorable **Quotes**

▷ LENNA

"Oh, you must have been so scared . . . It's okay now, don't worry. Come closer!"

—Calming the frightened moogle in the
Underground Waterway.

Lenna is kind to animals, and can empathize with all types of creatures. Even the skittish, wary moogle feels safe around Lenna.

"Give the dragon grass to Hiryu . . . quickly . . ."

—On North Mountain, searching for dragon grass for
her injured wind drake.

Lenna braves the poisonous undergrowth to retrieve the dragon grass that will heal her wind drake, Hiryu. After giving the dragon grass to Faris, Lenna collapses from the effects of poison—but continues to worry more about Hiryu than herself.

"Please, allow us the use of your vessel. I must get to the Wind Shrine—my father is in danger!"

—When the party is discovered while trying to make off with
the ship from the pirates' hideout.

Anxious to help King Tycoon, Lenna begs the pirates for their aid. Naively, she reveals her royal lineage, but her ability to treat all people as equals is one of her greatest virtues.

"Whenever I see Hiryu, I'm reminded of her . . ."

—On the uninhabited island, when asked by Faris why she risked
her life to save the wind drake.

While resting inside their tent, Faris tries to understand why her sister would brave the poisonous grass for the life of an animal. In Lenna's eyes, Hiryu is a symbol of the bond she shared with her late mother.

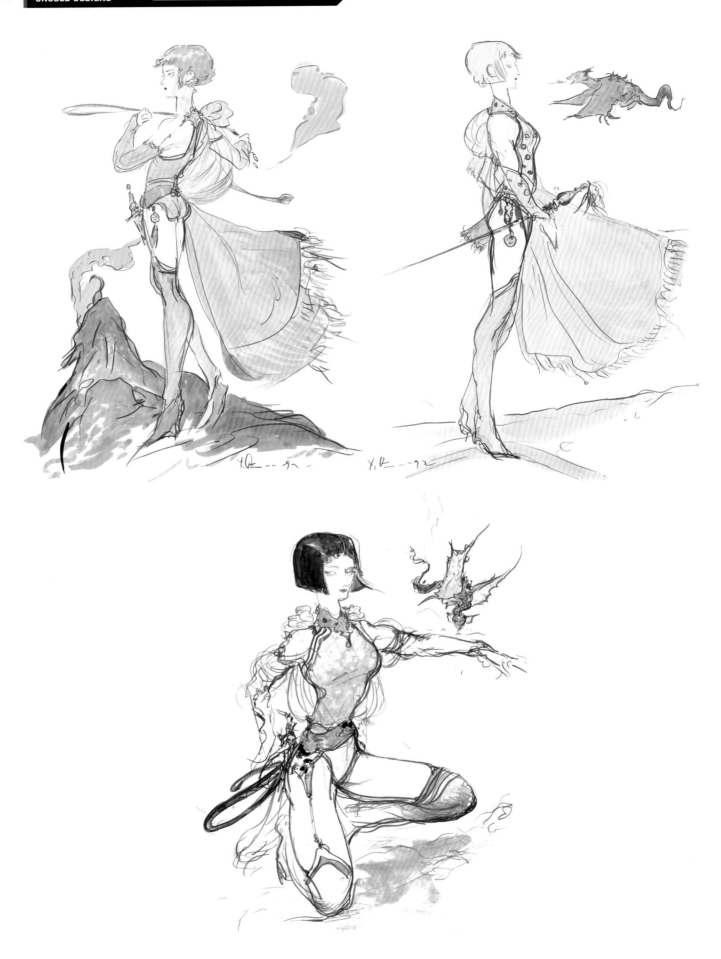

JOB APPEARANCES

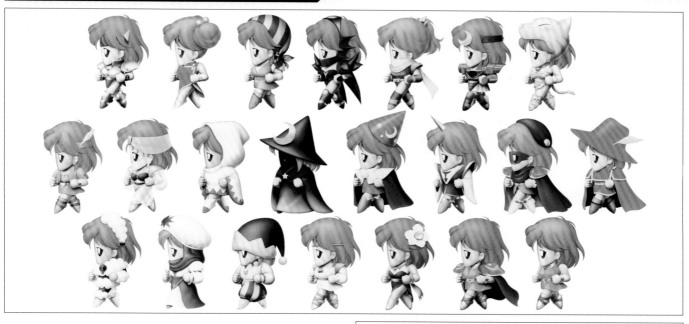

▶ Additional GBA Version Jobs ‡ Left to right: Necromancer, Oracle, Cannoneer, Gladiator

First row: Knight, Monk, Thief, Dragoon, Ninja, Samurai, Berserker
Second row: Ranger, Mystic Knight, White Mage, Black Mage, Time Mage, Summoner, Blue Mage, Red Mage
Third row: Beastmaster, Chemist, Geomancer, Bard, Dancer, Mime, Freelancer

That Pendant . . .

Encountering Faris on the terrace of Castle Tycoon, Lenna correctly surmises that the pirate captain is actually her sister. Faris tries to laugh it off, but she possesses the same pendant as Lenna, which only deepens the princess's belief.

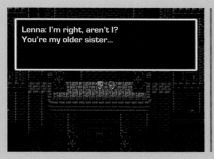

Lenna: I'm right, aren't I?
You're my older sister...

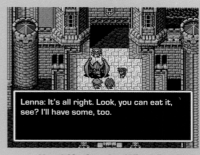

Lenna: It's all right. Look, you can eat it, see? I'll have some, too.

Memorable Scenes

▶ LENNA

Assaulted by Monsters

The wind drake rescues Lenna from Tycoon when the entire kingdom is swallowed by the Void, carrying her back to the party. But while she lies unconscious, Lenna is possessed by the demon Melusine and forced to fight her comrades.

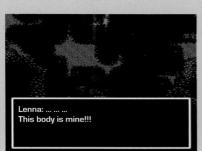

Lenna:
This body is mine!!!

Her Life for the Wind Drake's

In order to get the weakened wind drake to swallow a healing dose of dragon grass, Lenna demonstrates by eating some of it herself—despite it being poisonous to humans. The wind drake is saved, but Lenna's comrades scold her for her recklessness.

The queen mother has always cared deeply for Hiryu. Will you still cut out his tongue?

Yes
No

The Wind Drake's Tongue

As she observes Hiryu's final moments at the Phoenix Tower, Lenna relives a memory from her past. She had learned that her mother's illness could be cured with the tongue from a wind drake, and she approached Hiryu with a knife in her hand. The castle servant Jenica forced her to consider whether she could kill her mother's beloved wind drake.

Galuf ガラフ

Wisecracking warrior
missing his memories.

[Garafu/Galuf]

▶ *Galuf Halm Baldesion (Galuf Doe)* ガラフ・ハルム・バルデシオン（ガラフ・ドゥ）

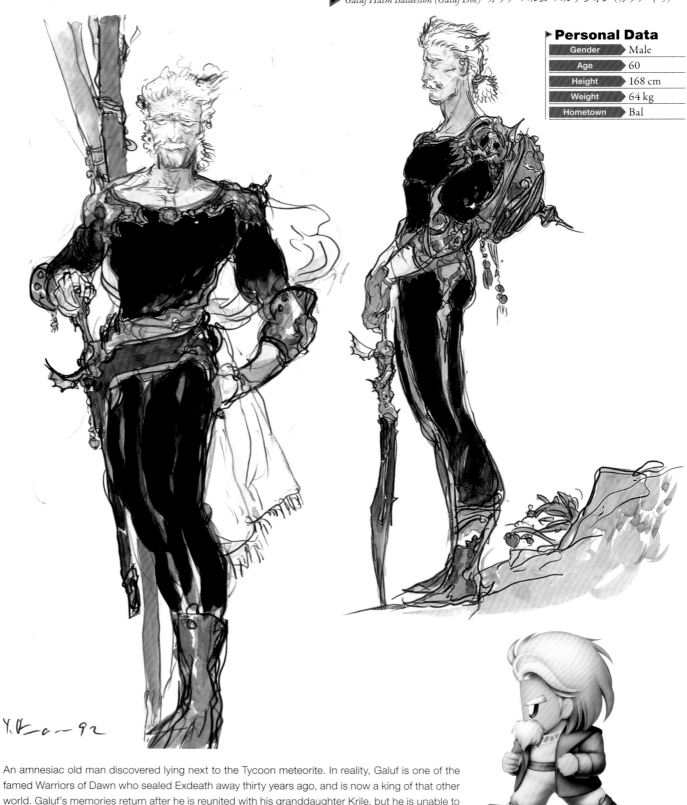

Personal Data	
Gender	Male
Age	60
Height	168 cm
Weight	64 kg
Hometown	Bal

An amnesiac old man discovered lying next to the Tycoon meteorite. In reality, Galuf is one of the famed Warriors of Dawn who sealed Exdeath away thirty years ago, and is now a king of that other world. Galuf's memories return after he is reunited with his granddaughter Krile, but he is unable to protect the crystals, allowing Exdeath to return. To continue fighting Exdeath, Galuf returns to his world. He meets a heroic end in the Great Forest of Moore, protecting Krile and the Warriors of Light.

JOB APPEARANCES

First row: Knight, Monk, Thief, Dragoon, Ninja, Samurai, Berserker
Second row: Ranger, Mystic Knight, White Mage, Black Mage, Time Mage, Summoner, Blue Mage, Red Mage
Third row: Beastmaster, Chemist, Geomancer, Bard, Dancer, Freelancer

Memorable Quotes

▷ GALUF

"... Ohh, my aching head! I can't remember a thing!"
—On the pirate ship, pretending to forget that stealing the ship was his idea.

Galuf's group is captured while trying to steal the pirates' ship. He complains about the "genius" who cooked up such a plan, then immediately uses his amnesia as a cover when his friends point out that it was his idea.

"I meant it, ya know, you really didn't have to come ... Meddlesome bums, the lot of you. Still ... it's good to see you again."
—On Gloceana, to Bartz, who apologizes for getting in the way while trying to help.

When Galuf saves his crew and flees from Castle Exdeath, the castle's barrier launches most of the party members to remote lands. Galuf quips back after hearing Bartz's apology, but he is secretly overcome with emotion at the fact that his comrades abandoned their world—possibly forever—just to save him.

"I'm ... I'm not from this world!"
—Slowly getting his memories back aboard the fire-powered ship.

After witnessing a conversation between Cid and Mid, Galuf realizes that he shared a similar exchange with Krile. The information is enough to trigger the memory that he arrived from the other world aboard the meteorite.

"Let me wait—just a bit longer. Just a minute more ..."
—In the Barrier Tower, waiting for Xezat to return.

Galuf's friend Xezat shared in the fate of the exploding Barrier Tower. While Galuf assumes Xezat has died, he keeps his final promise by waiting inside the submarine for the old warrior's return.

Don't You Ditch Me!
When the party falls underground, Galuf is separated from his allies. Through the wall, he hears the others planning to leave him behind, and forces his way to their location.

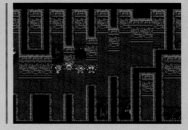

Going Alone for His Friends
Galuf borrows Krile's wind drake, flying to save his comrades from Castle Exdeath. He ventures into the dungeons by himself, and drives off the guard Gilgamesh.

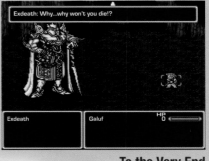

Exdeath: Why...why won't you die!?

Exdeath	Galuf	HP 0

▷ GALUF

To the Very End
Galuf challenges Exdeath to single combat, hoping to save his comrades and his beloved grandchild. His determination overwhelms Exdeath, who cannot defeat Galuf despite inflicting damage that reduced his health to nothing.

Memorable Scenes

The valiant pirate
of mysterious origins.

Faris

ファリス

[Farisu/Faris]

▶ *Faris Scherwiz (Sarisa Scherwil Tycoon)*
ファリス・シェルヴィッツ（サリサ・シュヴィール・タイクーン）

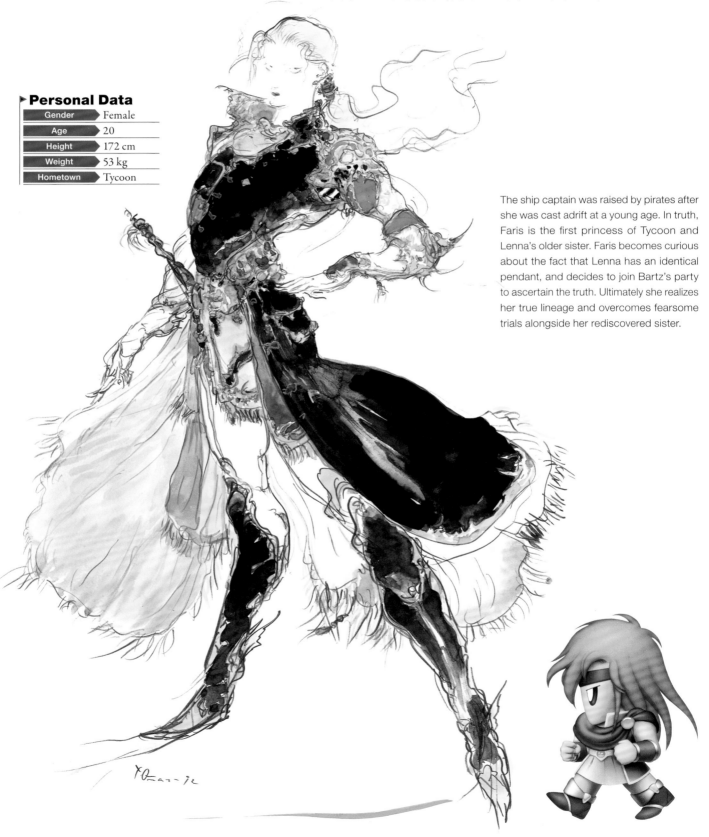

▶ Personal Data

Gender	Female
Age	20
Height	172 cm
Weight	53 kg
Hometown	Tycoon

The ship captain was raised by pirates after she was cast adrift at a young age. In truth, Faris is the first princess of Tycoon and Lenna's older sister. Faris becomes curious about the fact that Lenna has an identical pendant, and decides to join Bartz's party to ascertain the truth. Ultimately she realizes her true lineage and overcomes fearsome trials alongside her rediscovered sister.

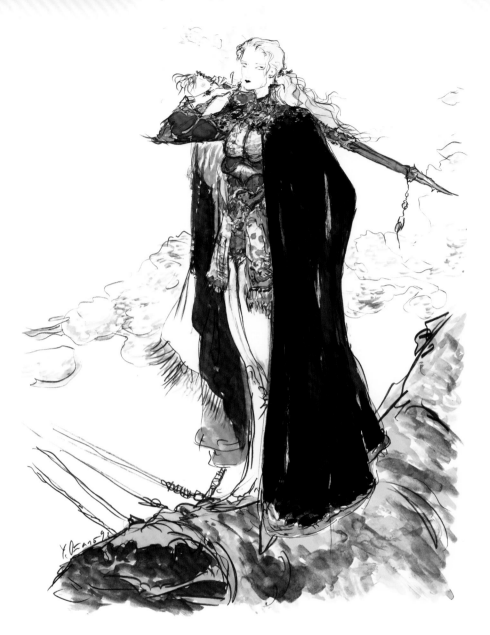

Memorable **Quotes**

FARIS

"Oho, the princess of Tycoon, here on my ship? I'm sure we could fetch a good price for this one."

—On the pirate ship, capturing Lenna's group in the act of stealing her ship.

After learning the identity of the girl who snuck aboard her ship, Faris has a little fun at the princess's expense. At the time, Faris had no idea that she and Lenna shared the same bloodline.

"I'm just not cut out for being a princess, I'm afraid."

—Leaving the castle and following Bartz's group through Death Valley.

Although Faris returned to Castle Tycoon as its first princess, she escaped the castle to rejoin Bartz's party. A life of royalty proved to be a poor fit for a veteran pirate captain.

"Beautiful, isn't she? Syldra and I were raised together. We're close as siblings."

—On the pirate ship, introducing the ship-pulling sea dragon called Syldra.

When asked by Lenna how a sailing ship can move without wind, Faris introduces Syldra. Faris brags about how Syldra can tow the pirate ship anywhere she wishes.

"Besides, a buccaneer like me, really a prince—er, princess? 'Tis a bit much, that!"

—In Castle Tycoon, laughing off Lenna when she calls her "sister."

Although she already suspected that she might be a princess, Faris had a hard time accepting the truth. Even after Lenna explains it to her on the castle terrace, Faris feigns ignorance and flees to the wilds.

JOB APPEARANCES

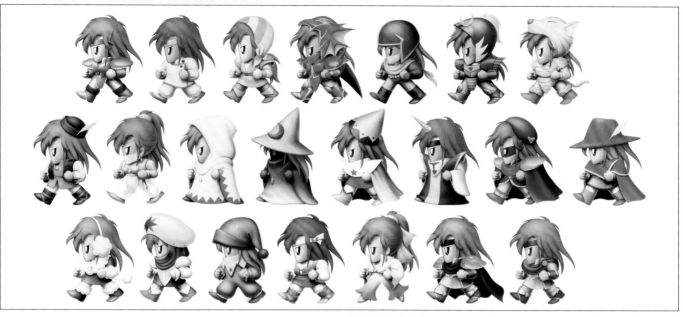

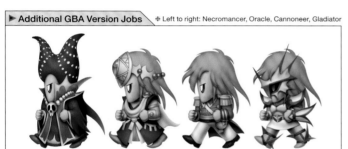

▶ Additional GBA Version Jobs ‡ Left to right: Necromancer, Oracle, Cannoneer, Gladiator

First row: Knight, Monk, Thief, Dragoon, Ninja, Samurai, Berserker
Second row: Ranger, Mystic Knight, White Mage, Black Mage, Time Mage, Summoner, Blue Mage, Red Mage
Third row: Beastmaster, Chemist, Geomancer, Bard, Dancer, Mime, Freelancer

Farewell to Syldra

The sea dragon Syldra, who had gone missing in Torna Canal, returns to save Faris and her friends from the sunken Walse Tower. Although suffering from fatal wounds, Syldra carries the four to the surface before disappearing beneath the waves with a final cry.

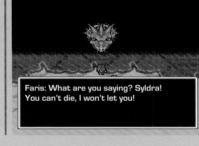

Faris: What are you saying? Syldra! You can't die, I won't let you!

Sleeping Beauty

Faris strikes off on her own in the village of Tule, deciding to take a nap on the inn's second floor. Bartz and Galuf check on her, and are taken aback by how beautiful she looks in her slumber.

Memorable Scenes

▶ FARIS

Sarisa: Hi-hi Lenna... Tomorrow, me 'n Papa're gonna ride the wind drake.

Royal Remembrance

In her bedroom, Faris recalls the last time she was in the castle. She had been instructed to put Lenna to bed, but Princess Sarisa was tired from her studies and fell asleep alongside her sister.

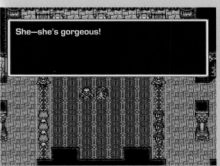

She—she's gorgeous!

Dressed to Depress

When she returns to Castle Tycoon, Faris is treated like a princess. The strange finery embarrasses her, but Bartz blushes when he sees her beauty.

Krile

Hopeful young girl,
inheriting her grandfather's determination.

クルル
[Kururu/Krile]

▶ *Krile Mayer Baldesion*　クルル・マイア・バルデシオン

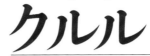

▶ **Personal Data**

Gender	Female
Age	14
Height	154 cm
Weight	40 kg
Hometown	Bal

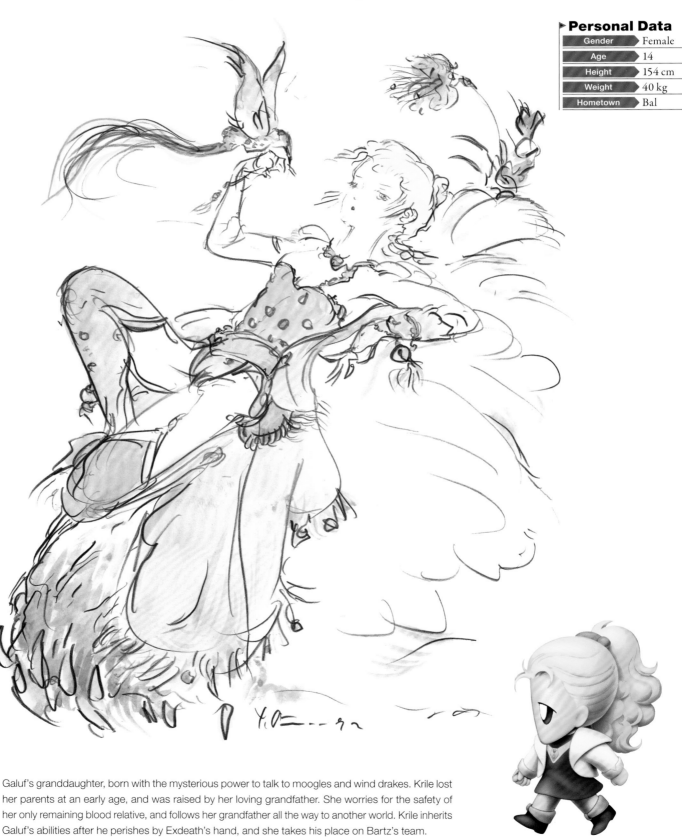

Galuf's granddaughter, born with the mysterious power to talk to moogles and wind drakes. Krile lost her parents at an early age, and was raised by her loving grandfather. She worries for the safety of her only remaining blood relative, and follows her grandfather all the way to another world. Krile inherits Galuf's abilities after he perishes by Exdeath's hand, and she takes his place on Bartz's team.

JOB APPEARANCES

First row: Knight, Monk, Thief, Dragoon, Ninja, Samurai, Berserker
Second row: Ranger, Mystic Knight, White Mage, Black Mage, Time Mage, Summoner, Blue Mage, Red Mage
Third row: Beastmaster, Chemist, Geomancer, Bard, Dancer, Mime, Freelancer

▶ **Additional GBA Version Jobs** ‡ Left to right: Necromancer, Oracle, Cannoneer, Gladiator

Memorable **Quotes**

▶ KRILE

"Ow! Take this!"
—In Castle Tycoon, when shoved by Bartz for teasing him.

Throughout their long journey, Krile grows to view the other members of the party as her brothers and sisters. Among such trusted friends, she feels comfortable telling a scathing joke and even roughhousing.

"Grandpa . . . it's warm . . . Grandpa— I feel you with me . . ."
—Inheriting Galuf's will in the Great Forest of Moore.

Krile feels her grandfather's spirit within her, and reflects on her strong bond with him. Although Galuf sacrifices his life against Exdeath, his fighting spirit lives on through Krile.

"Mid . . . Take good care of your grandpa."
—At the Catapult, to Mid, after he finishes remodeling the airship.

Krile empathizes with Mid, whose relationship with Cid reminds her of the bond she shared with her own grandfather. Having lost Galuf, she wants Mid to watch over Cid, lest he suffer a similar loss.

Making a Grand Entrance
Krile enters the Ronka Ruins on a meteorite, destroying the wall and smashing her way into the Crystal Room. She stuns the crazed King Tycoon by unleashing a "little strike of Thunder," which is enough to save Galuf and the other heroes.

Guided by the Moogles
Using telepathy, Krile learns from the moogles that Galuf and her friends have arrived in their village. The moogles teach her the village's location, and Krile and her grandfather reunite.

Krile: GRANDPA!!!
No! No! You can't leave me, you can't die!!!

Goodbye, Beloved Grandfather
Krile enters the Great Forest of Moore to rescue Galuf, but instead finds herself chased down by Exdeath. Her grandfather protects Krile, dying in the process. A shocked Krile is unable to do anything but cry.

▶ KRILE

Memorable **Scenes**

King Tycoon
(Alexander Highwind Tycoon)

タイクーン王 [Taikūn-ō]

Father to Lenna and Faris, and protector of the world's order. King Tycoon left his castle to investigate an unusual phenomenon at the Wind Shrine, but becomes a puppet of the evil Exdeath. He regains his sanity when the Earth Crystal is destroyed, and sacrifices himself to save his daughters and their companions from Exdeath's Dark Magic.

Memorable Quote

"Sarisa . . . Forgive me . . . I wasn't . . . much of a father . . . Lenna . . . Sarisa . . . Please, stay together . . . Become each other's strength . . . Bartz . . . take care of them . . . as I cannot . . ."

—Offering up his dying wish in the Ronka Ruins.

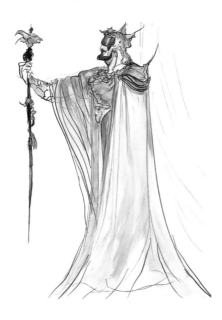

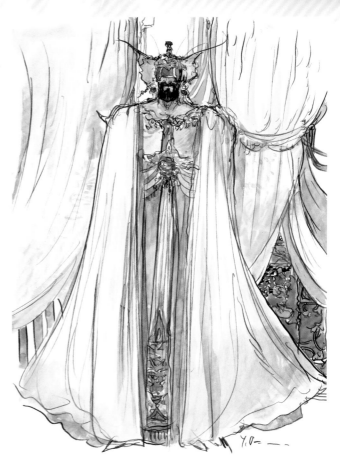

Dorgann
(Dorgann Klauser)

ドルガン [Dorugan]

▶ **Personal Data**

Gender	Male	Weight	59 kg
Height	170 cm	Hometown	Regole
Age	51 (deceased)		

One of the old Warriors of Dawn, and Bartz's father. Thirty years ago, Dorgann felt guilty over his part in sealing Exdeath away in another world. He decided to remain in this strange new land to watch over the seal. After the death of his wife Stella, Dorgann traveled the land with his young son Bartz. Three years ago he collapsed from sickness, and passed away forever.

Memorable Quote

"Stella—if anything should happen to me, never tell Bartz about the crystals . . . They aren't his burden to bear."

—During Bartz's flashback, when he sees Dorgann plead with his wife Stella to hide the full truth from their son.

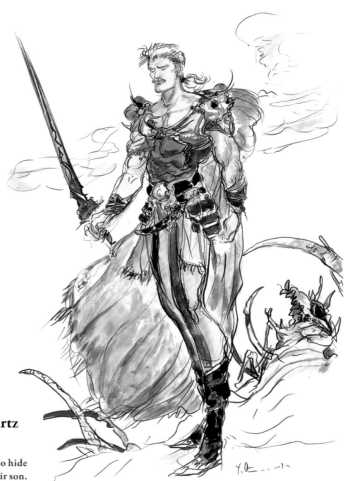

Kelger
(Kelger Vlondett)

ケルガー [Kerugā]

▶ Personal Data

Gender	Male	Weight	52 kg
Height	174 cm	Hometown	Quelb
Age	63		

The leader who unites the werewolf clan, Kelger is one of the Warriors of Dawn. He crosses swords with Bartz, believing that the warrior is an agent of Exdeath. He expends his power to destroy the illusion at Castle Exdeath, joining the rest of his fallen comrades.

Memorable **Quote**

"Son of Dorgann, anything you ask of me shall be done!"

—In Quelb, vowing to support Bartz, the son of his old war buddy.

Memorable **Scene**

Godspeed Skill: Lupine Attack

Hearing that the boy came from another world is enough to convince Kelger that Bartz works for Exdeath, and he demands a showdown. Although Kelger's Lupine Attack utilizes his natural speed, Bartz relies on a technique taught to him by his father. When the wolf man realizes that Bartz is the son of his friend, he swears to assist his new comrades.

Kelger: Hah! Let's see how you handle my lupine attack!!!

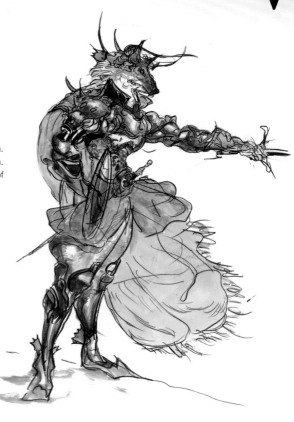

Xezat
(Xezat Matias Surgate)

ゼザ [Zeza]

▶ Personal Data

Gender	Male	Weight	69 kg
Height	177 cm	Hometown	Surgate
Age	58		

One of the Warriors of Dawn, his cool demeanor earned him the nickname "Xezat of Ice." Xezat is the king of Surgate, and stands on the front lines to lead his forces against Exdeath. After infiltrating the Barrier Tower from the ocean, Xezat helps bring down the tower but perishes when it explodes.

Memorable **Quote**

"Galuf . . . and Bartz, Lenna, Faris . . . The rest is up to you. Don't worry . . . I'll always be with you when you need me . . ."

—Xezat's last words as the explosion engulfs him in the Barrier Tower.

Memorable **Scene**

Leave It to the Next Generation

Although the heroes destroy the antenna inside the Barrier Tower, Xezat is trapped underground while halting the generator. Xezat did his duty, despite knowing that he would not be able to escape the generator room. He dies with honor, handing over the fight against Exdeath to the new warriors chosen by the crystals.

Xezat: Of course I knew... This was my plan, how could I not?

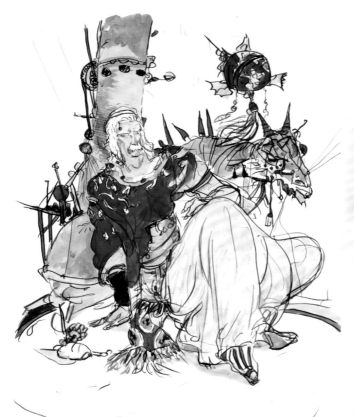

 # Cid (Cid Previa)

シド [Shido]

A genius engineer who invented the technology needed to bolster and exploit the power of the crystals. Cid felt deep regret over the fact that his inventions weakened the crystals until they shattered, but he gets back on his feet through the encouragement of his grandson, Mid. Cid helps out the heroes by making improvements to their airship.

Memorable **Quote**

"Nothing's impossible for me!"

—At the Catapult, vowing that he will convert the airship into a submarine.

 # Mid (Mid Previa)

ミド [Mido]

Cid's bookworm of a grandson. Mid was so immersed in the books found at the Library of the Ancients that he failed to notice that Bartz's party was fighting monsters right behind him. Mid and his grandfather provide essential technical support for the Warriors of Light.

Memorable **Quote**

"You always told me not to be afraid of failing . . . That if you messed up, you just had to start over and try again . . . What happened to that?!"

—In Cur Nakk, scolding the despondent Cid.

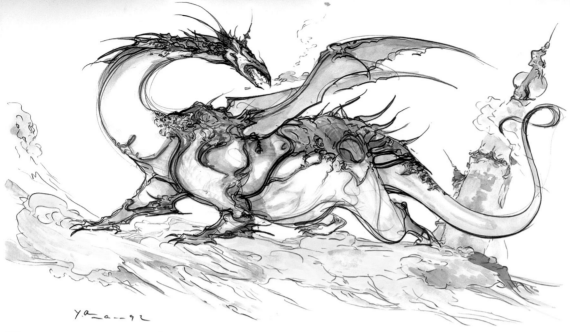

Wind Drakes

飛竜 [Hiryū]

Friendly dragons that spread their wings and soar through the skies. There is only one wind drake in each world—Castle Tycoon for the first, and Bal Castle for the second. The species is close to extinction in both worlds.

Syldra

シルドラ [Shirudora]

A sea dragon that grew up alongside Faris. She towed Faris's pirate ship until it fell under attack in Torna Canal, when she disappeared. Syldra survived and mustered up her remaining strength to rescue Faris and her friends from the submerged Walse Tower.

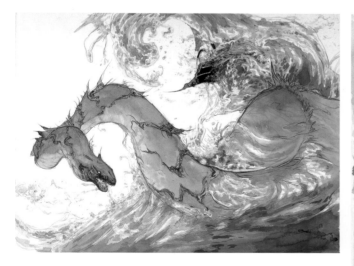

Memorable Scene

Always with Her Friend

When the two worlds merge, Faris seeks out the pirates' hideout. There, she is overjoyed to see her deceased friend once more. But this is merely the soul of Syldra, a presence that only Faris and Krile can detect. Wishing to help even after death, Syldra gives her power to Faris and makes herself available as a summonable magic creature.

Krile: Syldra's spirit says she wants to help Faris...

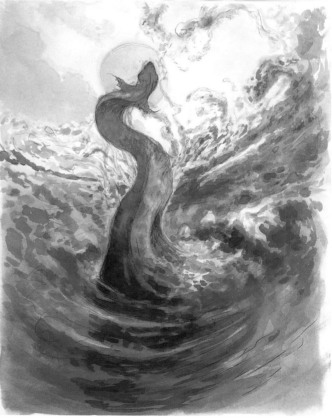

Ghido
ギード [Gīdo]

A wise turtle sage over seven hundred years old. Ghido lends his wisdom to Bartz's party in their fight against Exdeath, and attracts the warlock's wrath. After Exdeath seizes control of the Void, Ghido is swallowed up by the nothingness.

Memorable *Quote*

"You think I sat around seven centuries munching on pizza?"

—Facing down Exdeath in Ghido's Cave.

Memorable *Scene*

Strength of Seven Centuries
Based on his appearance, most would not imagine that Ghido possesses much battle prowess, yet he fights Exdeath with a speed too fast for the human eye to follow. Even Exdeath is taken aback, and screams in rage at his opponent's skill.

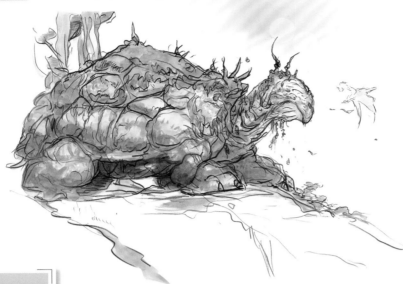

Exdeath: Turtle!

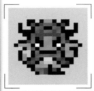

Gilgamesh
ギルガメッシュ [Girugamesshu]

The captain of Exdeath's guard, who serves his master alongside his monster companion Enkidu. Gilgamesh has enough strength to topple the forces guarding Bal Castle, but he finds arbitrary excuses to flee whenever battles aren't going his way. Each time that Gilgamesh crosses swords with Bartz's party, he grows increasingly fond of the heroes.

Memorable *Quotes*

"I suppose I misjudged! Fighting all four of you . . . Is just too tough for me . . . Not! Ha, I lied! Like a rug! Oh, I kill me!"

—Pretending to show surrender in the middle of a battle on the Big Bridge.

"Ehhh?! Why, I've been had! This is far from the strongest of swords! I feel so betrayed!"

—In Castle Exdeath, flabbergasted by the sword Excalipoor's power, or lack thereof.

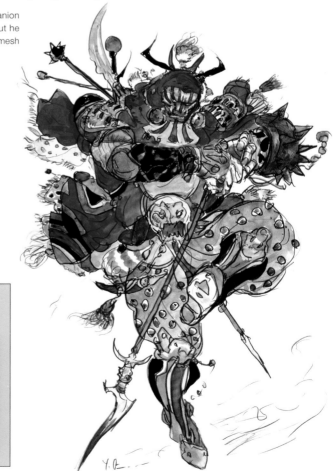

Memorable *Scene*

His Enemy's Protector
Gilgamesh so angers Exdeath that the villain banishes him to another dimension. There, he meets the heroes as they head into their final confrontation. Gilgamesh talks to the party like they're old friends, confirming his affection before he faces the powerful Necrophobe threatening the warriors. After offering each member of the group a few parting words, Gilgamesh sacrifices himself to protect his "comrades."

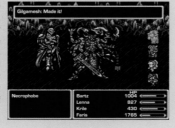

Gilgamesh: Made it!

Necrophobe

	HP
Bartz	1004
Lenna	827
Krile	430
Faris	1765

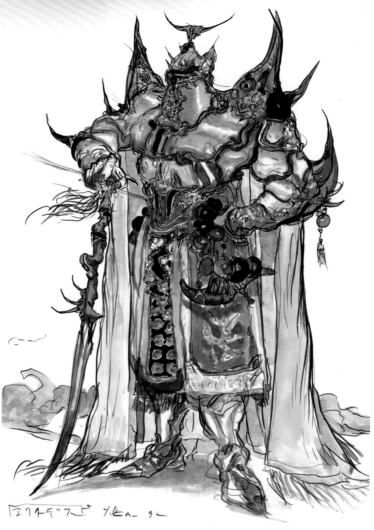

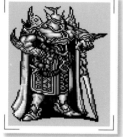
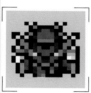

Exdeath

エクスデス [Ekusudesu]

A warlock born from evil spirits that inhabited a mighty tree inside the Great Forest of Moore. Thirty years ago, the Warriors of Dawn sealed Exdeath in Bartz's world. He is revived after the shattering of all four crystals. Exdeath reunites the two worlds that had been split a thousand years prior, in the process obtaining the power of the Void from the Interdimensional Rift between the twin realms.

Memorable **Quotes**

"Galuf. It's good to see you again . . . for it means I have returned! Mwa-hahahahaha!"

—In the Ronka Ruins, reviving after a thirty-year absence.

"Fool! All the hatred in existence would never be enough to defeat me!"

—In the Great Forest of Moore, panicking when facing a seemingly unbeatable Galuf.

"Nooo! Why?! The Void was mine to command! How could it—uwaaah!!!"

—In the Interdimensional Rift, when swallowed by the power of nothingness he thought he could control.

▶ Unused Design

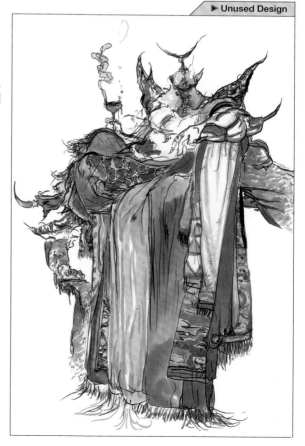

FINAL FANTASY V
ファイナルファンタジーV

WORLD

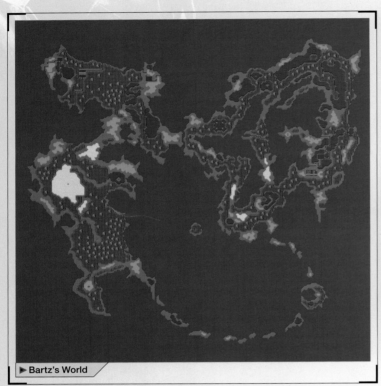

▶ Bartz's World

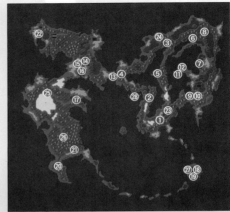

❶	Tycoon Meteorite	⓫	Walse Tower	㉑	Jachol Cave	
❷	Pirates' Hideout/	⓬	Walse Meteorite	㉒	Istory	
	Cave to Pirates'	⓭	Karnak Meteorite	㉓	Tycoon	
	Hideout	⓮	Cur Nakk	㉔	Lix	
❸	Wind Shrine	⓯	Karnak Castle	㉕	Desert of Shifting	
❹	Tule	⓰	Fire-Powered Ship		Sands	
❺	Torna Canal	⓱	Library of	㉖	Gohn, the Tower of	
❻	Ship Graveyard		the Ancients		Ruin/Ronka Ruins/	
❼	Carwen	⓲	Crescent		Gohn Meteorite	
❽	North Mountain	⓳	Black Chocobo	㉗	The Catapult	
❾	Castle Walse		Forest	㉘	Warp Point	
❿	Walse	⓴	Jachol			

▶ Galuf's World

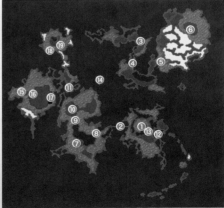

❶	Castle Exdeath	⓭	Barrier Tower	
❷	Big Bridge	⓮	Ghido's Cave	
❸	Regole	⓯	Moore	
❹	Sealed Castle of Kuza	⓰	Great Forest of Moore	
❺	Underground Waterway	⓱	Guardian Tree	
❻	Moogle Village	⓲	Sunken Cave	
❼	Bal Castle	⓳	Chocobo Forest	
❽	Ghido's Cave			
❾	Quelb			
❿	Drakenvale			
⓫	Surgate Castle			
⓬	Xezat's Fleet			

There are three worlds in total, in which the first two worlds are made from split fragments of the third. As the story progresses, the first two worlds fuse to restore the third back to its original shape. Putting the first two maps on top of one another reveals the general contours of the third map.

▶ Exdeath's World

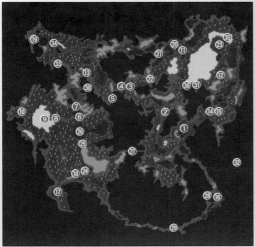

1. Tycoon/ Interdimensional Rift
2. Pirates' Hideout/ Cave to Pirates' Hideout
3. Tule
4. Death Valley
5. Ghido's Cave
6. Library of the Ancients
7. Surgate Castle
8. Guardian Tree
9. Pyramid of Moore
10. Moore
11. Wind Shrine
12. Carwen
13. Cur Nakk
14. Castle Walse (✳)

15. Walse (✳)
16. Crescent
17. Jachol
18. Jachol Cave
19. Istory (✳)
20. Lix (✳)
21. Regole
22. Sealed Castle of Kuza
23. Moogle Village (✳)
24. Bal Castle
25. Quelb
26. Drakenvale
27. Island Shrine
28. Fork Tower/Catapult
29. Phantom Village
30. Sealed Temple

31. Sunken Walse Tower
32. Great Sea Trench
33. Sunken Cave
34. Istory Falls
35. North Mountain
36. Phoenix Tower

✳ Cannot visit

MONSTERS

Karlabos

カーラボス [Karabosu]

Siren

セイレーン [Seirēn]

Magissa

マギサ [Magisa]

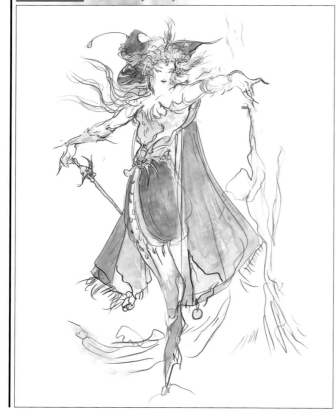

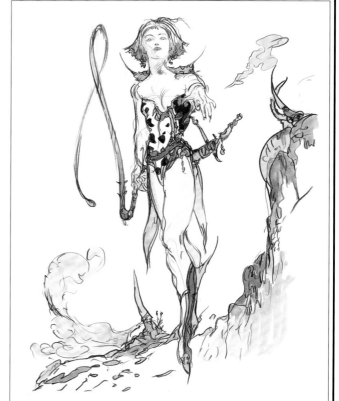

Forza
フォルツァ [Forutsu~a]

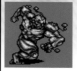

Byblos
ビブロス [Biburosu]

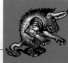

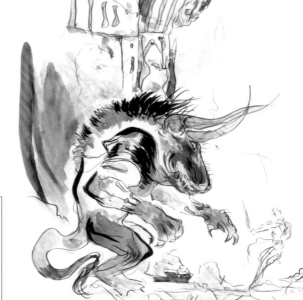

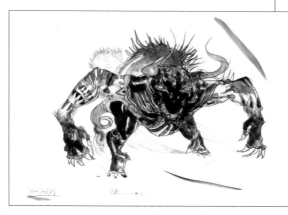

Soul Cannon
ソル カノン [Soru Kanon]

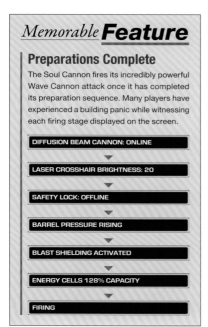

Memorable **Feature**

Preparations Complete

The Soul Cannon fires its incredibly powerful Wave Cannon attack once it has completed its preparation sequence. Many players have experienced a building panic while witnessing each firing stage displayed on the screen.

- DIFFUSION BEAM CANNON: ONLINE
 ▼
- LASER CROSSHAIR BRIGHTNESS: 20
 ▼
- SAFETY LOCK: OFFLINE
 ▼
- BARREL PRESSURE RISING
 ▼
- BLAST SHIELDING ACTIVATED
 ▼
- ENERGY CELLS 128% CAPACITY
 ▼
- FIRING

Atomos
アトモス [Atomosu]

Wendigo
ストーカー [Sutōkā]

Melusine
メリュジーヌ [Meryujīnu]

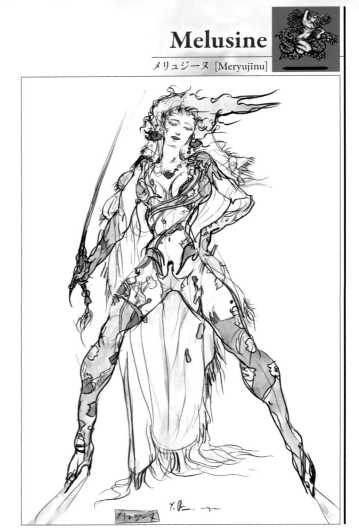

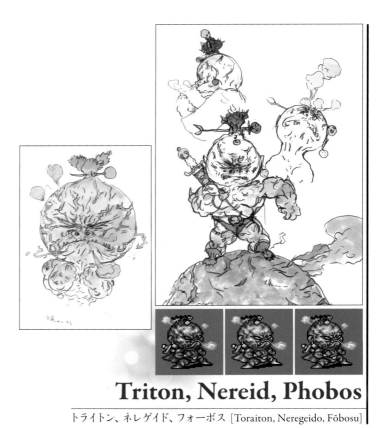

Triton, Nereid, Phobos
トライトン、ネレゲイド、フォーボス [Toraiton, Neregeido, Fōbosu]

232

Famed Mimic Gogo

ものまねし ゴゴ [Mono Maneshi Gogo]

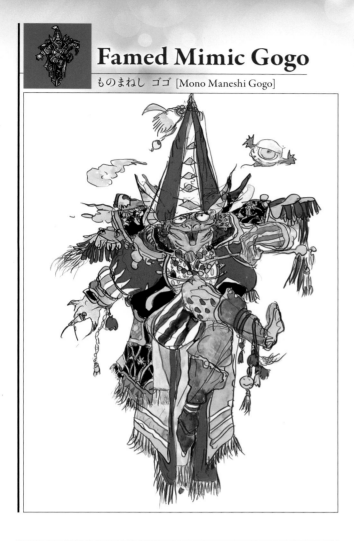

Memorable Feature

The Secret of Mimicry

Famed Mimic Gogo gives the player critical advice at the start of battle: "Could you imitate me, you'd certainly win." Gogo does nothing, so if the player follows suit and refrains from attacking, Gogo will recognize this mastery of his technique and surrender. On the other hand, if the player attacks without heeding his advice, they will suffer an onslaught of Meteor for their trouble.

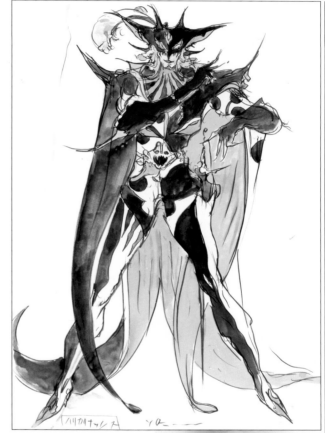

Halicarnassus

ハリカルナッソス [Harikarunassosu]

Twintania

ツインタニア [Tsuintania]

Memorable Feature

Powering Up for Gigaflare

Twintania's greatest ability is Gigaflare, a spell even stronger than Bahamut's Megaflare. Even so, Twintania is completely defenseless while powering up its attack, so hitting it with instant kill or petrify effects will quickly end the fight.

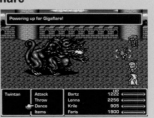

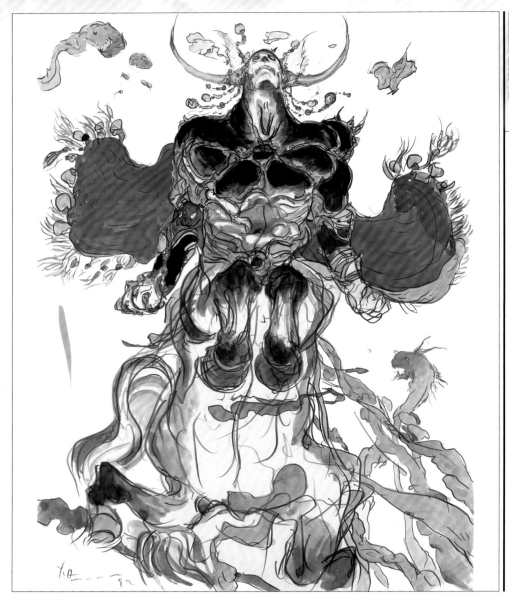

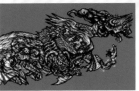

Neo Exdeath
ネオエクスデス [Neoekusudesu]

Memorable **Feature**

The Space-Warping Master of All Dimensions

Neo Exdeath wields the terrifyingly powerful spell Almagest, as well as the Grand Cross attack, which deals random status effects to the party members. Neo Exdeath boasts, "The laws of the universe mean nothing!" This heralds the coming of a devastating attack, and is one of the most memorable lines in *Final Fantasy V*.

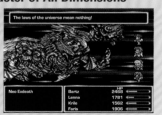

The laws of the universe mean nothing!

		HP
Neo Exdeath	Bartz	2468
	Lenna	1781
	Krile	1562
	Faris	1906

Enuo
エヌオー [Enuō]

A warlock who obtained the power of the Void a thousand years prior. This illustration was produced by Tetsuya Nomura for the GBA version, and the shoulders include elements used in Exdeath's design.

TETSUYA NOMURA MONSTER DESIGNS

Many monsters from *Final Fantasy V* use sprites that were based on Tetsuya Nomura's designs. Some of the monsters seen here did not end up appearing in *FFV*, and made their way into *Final Fantasy VI* instead.

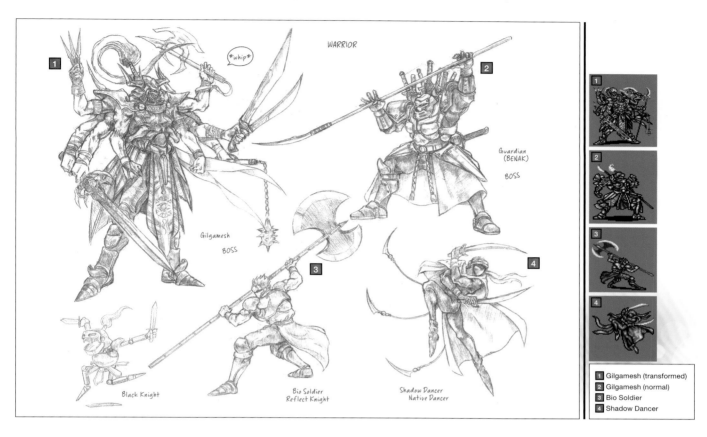

1

2 WARRIOR

whip

Guardian (BENAK) BOSS

Gilgamesh BOSS

3

4

Black Knight

Bio Soldier Reflect Knight

Shadow Dancer Native Dancer

1 Gilgamesh (transformed)
2 Gilgamesh (normal)
3 Bio Soldier
4 Shadow Dancer

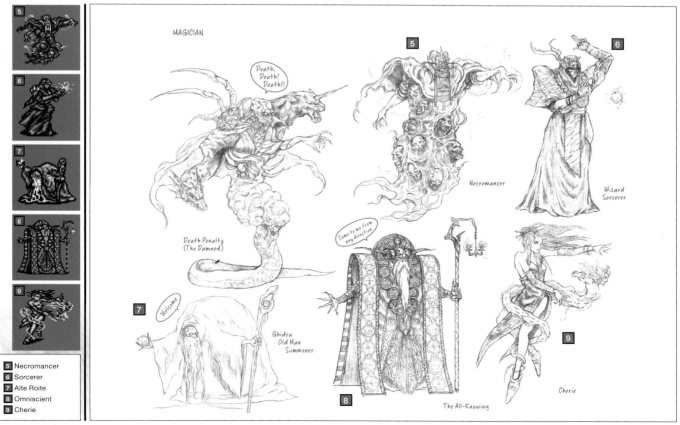

MAGICIAN

5

6

Death, Death! Death!!

Necromancer

Wizard Sorcerer

Death Penalty (The Damned)

Come to me from any direction

7 Welcome

Ghidra Old Man Summoner

8 The All-Knowing

9 Cherie

5 Necromancer
6 Sorcerer
7 Alte Roite
8 Omniscient
9 Cherie

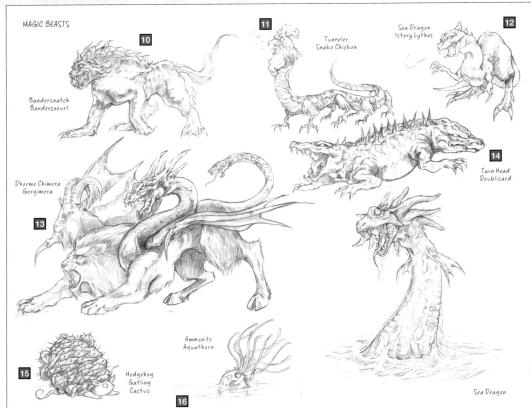

MAGIC BEASTS

10

Bandersnatch
Bandercoeurl

11
Tunneler
Snake Chicken

Sea Dragon
Istory Lythos

12

Dhorme Chimera
Gorgimera

13

14
Twin Head
Doublizard

15
Hedgehog
Gatling Cactus

Ammonite
Aquathorn

16

Sea Dragon

10 Bandersnatch
11 Litwor Chicken (*FFVI*)
12 Fafnir (*FFVI*)
13 Dhorme Chimera
14 Doublizard
15 Gatling
16 Aquathorn

17 Numb Blade
18 Ninja

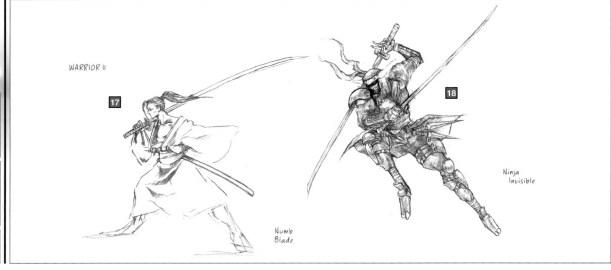

WARRIOR II

17

18

Ninja
Invisible

Numb
Blade

19 Lamia
20 Minotaur

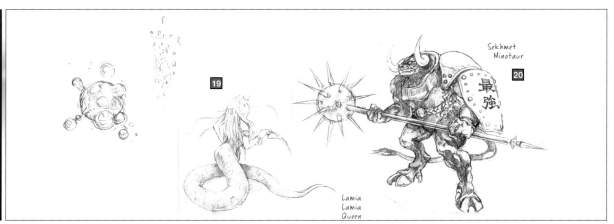

Sekhmet
Minotaur

20

19

最強

Lamia
Lamia
Queen

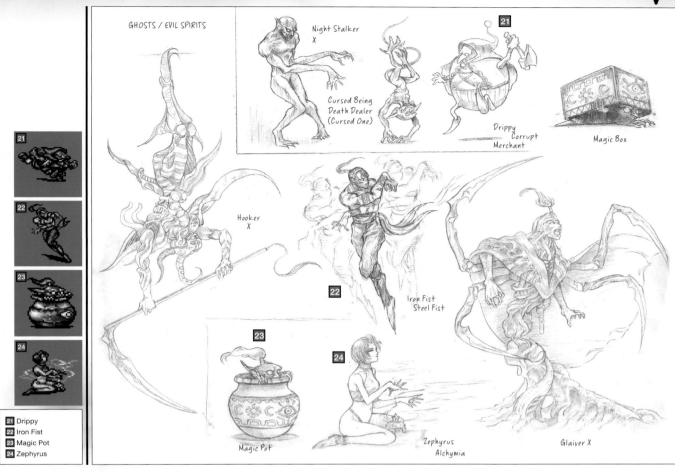

GHOSTS / EVIL SPIRITS

Night Stalker
X

Cursed Being
Death Dealer
(Cursed One)

21

Drippy
Corrupt
Merchant

Magic Box

Hooker
X

Iron Fist
Steel Fist

22

23

24

Magic Pot

Zephyrus
Alchymia

Glaiver X

21 Drippy
22 Iron Fist
23 Magic Pot
24 Zephyrus

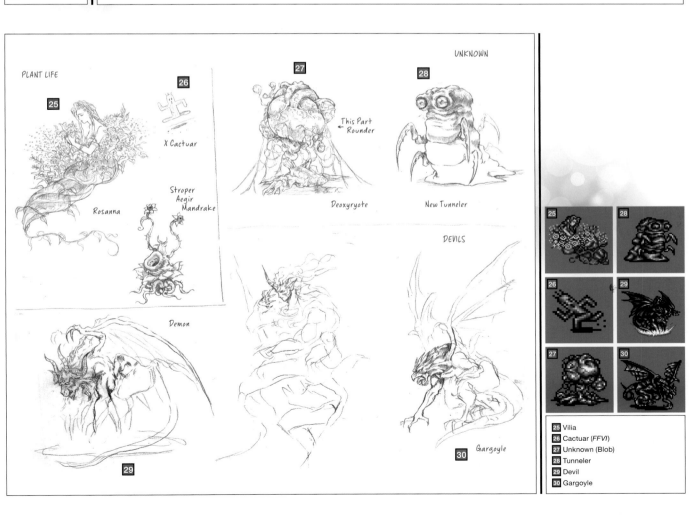

PLANT LIFE

UNKNOWN

26

27

28

X Cactuar

This Part
← Rounder

25

Stroper
Aegir
Mandrake

Rosanna

Deoxyryote

New Tunneler

DEVILS

Demon

30

Gargoyle

29

25 Vilia
26 Cactuar (FFVI)
27 Unknown (Blob)
28 Tunneler
29 Devil
30 Gargoyle

237

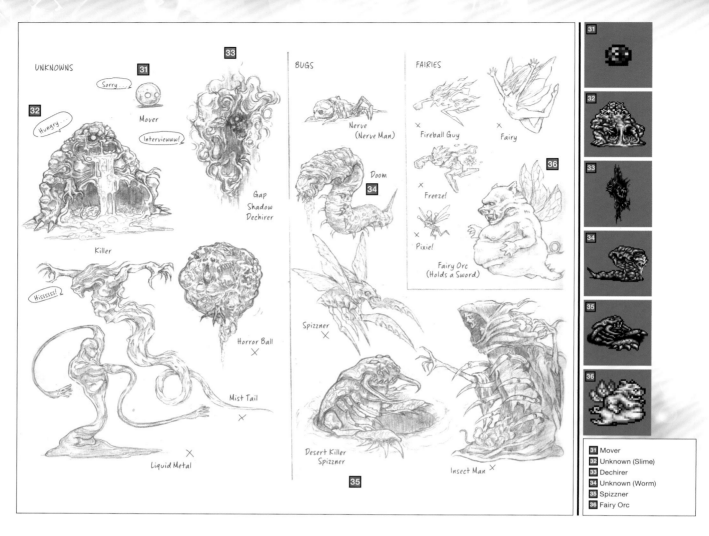

UNKNOWNS

31 Mover

Sorry...

Hungry...

Interviewwww!

32

Gap Shadow Dechirer

33

Killer

Hissssss!

Horror Ball ✕

Mist Tail ✕

Liquid Metal ✕

BUGS

Nerve (Nerve Man)

Doom

34

Spizzner ✕

35

Desert Killer Spizzner

Insect Man ✕

FAIRIES

Fireball Guy ✕

Fairy

Freeze! ✕

Pixie! ✕

36

Fairy Orc (Holds a Sword)

31 Mover
32 Unknown (Slime)
33 Dechirer
34 Unknown (Worm)
35 Spizzner
36 Fairy Orc

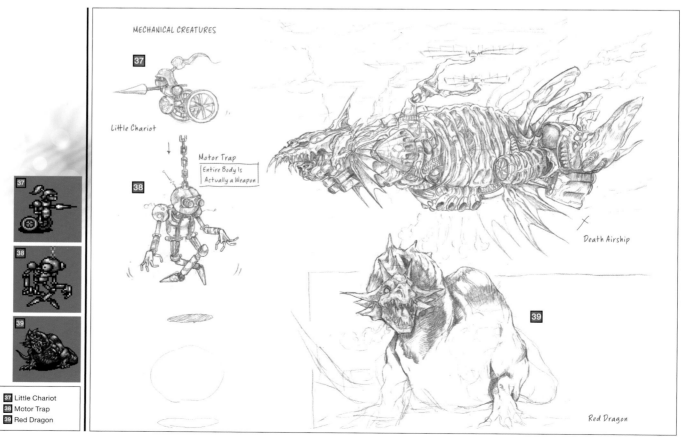

MECHANICAL CREATURES

37

Little Chariot

38

Motor Trap
Entire Body Is Actually a Weapon

Death Airship ✕

39

Red Dragon

37 Little Chariot
38 Motor Trap
39 Red Dragon

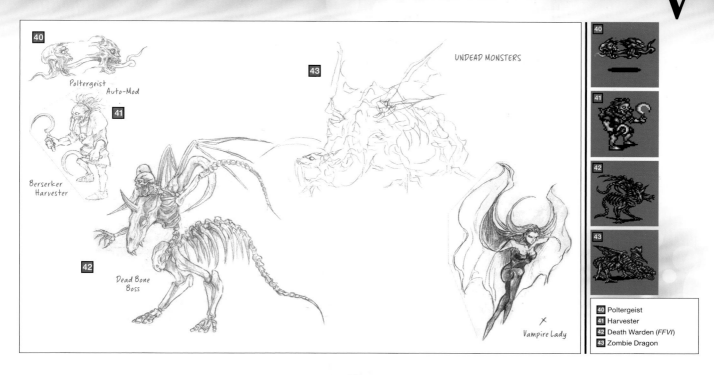

Poltergeist
Auto-Mod

Berserker
Harvester

41

42

Dead Bone
Boss

43

UNDEAD MONSTERS

Vampire Lady

40 Poltergeist
41 Harvester
42 Death Warden (*FFVI*)
43 Zombie Dragon

Neo Exdeath (Sprite Rough Sketch)

ネオエクスデス [Neoekusudesu]

A rough sketch drawn by Tetsuya Nomura for the in-game sprite. The top half is based off of a Yoshitaka Amano picture, and the bottom half is a mass of countless monsters.

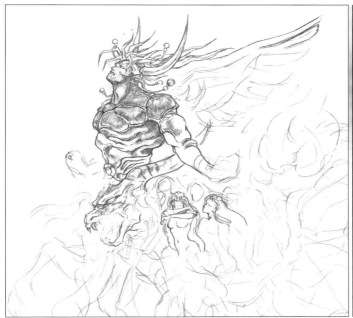

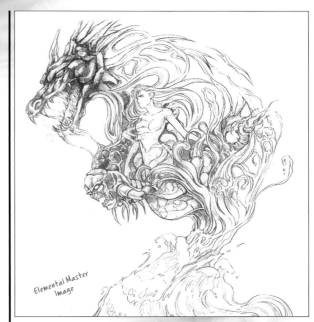

Elemental Master
Image

Elemental Master
(Melusine Prototype Image Illustration)

エレメンタルマスター [Erementarumasutā]

"Elemental Master" refers to Melusine (see Yoshitaka Amano's design order list on page 253). This illustration differs greatly from Melusine's actual sprite, but both designs use a gorgeous woman for the monster's face.

Shinryu (Sprite Rough Sketch)

しんりゅう [Shin ryū]

An illustration based off of Shinryu's sprite. Attention is focused on the neck up, and the creature's mane and head spikes are reproduced in-game.

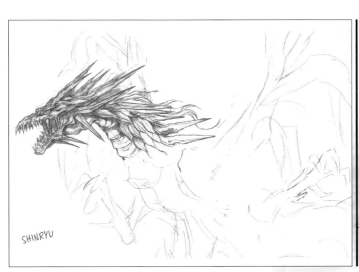

SHINRYU

EXTRA CONTENT

CHARACTER ILLUSTRATIONS

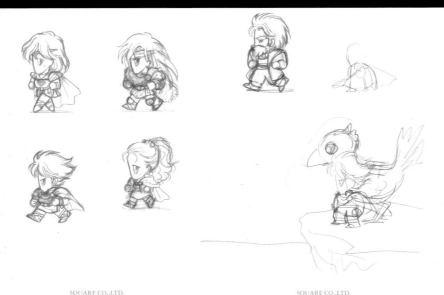

Protagonist Rough Sketches

Rough sketches acting as a base for the job illustrations. These contain small differences from the final designs, including everyone but Galuf wearing some type of cape. The rough sketch for the package illustration (see next page) had already been completed by this time.

► Rough Sketches ①

SQUARE CO.,LTD. SQUARE CO.,LTD.

► Rough Sketches ②

BARTZ

LENNA

FARIS

KRILE

GALUF

Illustration of Bartz on a Chocobo

An illustration of Bartz and his chocobo. Its composition resembles that used on the package art, but the reins and baggage help convey a sense of wide-ranging adventure. The sketched, angled views seen in the margin suggest the final ending.

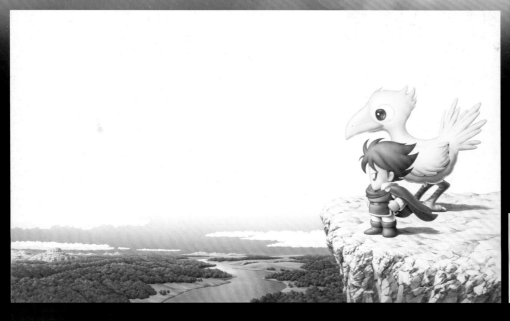

Package Illustration

One illustration used on the game's original Japanese packaging. The upper left side is left blank to allow for the later addition of the logo.

Mountable Creatures

Illustrations of the chocobo, black chocobo, and wind drake. The drafts were colored using colored pencils, and the finals were brushed-up versions of these sketches.

► Chocobo (Boko)

► Black Chocobo

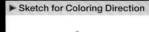

► Sketch for Coloring Direction

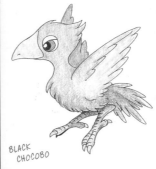

BLACK CHOCOBO

► Sketch

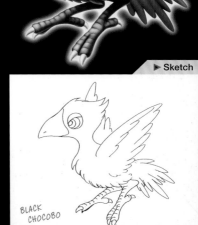

BLACK CHOCOBO

► Wind Drake

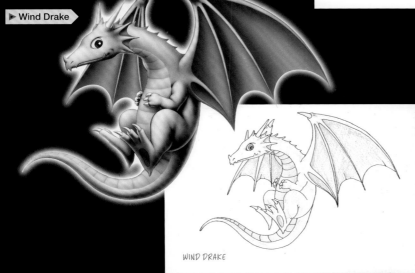

WIND DRAKE

► Sketch for Coloring Direction

WIND DRAKE

► Sketch

ORIGINAL JOB ILLUSTRATIONS

Character images for each job. All illustrations received minute tweaks before finalization.

Freelancer

Knight

Bartz is the only adventurer lacking headgear, but he shares the same headpiece as the others in the final design.

Monk

Bartz sports a headband in the final version. Krile's pants were later simplified, losing the slits on the hems.

Thief

Lenna's bandana is prominent in this illustration, but it became a patterned version like Faris's by the time the game shipped.

Dragoon

The series's legendary Dragon Knight class continues in this installment. Bartz's Dragoon design is exactly the same as Kain's from *Final Fantasy IV*.

Ninja

Bartz's pre-color design is very similar to the *Final Fantasy III* Ninja job class. The hair designs of characters do not change under most jobs, but Ninja Lenna wears her hair in a ponytail.

Samurai

Each Samurai character dons Japanese-style armor. The size and angle of the helmet's crescent moon shifts slightly from character to character.

Berserker

These designs incorporate wild beast motifs: wolves for the men, and wildcats for the women. Krile's costume is that of a stuffed animal.

Ranger

All characters have feathers sticking out of their caps and headbands. Each feather is a slightly different size for each character.

Mystic Knight

Arabian-style clothing. Faris's hair is done up in this design, but her actual sprite has the same style as her other jobs.

White Mage

The red, jagged design decorating the hems and sleeves of this white robe should be familiar to fans of the series. Krile's cat-ear hood is reminiscent of the Devout costume from *Final Fantasy III*.

Black Mage

The eyes sparkle in the darkness, much like the Black Mage designs from *Final Fantasy I* and *Final Fantasy III*. Bartz's design resembles the Magus from *FFIII*.

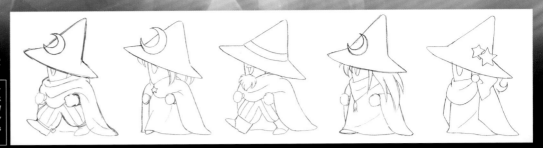

Time Mage

The trademark hat of the Time Mage sports a different pattern for each character. Bartz receives a plain version of this hat in his final design.

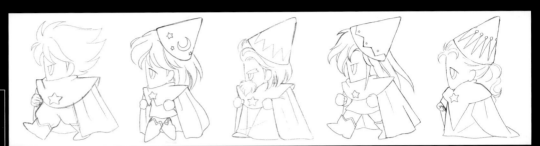

Summoner

The green robe, with shoulder pads and forehead horn, is shared among all characters. Only Krile has a short horn, which helps emphasize her youthfulness.

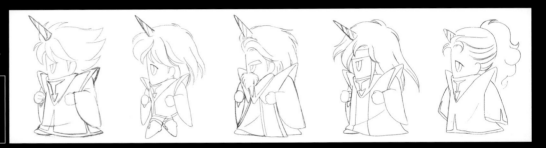

Blue Mage

Each character's eye mask is a different shape. These designs include details that are hard to see in sprite form.

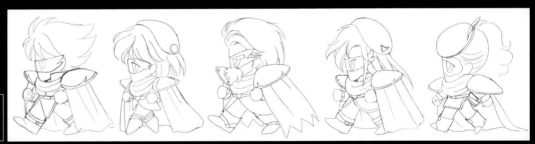

Red Mage

All of the characters have wide-brimmed hats, but only Bartz and Faris jauntily tip their brims forward.

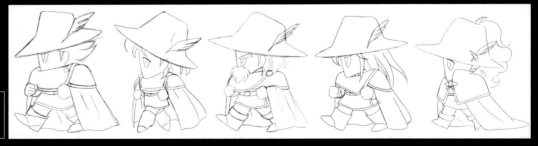

Beastmaster

The sheep-patterned clothes and skull-shaped chest mark appear on every character's version of this job costume. The tails, however, are exclusive to Faris and Krile.

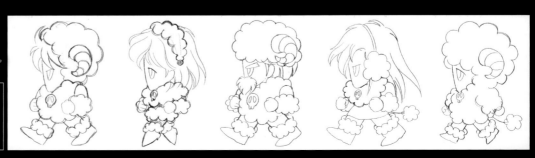

Chemist

This job costume includes a cloth that drapes from the back of the head to the mouth, crowned by a hat. Pants for the men and skirts for the women, though Lenna wears a slightly longer skirt.

Geomancer

These pajama-like garments are reminiscent of those in *Final Fantasy III*. While the *FFIII* version had a face resembling a Black Mage, here the face remains normal.

Bard

Lenna and Faris have similar hairbands in this illustration. In the final version, Lenna's hairband received a thinner strap.

Dancer

Each character wears clothes suitable for a different style of dancing. Faris's design included a version with a bandana, and another with a long dress.

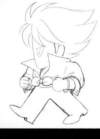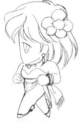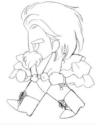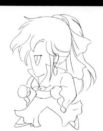

► Unused Dancer Faris Design

► Design Idea Rough Sketches

Mime

Each character's costume is almost identical to that worn by the Freelancer. The only differences are the additions of shoulder pads and a cape.

Colored Originals

These are colored pencil versions of the original illustrations from pages 242–245, including notes concerning major color schemes for creating the final versions.

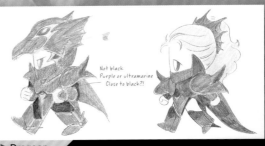

Not black
Purple or ultramarine
Close to black?!

▶ Dragoon

▶ Freelancer

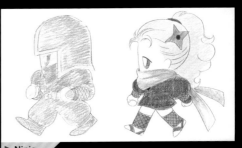

▶ Ninja

Clean red

▶ Knight

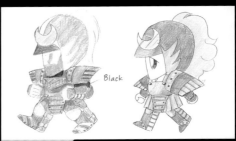

Black

▶ Samurai

*. Pant hem doesn't need decoration

▶ Monk

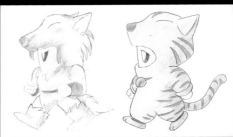

▶ Berserker

▶ Thief

▶ Ranger

Same color, gray-white

White-gray trim

▶ Mystic Knight

These are very close to the final in-game colors. The only difference is the inside of Bartz's cape, which was made red during a later stage.

Don't make too yellow

White

▶ White Mage

Gloves

Gradation

Gradation, hem is paler

▶ Black Mage

▶ Time Mage

▶ Summoner

▶ Blue Mage

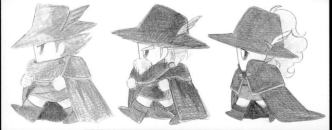

▶ Red Mage

Dark Gray

▶ Beastmaster

Front

More White

▶ Chemist

▶ Geomancer

▶ Bard

Deep red

White Flower

▶ Dancer

Shoulder
*Color is similar to Bartz's, but a little thinner.

Pastels

*Same clothes as Freelancer

Eye

Eye

▶ Mime

SPRITE JOB ILLUSTRATIONS

In-game sprites and the illustrations used as their bases. Some jobs are exactly the same as their early sketches, while other designs changed completely. Note that Galuf also had a Mimic sprite created for his character.

Drafts

Bartz

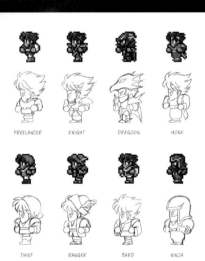
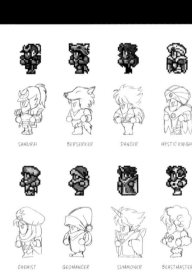
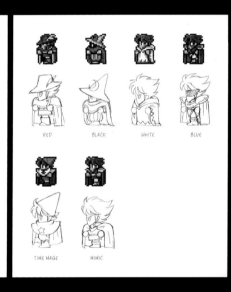

Lenna

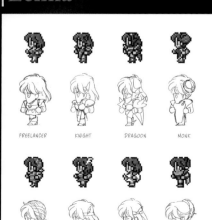
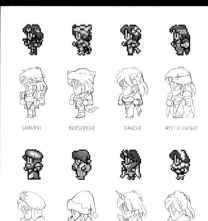
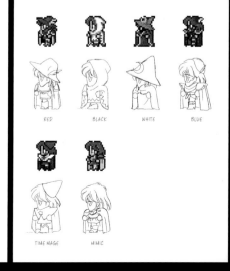

Galuf

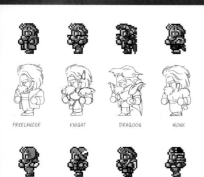
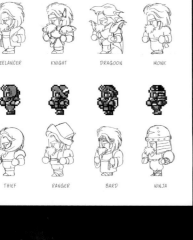
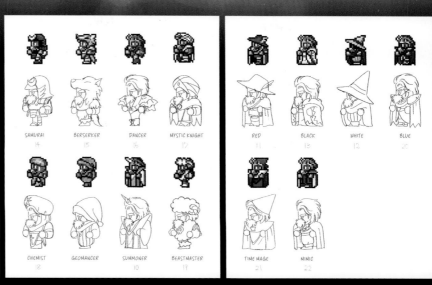

FREELANCER	KNIGHT	DRAGOON	MONK
THIEF	RANGER	BARD	NINJA

SAMURAI 14	BERSERKER 15	DANCER 16	MYSTIC KNIGHT 17
CHEMIST 18	GEOMANCER	SUMMONER 10	BEASTMASTER 19

RED 11	BLACK 13	WHITE 12	BLUE 20
TIME MAGE 21	MIMIC 22		

Faris

FREELANCER	KNIGHT	DRAGOON	MONK
THIEF	RANGER	BARD	NINJA

SAMURAI	BERSERKER	DANCER	MYSTIC KNIGHT
CHEMIST	GEOMANCER	SUMMONER	BEASTMASTER

RED	BLACK	WHITE	BLUE
TIME MAGE	MIMIC		

Krile

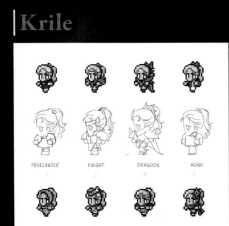
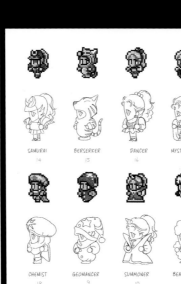
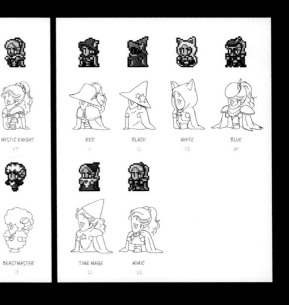

FREELANCER 1	KNIGHT 2	DRAGOON 3	MONK 4
THIEF 5	RANGER 7	BARD 6	NINJA 8

SAMURAI 14	BERSERKER 15	DANCER 16	MYSTIC KNIGHT 17
CHEMIST 18	GEOMANCER 9	SUMMONER 10	BEASTMASTER 19

RED 11	BLACK 12	WHITE 13	BLUE 20
TIME MAGE 21	MIMIC 22		

SPRITE MATERIALS

Field Sprites

Sprites used in the field, including people, objects, effects, and word balloons. Some of these sprites only appear once, such as Faris wearing a dress and the tied-up versions of Bartz, Lenna, and Galuf.

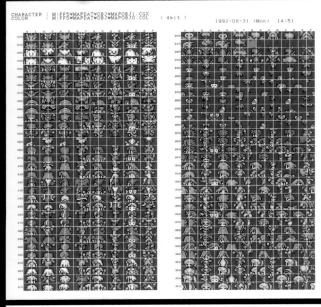

Wind Drake Animation Pattern

Sprite animation patterns used for the wind drakes. The patterns on the right are based on the list of movements seen here.

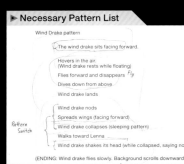

▶ **Necessary Pattern List**

Wind Drake pattern

The wind drake sits facing forward.

Hovers in the air.
(Wind drake rests while floating)
Flies forward and disappears *Fly*
Dives down from above
Wind drake lands

Wind drake nods
Spreads wings (facing forward)
Wind drake collapses (sleeping pattern)
Walks toward Lenna
Wind drake shakes its head (while collapsed, saying no)

(ENDING: Wind drake flies slowly. Background scrolls downward.)

In-Battle Sprite Specifications

Specification documents that detail the programming for sprites during battles. Notes at bottom right explain how characters' exterior appearances change during status ailments.

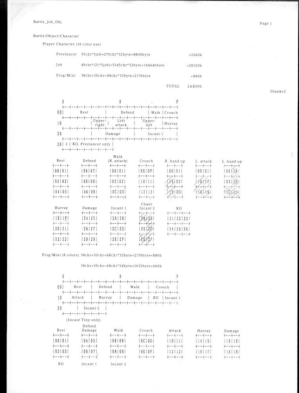

Battle Sprites (Bartz, Lenna, Faris)

All job sprites used for Bartz, Lenna, and Faris. The game's sprites continue the tradition of combining 8x8–pixel blocks in a 3x2 pattern.

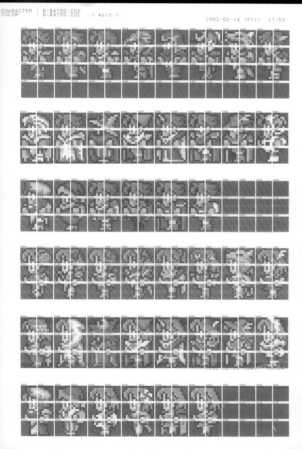

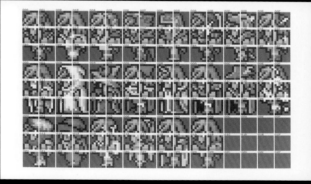

Summoned Monster Sprites

Summon sprites outputted for color tests. Odin's Gungnir design is different from the javelin he throws in-game.

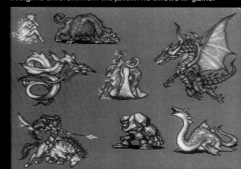

MISCELLANEOUS DEVELOPMENT

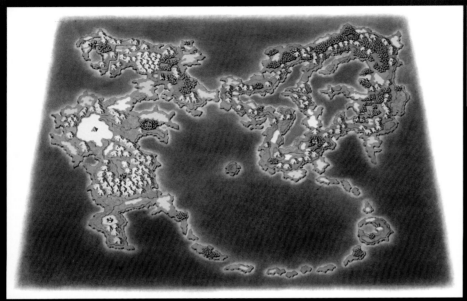

Publicity World Map

An illustration of the first world (the World of Balance). This image was publicized prior to the release of *Final Fantasy V* and also appears in the game manual.

Item Illustrations

Illustrations of items created for the strategy guide, released around the time of *Final Fantasy V*'s launch. Almost all equipment and consumable items have their own illustrations.

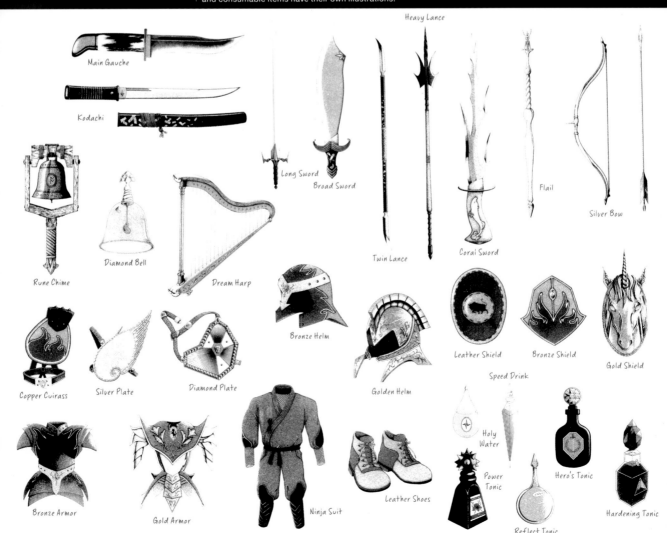

Yoshitaka Amano's Design Order List

A list of characters and monsters to be designed by Yoshitaka Amano. At this point, the sage Ghido was a tree instead of a turtle, and was going to be Exdeath's master. Kelger was set to appear as a lizard man before becoming a werewolf in the final version.

Yoshitaka Amano Order List

(1) Bartz — Protagonist. Nomad warrior riding a chocobo. Twenty years old. Traveled the world with his father from a young age. He lost his mother at birth, and his father at ten years old. He saves Lenna, princess of Tycoon, and gets caught up in an unexpected destiny.

(2) Lenna — Princess of Tycoon. Nineteen years old. Left the castle to search for her missing father, the king. Shoulder-length hair. Tomboy. Learned martial arts from her father, and her swordsmanship is superior to even the royal guard. Very nice on the inside. Never forgets to show kindness to the weak.

(3) Faris — Pirate captain. Twenty years old. Seems like a long-haired, nihilistic pretty boy, but is actually a woman in disguise. Lenna's big sister. She was separated from Lenna fifteen years ago during a storm, and was raised as a boy by pirates. The secrets of her birth help propel her into an incredible destiny.

(4) Galuf — Amnesiac warrior. Sixty years old. He acts like an old lecher, but is actually a warrior from another world. He rode a meteorite to this world to prevent the destruction of its crystals. He joins Bartz's party hoping to regain his memories. After they return, he does an about-face to become a seasoned warrior.

(5) Krile — Galuf's beloved granddaughter. Fourteen years old. A precocious child. She has a unique sensitivity that allows her to communicate with creatures like wind drakes and moogles. She inherits her grandfather's abilities when he dies protecting her, and joins the heroes in their fight.

(6) King Tycoon — Father to Lenna and Faris. He wielded a sword as a mercenary during his youth. The previous king, who had no heirs, put him on the throne based on his popularity and leadership ability. He leaves Tycoon to prevent the destruction of the crystals before he disappears.

(7) Cid — An engineer. He searches through the ancient tomes at the Library of the Ancients, creating machines to amplify the power of the crystals. He worries that this is what caused the crystals to shatter.

(8) Mid — Cid's grandson. He inherits Cid's blood, and demonstrates great skill as a young scholar. A bookworm who wears huge spectacles.

(9) Sage Ghido — A thousand-year-old tree. A sage from the other world who guides Bartz's group. Ghido was once master to Exdeath.

(10) Xezat — Galuf's comrade-in-arms. King of Surgate Castle in the other world. After Exdeath was sealed 30 years ago, he, Galuf, Dorgann, and Kelger fought together as the Dawn Warriors. He commands a fleet and attempts to invade Exdeath's castle. He dies entrusting Bartz and company with the mission of defeating Exdeath.

(11) Kelger — An old lizard man from the other world. Fought with Galuf, Xezat, and Dorgann as a member of the Dawn Warriors. Much older than the other three. Wields a dark sword.

(12) Dorgann — Warrior of the other world. Bartz's father. He fought against Exdeath thirty years ago as a Dawn Warrior with Galuf, Xezat, and Kelger. He opposed the decision to seal Exdeath in this world, and decided to remain. Dies when Bartz is ten years old.

(13) Wind Drake — Helps the heroes throughout the story (mostly as a mount). Symbolic character of FF5. Please note that we want to use it in the logo mark as well (We want to put the wind drake sideways between "FINAL" and "FANTASY"—where Kain was, in the FF4 logo).

Monster List

(14) Exdeath — A Dark Mage plotting to resurrect Enuo. Thirty years ago, he tried to destroy the crystals in Bartz's world believing it would revive Enuo. But the Dawn Warriors followed him from the other world and sealed him away. When humans used too much of the crystals' power, it caused this seal to weaken. Though Exdeath takes a humanoid shape, his true form is that of a tree like the sage Ghido.

(15) Enuo — An incarnation of evil sealed away in the dimension that was created after the legendary warriors split the world in two a thousand years ago. He commands the power of nothingness, and seeks to destroy the world.

(16) Neo Exdeath — A monster born when a branch of Exdeath's body enters Enuo's body. Neo Exdeath possesses Exdeath's will, as well as Enuo's power over nothingness.

↑ (14) (15) (16) are the final bosses.

These are the mid-bosses:

(17) Karlabos
Appearance: Torna Channel
A prawn-like monster. Whips up big waves with its tail, sending party members off the battle screen one by one. Target its tail first, to get rid of it early for an easy win.

(18) Siren
Appearance: Ship Graveyard
Drifts between life and death. When undead, she uses her fingers to age and zombify; when alive, she uses kicks. Fire and cure spells work against her when undead, but she is a beautiful woman in either form so it might not be easy to figure out which is which . . .

(19) Forza & Magissa
Appearance: North Mountain
Forza is a powerful warrior, while Magissa is an excellent mage. Fighting both at once would prove difficult even for seasoned heroes. There may be a way to block one of their skills, or to brute force your way through the encounter . . .

(20) Syldra
Appearance: Sunken Walse Tower
Summon beast
The sea dragon that pulled Faris's ship. A goodhearted creature, but you must face it as an enemy. For Syldra, it's almost a fight with itself. And what will Faris do?!

(21) Byblos
Appearance: Library of the Ancients Underground
All the monsters that sleep in the underground library spawn from books. Byblos is one of them. Is said to have the ability to turn everything into text. That was a type of hieroglyph.

(22) Triton/Nereid/Phobos
Appearance: Tycoon Meteorite
Male version of Mindy, Sandy, and Cindy from FF4. Their names are based on satellite planets, but might be simplified. Unlike the fat/skinny/tiny Magus Sisters from the last game, this time they're identical triplets. Although their expressions look innocent, their attack power is high.

(23) Soul Cannon
Appearance: Ronka Ruins
The ruins are actually an ancient battleship and this is a giant cannon from that ship. Destroying three secondary cannons will make the main Soul Cannon appear: an ancient weapon made of wood and stone.

(24) Gilgamesh
Appearance: Hades Castle Dungeon
Top-tier warrior of Gojo Bridge. Looks like Benkei? You fight him four times in total, and he adds weapons and skills each time. He becomes the ultimate warrior by the final fight. Weak at first. First time he fights Galuf one on one.

(25) Atomos
Appearance: Barrier Tower
Opposite of Demon Wall. When he gets close, the party members get sucked one by one into the black hole in Atomos's stomach. Its stomach is more like a black mirror to another dimension than a human stomach.

(26) Melusine
Appearance: Ghido's Cave
Elemental master. Her weakness changes with a four-element barrier shift. White silk cloth wraps her body, making her look quite scandalous. Chain-like tattoos cover her body. A female version of Hein.

(27) Halicarnassus
Appearance: Sealed Forest
Elite guard captain sent by Hades. Appears with Imperial soldier subordinates.

(28) Stalker
Appearance: Istory Falls
Has no presence. Appears only when hit or attacking, before vanishing back into the darkness.

(29) Gogo
Appearance: Second Walse Tower
Partakes in mimicry in all its forms. The only funny boss this time around. Like a clown or jester, he can turn fat or thin. A real work of art.

(30) Twintania
Appearance: Interdimensional Rift (last dungeon)
The ultimate beast. A monster made by fusing all living creatures. Immunological rejection constantly occurs within its body, creating an abnormal degree of power and ability. Fifth strongest monster (still weaker than Neo Exdeath or Enuo).

That's all, good luck.

Kazuko Shibuya Character Illustrations

Illustrations of Lenna, Faris, and Krile drawn by object graphics lead Kazuko Shibuya. Included here is a colored piece for Lenna as well as an illustration of Faris wearing her dress.

▶ Lenna

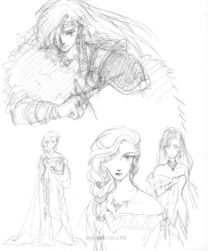

▶ Krile

▶ Faris

FINAL FANTASY V
MEMORIES

King Tycoon: Something is wrong with the wind...

Old Man: Where am I...
Oh...my aching head!

The world's crystals face calamity. A chance meeting at the fallen meteorite.
—AT THE TYCOON METEORITE

Explosion imminent! But treasure and the Death Claw skill beckon.
—IN KARNAK CASTLE

It's a trap! Monster attack!

03:59

Level 5 Death

Page 64

		HP	
Bartz		465	
Lenna		406	
Krile		405	
Faris		412	

Party members whose levels are multiples of five tremble with fear when facing the spell Level 5 Death.
—IN THE LIBRARY OF THE ANCIENTS

Gilgamesh has been waiting so long he started to worry. He's an enemy you can't help but love.
—AT THE BIG BRIDGE

Took you long enough, too... I was just getting worried you might have gotten lost!

The power of the Void swallowing village after village, including Bartz's . . .
—IN THE AIRSHIP

Wormhole

		HP	
Atomos	Bartz	597	
	Lenna	0	
	Krile	442	
	Faris	0	

The terror of Atomos, who swallows allies that have been knocked out.
—AT THE BARRIER TOWER

If you're a coward, take what's in the one on the right.
What's it gonna be?

Brave Blade, or Chicken Knife?
The ultimate choice.
—AT MOORE

Piano lessons in far-flung cities.
Become a true maestro!
—IN PHANTOM VILLAGE

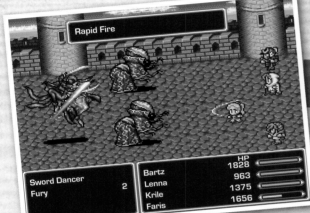

Rapid Fire

Sword Dancer	2		HP
Fury		Bartz	1828
		Lenna	963
		Krile	1375
		Faris	1656

Dual Wield plus Rapid Fire equals a grand old time!
—IN THE INTERDIMENSIONAL RIFT

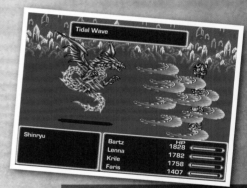

Tidal Wave

Shinryu		HP
	Bartz	1828
	Lenna	1782
	Krile	1758
	Faris	1407

Borrowing the Dawn Warriors' power to put an end to Exdeath and the Void.
—ON THE LAST FLOOR

Open the treasure chest to face Shinryu, and be washed away by his Tidal Wave.
—ON THE LAST FLOOR

Onward,
Light Warriors!!!

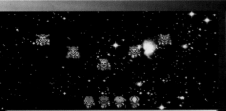

King Tycoon: The world still needs you.

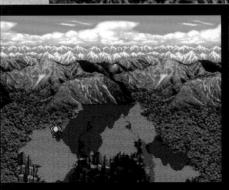

The crystals have regained their power.
This time it's up to us to protect them.

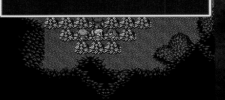

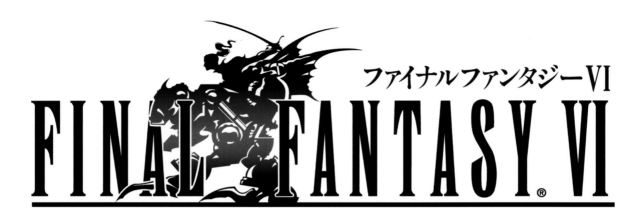

ファイナルファンタジーVI

FINAL FANTASY. VI®

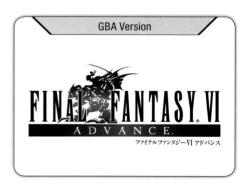

GBA Version

FINAL FANTASY. VI®
ADVANCE.
ファイナルファンタジーVI アドバンス

Crisscrossing tales in a world steeped in sci-fi elements

Final Fantasy VI incorporates a steampunk aesthetic into its world building. Beginning with the magic user Terra and the treasure hunter Locke, this adventure eventually encompasses fourteen protagonists, crafting an intricate and enthralling narrative. The ability to assemble your party from a huge bench of potential members is an element continued in future installments of the franchise.

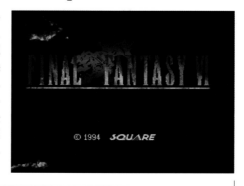

Super Famicom/SNES	PlayStation	PlayStation	PlayStation (Limited Edition)

Final Fantasy VI

JP Launch Date ● April 2, 1994
NA Launch Date ● October 20, 1994
✻ NA version released as *Final Fantasy III*

Final Fantasy VI

JP Launch Date ● March 11, 1999
NA Launch Date ● September 30, 1999
✻ JP version convenience store exclusive

Final Fantasy Collection

Launch Date ● March 11, 1999

Final Fantasy Collection Anniversary Package

Launch Date ● March 11, 1999

Game Boy Advance	Wii/Wii U (Virtual Console)	PlayStation 3/ PlayStation Portable/ PlayStation Vita (PS one Classics)	PlayStation (Limited Edition)

Final Fantasy VI Advance

JP Launch Date ● November 30, 2006
NA Launch Date ● February 5, 2007

Final Fantasy VI
(Super Famicom/SNES Version)

JP Launch Date ● March 15, 2011
NA Launch Date ● March 18, 2011

Final Fantasy VI
(PlayStation Version)

JP Launch Date ● April 20, 2011
NA Launch Date ● December 6, 2011
✻ Available on PS Vita from August 28, 2012

Final Fantasy 25th Anniversary Ultimate Box

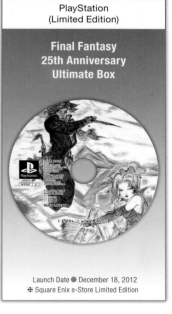

Launch Date ● December 18, 2012
✻ Square Enix e-Store Limited Edition

ART

The City
Terra riding Magitek Armor
(SFC package illustration)

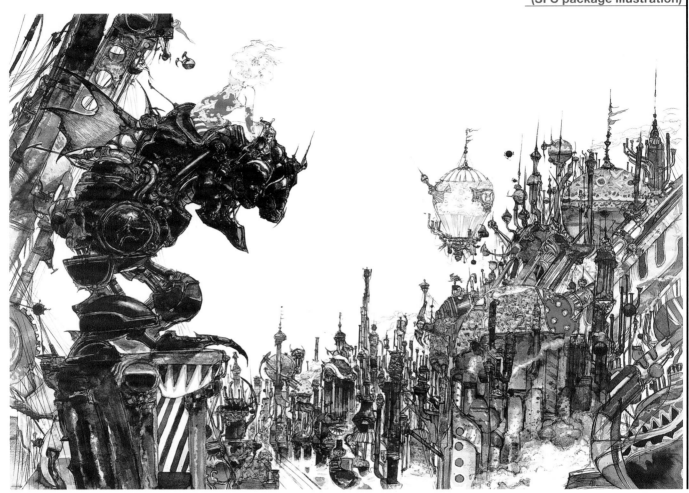

Opera House

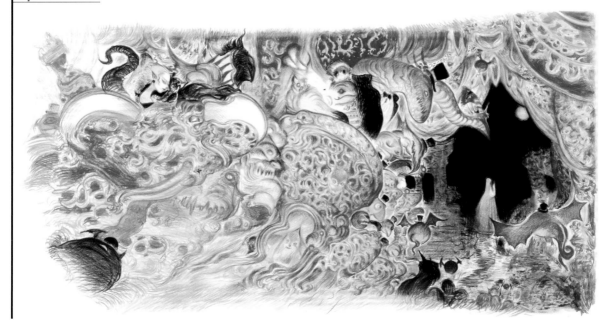

Magic and the Machine

Terra riding Magitek Armor

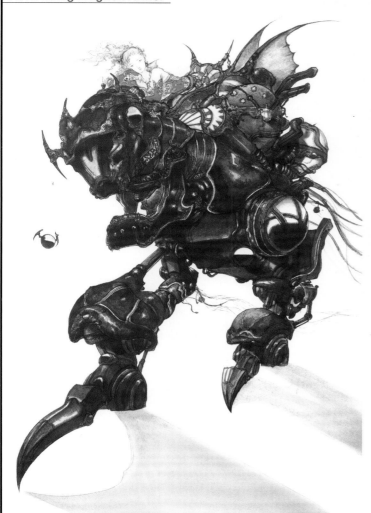

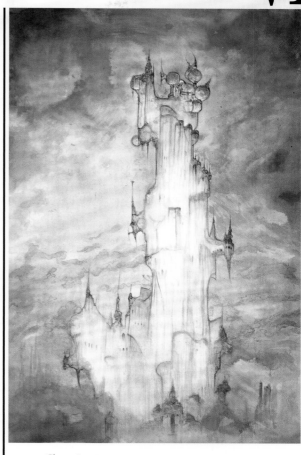

Kefka's Tower

Spirit and Steel

Illustration

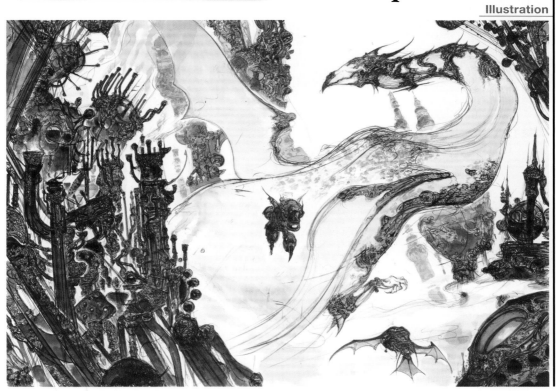

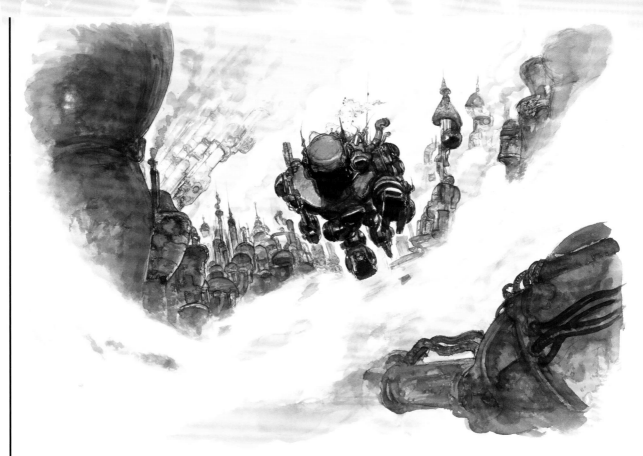

City of Sorcery
Terra moving through the city in Magitek Armor

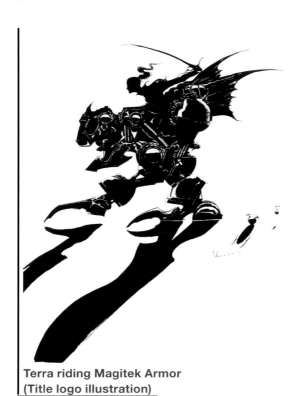

**Terra riding Magitek Armor
(Title logo illustration)**

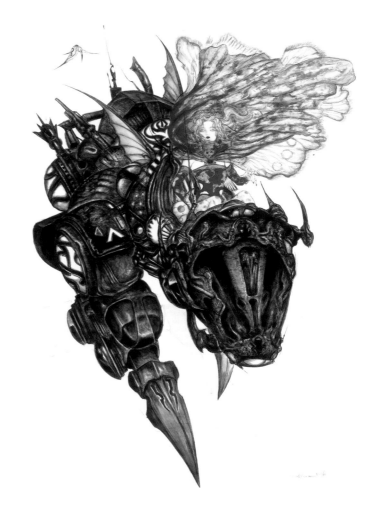

Terra riding Magitek Armor

**Illustration
(Desert Castle)**

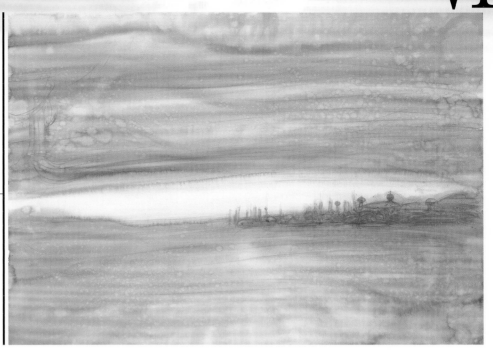

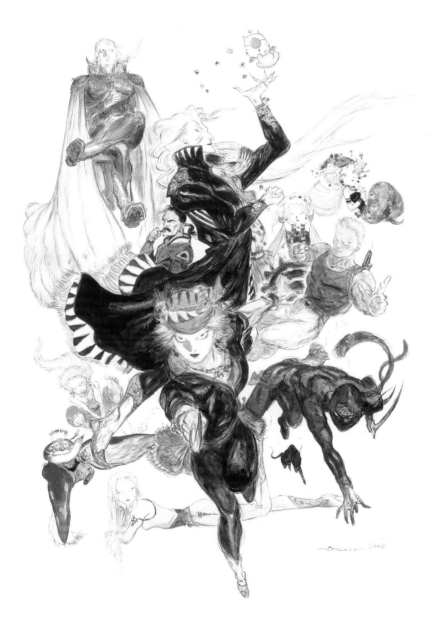

The Ensemble
Comrades

The ancient War of the Magi...
When its flames at last receded, only the
charred husk of a world remained. Even the
power of magic was lost...

Edgar: Really...something!?
That was magic!
MA-GIC!!!

You are this world's last ray of light...
our final hope.

Impresario: Hmm... Might as well make the most of this.
MUSIC!

FINAL FANTASY VI
STORY

Gestahl: Some of my men still do not believe we
should have ended the war. I felt they might better
understand if they could meet you face to face.

Typhon: Fungahhh!!!

Celes: He's alive...Locke's alive!

Ultros	Edgar	956
	Terra	724
	Locke	846

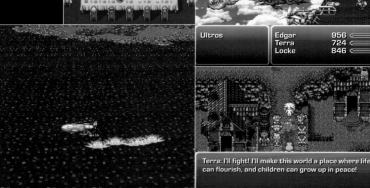

Terra: I'll fight! I'll make this world a place where life
can flourish, and children can grow up in peace!

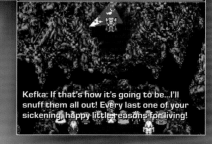

Kefka: If that's how it's going to be...I'll
snuff them all out! Every last one of your
sickening, happy little reasons for living!

In a world where humans and espers once lived together in peace, humans exploited the power of the espers to wage a war of conquest. This "War of the Magi" razed the world to the ground. In its aftermath, the surviving espers hid away in their own realm to prevent their powers from being further abused. As a result, magic disappeared from the human world.

A thousand years after this conflict, war once again ravages the land. The air is thick with the stench of iron and gunpowder. Steam engines have fostered a technological renaissance. But the Gestahlian Empire has somehow revived the lost power of magic, and intends to use its new prize to subjugate the world. Imperial forces have already unleashed this mighty power and overthrown the Empire's neighbors, but not everyone is willing to meekly fall in line under the Imperial banner.

To save the world, to exact revenge, or to find their reason for existing . . . these are some of the motivations driving the anti-Imperialists in the Returners as the group assembles to oppose the Gestahlian regime. The clash between these two forces will drag the espers back into the fray, as the stakes grow to threaten the existence of the world itself.

CHARACTERS

✤ Some images are from the GBA version

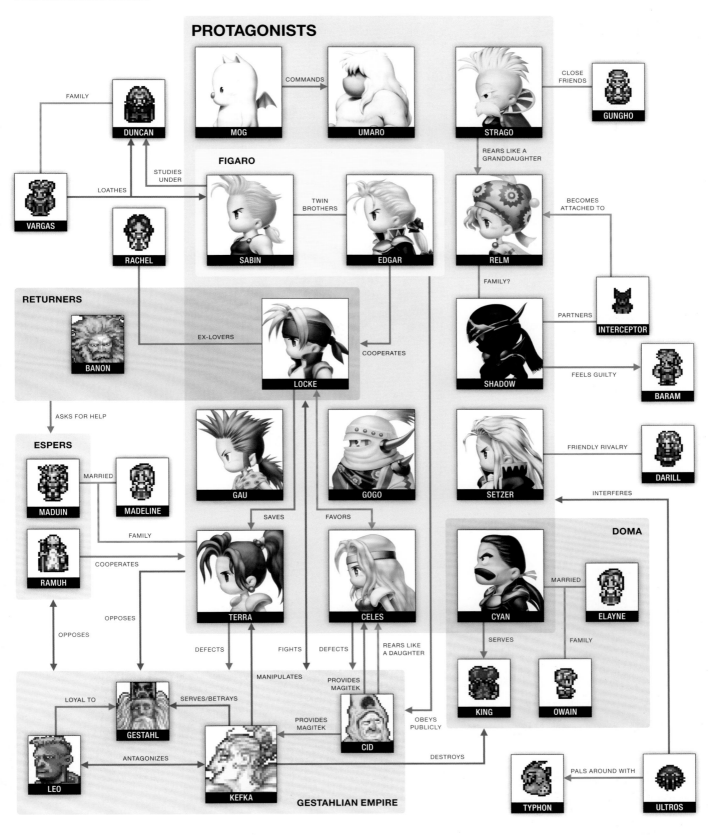

PROTAGONISTS

MOG — COMMANDS → UMARO

STRAGO — CLOSE FRIENDS → GUNGHO

FAMILY → DUNCAN

VARGAS — LOATHES → SABIN
STUDIES UNDER → DUNCAN

FIGARO

SABIN — TWIN BROTHERS → EDGAR

RACHEL

STRAGO — REARS LIKE A GRANDDAUGHTER → RELM

RELM — BECOMES ATTACHED TO → INTERCEPTOR

RELM — FAMILY? → SHADOW

SHADOW — PARTNERS → INTERCEPTOR

SHADOW — FEELS GUILTY → BARAM

RETURNERS

BANON

RACHEL / BANON — EX-LOVERS → LOCKE

LOCKE — COOPERATES → EDGAR

BANON — ASKS FOR HELP → ESPERS

ESPERS

MADUIN — MARRIED → MADELINE

GAU

GOGO

SETZER — FRIENDLY RIVALRY → DARILL

SETZER — INTERFERES

MADUIN / MADELINE — FAMILY → TERRA

RAMUH — COOPERATES → TERRA

GAU — SAVES → TERRA

GOGO — FAVORS → CELES

RAMUH — OPPOSES
OPPOSES

DOMA

CYAN — MARRIED → ELAYNE

CYAN — SERVES → KING

ELAYNE — FAMILY → OWAIN

TERRA — DEFECTS
FIGHTS
CELES — DEFECTS
REARS LIKE A DAUGHTER
MANIPULATES
PROVIDES MAGITEK
OBEYS PUBLICLY

GESTAHLIAN EMPIRE

LEO — LOYAL TO → GESTAHL

GESTAHL — SERVES/BETRAYS → KEFKA

CID — PROVIDES MAGITEK → KEFKA

LEO — ANTAGONIZES → KEFKA

KEFKA — DESTROYS

TYPHON — PALS AROUND WITH → ULTROS

Terra ティナ

Warrior without love.
Born of human and esper.

[Tina]

▶ *Terra Branford* ティナ・ブランフォード

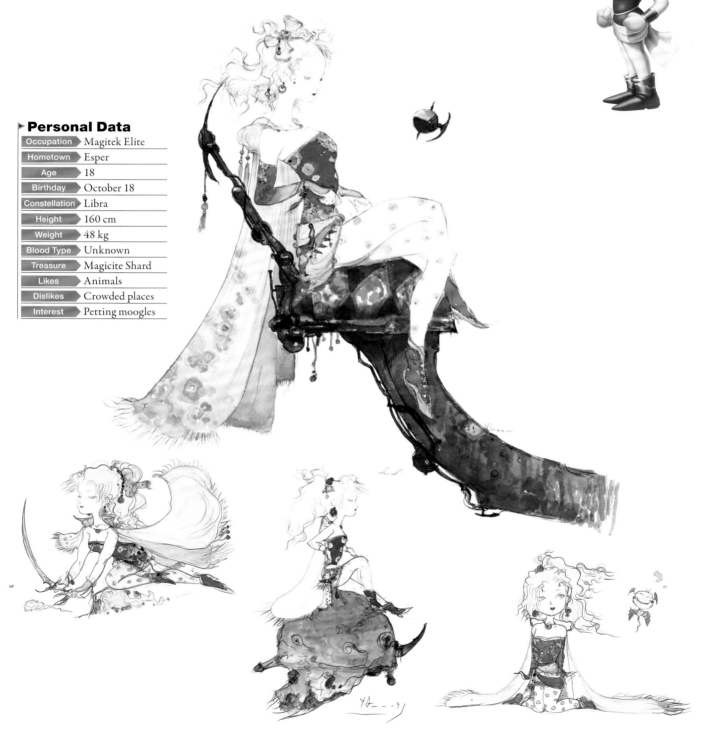

▶ Personal Data

Occupation	Magitek Elite
Hometown	Esper
Age	18
Birthday	October 18
Constellation	Libra
Height	160 cm
Weight	48 kg
Blood Type	Unknown
Treasure	Magicite Shard
Likes	Animals
Dislikes	Crowded places
Interest	Petting moogles

A girl with the blood of both humans and the magical beings known as espers, Terra has possessed incredible magic power since birth. After she was forced to serve the Gestahlian Empire, she received the title of a Magitek Elite. When Terra is freed by Locke, she begins to cooperate with the Returners fighting the Gestahlian Empire. Eventually the Imperial mage Kefka remakes reality, creating a world in which Terra lives with a group of children who teach her the power of love—an emotion she never knew. Awakened to this new form of interpersonal connection, Terra resolves to protect the world for the sake of her friends.

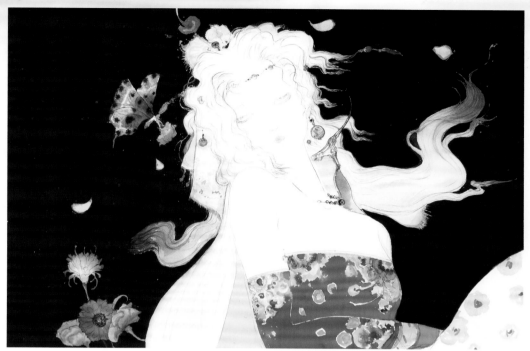

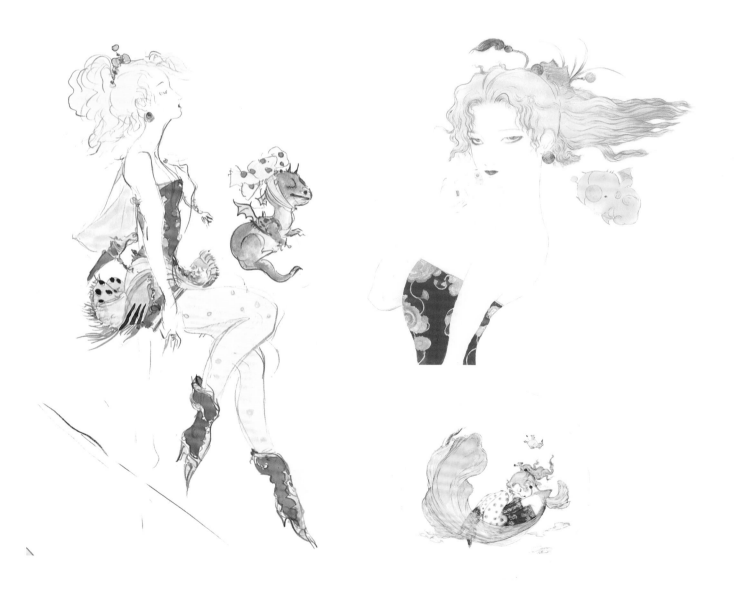

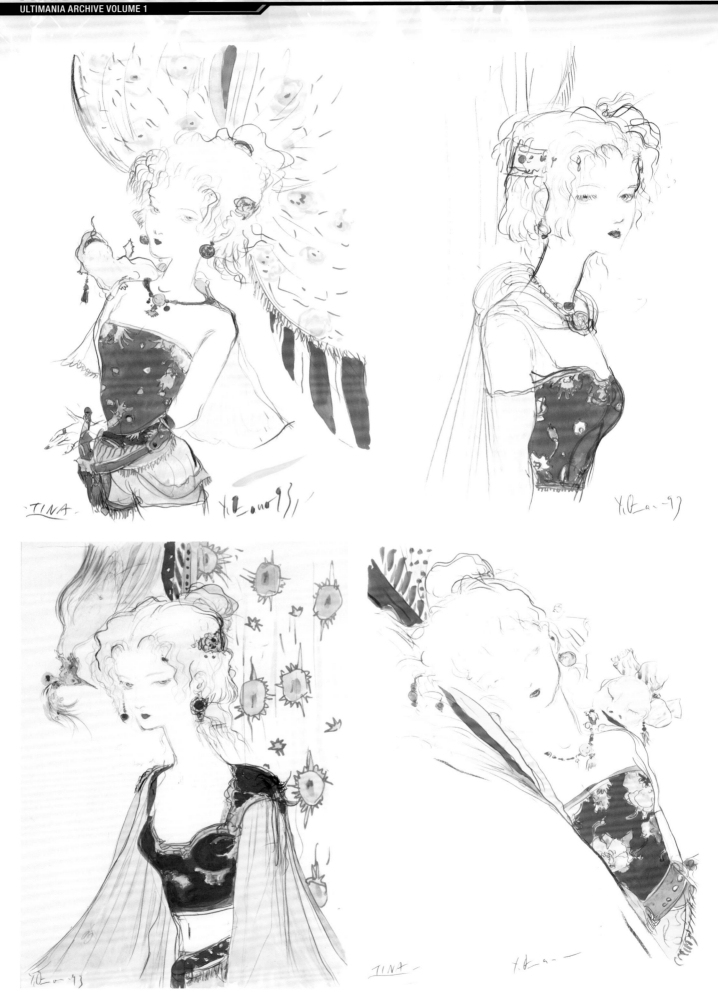

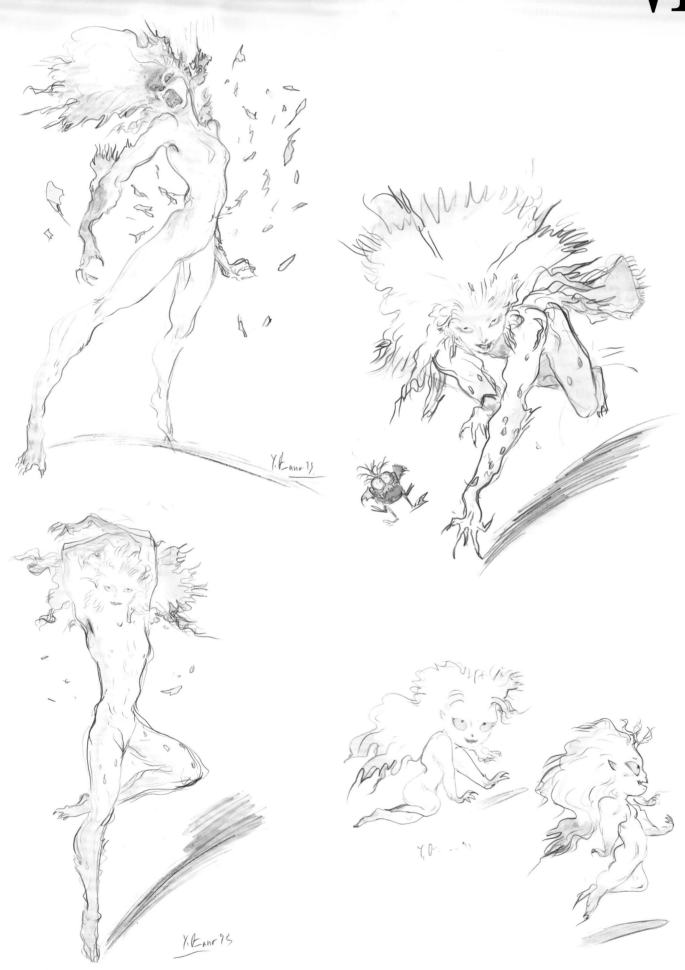

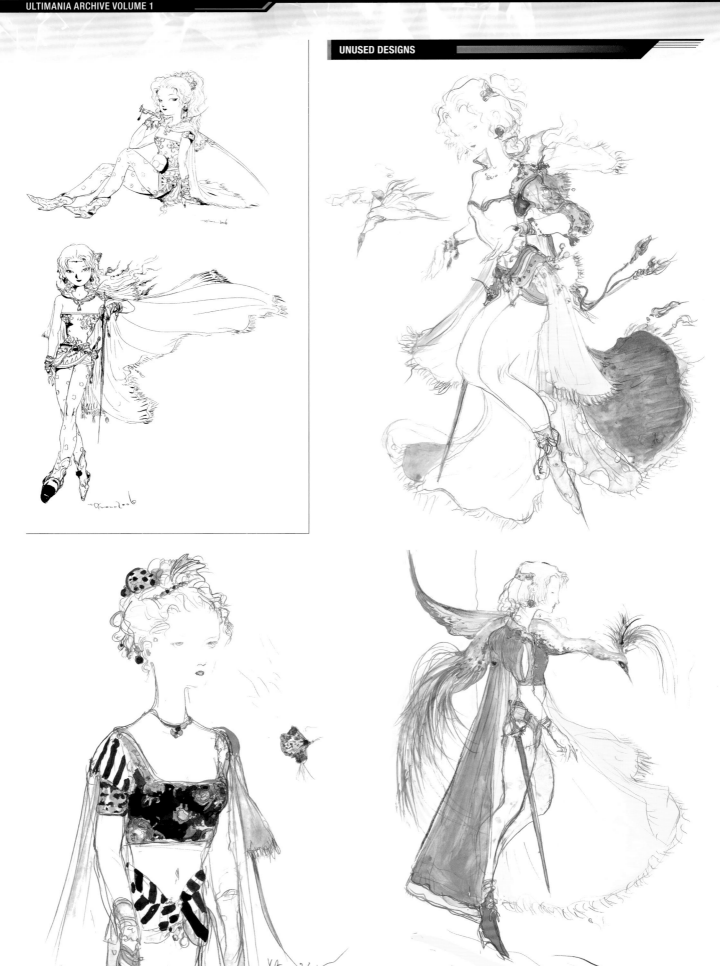

Memorable Quotes

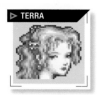
▷ TERRA

"If humans and espers were truly incompatible . . . I would never have been born . . . I'll do it. I'm the only one who can!"

—In Narshe, when accepting the duty of persuading the espers.

Terra is tasked by Banon of the Returners to bridge the gap separating humans from espers. The responsibility leaves her stunned. But with the proof that she is the living embodiment of the union between humans and espers, Terra comes to gain confidence in her role.

"Even though the only difference was that they could use magic . . ."

—In Thamasa, after hearing from Strago how, long ago, magi had been cruelly hunted down.

It is said that people persecuted magic users and drove them into the frontier, fearing the power they had displayed during the War of the Magi. For Terra, who had suffered cruel treatment due to her magical gifts, this story hit close to home.

"Hmm . . . I suppose a normal girl would have felt something from those words. But . . . not me . . ."

—In Figaro Castle, while dejected about feeling no emotions at all, even after Edgar makes a pass at her.

Even the sweet words of the lady-killer have no effect on Terra, who has no experience with love. Terra realizes that she is the odd one in not being intrigued by Edgar's advances, and this revelation sends her into a depression.

"I'll fight! I'll make this world a place where life can flourish, and children can grow up in peace!"

—In Mobliz, upon declaring her resolve to fight for the children.

Terra's time living with the orphans taught her the meaning of love. After discovering the value of protecting those one cares for, she sets out for the battlefield.

"But, there's no one important in my life."

—At the Returner Hideout, when Locke tells her he fights the Empire because he lost someone important to him.

Terra feels that she has no one who is important to her, and thus she cannot understand the sadness at having someone taken away. She cannot share Locke's clear motivation for fighting the Empire. Because of this, Terra is reluctant to join the Returners in their cause.

"If a human and an esper can love one another . . . Do you think a human and I could love each other?"

—On the transport, confiding her troubles to General Leo.

Terra knows the true nature of her parents, and is anxious to learn more about love. Leo understands her quite well, but their time together is short . . .

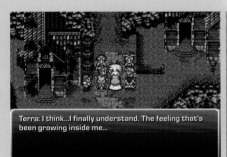

Wedge: Wh-where's that light coming from!? Uwaaagh!

Sympathy for the Esper

Under the control of the brainwashing slave crown, Terra rides to Narshe aboard Magitek Armor. She aims to secure the frozen esper in the mines, but her hybrid blood causes the magical being to resonate with her life essence . . .

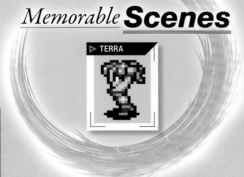

Terra: I think...I finally understand. The feeling that's been growing inside me...

Live with Love, Fight for Love

Living with the orphan children in the village of Mobliz sparked Terra's sense of maternal love. At first this feeling eludes the warrior, but once she identifies its power, she will do anything to protect those under her care.

Memorable Scenes

▷ TERRA

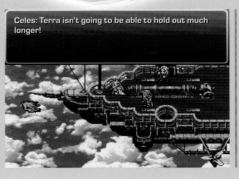

Celes: Terra isn't going to be able to hold out much longer!

Trance!

Approaching the frozen esper at Banon's behest, Terra's magical power resonates in sync with the creature and spirals out of control. Terra transforms into her esper form via Trance, flying off to parts unknown.

Maduin: ...I'll give it to you. A charm from the esper world!

Secrets of Birth Revealed

As Terra endures her Trance state in the town of Zozo, her father Maduin's magicite reveals her shocking past. Maduin reminisces about a love that transcended boundaries—the bond between a human woman, Madeline, and himself, an esper.

I Can Still Fight

The heroes barely defeated Kefka, who had absorbed the powers of the Warring Triad. But destroying the villain in that state caused magic to disappear from existence. The magical blood of espers that runs through Terra's veins threatens to erase her too, but the humanity she developed on her journey gave her an anchor to the real world.

Globetrotting treasure hunter.
Serving the rebellion.

Locke ロック

[Rokku/Lock]

▶ *Locke Cole* ロック・コール

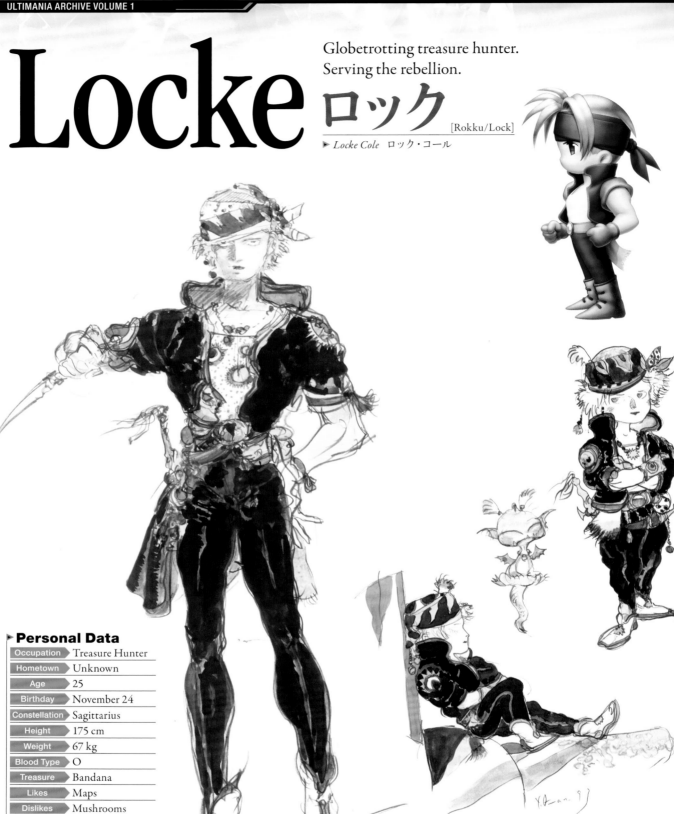

Personal Data

Occupation	Treasure Hunter
Hometown	Unknown
Age	25
Birthday	November 24
Constellation	Sagittarius
Height	175 cm
Weight	67 kg
Blood Type	O
Treasure	Bandana
Likes	Maps
Dislikes	Mushrooms
Interest	Napping in fields

A lighthearted member of the Returners who is searching for ancient treasure. After rescuing Terra in the city of Narshe, Locke throws himself into the fight against the Gestahlian Empire. Tormented with regret over his failure to protect his lover from the Empire, Locke cannot help himself from offering assistance to any girl in need. Locke and the former Imperial general Celes share a mutual attraction, but their histories prevent them from acting on their feelings. As soon as Locke puts his treasure-hunting days behind him, the two begin to pursue a future together.

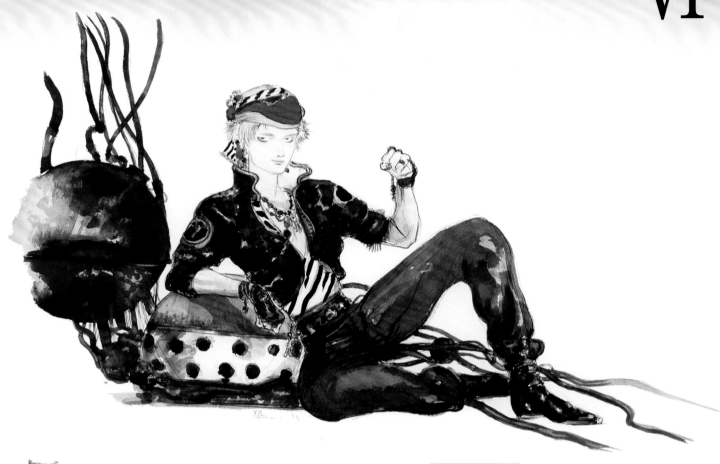

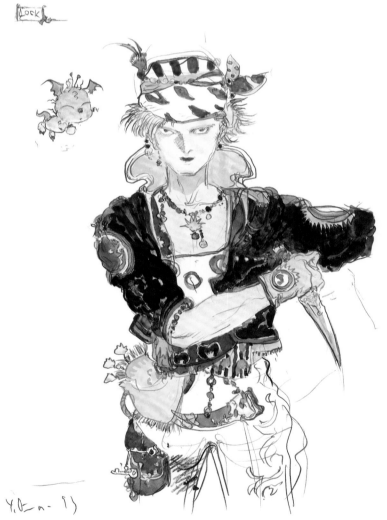

▶ Unused Design

Celes

Feminine fire within an icy exterior.
Former general of the Empire.

セリス [Serisu/Celes]

► *Celes Chere* セリス・シェール

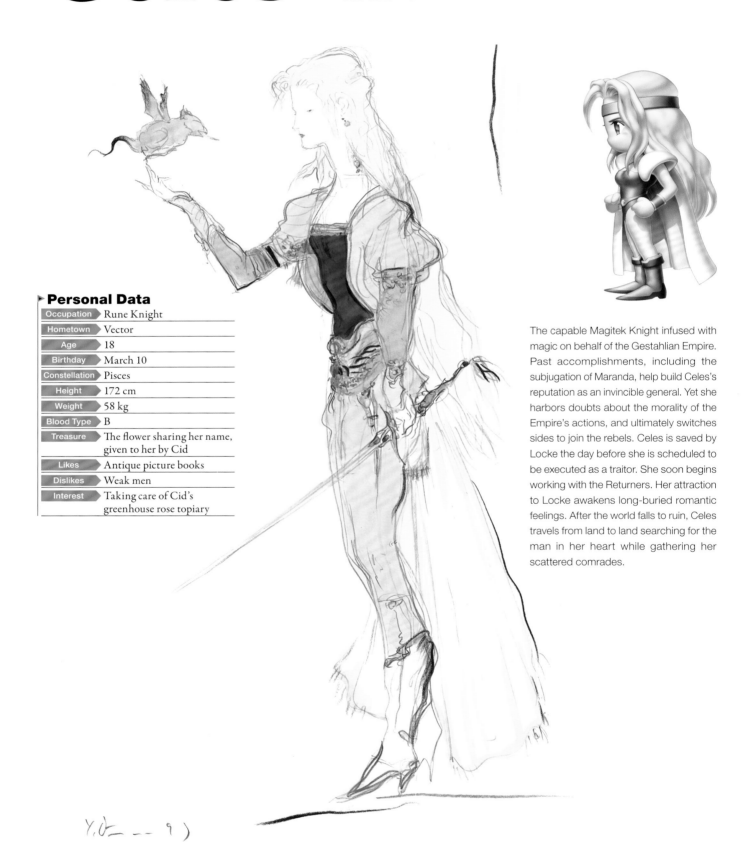

► Personal Data

Occupation	Rune Knight
Hometown	Vector
Age	18
Birthday	March 10
Constellation	Pisces
Height	172 cm
Weight	58 kg
Blood Type	B
Treasure	The flower sharing her name, given to her by Cid
Likes	Antique picture books
Dislikes	Weak men
Interest	Taking care of Cid's greenhouse rose topiary

The capable Magitek Knight infused with magic on behalf of the Gestahlian Empire. Past accomplishments, including the subjugation of Maranda, help build Celes's reputation as an invincible general. Yet she harbors doubts about the morality of the Empire's actions, and ultimately switches sides to join the rebels. Celes is saved by Locke the day before she is scheduled to be executed as a traitor. She soon begins working with the Returners. Her attraction to Locke awakens long-buried romantic feelings. After the world falls to ruin, Celes travels from land to land searching for the man in her heart while gathering her scattered comrades.

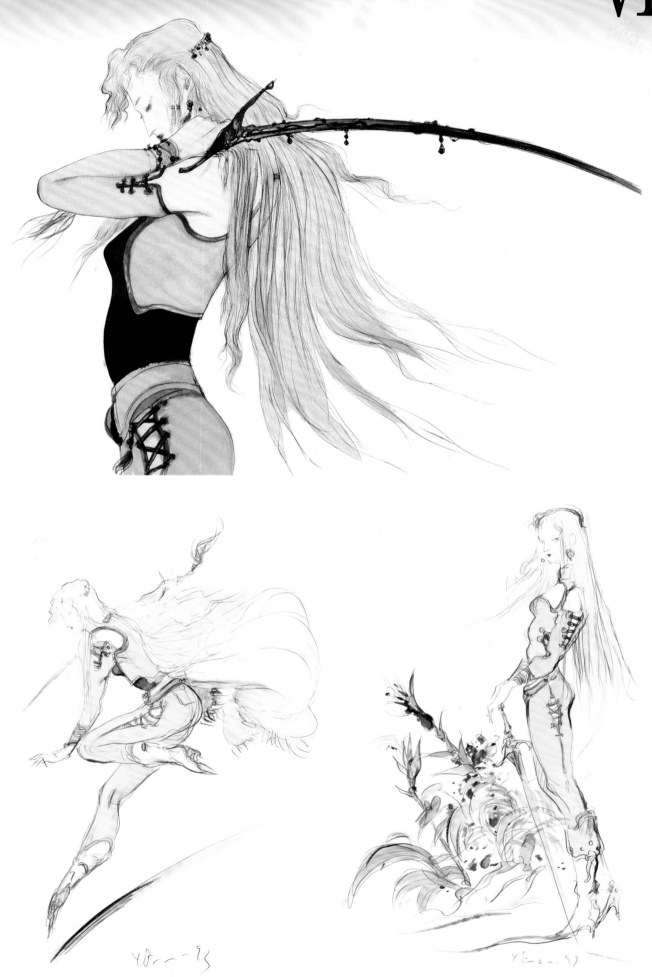

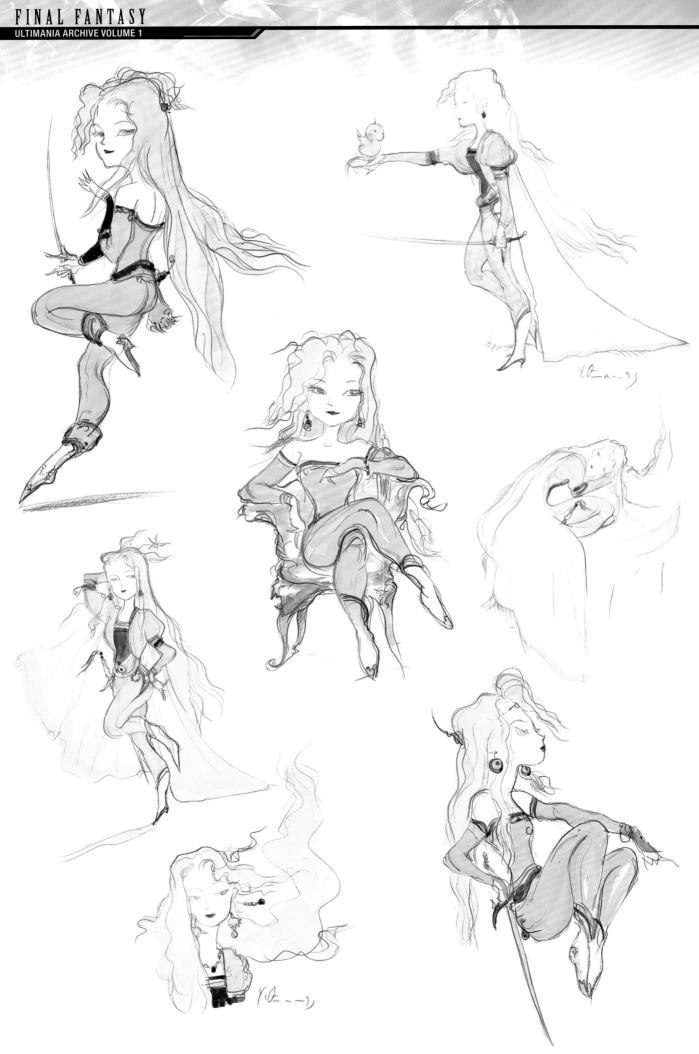

Memorable Quotes

▷ LOCKE ▷ CELES

"Oh, now that was just plain rude. I'm a treasure hunter . . . and don't you forget it!"

—In Narshe, after being called a thief.

Locke is proud of being a treasure hunter, and takes offense when he is referred to as a mere thief. Despite this, he can often be relied upon to perform actions befitting a thief, such as nabbing clothes to make a suitable disguise.

"Thanks for your concern, but I'm a soldier, not some love-starved twit."

—In Narshe, when told by Edgar not to fall for Locke.

At first Celes has a strong-minded and militaristic attitude, using prickly words to indicate her dedication to her mission. Celes rejects Edgar's advice and falls in love with Locke, just as his brother predicted.

"You remind me a lot of someone . . . What's it matter, anyway? I'm helping you because I want to!"

—In South Figaro, when asked by Celes why he chose to rescue her.

Locke rescues Celes from the Empire, in part because she reminds him of his dead lover, Rachel. But as the two journey together, the ex-general finds a place in his heart that is brand new, and unrelated to his lost love.

"I'm all right. Rachel put my heart at ease . . ."

—In Kohlingen, upon hearing Rachel's words and letting go of the past.

Rachel is temporarily revived with the Phoenix's treasure, and she blesses Locke's new love. Rachel's words free Locke from the curse of his past, and allow him to pursue a new future with Celes.

"Am I just a replacement . . . for her?"

—At the Opera House, after Locke confesses his love to her in a roundabout way, involving the memory of his dead lover Rachel.

Celes's feelings for Locke get stronger as she spends more time with him, but the revelation of his ex-girlfriend Rachel—which she learns in Kohlingen—casts a shadow over her heart. Despite Locke's reassurances of his romantic interest, Celes cannot accept his words so easily . . .

"I'm afraid you've been hustled, Mr. Gambler. But that's part of the game, now, isn't it?"

—On the *Blackjack*, when using a two-headed coin to win Setzer's wager.

Faced with the choice of winning Setzer's help or becoming his new girl, Celes pulls out the two-headed coin she borrowed from Edgar to guarantee a victory. The unwavering pluck that Celes displays—even after her trick is exposed—wins over Setzer.

I'll Protect You!

Locke reassures the amnesiac Terra that he will protect her. He is driven by the memory of his failure to protect his lover Rachel after she lost her own memories . . .

The Actress Disguise, the Opera Debut

Celes closely resembles Maria, a popular opera star on whom Setzer is fixated. Thus, Celes is disguised to take Maria's place onstage. Using her beauty and superb voice to their fullest, she perfectly fulfills her role as the opera's heroine.

Lovers of the Past

Locke's former lover Rachel lost her memory while protecting him, and later lost her life in an Imperial attack. Now the treasure hunter is stricken with regret over what happened to Rachel, and he is reluctant to explore the possibility of new love.

Trust Me, Locke

Celes's comrades begin to doubt her when Kefka claims that she is actually an Imperial spy. To redeem herself in the eyes of her friends, Celes uses magic to spirit herself and Kefka far away, giving the others time to escape the Magitek Factory.

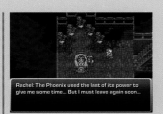

Search for the Phoenix Treasure

Locke believed he could return to the way things were by resurrecting Rachel, and searched for the legendary esper Phoenix in the aftermath of the world's collapse.

▷ LOCKE ▷ CELES

Memorable Scenes

He Is, in Fact, Successful . . .

A year after the world falls to ruin, Celes awakes on Solitary Island under the care of her beloved Cid. But her mentor is the next one to fall to illness, and Celes struggles to nurse him back to health.

Gearhead gentleman.
Ruler of the desert.

Edgar エドガー

[Edogā/Edgar]

▶ *Edgar Roni Figaro* エドガー・ロニ・フィガロ

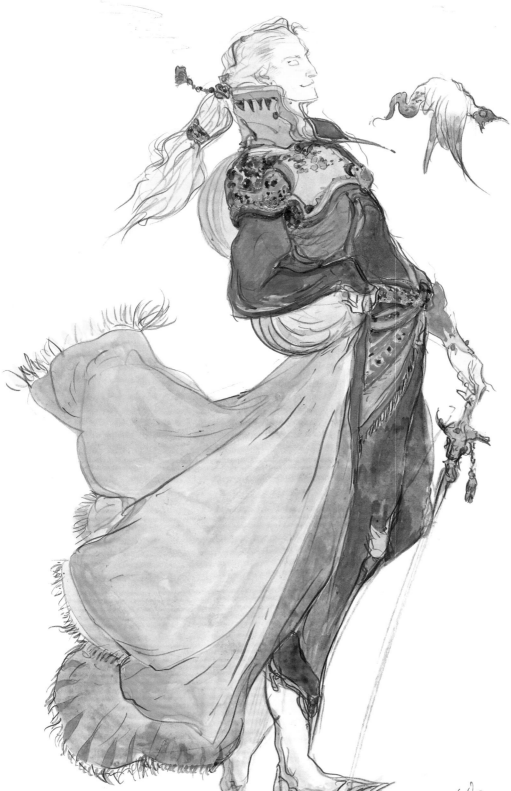

▶ Personal Data

Occupation	Machinist
Hometown	Figaro
Age	27
Birthday	August 16
Constellation	Leo
Height	183 cm
Weight	77 kg
Blood Type	O
Treasure	Two-headed coin
Likes	Women
Dislikes	Sermons
Interest	Developing weird weapons, decorating his bedroom

Young monarch of Figaro, the desert kingdom that sets the standard for technical civilization. Twin brother to the monk Sabin, Edgar utilizes Figaro's advanced technology to build amazing inventions. He supports the Returners from the shadows while maintaining a veneer of friendliness with the Gestahlian Empire, but the alliance shatters when Edgar shelters Terra, causing him to join the movement wholeheartedly. Edgar is a playboy who believes that flirting is a matter of etiquette.

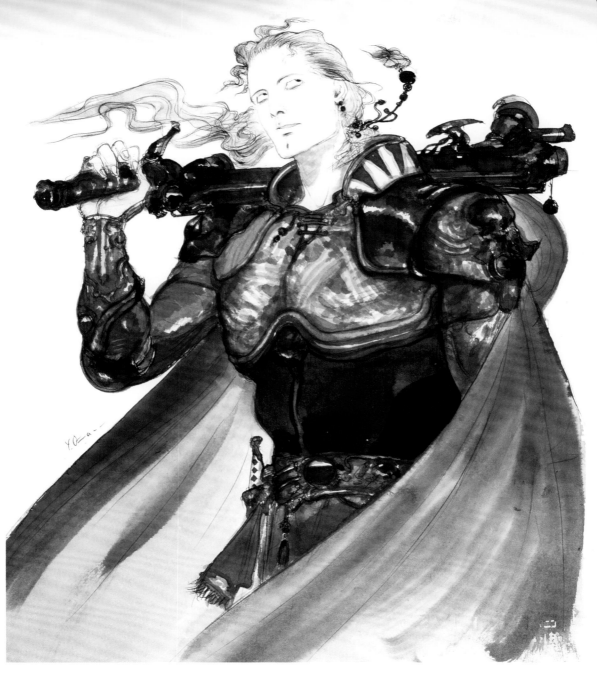

Sabin マッシュ

[Masshu/Mash]

Heroic and righteous monk.
Putting martial arts before personal status.

▶ *Sabin Rene Figaro*　マッシュ（マシアス）・レネ・フィガロ

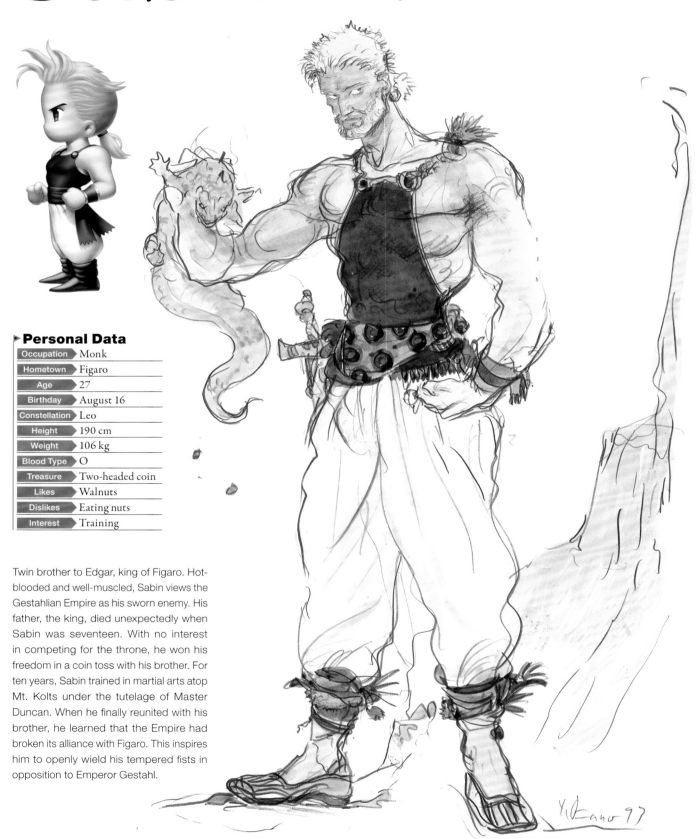

▶ Personal Data

Occupation	Monk
Hometown	Figaro
Age	27
Birthday	August 16
Constellation	Leo
Height	190 cm
Weight	106 kg
Blood Type	O
Treasure	Two-headed coin
Likes	Walnuts
Dislikes	Eating nuts
Interest	Training

Twin brother to Edgar, king of Figaro. Hot-blooded and well-muscled, Sabin views the Gestahlian Empire as his sworn enemy. His father, the king, died unexpectedly when Sabin was seventeen. With no interest in competing for the throne, he won his freedom in a coin toss with his brother. For ten years, Sabin trained in martial arts atop Mt. Kolts under the tutelage of Master Duncan. When he finally reunited with his brother, he learned that the Empire had broken its alliance with Figaro. This inspires him to openly wield his tempered fists in opposition to Emperor Gestahl.

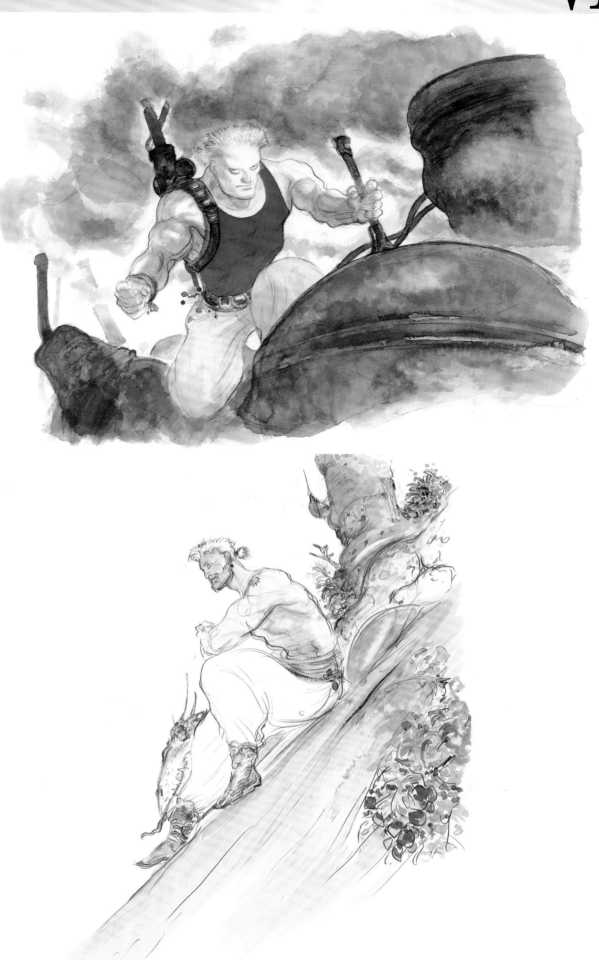

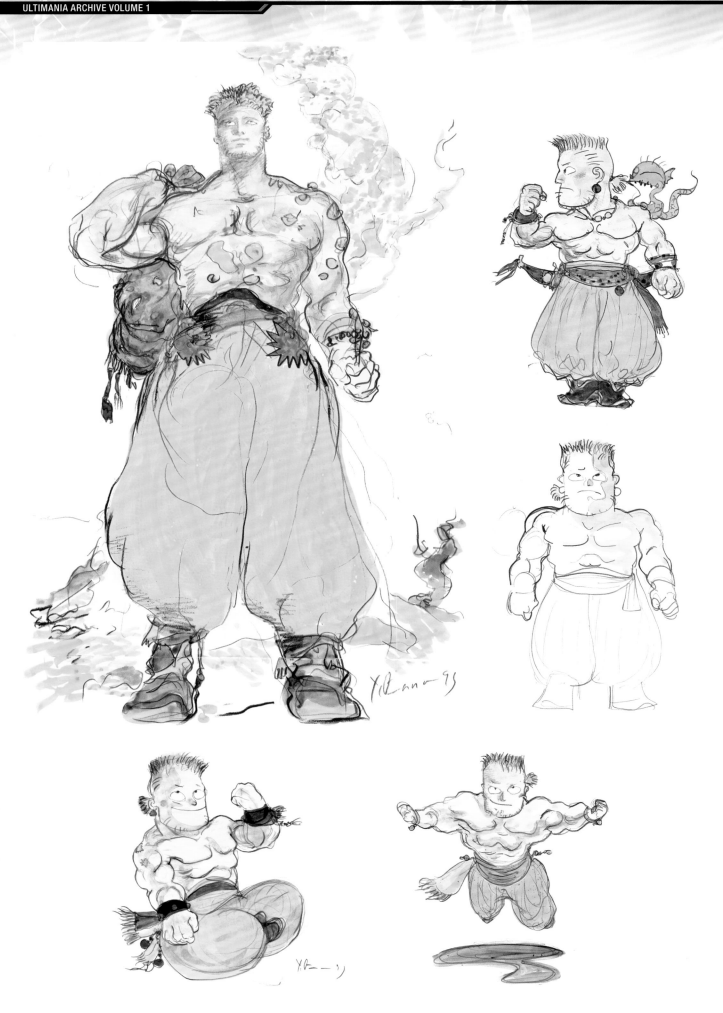

Memorable **Quotes**

> EDGAR

> SABIN

"Did you think I could be so rude as to meet a lady and not make any moves at all? It was a matter of courtesy, dear brother! Courtesy!"

—In Thamasa to Sabin, who is shocked that he received information from the Gestahlian girl with whom he "exchanged pleasantries."

Edgar is renowned for his skills as a playboy. From the High Priestess he treats like his own grandmother to the children running freely through the castle corridor, everyone knows how accommodating Edgar can be. Citizens from enemy nations are no exception.

"You thought I was a . . . bear? I guess I'll, uh . . . take that as a compliment!"

—On Mt. Kolts, laughing at Terra, who mistakes him for a bear.

Sabin shows no offense at Terra's rude comment; in fact, he laughs it off. Sabin's bighearted nature is one of his most endearing qualities.

"Sabin . . . Do you think Dad would be proud of me?"

—At Figaro Castle, when talking with Sabin at night.

Edgar assumed his kingly duties at the age of seventeen. He took the throne to give his twin brother the freedom he craved, but Edgar quickly devotes himself to becoming a proper monarch.

"The Empire is evil, but that doesn't mean that all of its citizens are."

—In Narshe, while calming Cyan, who presses the former Imperial general Celes.

Although he was careful to maintain friendly relations with the Gestahlian Empire, Edgar suspects that agents of the emperor poisoned his father, the king. Still, Edgar understands that he cannot direct his hatred against those living under the emperor's rule.

"He's always thought of my needs before his own, ever since we were little. I think you should trust him, too."

—At the Returner Hideout, to Terra, who hesitates to work with the Returners.

Sabin left the country to pursue his own freedom, and still carries a deep sense of gratitude toward the brother who allowed him to make that choice. Their bond is strong; even Sabin's monk training was ultimately so that he could better support his brother, the king, from the shadows.

"Did you think a little thing like the end of the world was gonna do me in?"

—In Tzen, after reuniting with Celes in the World of Ruin.

Even after the world collapsed and his comrades were thrown to the four winds, Sabin never lost hope. He paved a new way forward with his own strength. Sabin inherited his attitude from Master Duncan, who spoke the same words.

The Royal Flirting Technique

Wooing women with well-chosen words is Edgar's specialty. Even so, his success rate is suspect. Terra reacts poorly to his advances, Celes ends up falling for Locke, and Relm is too young. Within the party, Edgar's lady-killing techniques fall flat.

Regarding the Past on the Midnight Parapet

Edgar sensed his brother's hidden desire, and used their father's two-headed coin to ensure that he would be the one to take up the crown while Sabin gained the freedom to leave the castle. Ten years later . . . Sabin returns, and Edgar is overwhelmed with emotion at their reunion.

Bandit Chief Gerad?

After the world collapses, Edgar assumes the alias of the master thief Gerad and recruits a gang of raiders. He conceals his true identity until after he saves Figaro Castle from beneath the desert sands. Still, he cannot entirely stifle his flirtatious side . . .

> EDGAR > SABIN

Memorable **Scenes**

Disciple vs. Disciple

Not only did Vargas beat Master Duncan to the brink of death, he also attacks the adventuring party in a blind rage. Sabin tells his fellow disciple Vargas that Master Duncan wanted Vargas to be his successor, but his words fall on deaf ears. Thus, Sabin must accept his rival's challenge.

Furious Plunge into the River

Sabin dives from the raft into the Lethe River to put an end to Ultros's relentless assault. After this incident, a great deal of time passes before he is able to meet up with his comrades once more.

Broken Homes

Sabin maintains his muscleman habits and good nature after the destruction of the World of Balance. In Tzen, he hoists a house left crumbling after Kefka's assault, giving time for a child inside to find rescue.

Death-defying conviction.
The halcyon samurai.

Cyan カイエン
[Kaien/Cayenne]

▶ *Cyan Garamonde* カイエン・ガラモンド

▶ Personal Data

Occupation	Samurai
Hometown	Doma
Age	50
Birthday	January 3
Constellation	Capricorn
Height	178 cm
Weight	72 kg
Blood Type	A
Treasure	Pocket watch containing a family portrait
Likes	Traditional things
Dislikes	Machines
Interest	Collecting ancient weapons

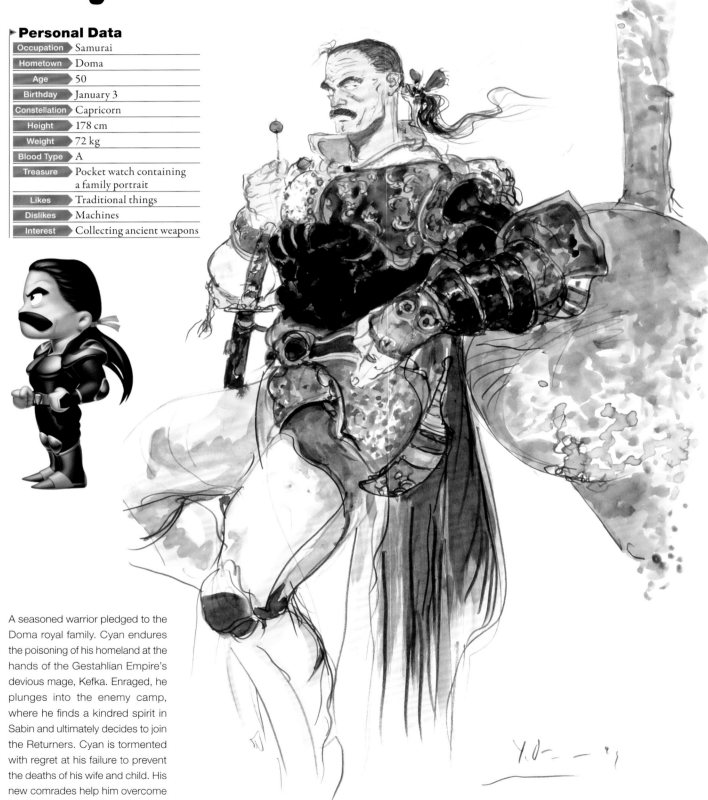

A seasoned warrior pledged to the Doma royal family. Cyan endures the poisoning of his homeland at the hands of the Gestahlian Empire's devious mage, Kefka. Enraged, he plunges into the enemy camp, where he finds a kindred spirit in Sabin and ultimately decides to join the Returners. Cyan is tormented with regret at his failure to prevent the deaths of his wife and child. His new comrades help him overcome the ghosts of his past.

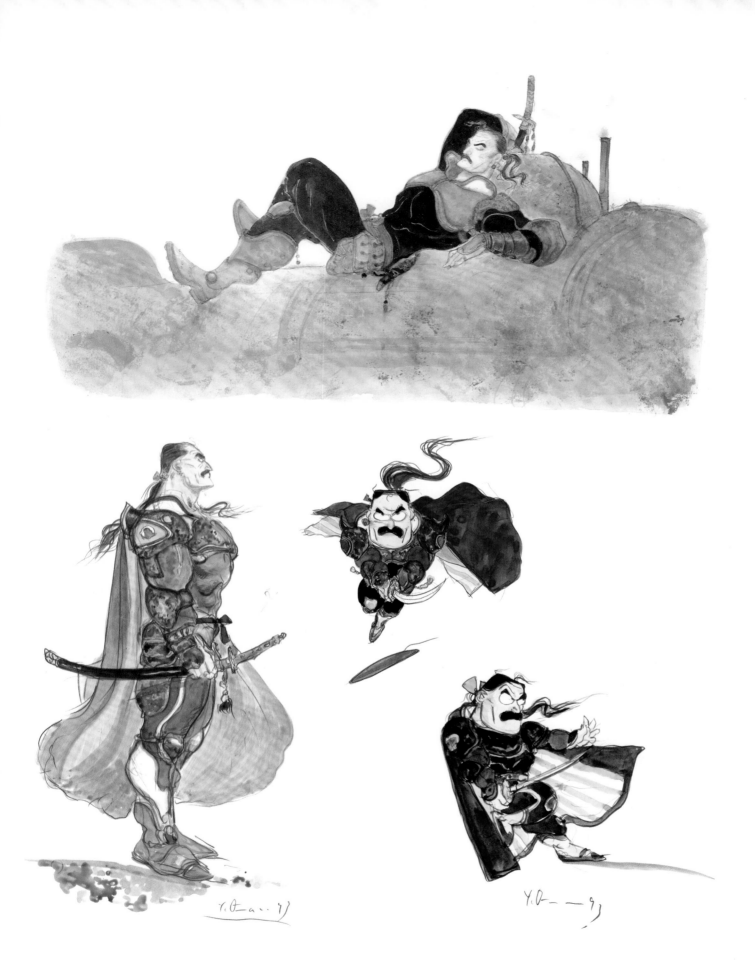

Shadow シャドウ [Shadō/Shadow]

Past shrouded in darkness.
The lone-wolf assassin.

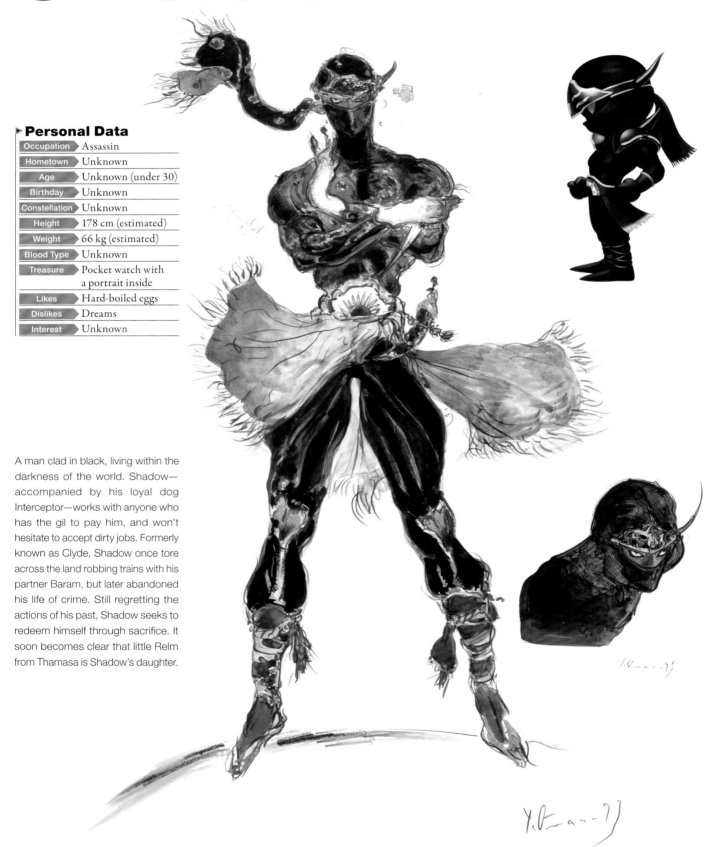

▶ Personal Data

Occupation	Assassin
Hometown	Unknown
Age	Unknown (under 30)
Birthday	Unknown
Constellation	Unknown
Height	178 cm (estimated)
Weight	66 kg (estimated)
Blood Type	Unknown
Treasure	Pocket watch with a portrait inside
Likes	Hard-boiled eggs
Dislikes	Dreams
Interest	Unknown

A man clad in black, living within the darkness of the world. Shadow—accompanied by his loyal dog Interceptor—works with anyone who has the gil to pay him, and won't hesitate to accept dirty jobs. Formerly known as Clyde, Shadow once tore across the land robbing trains with his partner Baram, but later abandoned his life of crime. Still regretting the actions of his past, Shadow seeks to redeem himself through sacrifice. It soon becomes clear that little Relm from Thamasa is Shadow's daughter.

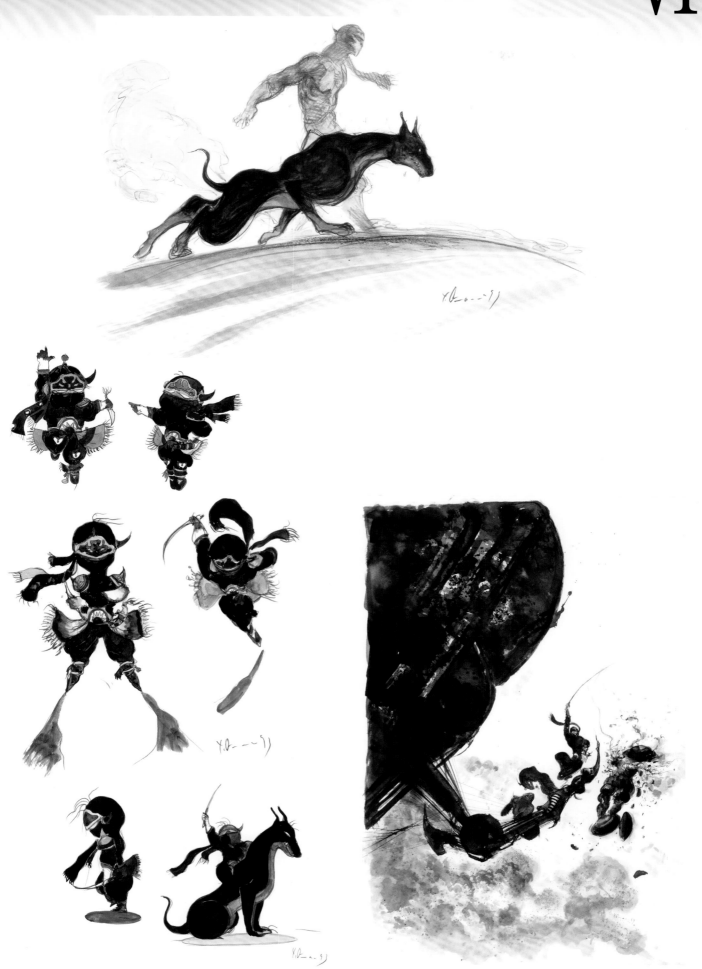

Memorable **Quotes**

> CYAN

> SHADOW

"Enough of that! A proper woman should have modesty, and . . . and decency! And . . . *rant* . . . *rant* . . . *rant* . . ."

—In Nikeah, when a seductive inn dancer flirts with him.

Despite having been married, Cyan is easily flustered by female charms. His rigid personality causes him to lose his composure when confronted with a busty dancer's wiles. Cyan angrily rejects the woman's attempts at seduction.

"I . . . I love you . . . I love you, my darling."

—In Cyan's dream, when asked by his wife Elayne if he loves her.

Cyan is an old-fashioned man, reluctant to express his feelings openly. He pushes through his reticence to answer his beloved's request, and is subsequently teased by his son. The episode illustrates happier days spent with family.

"Stand and meet thy judgment, Imperial b—"

—At the Returner Hideout, expressing anger at Celes.

The Gestahlian Empire is the enemy of both his country and his family, and Cyan's hatred toward the regime runs deep. Cyan's prejudice causes him to fly into a rage when he meets former Imperial general Celes. Despite assurances that Celes is now cooperating with the Returners, he cannot bring himself to trust her.

"My job is done. I've earned my pay. So long . . ."

—In each area, when leaving the party.

As his reputation suggests, Shadow is a man who only takes action when he is well paid. When supplied with gil, he will sometimes leave the party suddenly at the end of a battle.

"There are people in this world who have chosen to kill their own emotions. Remember that."

—To Terra on the transport ship, when she worries about her inability to understand love.

Shadow tries not to get involved with others, but in this instance he goes out of his way to offer some memorable advice. Shadow's emotional distance stems from when he left his bandit partner, Baram, to die. This incident comes back to haunt him during a nightmare at the inn.

"The only thing I know how to do . . . I'm fighting."

—At the Coliseum, when asked his reason for appearing there.

Shadow dives even deeper down the path of carnage following the end of the world, venturing into the Coliseum to obtain the ultimate ninja dagger, the Ichigeki. He justifies rejoining the party as a way to put his skills to their ultimate test.

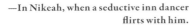

Cyan: Sir Sabin! How does one manipulate these abominations?

The Noble Luddite

Cyan is hopeless when it comes to technology, perhaps due to his traditional Doman upbringing. Even after he steals Magitek Armor, he has a terrible time controlling it. Later, Cyan tries to learn about machines from books, but some of the volumes are more than a little off topic . . .

His Beloved Interceptor

The black dog Interceptor is always at Shadow's side, protecting him. This faithful canine has remained in his master's company since they met in Thamasa ten years ago, after which the dog lived with Shadow and his daughter Relm.

Woman: In a small village called Tha...sa... Come on now, pull yourself together!

The Poor, Pining Girl Longing for Her Late Lover

In the World of Ruin that follows, Cyan takes pity on a villager who wants to send a letter to her dead lover. He corresponds with the girl in place of her dead lover. Realizing that this deception only causes both parties to escape reality, Cyan writes one final letter before rejoining his comrades.

Cyan: As I wrote to that girl, I began to realize that I was no different from her... I was refusing to move on.

Shadow: Go!

Protect the World!

Suffering grievous wounds after the Empire's betrayal, Shadow spurs himself to stop Kefka from moving the Warring Triad out of alignment on the Floating Continent. When it truly counts, this standoffish comrade pledges his life to serve the party.

I can no longer dwell on the past. I must follow the road which I believe to be right...

Trapped in a Dream

Racked with guilt over his role in the deaths of his wife and son, Cyan is trapped in an endless nightmare inside Doma Castle. His comrades help him fight back, and Cyan uses the dream to reunite with his family—allowing him to move on at last.

> CYAN

> SHADOW

Memorable **Scenes**

Shadow: Baram... It looks like I can finally stop running... Come and find me, all right?

To Baram's Side . . .

After the final battle, he takes a different path than his comrades out of Kefka's Tower. Shadow lets Interceptor flee with the others, and goes to where his old partner waits for him.

Gau ガウ
[Gau]

Pure and rambunctious
wild child raised by monsters.

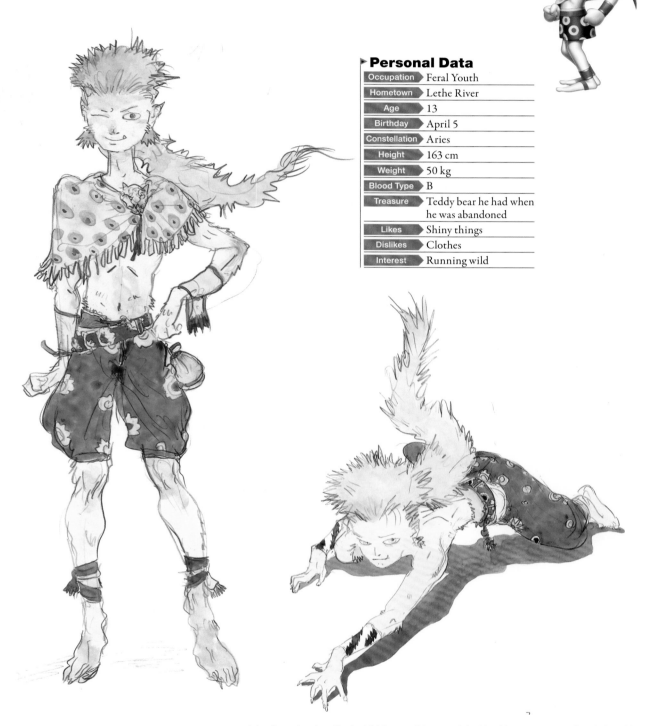

▶ Personal Data

Occupation	Feral Youth
Hometown	Lethe River
Age	13
Birthday	April 5
Constellation	Aries
Height	163 cm
Weight	50 kg
Blood Type	B
Treasure	Teddy bear he had when he was abandoned
Likes	Shiny things
Dislikes	Clothes
Interest	Running wild

A feral youth raised in the Veldt—a wilderness inhabited by monsters—Gau is lured into joining the party when Sabin offers him his favorite food, dried meat. Gau's father mistook him for a monster at birth and abandoned him. Despite his tragic past, Gau is an outgoing and strong-willed boy who doesn't let his past define him. Because he grew up without human contact, Gau can barely speak. He uses body checks to bond with his comrades and rampages across the battlefield during combat using monster-taught techniques.

Setzer

Wandering gambler.
Masculine romance in flight.

セッツァー
[Settsu~ā/Setzer]

▶ *Setzer Gabbiani* セッツァー・ギャッビアーニ

▶ Personal Data

Occupation	Gambler
Hometown	Unknown
Age	27
Birthday	February 8
Constellation	Aquarius
Height	175 cm
Weight	62 kg
Blood Type	AB
Treasure	The *Blackjack*
Likes	Playing for keeps
Dislikes	Cowardice
Interest	Playing solitaire

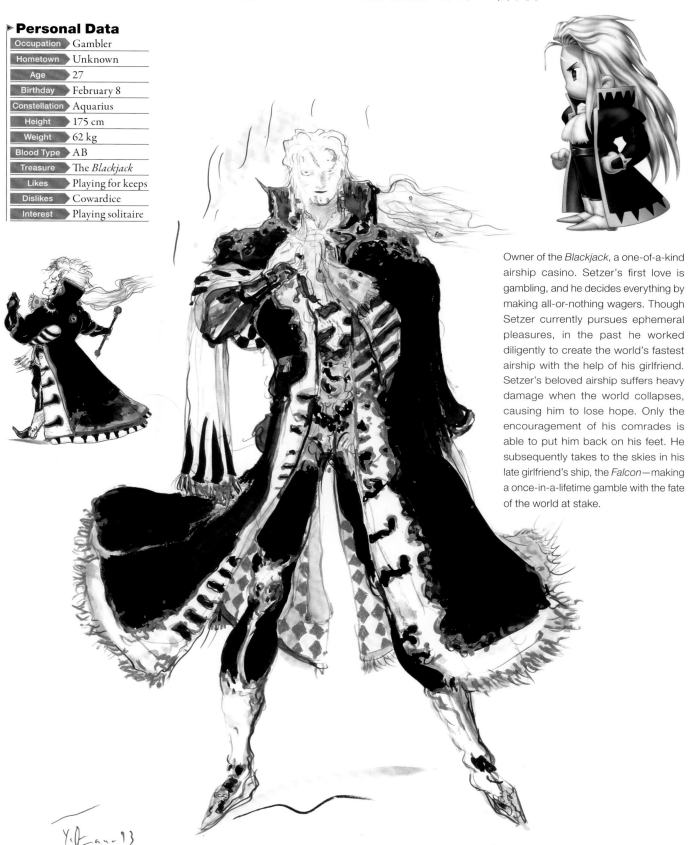

Owner of the *Blackjack*, a one-of-a-kind airship casino. Setzer's first love is gambling, and he decides everything by making all-or-nothing wagers. Though Setzer currently pursues ephemeral pleasures, in the past he worked diligently to create the world's fastest airship with the help of his girlfriend. Setzer's beloved airship suffers heavy damage when the world collapses, causing him to lose hope. Only the encouragement of his comrades is able to put him back on his feet. He subsequently takes to the skies in his late girlfriend's ship, the *Falcon*—making a once-in-a-lifetime gamble with the fate of the world at stake.

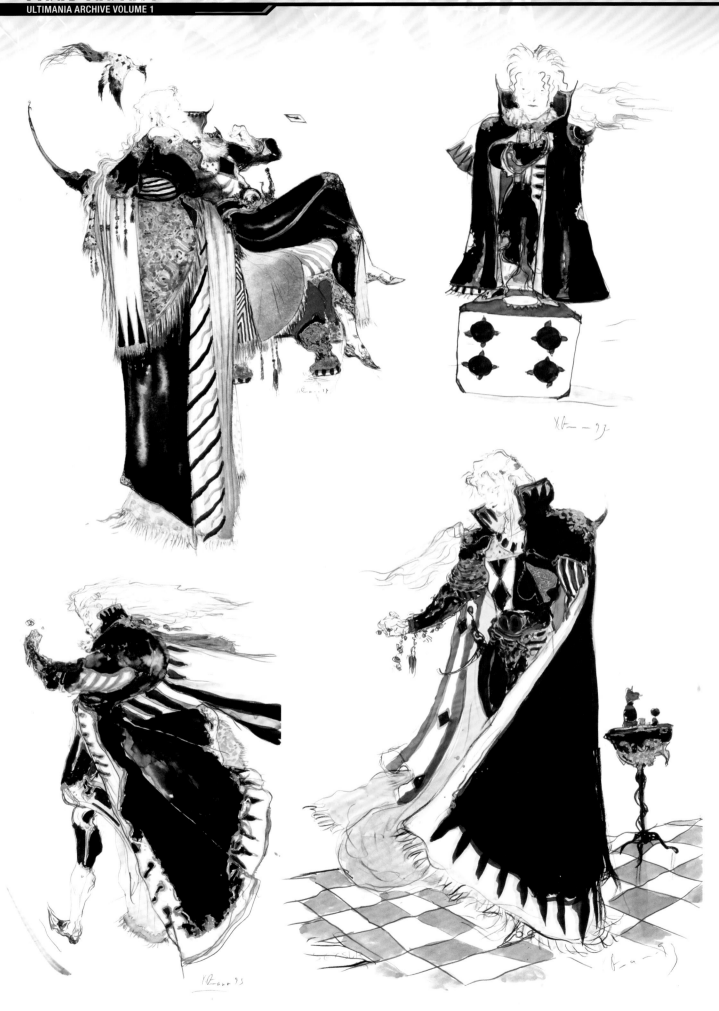

Memorable Quotes

 ► GAU

 ► SETZER

**"You . . . strangers . . . !
Go away! You scare animals!"**

—In the Veldt, when under attack by Sabin's party without receiving dried meat.

The youth is mixed in among a horde of monsters. At that time, he still views the group as hostile strangers.

"Yaoooo . . ."

—In Jidoor, when he replies with a combination of "Yes" and "Uwaoo."

"Uwaoo" is Gau's signature cry. He tries to reply to his comrades using proper speech, but his attempts are inevitably mixed up.

"Get strong, smash Kefka!"

—On the *Blackjack* when encountering other comrades.

The monster den known as the Veldt is a fierce land that Gau holds dear. Gau learned to fight and grew strong among the monster packs roaming the Veldt.

"Fa-ther alive . . . Gau h-appy."

—In Gau's father's house, expressing joy at the reunion with his father.

After such a long time, Gau's father no longer recognizes him, and unknowingly remarks on how he abandoned his "demon child." His callous words infuriate Gau's comrade, but the pure-hearted boy is just happy to know that his father still lives.

"My life is a chip in your pile! Ante up!"

—On the *Blackjack* when joining Locke's party.

Gambling is no mere diversion to Setzer. It is the foundation of his entire life. Celes's trickery should be cause for anger, but instead Setzer admires her. He bets his life on a "gamble to the death" against the Empire.

". . . I can't very well be the world's fastest pilot if I can't even fly. I need your help . . . *Falcon*!"

—On the *Falcon* while raising the wrecked ship at Darill's Tomb.

Following the world's collapse, Setzer eventually regains a sense of purpose with some help from his friends. His girlfriend Darill's vessel, the *Falcon*, was the expression of her dream to build the world's fastest airship. Now, it must bear the burden of restoring the entire world.

". . . Whenever you think you're right, you're wrong. And that's a big mistake."

—Whispering Darill's old saying during the finale.

Darill often reproached her cynical boyfriend by saying, "The opposite of what you think is correct." In other words, Setzer needed to think with his gut. That advice became burned into his heart. When Setzer is lost in the escape from Kefka's Tower, he uses Darill's words to find the way out.

Mischief Maker Gau

Gau takes an interest in Cyan's archaic way of speaking, and echoes his frequent use of "thou." Yet there is not a mean bone in the boy's body, and even Cyan has a feeling they will get along nicely.

Gau: Thou! Thou!

Marrying the Lead Actress?!

Setzer announces that he has decided to make the actress Maria his wife, and threatens to kidnap her to make it so. Even though he abducts Celes instead, Setzer falls for the plucky general in disguise and joins her on her quest.

Impresario: Setzer!
Setzer: I'm a man of my word, Impresario. I'm taking Maria!

Gau's Sparkly Treasure

Gau loves sparkly things, and his favorite treasure is a diving helmet containing shiny glass. He gives this precious object to Sabin and company to show them his gratitude for the gift of dried meat.

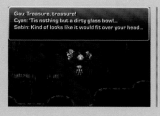

Gau: Treasure, treasure!
Cyan: 'Tis nothing but a dirty glass bowl...
Sabin: Kind of looks like it would fit over your head...

Daring Days with Darill

In the past, Setzer competed with his girlfriend to see who could build the world's fastest airship, but she flew off in a test ship one day, never to return. Setzer lost his passion, abandoning his quest for speed and installing a casino inside his airship.

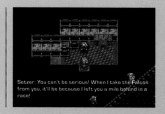

Setzer: You can't be serious! When I take the Falcon from you, it'll be because I left you a mile behind in a race!

Father-Son Reunion

During the journey, the heroes determine that a man living north of Doma Castle is Gau's father. Gau's comrades spruce him up for what looks to be a nerve-racking family reunion.

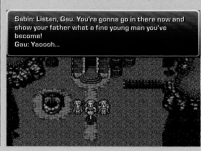

Sabin: Listen, Gau. You're gonna go in there now and show your father what a fine young man you've become!
Gau: Yaoooh...

Revived Wings

In a world devoid of dreams, Setzer loses himself in despair. With the help of his comrades, he regains his hopes for the future, and even recovers his lost love's wings.

Setzer: And we'll be able to look for the rest of our friends...

 ► GAU ► SETZER

Memorable Scenes

Strago

Skill hidden behind buffoonery.
Hale and hearty Blue Mage.

ストラゴス [Sutoragosu/Stragus]

▶ *Strago Magus* ストラゴス・マゴス

▶ Personal Data

Occupation	Blue Mage
Hometown	Thamasa
Age	70
Birthday	June 13
Constellation	Gemini
Height	151 cm
Weight	43 kg
Blood Type	O
Treasure	His collection of monster costumes
Likes	Monsters
Dislikes	Being treated like an old person
Interest	Making costumes

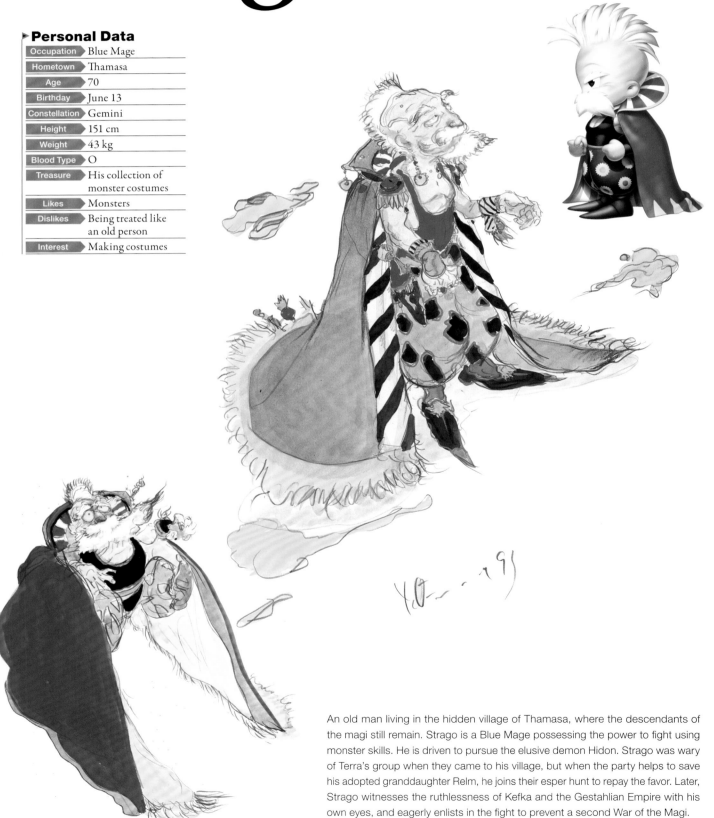

An old man living in the hidden village of Thamasa, where the descendants of the magi still remain. Strago is a Blue Mage possessing the power to fight using monster skills. He is driven to pursue the elusive demon Hidon. Strago was wary of Terra's group when they came to his village, but when the party helps to save his adopted granddaughter Relm, he joins their esper hunt to repay the favor. Later, Strago witnesses the ruthlessness of Kefka and the Gestahlian Empire with his own eyes, and eagerly enlists in the fight to prevent a second War of the Magi.

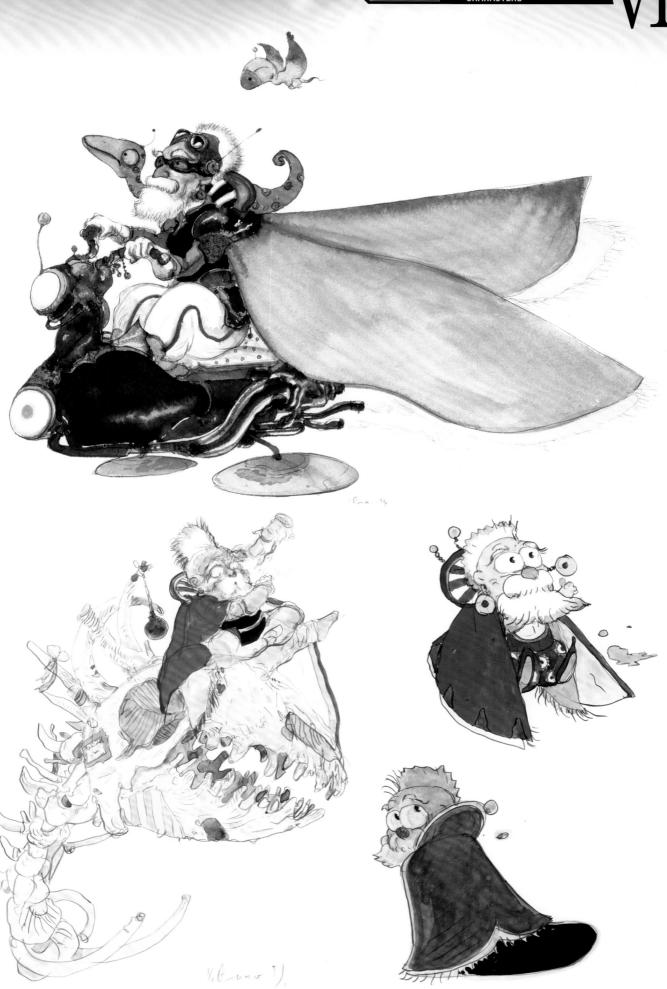

Breathing life into art.
Genius of the magi village.

Relm リルム [Rirumu/Relm]
▶ *Relm Arrowny* リルム・アローニィ

▶ Personal Data

Occupation	Pictomancer
Hometown	Thamasa
Age	10
Birthday	September 9
Constellation	Virgo
Height	153 cm
Weight	40 kg
Blood Type	B
Treasure	Her mother's handmade ribbon
Likes	Fluffy maple syrup pancakes, big people
Dislikes	Hairy caterpillars, scary people, bitter cold medicine
Interest	Painting, collecting ribbons

A young girl living with her grandfather Strago in the village of Thamasa. Already a gifted magic user by the age of ten, Relm also shows signs of becoming a painting prodigy. The monsters that she paints can leap from the canvas into the real world. Her youthfulness makes Relm oblivious to danger. She often shouts harsh remarks in Strago's direction as a backhanded way to show her affection. Afraid of being left behind, Relm forces her way into the heroes' party to support her grandfather and his new friends.

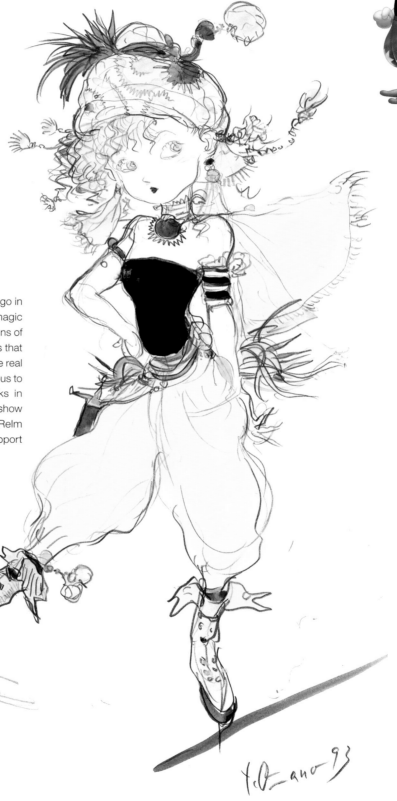

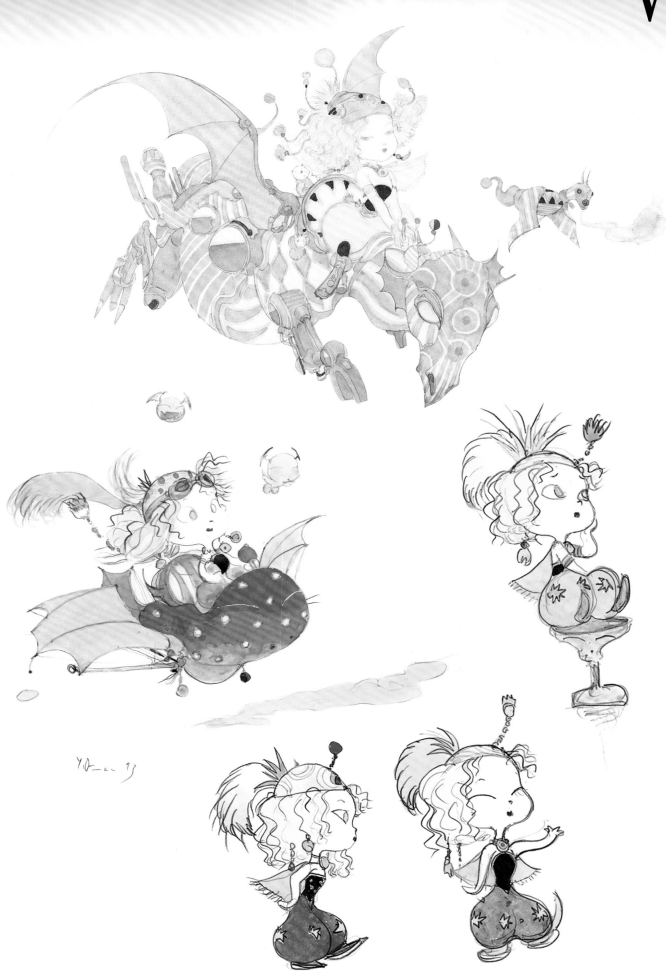

Memorable Quotes

▶ STRAGO

▶ RELM

"Nope, can't say I do! Don't know a thing. Not one thing!"

—In Thamasa, when asked about espers.

The citizens of Thamasa are descended from victims of the magi hunt, and conceal their knowledge of magic in front of strangers to prevent a repeat of the tragedy. In deference to the local customs, Strago feigns ignorance about espers during his first meeting with the heroes.

"Grr . . . ! I'm gonna paint your picture!"

—In Thamasa, when getting irked that Sabin treats her like a child.

For a girl with the ability to attack foes using sketches, these words constitute a serious threat. Relm displays her power in the Esper Caves, while everyone around her reels at her words.

"Oh, you're as foul-mouthed as ever, bless your heart!"

—At the Cultists' Tower, reuniting with Relm, whom he believed to be dead.

Strago's "granddaughter" Relm is not actually related to him by blood. Even so, Relm is precious to the Blue Mage, and everything about their reunion in the World of Ruin fills him with joy—even her foul mouth.

"Yes! She was on fire . . . and then it caught the neighbor's house on fire . . ."

—In Thamasa, while distressed about asking Locke's party to save Relm.

Relm is the apple of Strago's eye. When she is trapped in a blazing house, the old man panics and jumbles up his words.

"Come on now, you stubborn old bag of bones! Snap out of it!"

—At the Cultists' Tower, scolding Strago for joining the other cultists.

These biting words directed at Strago are proof of her love for the old mage. After the end of the world, Strago fell into despair at the thought of Relm's death, but her voice helped him regain his sanity.

"Let's do it! Let's go get that madman!"

—On the *Falcon* before the final battle against Kefka.

Relm gives nicknames to everyone she meets, a consequence of her childlike and straightforward personality. She calls Ultros "Ulty," Sabin "muscle-man," and Edgar "lover-boy." To Relm, the god ruling over the World of Ruin is not Kefka, merely a "madman."

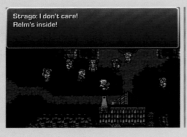

Save My Granddaughter

Strago hid his ability to use magic, but when Relm is in danger, it changes the equation. He unleashes ice magic in full view of the party, as the village elders mobilize to extinguish the flames.

A Portrait for Ulty

When Ultros attacks on the Floating Continent, Relm threatens to jump off a cliff if he won't let her draw his portrait. After she completes the painting, her creation attacks Ultros and forces him to flee. This cements Relm's place with the party.

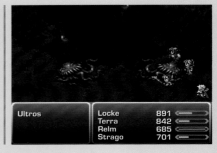

Settling Things at Ebot's Rock

Just as Strago begins to feel his age, his old friend Gungho suffers grievous injuries at the hands of Hidon, a demon the two had long pursued. Strago sets out to exterminate Hidon and exact revenge for his friend. His success washes away any lingering regrets from his younger years. But behind this whole tale is . . .

Putting On a Show for Love

The story of Gungho's injuries was actually a performance orchestrated by Relm. She believed that setting Strago on a monster hunt would lift his spirits, so the two of them arranged a show for the old-timer.

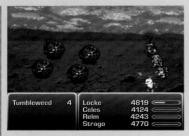

A Closet Cosplayer?

Sometimes Strago fights while wearing his favorite costumes. The Moogle Suit causes him to take on the appearance of a moogle, with no hint of the old man inside.

▶ STRAGO

▶ RELM

Memorable Scenes

Interceptor and Me

Perhaps it is because they once lived together, but Relm gets along well with Shadow's partner, Interceptor. No matter if it's in a sea of flames or in a cave following the end of the world, the loyal canine always comes to her aid.

Mog

The adorable mascot.
The hard-working warrior.

モグ

[Mogu/Mog]

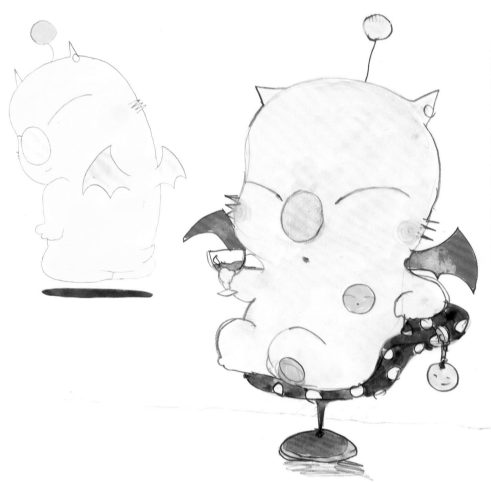

▶ Personal Data

Occupation	Moogle
Hometown	Narshe
Age	11
Birthday	May 11
Constellation	Taurus
Height	122 cm
Weight	43 kg
Blood Type	Black-footed duck (according to Mog)
Treasure	A crystal charm given to him by his lover Molulu
Likes	People who pet him
Dislikes	People who touch his tail
Interest	Singing and dancing

A moogle warrior living in the northern mines of Narshe. Moogles generally hate fighting, but when the chips are down Mog will wield a spear and summon the power of nature through a special dance. After saving Terra and Locke, Mog learns human language by imitating the esper Ramuh, and joins the party. Despite losing his moogle brethren when the world collapses, Mog does not give up hope. He reunites with the other party members to save the world.

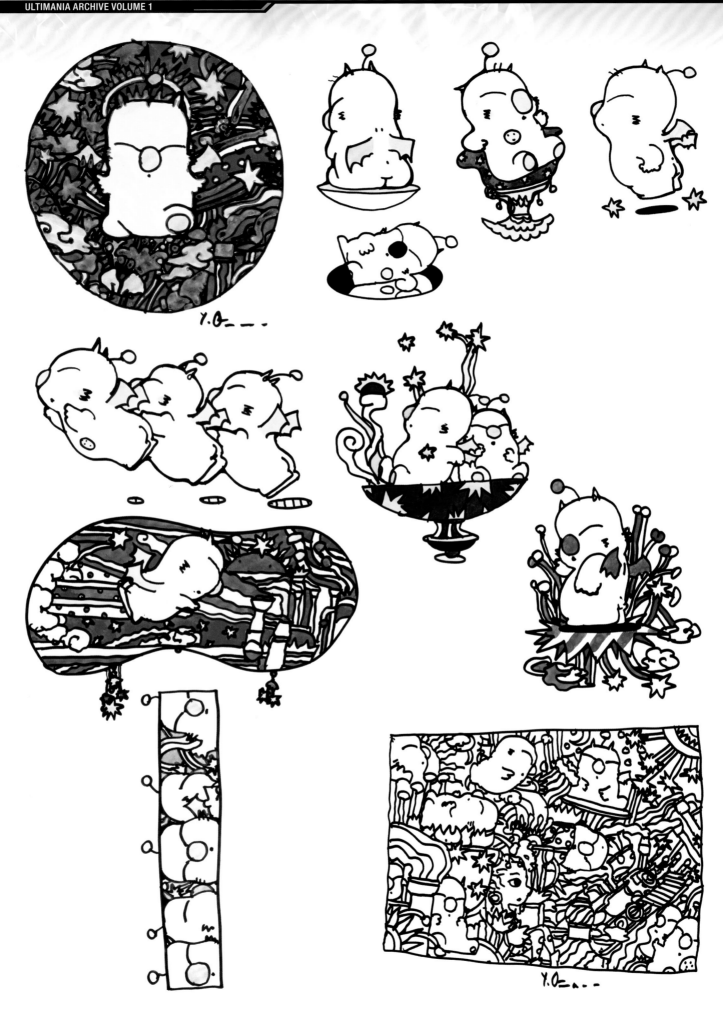

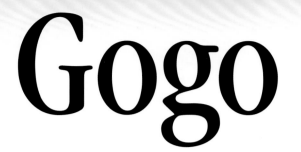

The mimicry master
of unknown origins.

Gogo ゴゴ

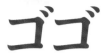

► Personal Data

Occupation	Mime
Hometown	Wrapped in mystery
Age	Wrapped in mystery
Birthday	Wrapped in mystery
Constellation	Wrapped in mystery
Height	166 cm (estimated)
Weight	60 kg (estimated)
Blood Type	Wrapped in mystery
Treasure	Wrapped in mystery
Likes	Wrapped in mystery
Dislikes	Wrapped in mystery
Interest	Mimicking

Lineage, gender, and even species are unknown for this creature wrapped head to toe in cloth. They have the ability to perfectly mimic anyone's actions. Gogo meets Celes's party inside the body of the massive monster Zone Eater. They learn that the others aim to save the world from Kefka, and Gogo joins them in order to mimic their deeds.

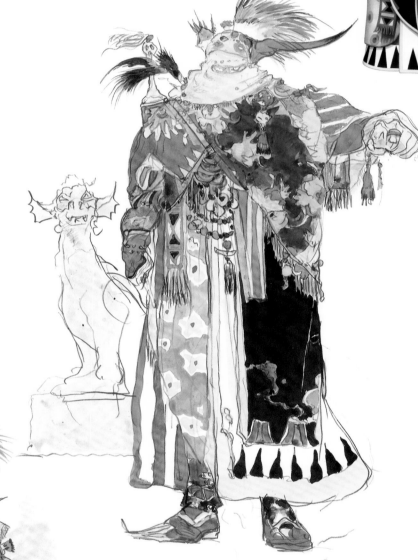

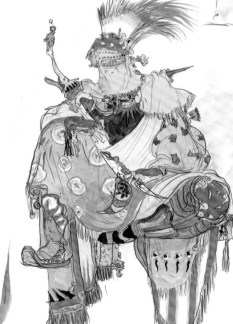

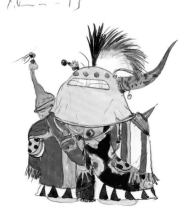

Umaro

Wild and hot-tempered artistic sculptor yeti.

ウーマロ
[Ūmaro]

▶ Personal Data

Occupation	Yeti
Hometown	Northern Narshe
Age	4 years counted
Birthday	September 9
Constellation	Virgo
Height	209 cm
Weight	198 kg
Blood Type	Red
Treasure	His favorite club (made from Behemoth bone)
Likes	Bones
Dislikes	Hairy caterpillars
Interest	Bone sculpting

An abominable snowman dwelling in the mines of Narshe. Umaro is just as strong as he looks, but is somehow no match for Mog. He treats the moogle as his boss, and joins the party at Mog's command. Though kind and docile, Umaro easily blows his top and loses himself in wild rampages.

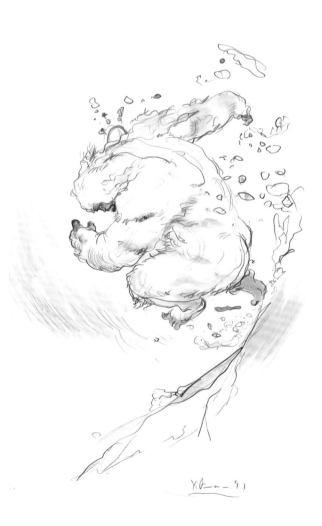

Memorable Quotes

MOG

"He kept showing up in my dreams and telling me to help you, kupo! So . . . I'm gonna help you, kupo!"

—In northern Narshe when asking Locke and friends for help.

The "old man" who taught Mog speech was actually the esper Ramuh. Wanting to aid Terra in her quest, he enlists Mog by using dreams to convince the moogle to answer the call.

"Kupoppo! You're alive! I thought you were all feeding the worms, kupo! Kupohoho! Let's go!"

—In Narshe, when reuniting with Celes's party in the World of Ruin.

After the world's collapse, all of the moogles in Narshe—save Mog—were wiped out. The solitary moogle is thrilled to reunite with his old comrades, and heads back to the battlefield holding his lover's keepsake charm.

GOGO

"I see . . . So, you seek to save the world? Then I guess that means I shall save the world as well. Lead on! I will copy your every move."

—In the Zone Eater's stomach when joining Celes's party.

Gogo joins the party not out of any heroic impulse, but for the chance to mimic those they deem interesting. This is the only time in the entire story that Gogo speaks.

UMARO

"Ooo . . . me Umaro . . . Yes, boss . . . Me join you!"

—In the Yeti's Cave when joining Celes's party.

While the details are fuzzy about how Umaro becomes Mog's underling, the orders issued by the moogle boss seem absolute to the yeti. Obeying Mog's commands, Umaro employs broken human speech to introduce himself to Celes's party.

"Ughaaa!"

—When destroying rocks to secure an escape route during the finale.

While fleeing Kefka's Tower, the party is unable to open a sealed door. Umaro uses his strength to open a path through a solid rock wall. The yeti's reputation for strength was clearly well deserved.

Fight to Protect Terra

Mog and ten of his moogle comrades help Locke protect Terra. Each moogle has a different name and skill, and Mog's lover Molulu is among them.

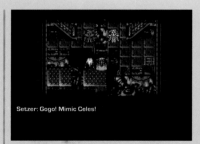

Mimic to Save

When escaping Kefka's Tower, the party reaches a room where two buttons need to be pressed at the same time. Gogo mimics Celes to press the buttons, allowing their comrades to escape.

His Precious Sculpture

Umaro's love of sculpture leads him to decorate his den with his own work of art. When the heroes try to touch the magicite used for the sculpture's eyes, the yeti goes ape and attacks the party.

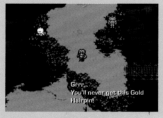

Hairpin or Hairy Pal?

Mog is taken hostage by Lone Wolf the Pickpocket. When he tries to resist, both of them fall off the cliff. Ramuh's words and Mog's gratitude that Locke and friends prioritized his safety over obtaining the thief's Gold Hairpin convince Mog to join the party.

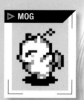
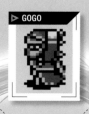

Memorable Scenes

I Came to Help!

In the end, any party members that did not join the final battle come to save their comrades in Kefka's Tower. If the taciturn Umaro or Gogo is among these members, players are treated to one more opportunity to hear them speak.

Kefka ケフカ
[Kefuka/Cefca]

Clown adrift in madness,
opposing Returner and emperor alike.

▶ *Kefka Palazzo* ケフカ・パラッツォ

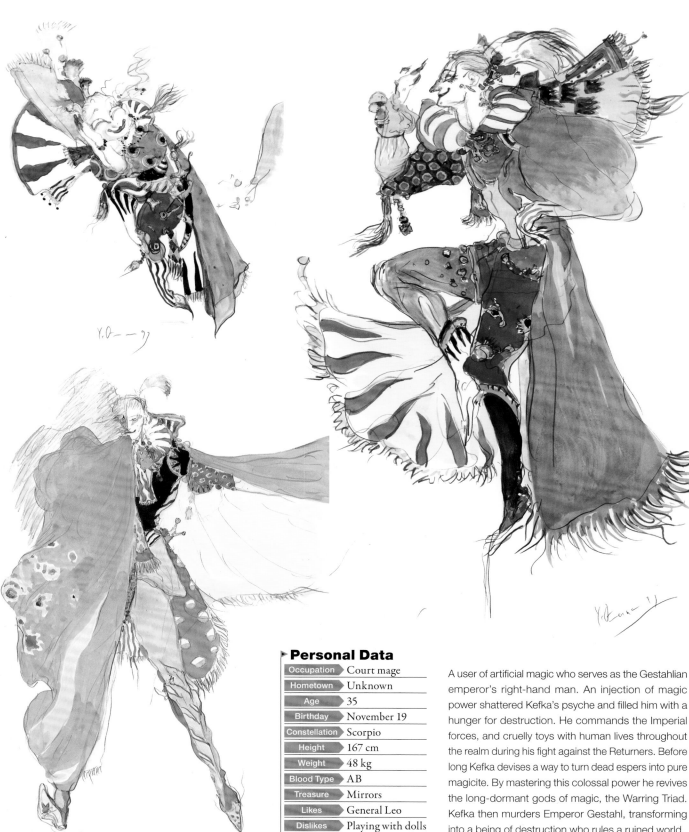

▶ Personal Data

Occupation	Court mage
Hometown	Unknown
Age	35
Birthday	November 19
Constellation	Scorpio
Height	167 cm
Weight	48 kg
Blood Type	AB
Treasure	Mirrors
Likes	General Leo
Dislikes	Playing with dolls

A user of artificial magic who serves as the Gestahlian emperor's right-hand man. An injection of magic power shattered Kefka's psyche and filled him with a hunger for destruction. He commands the Imperial forces, and cruelly toys with human lives throughout the realm during his fight against the Returners. Before long Kefka devises a way to turn dead espers into pure magicite. By mastering this colossal power he revives the long-dormant gods of magic, the Warring Triad. Kefka then murders Emperor Gestahl, transforming into a being of destruction who rules a ruined world.

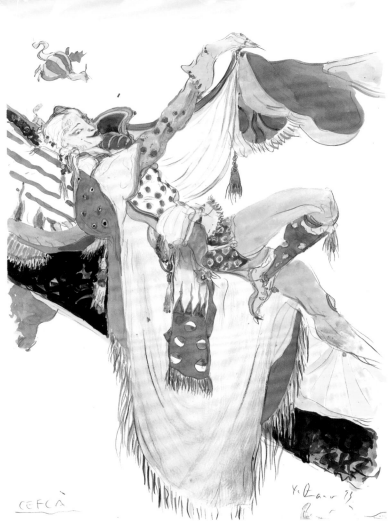

CEFCA

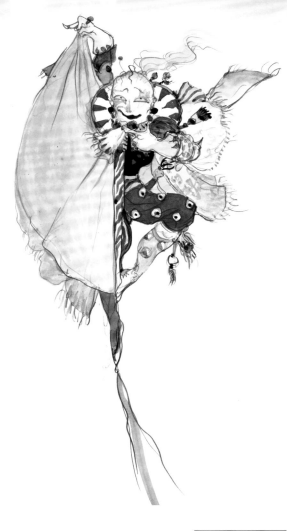

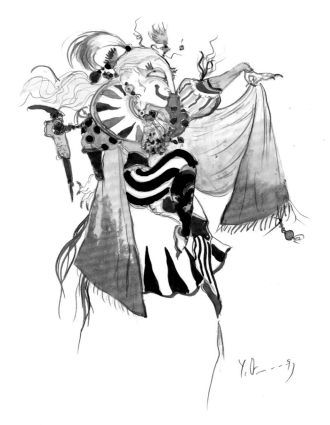

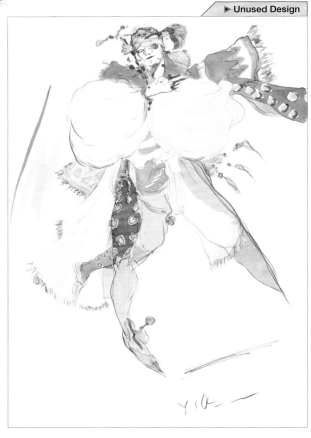

Memorable **Quotes**

▶ KEFKA

"Such magnificent power! You're all nothing more than fleas compared to me now! Embrace your destruction . . . It is the fate of all things."

—At Kefka's Tower, when confronting the heroes during the final battle.

Channeling the immeasurable power of the Warring Triad, Kefka intends to destroy everything other than himself. His perception of everyone else as mere insects demonstrates his contempt for other beings.

"I just can't believe it! What a bore."

—In the Imperial Palace, while expressing his displeasure at being imprisoned for his role in poisoning Doma Castle.

Kefka's habit of triumphantly shouting, only to pout sullenly mere moments later, is part of his clownish charisma.

"'Wait,' he says . . . Do I look like a waiter?"

—At Doma Castle, when fleeing from Sabin's pursuit.

With Sabin hot on his heels following the poisoning of Doma, the maniacal clown tries to flee the camp. Despite the grim circumstances behind the confrontation, this cat-and-mouse chase seems almost comical.

"You know, you really are a stupid . . . vicious . . . arrogant, whiny, pampered, backstabbing, worthless . . . little brat!!!"

—On the Floating Continent, handing Celes a knife so she can kill her comrades, only to lash out when he is stabbed instead.

Kefka, who loves seeing the blood of others, hates to suffer any injury to himself. He flies off the handle upon seeing his bloody wound, and descends into madness before the emperor's eyes.

"Hee-hee-hee . . . Behold! A magicite mother lode!"

—In Thamasa, when turning the attacking espers into magicite.

After massacring the espers and claiming their crystallized souls, Kefka laughs gleefully when procuring such a "mother lode" of magicite. Kefka's twisted brutality is fully revealed in this moment.

"Life . . . dreams . . . hope . . . Where do they come from? And where do they go . . . ? Such meaningless things . . . I'll destroy them all!"

—In Kefka's Tower during the final battle.

Each hero seeks their own light in the World of Ruin, but Kefka is filled with emptiness and works to deny their dreams. He wishes for a world of death, which inevitably culminates in a showdown with the party. The heroes' declaration of their individual reasons for living before the final battle is one of the game's most memorable moments.

Kefka: Oh? Then...enjoy the barbecue! Hee-hee-hee!

Figaro Invasion

Kefka marches on Figaro on the emperor's orders, despite the long history of friendly relations between the two kingdoms. With the alliance broken, flames rain upon the castle in an effort to smoke out Terra.

Leo: Kefka! What do you think you're doing!?
Kefka: Hee-hee-hee... Emperor's orders! I'm to turn all these espers into magicite.

The Thamasa Tragedy

The emperor orders Kefka to Thamasa to seek peace, but Kefka secretly hopes to draw the espers out of hiding and steal their power. Kefka kills the espers and transforms them into magicite, then deviates from his Imperial orders by killing his rival, General Leo.

A Coward's Poison

Maintaining a certain level of humanity is customary even on the battlefield, but the rules of war mean nothing to Kefka. Dismissing his subordinates, he poisons the river that supplies water to Doma Castle—killing every man, woman, and child within its walls.

Memorable **Scenes**

▶ KEFKA

Kefka: Oh dear... Well, I guess I was a bit hasty in calling you a useless old man before...

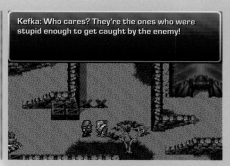
Kefka: Who cares? They're the ones who were stupid enough to get caught by the enemy!

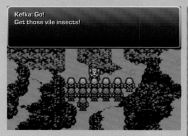
Kefka: Go! Get those vile insects!

Battle for the Frozen Esper

Kefka invades Narshe, making a second attempt to secure the frozen esper that Terra failed to obtain at the start of the game. He orders his troops to slaughter any resident who disobeys, and battles the Returners.

Not Even the Emperor Is Safe

After Thamasa, Kefka proceeds to the Floating Continent. His deference to Emperor Gestahl ends here. Kefka uses the power of the awakened Warring Triad to kill Gestahl, whom he secretly despised, and remakes the entire world.

Emperor Gestahl

ガストラ皇帝 [Gasu Tora Kōtei]

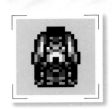

▶ **Personal Data**

Occupation	Emperor	Hometown	Unknown	Age	50
Birthday	October 26	Constellation	Scorpio	Height	179 cm
Weight	71 kg	Blood Type	B	Likes	Power
Dislikes	Obeying others			Interest	Collecting paintings

The despotic ruler who built up the Gestahlian Empire in a single generation. Gestahl researched the power of magic, which had been lost following the War of the Magi. By injecting magical power into the soldiers and weapons that made up his army, the emperor gained the power to conquer neighboring countries through military might. Emperor Gestahl raises the Floating Continent and restores the power of the legendary Warring Triad, but meets his end through the betrayal of his chief lieutenant, Kefka.

Memorable Quote

"This world will be mine to rule! Ha-ha-ha . . ."

—During Maduin's flashback of securing Terra,
with plans to exploit her esper blood.

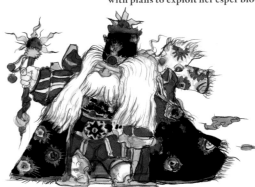

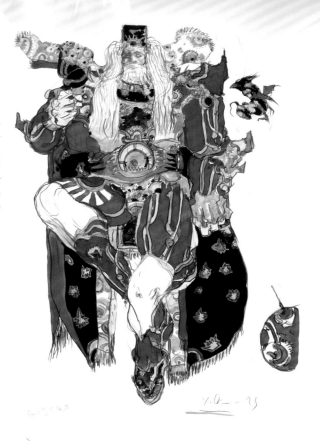

Leo (Leo Cristophe)

レオ [Reo]

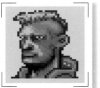

▶ **Personal Data**

Occupation	General	Hometown	Vector	Age	30
Birthday	July 8	Constellation	Cancer	Height	188 cm
Weight	83 kg	Blood Type	O	Likes	Chivalry
Dislikes	Cowardly deeds			Interest	Appreciating music

An exemplary commander in the ranks of the Gestahlian Empire. Leo, a chivalrous man who respects human life, is a natural antagonist to Kefka. Leo has no idea the peace talks at Thamasa are a charade, and goes there in good faith as the emperor's proxy. He tries to stop Kefka from turning the espers into magicite, only to be killed by the clown.

Memorable Quote

"You're a human being before you're a soldier. Don't be so eager to throw away your life."

—In the Imperial Camp, rousing his troops into raiding Doma Castle.

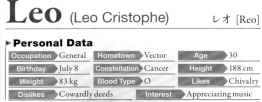

Cid (Cid Del Norte Marguez) シド [Shido/Cid]

▶Personal Data

Occupation	Inventor	Hometown	Vector	Age	46
Birthday	May 27	Constellation	Gemini	Height	163 cm
Weight	60 kg	Blood Type	B	Likes	Meditation, scholarship
Dislikes	Worldly things, especially money	Interest	Cultivating new species of plants		

A Gestahlian researcher of magic. Cid used the power extracted from espers to mass-produce magic-using warriors called Magitek Knights. He also treated Celes like his own daughter. During his interactions with the Returners, Cid realizes the heartlessness behind the application of his research. This motivates him to spearhead peace talks in the Imperial capital.

Memorable **Quotes**

"**You've helped me come to a decision. I'm going to talk to the emperor and make him realize how foolish this whole war is!**"

—In the Magitek Research Facility, upon realizing how espers are exploited.

"**Granddad, eh? Heh-heh . . . You're going to make an old man blush! All of a sudden I have a granddaughter!**"

—On Solitary Island, when Celes calls him "Granddad."

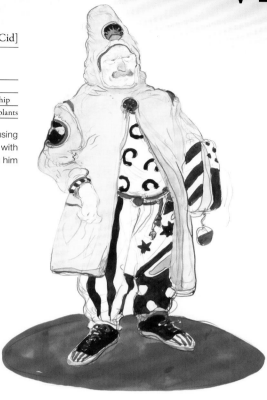

Banon

バナン [Banan]

▶ **Personal Data**

Occupation	Returner leader	Hometown	South Figaro	Age	54
Birthday	October 23	Constellation	Libra	Height	172 cm
Weight	70 kg	Blood Type	A	Likes	Peace
Dislikes	Chaos			Interest	Reading

The leader of an anti-Imperialist resistance group, the Returners. Banon grows curious about Terra after Locke brings her to the Returner headquarters. Believing that Terra can get them enough power to take on the Empire directly, he asks if she will negotiate with the espers on his behalf.

Memorable **Quote**

"You are this world's last ray of light . . . our final hope."

—At the Returner Hideout when persuading Terra, who fears her power.

Memorable **Scene**

Banon's Game Over

When the heroes escape the Returner Hideout and fall into the Lethe River, Banon temporarily joins the party. The man is more of an escort than a fighter. Banon acts as a cleric, allowing him to heal hit points for all allies, but his combat ability is poor. If he falls in battle, it's all over for the party.

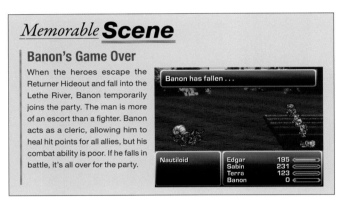

Biggs & Wedge

ビックス＆ウェッジ [Bikkusu & U~ejji]

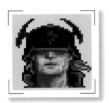

A pair of Gestahlian soldiers. Biggs and Wedge accompany the mind-controlled Terra to Narshe, and try to secure the frozen esper Valigarmanda. They are obliterated by the esper's power.

Memorable **Quote**

"Ah, yes . . . our witch. I hear she fried fifty of our Magitek armored soldiers in three minutes . . . Kinda makes your skin crawl, don't it?"

—Commenting on their traveling companion, Terra, during the opening scene.

Memorable **Scene**

Bathed in the Esper's Light . . .

Ordered to secure the frozen esper, Biggs and Wedge travel to Narshe with the brainwashed Terra. They defeat the town guards and the guardian beast Ymir, but when the esper resonates with Terra, it emits a beam of light that annihilates the pair.

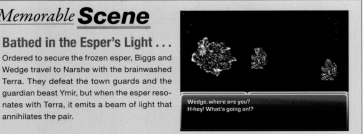

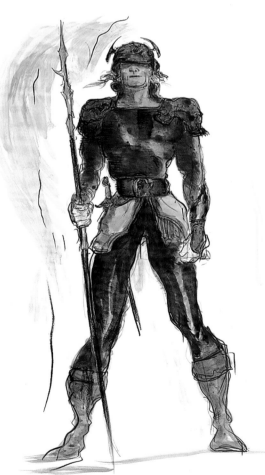

??????

ゆうれい [Yū Rei]

▶ **Personal Data**

Occupation	Ghost	Likes	Hell
Dislikes	Heaven	Interest	Floating

Ghosts that wander the interior of the Phantom Train, a vehicle that transports the souls of the dead to the spirit world. Most ghosts act belligerently toward the living, but some can be persuaded to help out.

Memorable **Quotes**

"...No...escape..."

—On the Phantom Train, when chasing Sabin's party after they defeated the ghost's comrades.

"Will you be dining with us?"

—On the Phantom Train, asking for Sabin's order after he takes a seat in the dining car.

Memorable **Scene**

Attacking or Befriending

Most of the ghosts will attack the members of Sabin's party, but some will offer items or food instead. There are also ghosts who will join the party, using their unique Possess skill to dispatch themselves and their target to the underworld.

Sabin: What's with this guy?
Cyan: He seems to want to accompany us.

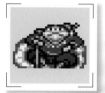

Owzer

アウザー [Auzā]

A wealthy man of Jidoor known for his art collection. Owzer hears rumors of Relm's special talent, and summons her to his mansion to paint a portrait of a goddess. But the painting is possessed by an evil spirit, forcing the heroes to lend a hand.

Memorable **Scene**

His Precious Painting, Possessed

Owzer purchased the magicite of the goddess Lakshmi at an auction. He wanted a goddess painting to accompany the magicite, and commissioned Relm for the job. Perhaps due to the power of the magicite, various paintings inside his mansion become animated by evil spirits, starting with Relm's creation. Celes and her friends handle the situation, causing a grateful Owzer to give the magicite to them. He awaits the day Relm returns to finish her painting.

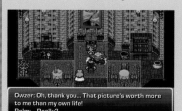

Owzer: Oh, thank you... That picture's worth more to me than my own life!
Relm: ...Really?

Memorable **Quote**

"P-please...Help the painting..."

—In Jidoor, begging Celes's party to deal with the possessed painting in his home.

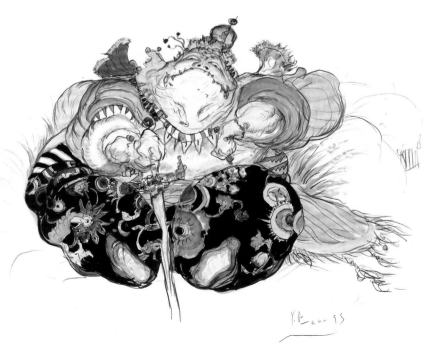

WORLD

FINAL FANTASY VI

ファイナルファンタジーVI

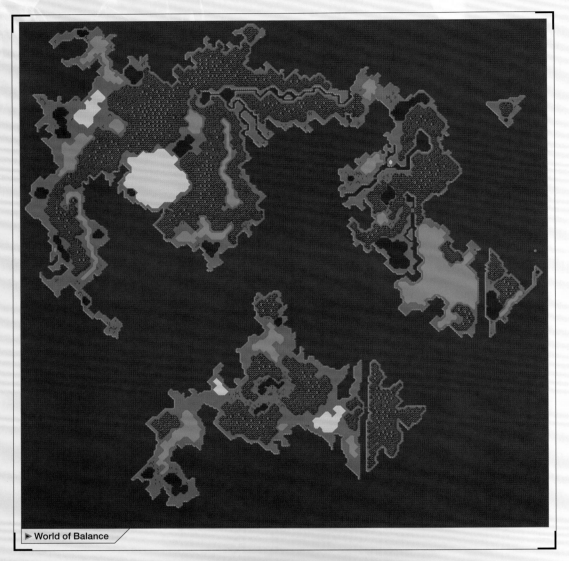

► World of Balance

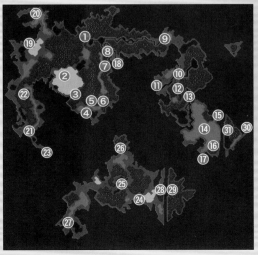

1 Narshe
2 Figaro Castle
3 South Figaro Cave
4 South Figaro
5 Duncan's Cabin
6 Mt. Kolts
7 Returner Hideout
8 Lethe River
9 Gau's Father's House
10 Imperial Camp
11 Doma Castle
12 Phantom Forest/
 Phantom Train

13 Baren Falls
14 Veldt
15 Mobliz
16 Crescent Mountain
 Cave
17 Serpent Trench
18 Nikeah
19 Kohlingen
20 Dragon's Neck Cabin
21 Jidoor
22 Zozo
23 Opera House
24 Albrook

25 Vector
26 Tzen
27 Maranda
28 Imperial Observation
 Post
29 Cave to the Sealed
 Gate
30 Thamasa
31 Esper Caves

At the start of the adventure there are two continents to the north and south, with the latter occupied by the Gestahlian Empire. After Kefka unleashes the power of the Warring Triad, the wild magic dramatically alters the landscape. The Serpent Trench rises above the water in the remade world to form a land bridge linking Mobliz and Nikeah.

► World of Ruin

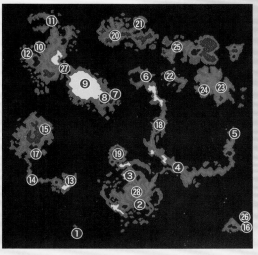

1 Solitary Island
2 Albrook
3 Tzen
4 Serpent Trench
5 Mobliz
6 Nikeah
7 South Figaro
8 South Figaro Cave
9 Figaro Castle
10 Kohlingen
11 Dragon's Neck Coliseum
12 Darill's Tomb
13 Maranda
14 Opera House
15 Zozo/Mt. Zozo
16 Thamasa
17 Jidoor
18 Cultists' Tower
19 Phoenix Cave
20 Narshe
21 Duncan's Cabin
22 Doma Castle/ Dreamscape
23 Veldt
24 Cave on the Veldt
25 Gau's Father's House
26 Ebot's Rock
27 Ancient Castle
28 Kefka's Tower

MONSTERS

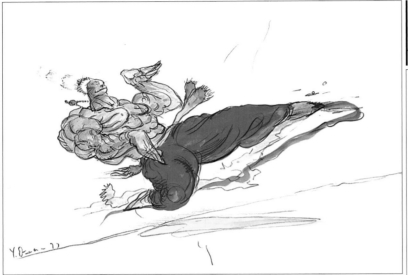

Dadaluma
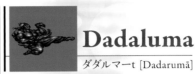

ダダルマーt [Dadarumā]

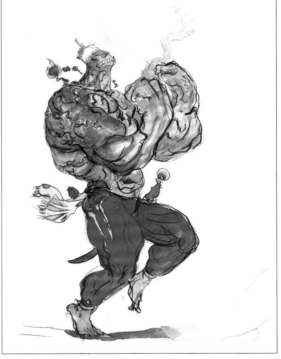

Magna Roader

マグナローダーズ
[Magunarōdāzu]

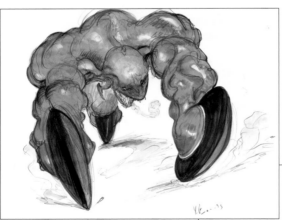

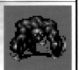
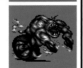
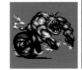

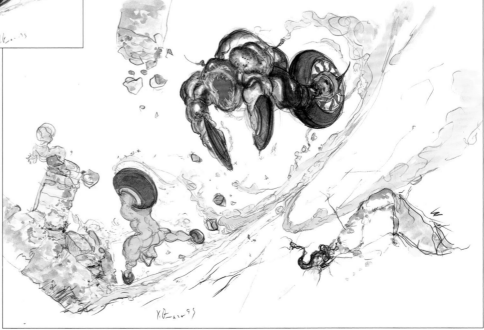

Number 024

ナンバー024 [Nanbā 024]

Number 128

ナンバー128 [Nanbā 128]

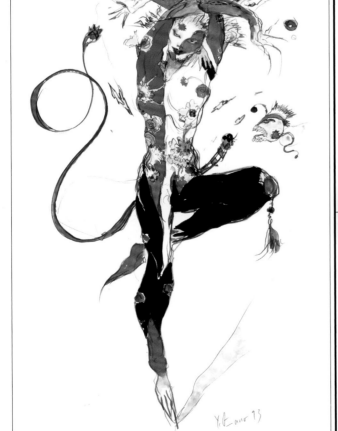

Nelapa

ネラパ [Nerapa]

Memorable Feature

The Final Monster of the Floating Continent

Nelapa waits near the exit as the party tries to escape the Floating Continent. Players must fight the monster as the continent counts down to its own destruction. Nelapa also casts Doom on the party at the start of the battle, increasing the general air of panic.

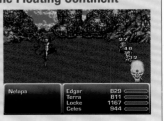

Tentacle
しょくしゅ [Shi~yokushu]

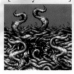

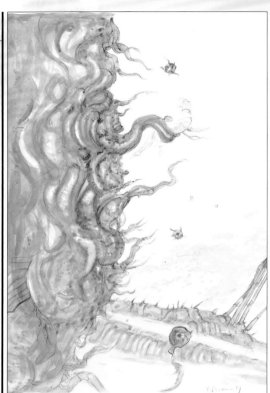

Clymenus
クリュメヌス [Kuryumenusu]

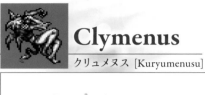

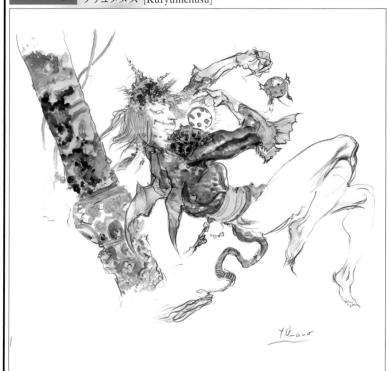

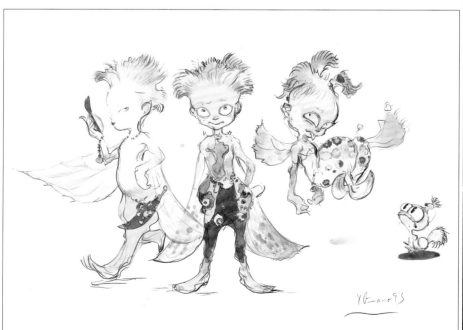

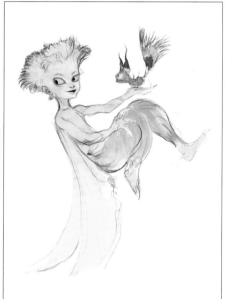

Dream Stooges
(Curlax, Laragorn, Moebius)

夢の三兄弟 (レーヴ、ソーニョ、スエーニョ)
[Yume no Sankyōdai (Rēvu, Sōnyo, Suēnyo)]

✤ From left: Moebius, Laragorn, Curlax

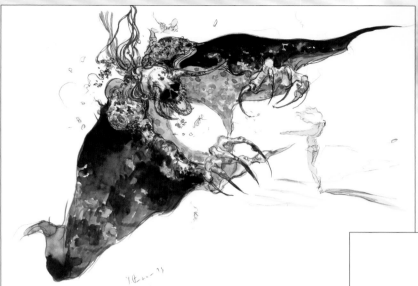

Deathgaze
デスゲイズ [Desugeizu]

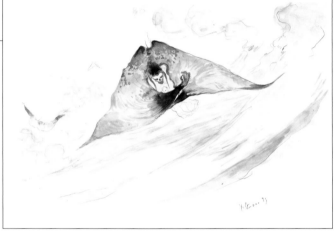

Memorable **Feature**

The Ruined World's Aerial Menace

The party may encounter the elusive Deathgaze while flying the airship through the skies of the World of Ruin. This monster is known for fleeing battle, though it will not regenerate its hit points. To defeat Deathgaze and obtain the Bahamut magicite, you must chase the monster all over the map and weaken it through multiple encounters.

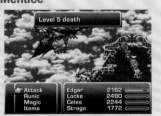

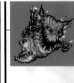

Typhon
テュポーン [Te~yupōn]

Memorable **Feature**

Huffing, Puffing Coliseum Combatant

Typhon appears on the Floating Continent as Ultros's bodyguard, but following the world's destruction the two are seen working together at the Dragon's Neck Coliseum. Wagering common items—like potions—will cause Typhon to show up for the fight, where he will use Snort to blow your party members away.

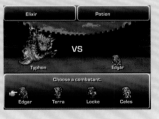

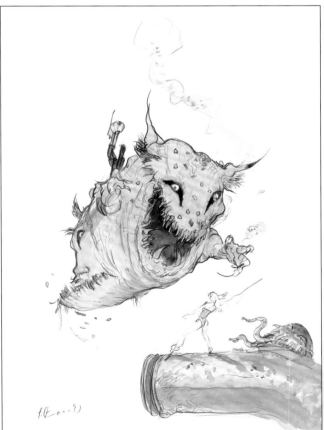

Ultros
オルトロス [Orutorosu]

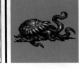

TETSUYA NOMURA MONSTER DESIGNS

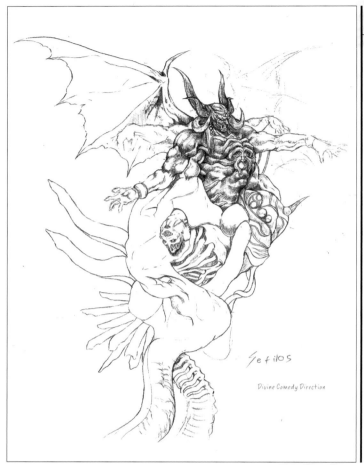

Sefilos

Divine Comedy Direction

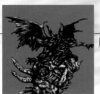

Fiend

魔神 [Majin]

One of the Warring Triad, the source of all magic. The word "Sefilos" is written as a temporary name in the sketch, as well as the idea that the Fiend is related to *The Divine Comedy*.

Memorable **Feature**

Force Field Cram Session

The Fiend is the only caster of the learnable skill Force Field. For Strago to learn this ability, he must be in one of the parties that climb Kefka's Tower, and must be the one who fights the Fiend.

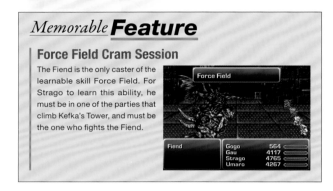

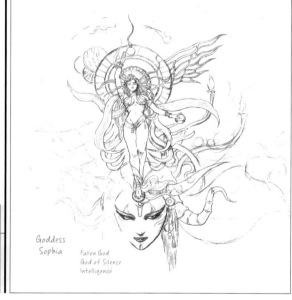

Goddess Sophia

Fallen God
God of Silence
Intelligence

Goddess

女神 [Megami]

A deity of the Warring Triad that appears as a beautiful woman. Though only half of the massive witch face at the Goddess's feet appears in-game, you can still make out its sly smile. During development, her proposed name was Sophia, after the pagan goddess of wisdom.

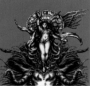

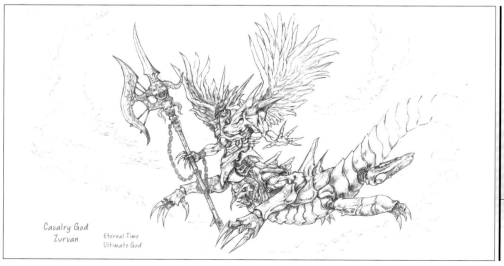

Cavalry God
Zurvan

Eternal Time
Ultimate God

Demon

鬼神 [Kishin]

A ferocious deity clutching a menacing war axe. Its weapon is adorned with demon skulls. Notes mention Demon's temporary name (Zurvan), "eternal time," and "ultimate god."

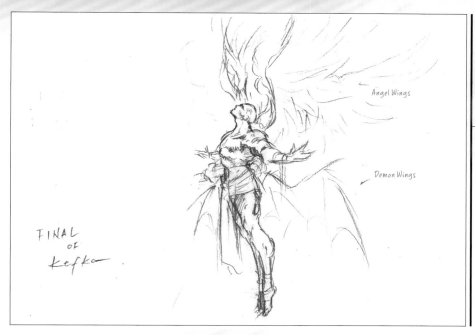

Angel Wings

Demon Wings

FINAL
of
Kefka

Kefka (Final Form)

ケフカ（最終形態）
[Kefuka (Saishū Keitai)]

Having absorbed the power of the Warring Triad, Kefka controls all reality as the god of magic. His transformed appearance is an ominous mix of good and evil divinity, with angel wings sprouting from his shoulders and devil wings growing from his waist.

The Warring Triad

神々の像 [Kamigami no Zō]

The statue fought in three stages during the final confrontation. The Triad must be fought from the bottom upward, with the music changing as the player progresses through each stage. Their complex design incorporates elements from humans, demons, and machinery. Some parts are reminiscent of Kefka himself.

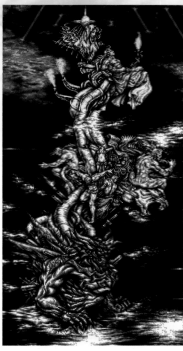

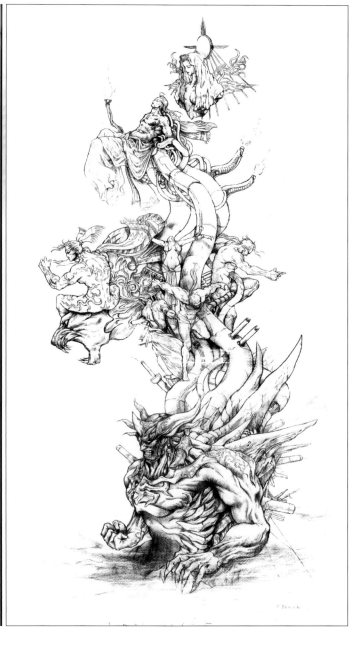

Memorable Feature

A Final, Brutal Blow

The statue battle is split into parts, and each section unleashes an attack when beaten. Repose—an instant kill attack—is particularly troublesome, as characters struck by this ability will be removed from the party before the final battle with Kefka. If this happens to a player's go-to character, disaster will likely follow.

Celes	2531
Terra	2395
Locke	2258
Edgar	2648

EXTRA CONTENT

ESPERS

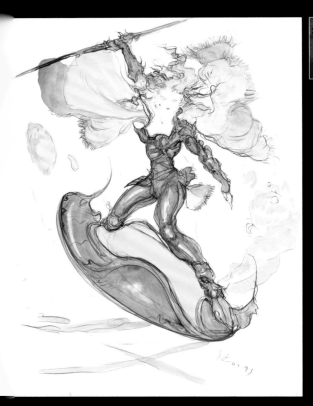

Goddess (Crusader)

One of the Warring Triad. The three deities appear when the Crusader magicite is used, inciting their final battle and catching friend and foe alike in the crossfire.

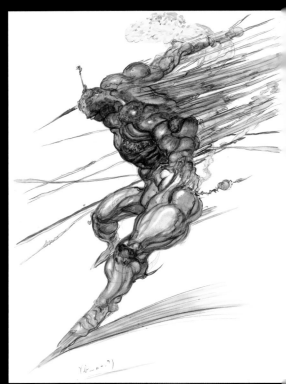

Devil (Crusader)

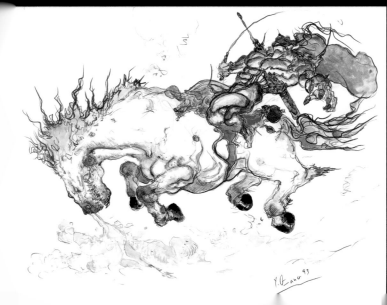

Raiden

A more powerful version of the esper Odin, powered up through the tears of the queen at the Ancient Castle. He uses Shin-Zantetsuken to cleave enemies in half at a much higher rate than his previous form.

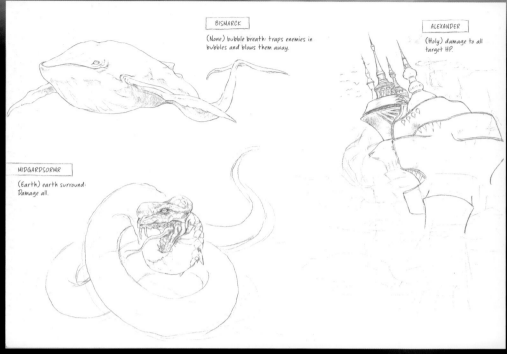

BISMARCK
(None) bubble breath: traps enemies in bubbles and blows them away.

ALEXANDER
(Holy) damage to all target HP.

MIDGARDSORMR
(Earth) earth surround: Damage all.

Esper Rough Sketches
(Bismarck, Midgardsormr, Alexander)

Rough sketches of three espers that appear in *Final Fantasy VI*. The sprites to the left were created based on these sketches. In addition to the esper names, the notes also comment on their attacks, effects, and attributes.

OTHER ILLUSTRATIONS

Imp

Illustrations of the characters' appearances when under "Imp" status. Opening the menu while a character is in Imp status will display a character illustration similar to the one at left.

CHARACTER SPRITES

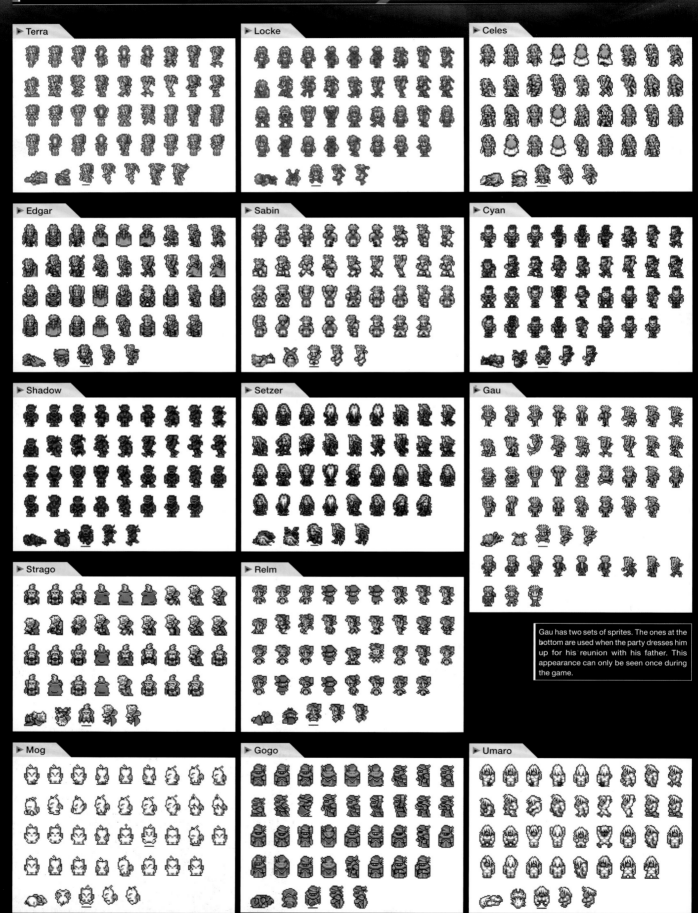

▶ Terra

▶ Locke

▶ Celes

▶ Edgar

▶ Sabin

▶ Cyan

▶ Shadow

▶ Setzer

▶ Gau

▶ Strago

▶ Relm

Gau has two sets of sprites. The ones at the bottom are used when the party dresses him up for his reunion with his father. This appearance can only be seen once during the game.

▶ Mog

▶ Gogo

▶ Umaro

▶ Kefka

▶ Leo

▶ Banon

▶ ??????

▶ Imperial Soldier

▶ Merchant

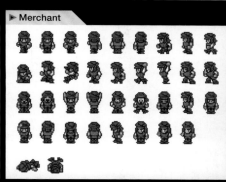

▶ Imp

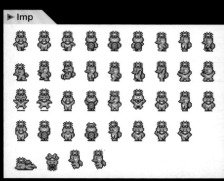
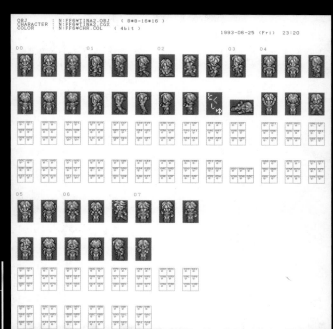

Early Development Terra

Sprites of Terra before her design was finalized. Not only is her hair blond—as in the illustrations on pages 264–268—but it is not put up in a ponytail. This makes her look like a completely different person.

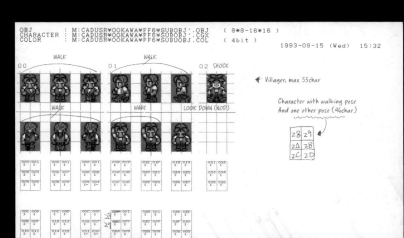

Villager

Sprites of a villager. Made from 8x8-pixel blocks in a 3x2 layout, these were enlarged to the same size of the battle sprites in previous Final Fantasy games.

TETSUYA NOMURA CHARACTER SKETCHES

Character Caricatures

Caricature sketches of the main characters. Drawn in the traditional left-facing pose, these cute renditions provide a variety of expressions for each character.

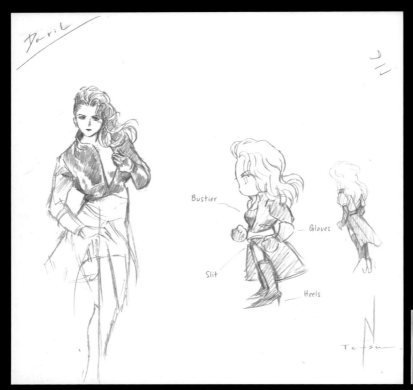

Bustier

Gloves

Slit

Heels

Darill

A sketch of Setzer's dearly departed girlfriend. A signature *Final Fantasy* caricature is drawn next to a more realistic portrait, with added details regarding Darill's garments.

SCENARIO PLANNING

World of Balance World Map

A map of the world before it falls to ruin. Regions and areas are numbered in order of story progression. The darker areas represent impassable mountain regions.

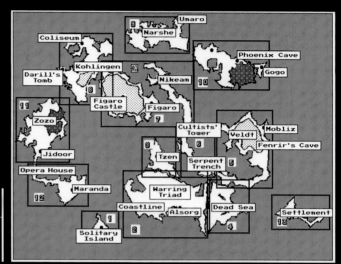

World of Ruin World Map

A map of the collapsed world, with the placement of key facilities. There are a few notable differences when compared to the final map, including Mobliz's connection to the Veldt, and the Phoenix Cave on the northern continent. Thamasa was a settlement here, and some places bore different names.

Floor	Dungeon	Enemy Type
1	Celes's Solitary Island	Extinct monsters
	World map [2] [3] [4] [5] [6] [7]	
4	Tzen rubble dungeon (Sabin rescue)	Monsters
1	Veldt (with Gau)	Monsters
5	Veldt (with Interceptor)	[Mid-boss] Wolf enemies
?	Humbaba (traversing world map)	[Mid-boss] Humbaba
5	Under Figaro Castle, to engine room	Underground monsters [Mid-boss] Tohu Bohu
7	Desert underground cave/ancient castle (get Odin)	Monsters
	When Figaro Castle gets running . . . You can go to the world map [8]	
9	Darill's Tomb	Monsters [Mid-boss] Ultima Weapon
	(Built a nest in the tomb)	
	Enter the tomb and get the airship, and you can go anywhere on the world map	
?	Sky	[Mid-boss] Deathgaze
?	Narshe (frozen esper)	[Mid-boss] Valigarmanda (Puzzle-solving battle)
6	Mt. Zozo (When you walk further into Zozo . . .)	Monsters
50	Phoenix Cave	Monsters
3	Jidoor noble's house	Painting monsters [Mid-boss] Chadarno
8	Settlement 2 dungeon (different than before)	Monsters
10	Dream castle	Monsters [Mid-boss] Laragorn, Curlax, Moebius
10	Last dungeon	[Boss] Warring Triad [Boss] Kefka 6 [Boss] Weakened Kefka 7

Story Order Dungeon List (World of Ruin)

Dungeons are listed by the order in which they are visited in the World of Ruin. Dungeon floors and boss names appear side by side. The Phoenix Cave has fifty floors, and there is a proposal to fight Kefka again after you defeat him the first time.

OPERA EVENT PLANNING

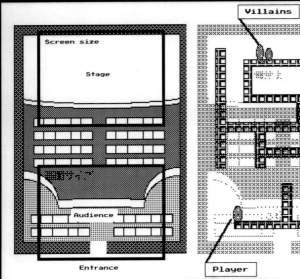

▶ Theater and Catwalk Sketches

Catwalk Event Ideas

A design document outlining the events that occur at the Opera House. The set piece where a four-ton weight falls from the catwalk remains the same in the final game, but ultimately Ultros would be the one to interrupt the opera instead of Biggs and Wedge.

▶ Early Plot Portion

S030M02:
Biggs: Okay! Let's go with that plan. ↓
Wedge: I'll climb into the catwalk, and from there ↓
I'll drop icicles on their heads. ●
Biggs: How heavy are they? ↓
Wedge: 4 tons. ↓
Biggs: Hee hee hee. They'll be ↓
squashed for sure. ●
Wedge: Yep, they'll leave this world. ↓
Heh heh heh heh heh heh.

Timed Battle Ideas

Ideas for a battle against Biggs and Wedge, the enemies who would drop the weight from the catwalk. The fight would play out similar to the image below, as a timed battle where Biggs would drop weights while Wedge would prevent him from being targeted.

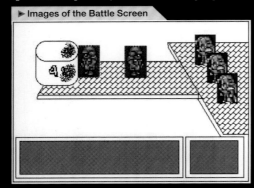

▶ Images of the Battle Screen

▶ Early Plot Portion

S031M09_1:
Biggs: This thing's heavy!
It'll take some time to drop it. ▽
S031M09_2:
Wedge: I'll keep these guys busy
in the meantime. ▽

[Auto-timing to here ▲]
[Time flows naturally from here ▼]
; ■ Jump to ceiling beam map (music loops from the top)
; The beams are like a maze.
; Biggs and Wedge objects in the middle.
;
; There's a battle when you get to them. [Time limit battle]
; Go to battle scene......
 Biggs pushes the 4-ton weight to drop down.
 It moves slowly along the top of the screen.
 Wedge supports in front.
 The party only fights with Wedge (Biggs cannot be targeted).
 If you lose the battle, or if time runs out:
 The weight falls onto the stage.
 Celes dodges at the last second, but the performance is ruined.
 If you defeat Wedge:
 Return to main
S031M0a:
Biggs: Ah, dammit! ▽
; The party tackles Biggs.
; Everyone falls onto the stage with force.
;
; ■ Jump to the onstage map.
; Biggs and the party fall onto Draco
; and Ralse.

S032M09:
Impresario: Oh noooo!
If those two flake out the show can't go on!
Who in the world will act as the queen? ▽
S032M0a:
Locke: The one to
marry Maria won't be
Draco or Ralse!! ●
It'll be the world's greatest
adventurer, Locke! ▽
S032M0b:
Impresario: Oh nooo,
What terrible acting! ▽
S032M0c:
Wedge: Shut your yap!
We're soldiers of the Empire!
We won't lose to the likes of you!
We'll fight you before you
defeat the icicles! ▽
S032M0d:
Audience Member 1: The Empire?
That's not what this play is about, is it?
Audience Member 2: What the heck
is an icicle?
Ah who cares, this's just gotten interesting!
Audience Member 1: Yeah, you guys go for it! ▽
S032M0e:
Elder: Grr, I don't care anymore!
Start the music! ▽

; At first Locke is flustered, but his quick wit prevails . . .

; [Mid-boss] [Wedge]
;
; [To battle scene]
; (The music turns up-tempo. "Opera 6")
;
; The battle takes place on the stage.
; The audience cheers during the battle.
; For example, if you block an attack with a shield, they'll go "Oooo,"
; if you use cool magic they'll clap,
; if someone is KO'd they scream.
; *If you lose the battle:
; Game Over.
; *If you win the battle:
; Transition directly into battle screen event.
; Locke: We got you!
; Celes appears on the left side of the screen.
; "Thanks for protecting me."
; "Yes. In this world, the Empire is evil!
; The ones to punish that evil won't be the
; east or west armies. It'll be us, the Returners!
; ...Oh, princess...would you be my bride?"
; "Yes, of course!"
; A spotlight shines on them as they embrace.
; The audience gives a standing ovation!
; Return to main.
;
; Onstage.
; All actors join hands for a curtain call
; and smile at the audience's praise. The troupe leader
; takes to the stage.
; The collapsed Wedge is pulled offstage by a stagehand.

▶ Early Plot Portion

Stage Battle Ideas

A draft for a battle to take place after friend and foe fall from the catwalk onto the stage. The audience would react to various battle actions, and after victory had been achieved the opera would continue on the battle screen.

FINALE PLANNING MATERIALS

Cutscene Images

Ideas for cutscenes displaying episodes for each character during the first half of the finale. Graphic director Hideo Minaba wrote these specifications for how each character's items should be displayed at the start of their respective episodes.

Cyan

Not much for this one.
Three sparkles of light appear in a line on the sword blade.
It'll probably be cooler to let it keep scrolling.

Setzer

(A die might appear.)
When the screen stops...
↓

Cards flutter down from the top of the screen.
(Maybe it's too slow to let some of the cards disappear?)

✴ Edgar

Opens on an open space.
...And then...

A coin comes spinning out from the darkness on the left.
It stops dead on Edgar's side.
(Scrolling stops at that moment.)

Celes, Locke

The pattern of stopping in the middle of the screen.

Tip of the bandana blows in the wind.
↓
(Celes's name is displayed.)

This part falls off.
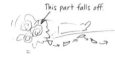
This time the bouquet rustles in the wind.
...At the same time, a single flower falls from the bouquet and floats around.
↓
(Locke's name is displayed.)

✴ Terra
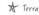
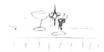
The pendant draped on the glass sparkles.
(Nonstop.)

Umaro
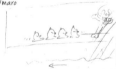
When it fades in, moogles from earlier run in.

Creak

The skull's jaw falls off, scaring the moogle in front.

(Scrolls nonstop.)

✴ FIELDINN, scr

'869
196 9
1F

14 0
13 3
11
13

Finale Item Cutscenes Early Plot

The plot, before the finale cutscenes were finalized. From these, we know that each character's unique item was to be placed on the top of the table. Details for each item are written here. The majority of the names went unchanged in the final release.

The FF main theme plays with static mixed in (like a gramophone).
The screen slowly scrolls up onto a phonograph.
It opens, and the screen cuts to black.
(The music changes from gramophone mode to clear sound.)

A spotlight shines on the stage, revealing a round table for props.
Various props sit atop the table.

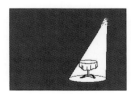

When you scroll up, you see a collection of names and data (unnecessary?).

Terra
Locke Bandana? Some kind of event, to an item tying Locke and Celes...
Edgar The coin turns, showing Edgar and Sabin on each head
Sabin Coin
Celes Locke's bandana
Cyan Picture of his wife and son, or a Japanese sword
Gau Gau's treasure (diving helmet)
Strago A scroll of legendary monster techniques (text on an object)
Relm Sketches (easel in the corner of the room)
Shadow Shuriken
Setzer Cards or dice
Mog Odd fruit (an event involving his favorite food . . .)
Gogo Mask
Umaro Sculpture

Note: Interceptor Food dish

Second Half Finale Storyboards

Storyboards for the latter half of the finale, in which the heroes escape Kefka's Tower aboard the airship. These were ultimately redone several times, but what is written here remains very close to the final version.

1

(OKATA) — Okata mine cart shot

(HARADA) — Sea of clouds spreads out below from the whiteout.

(5 Seconds) (note) no rotating, just a straight path

(KITASE) — Sub event
Esper Terra flies in front.
But her power wanes, and she falls from the sky.

(HARADA) — (2–3 Seconds)
Another first-person scene.
Terra falls into the sea of clouds.
The airship chases after her, and clouds approach from the front.

(Sub-event) — A scene of Katarina thinking about Terra.
On deck, they succeed in saving Terra.
Everyone celebrates.

Setzer: All right, let's go!

Music (part 1)
Part 2. 1 Minute 15 seconds
Part 3 Setzer's melody

SQUARE

2

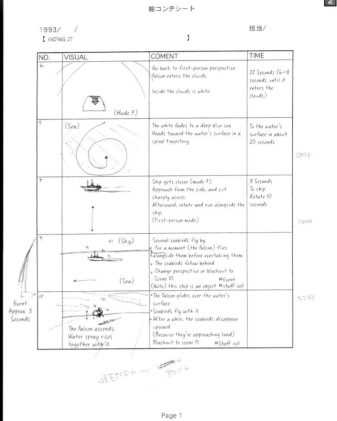

絵コンテシート

1993/　/　　　　　　　　　　　　　担当/
【 ENDING 2T 】

NO.	VISUAL	COMENT	TIME
6	(Mode 7)	Go back to first-person perspective. Falcon enters the clouds. Inside the clouds is white.	22 Seconds (6–8 seconds until it enters the clouds)
7	(Sea)	The white fades to a deep blue sea. Heads toward the water's surface in a spiral trajectory.	To the water's surface in about 20 seconds
8		Ship gets closer (mode 7). Approach from the side, and cut sharply across. Afterward, rotate and run alongside the ship. (First-person mode)	8 Seconds To ship Rotate 10 seconds
9	(Sky) (Sea)	Several seabirds fly by. For a moment (the falcon) flies alongside them before overtaking them. The seabirds follow behind. Change perspective or blackout to Scene 10. #Event (Note) this ship is an object #staff roll	
10	The Falcon ascends. Water spray rises together with it.	The Falcon glides over the water's surface. Seabirds fly with it. After a while, the seabirds disappear upward. (Because they're approaching land) Blackout to scene 11. #Staff roll	

Event Approx. 5 Seconds

d8E000H ～ 8000H

Page 1

3

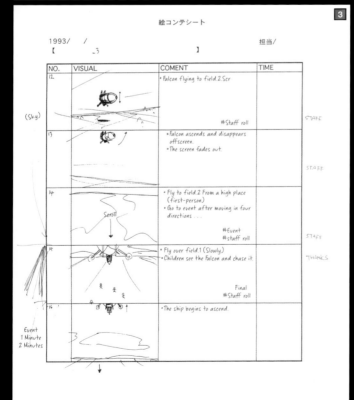

絵コンテシート

1993/　/　　　　　　　　　　　　　担当/
【　　　 3 】

NO.	VISUAL	COMENT	TIME
12	(Sky)	Falcon flying to field 2.Scr #Staff roll	STAFF
13		Falcon ascends and disappears offscreen. The screen fades out.	STAFF
14	Scroll	Fly to field 2. From a high place (first-person) Go to event after moving in four directions.... #Event #staff roll	STAFF
15		Fly over field 1. (Slowly.) Children see the Falcon and chase it. Final #Staff roll	THANKS
16		The ship begins to ascend.	

Event 1 Minute 2 Minutes

Page 1

4

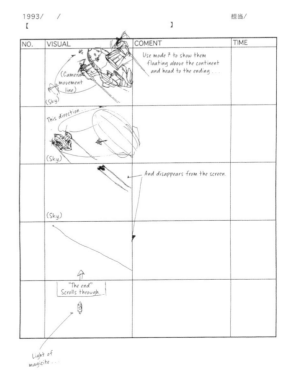

1993/　/　　　　　　　　　　　　　担当/
【　　　　 】

NO.	VISUAL	COMENT	TIME
	(Camera movement line) (Sky)	Use mode 7 to show them floating above the continent and head to the ending....	
	This direction (Sky)		
		And disappears from the screen.	
	(Sky)		
	"The end" Scrolls through		

Light of magicite....

Page 1

► Scene Details ①

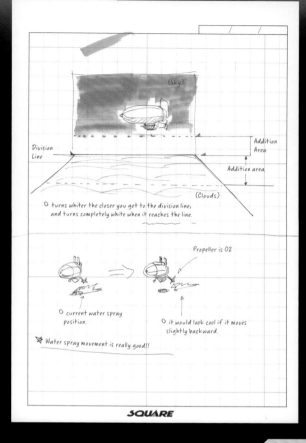

(Sky)

Division Line

Addition Area

Addition area

(Clouds)

○ turns whiter the closer you get to the division line, and turns completely white when it reaches the line.

Propeller is 02

○ current water spray position.

○ it would look cool if it moves slightly backward.

✗ Water spray movement is really good!!

SQUARE

► Scene Details ②

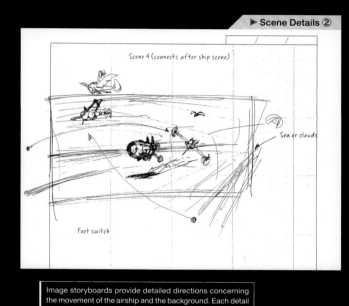

Scene 4 (connects after ship scene)

Sea or clouds

Foot switch

► Scene Details ③

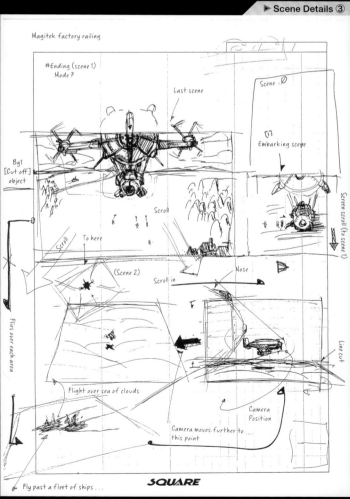

Magitek factory railing

#Ending (scene 1) Mode 7

Scene .0

Last scene

Embarking scene

Bg1 [Cut off] object

Screen scroll (→ scene 1)

Scroll

Scroll

To here

(Scene 2)

Nose

Scroll in

Flies over each area

Flight over sea of clouds

Line cut

Camera Position

Camera moves further to this point

Fly past a fleet of ships . . .

SQUARE

Image storyboards provide detailed directions concerning the movement of the airship and the background. Each detail in these images was faithfully re-created in the game. The sheet of spray kicked up by the airship was a favorite detail among the staff.

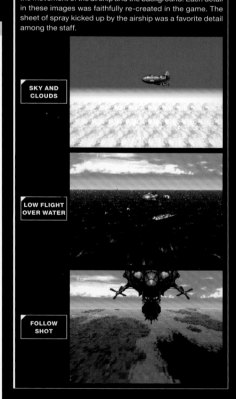

SKY AND CLOUDS

LOW FLIGHT OVER WATER

FOLLOW SHOT

DUNGEON GIMMICK IDEAS

Various ideas for gimmicks to be implemented into dungeons. Many of these have strong puzzle elements. Originally, plans existed for a minigame in which the player would ride the rail car to escape the Magitek Research Facility.

Dungeon gimmicks

#1

⑥ Object monsters wandering around when you go down a floor.

Ⓖ Tiles turn gray where the player character walked.

Ⓖ When all tiles are gray, the stairs down to the next floor appear.

Ⓖ Running into an object monster will cause a battle. (< Strong.)

(Maybe wiping out all the monsters on a floor opens up the stairs?)

#3

Lowers (set interval)

Ceiling lowers with a resounding crash.
There are safe spaces in the ceiling.

Gimmicks similar to #3 and #5 were adapted into the final game. Specifically, the "falling ceiling" gimmick from #3 appeared inside the Zone Eater's belly, and players must reassemble a scattered party similar to #5 while inside the Dreamscape dungeon.

#5

⑥ The four members of the party get separated in a dungeon or maze. (A teleporter-like trap or something.)

①~④

Trap

Play as someone and explore the dungeon (maze) for their comrades.
(Maybe defeat a boss with 1–2 characters.)

Does not open until all four members are present

4 Shift tiles

Each space has a patterned tile on it (◎, ◻, ◢, ▦, etc.)

When the player steps on a tile, each one will move up, down, left, or right until it hits other tiles or walls.

The player must ride the tiles to move. Afterward you walk the path you made to proceed to the next area.

Making all of the tiles the same pattern, to confuse people, could be fun.

Flaw: might make a rather large area necessary.

#2 Object monsters take a step each time the player character takes a step

Type A 🐺 Moves same direction as player

Type B 🐑 Moves opposite direction of player

Type C 🦊 Does not move

When players stand on same tile as/tile next to a monster

Battle ← Strong

#4 Dungeon in a deep, distant place.

Specialty Store

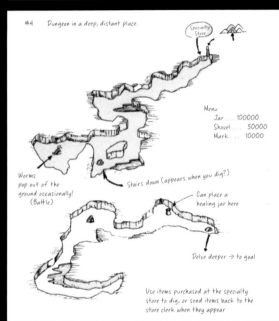

Menu
Jar 100000
Shovel 50000
Mark 10000

Worms pop out of the ground occasionally! (Battle)

Stairs down (appears when you dig?)

Can place a healing jar here

Delve deeper → to goal

Use items purchased at the specialty store to dig, or send items back to the store clerk when they appear

Sculpture blocking the corridor

Map: 1

Strange Statue

To map 2 ←

To map 3 ←

Entered from here

. When going through the passages, a stone sculpture blocks your way.

. When you get a step away from the statue, it moves forward to meet you.

. Return the way you came and it'll follow behind (4 steps in the map to the left)

. It follows by mimicking your movement. If you go to the right and there's a wall to the statue's right, it will not move, although it will face to the right.

Map: 2 Complicated road

. The player character goes to map:3, guiding the statue into the corridor of map:2. Walking around the space will fix the statue and let you leave.

. If the player character falls into a pit or removes the statue from the screen to try again, the statue will return to its initial position.

Map: 3 Open space

Pitfalls everywhere and stairs going down.
Pitfalls go into a black room with nothing but stairs.

. Set the statue into the right place to continue ahead.

Lower floor

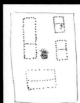

Rotation panel

Stepping on the panel will make the floor above rotate 90°

Upper floor

Only 1 pattern lets you through. Cannot proceed if you do not rotate the bottom floor properly.

Quite large

The player will fall, bounce around, and land. Where they land depends on where they fell from. Forced scrolling—maybe trace the character's path to show where they've fallen?

Settlement dungeon (digging dungeon)

When you find the entrance to this dungeon in the settlement:
"The soil is soft, you can dig here.
But if you dig too much you'll trigger a cave-in. XX more seconds."

Dig freely to uncover treasure chests (in set locations).

Of course, it is possible not to find anything.

Dungeon where everything is transparent except for the floor. Treasure chests and the like are transparent. Shines like glass here and there every once in a while.

Avoid combine at all costs. Guard monsters pass through horizontally. They will sound an alarm if they see you, and strong monsters will appear en masse.

MINE CART (to escape the Magitek Research Facility)
Side-scrolling (isometric view)

Directional buttons = press up and down repeatedly to speed up
(Stop pressing to slow down)

Mine cart connection . . . Touch to connect
Disconnection . . . A button

Transfer (Forward) . . . Right button
(Backward) . . . Left button

As the mine cart progresses the path splits and merges, and empty carts run along and stop.

Merge

Use the Up/Down buttons to speed up and attach to mine carts that merge and run parallel to yours. (Linking them will make you slow down.)

$$1/2 M v^2 = 1/2(2m)v^2$$
$$1/2(M v^2 + h v^2) = 1/2(M+m)v^2$$
etc.

Right button to transfer, release the mine cart with the A button. The enemy will slow down and you will speed up!

Road Fork

Lure them in until they're about to touch, then press the Up button (or Down) to branch off and lose your tail for a while.

EARTHQUAKE (dungeon)

Walking into a wide area will make an earthquake suddenly occur. Step count?

Players head toward the exit, but each tremor reduces the amount of space to walk upon. What's more, the tremors move the player character to an adjacent tile (at random).
Suddenly the exit is buried, after which another exit is made from a fissure (maybe at random?).

Depending on where it appears, it could be close or far away (treasure chests en route will also be swallowed).

By using the magic float you can go straight to the exit and avoid falling into fissures (earthquakes will not occur either).

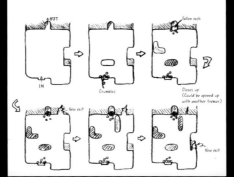

BARRICADE

Before the simulation battle in the cave, you freely set rocks onsite within the time limit.

Until enemies arrive

0:55 Seconds

Beeps when time runs out.

CURSOR

Move the cursor with the directional buttons, and press the A button to gather/place rocks. Even if you move all of them and finish, the countdown will continue (to allow rests). If time runs out while the player is moving them, the rocks will remain where they are.

Enemies enter from here

It takes allies and enemies two actions to climb over a rock.

In other words:

Movement from A to B will take 2 seconds, but if there's a rock in the way it'll take an extra second (3 seconds total).

Moving over two rocks as in C to D takes 5 seconds (3 rocks takes 7 seconds).

Cave of Wisdom

A stone statue blocks your way. Pressing A button talks to it and it will explain the cave, after which it will ask questions.

Explanation Outline — Answer the statue's question to have it open the path (only one right answer).
— Answer correctly to go further within, encounter another statue, and answer another question tougher than the last
— Answer incorrectly and go to a small room with a treasure chest inside, whose contents depend on how many questions were answered correctly. (Players warped aboveground after opening it and cannot go inside anymore.)

Deeper in the statue will talk before it asks its question.
"Feel like dropping out now? You'll get XXX if you do."
"Will you drop out?" Yes/No

Yes —> get item, warp aboveground
No —> "I see...guess you're feeling confident. All right then, let's do it." —> Question

Right answer Wrong answer

Will move regardless of answer

Stone statue
Stone pillar?
Slightly humanoid (Cheshire cat smile?)

Entrance

Opens the way when you answer correctly. "You may pass."
If you answer incorrectly: "It looks like you are not qualified to enter here. You should leave."

Final treasure is the Wisdom Medal?

Black and White Gaps

The floor in this large open space has a black and white checkered pattern (like a chessboard).
The black and white parts swap places after a set period of time.

Every 1-2 seconds?

Entrance Entrance

There are invisible walls between the black and white sections, so you cannot get to the exit or treasure chests easily. There are also object monsters walking around, and touching one will start a battle.

Unseen wall placement

Checking the plaque at the entrance will give a hint like, "Those who switch between light and darkness and neglect their foes will fall into an eternal abyss."

(Vertical scroll mine cart)

Vertical scroll mine cart
General view

Has a top-down isometric view like Virtua Racing.

There's a straight path and forks. Arrows will appear 5 seconds ahead of time, and you can control the direction with the directional buttons. Messing up will inflict damage (1/4 of current HP) and time loss (easier to be caught).

Shows a fork to the right up ahead the player can take

There are rest stops here and there (with treasure?) where you can stop and get off. (Will lead to a time loss.)

Track cuts off en route

The area expands and you can move freely with the direction buttons. However, you gradually slow down. (Scroll speed reduces.) Press up and down to stay in the game!

The pursuers catch up in the wide space
—> Pincer attack battle
You can move them both to one side for a regular battle, you can even speed off or head back.

When they get close to the exit (?) an arrow will display at the top of the screen showing the direction of the tracks.

Indication rail is to the right Indication you're on the track

The arrow will change when you're facing ahead (flashes about once a second).

Arrow will display until you're back on the track. (The arrow blinks faster the closer you get.)

FINAL FANTASY VI
MEMORIES

Biggs: Hard to believe an esper's been found frozen there a thousand years after the War of the Magi...

Magitek Armors marching across the barren fields as snowflakes fall around them.
—DURING THE OPENING SCENE

You cannot defeat Vargas unless you use the Blitz technique correctly.
—AT MT. KOLTS

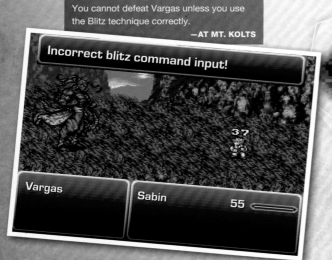

Incorrect blitz command input!

Vargas | Sabin 55

I'd love to get my tentacles around her...

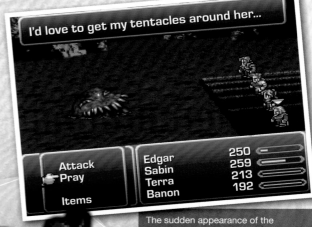

Attack
Pray

Items

Edgar 250
Sabin 259
Terra 213
Banon 192

Sabin throwing the bizarre Phantom Train engine with ease, or using a Phoenix Down to kill it.
—WITH THE PHANTOM TRAIN

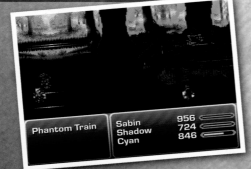

Phantom Train | Sabin 956
Shadow 724
Cyan 846

The sudden appearance of the "eight-armed freak," or Ultros. Surely this won't be the last time . . .
—ON LETHE RIVER

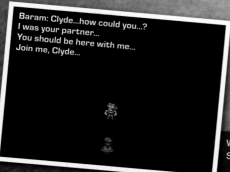

Baram: Clyde...how could you...?
I was your partner...
You should be here with me...
Join me, Clyde...

Celes taking the opera stage in Maria's place, only to fumble the lyrics . . .
—AT THE OPERA HOUSE

Oops... That wasn't it, was it?
Sorry!

Witnessing a nightmare at the inn with Shadow. What in the world does it mean?
—AT KOHLINGEN

The Floating Continent falls apart, and the party leaves without realizing that Shadow could have made it.
—ON THE FLOATING CONTINENT

Cid: No matter what happens to me...you mustn't lose hope!
cough... *wheeze*...

Despite catching many nutritious fish, Cid's condition only worsens . . .
—ON THE SOLITARY ISLAND

Entering the Coliseum again to score some of the most powerful gear.
—IN THE DRAGON'S NECK COLISEUM

What do you say?
Shall I make a sword out of it?
▶ Leave it as the magicite, "Ragnarok."
Turn it into the sword, "Ragnarok."

Choosing your party wisely before the final battle against Kefka.
—AT KEFKA'S TOWER

Which will you choose? The mysterious magicite called Ragnarok, or the sword from which it can be forged?
—AT NARSHE

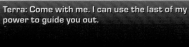
Terra: Come with me. I can use the last of my power to guide you out.

CREATORS' VOICES

Twenty-five years of *Final Fantasy**, Vol. 1

AKITOSHI KAWAZU
河津 秋敏

Final Fantasy I—Game design (battle), scenario composition (group work)
Final Fantasy II—Game design (battle), story baseline, character settings
Final Fantasy XII—Executive producer

Congratulations to *Final Fantasy* on its twenty-fifth anniversary. This may sound like the words of an outsider, but *Final Fantasy* is a series made by the creators, the vendors, the customers, and the players. If you think of things this way, it's only natural to congratulate everyone. From a developer's standpoint, I think the lack of fear about making major changes during the creation of *FFI* and *FFII* was quite a feat.

At the time I heard some people say that a role-playing game doesn't need to change its systems as long as the plot is different. But the fact that we have made it twenty-five years is due to the uncompromising efforts of each development team working without fear in the face of change.

HIROMICHI TANAKA
田中 弘道

Final Fantasy I—Game design (general systems, UI)
Final Fantasy II—Game design (general systems, UI)
Final Fantasy III—Game design (general systems, UI)
Final Fantasy III—Director (DS version)
Final Fantasy III—Director (iOS version)
Final Fantasy XI—Producer

"What exactly is *Final Fantasy*?"

Over the last twenty-five years I have often had to answer this question. From *FFI*, *FFII*, and *FFIII*, to *FFXI*, which continued development for ten-odd years out of the last twenty-five, I have been involved in the series for quite some time. Still, I've always felt a bit uncomfortable trying to put into words just what makes *Final Fantasy* . . . well, *Final Fantasy*. Each game demonstrates different stories and systems, within unique game worlds. Do these titles have any points of commonality? After twenty-five years in the world of *Final Fantasy*, I have to say that crystals and the four elements are symbolic of the series. On the other hand, the world-building principles that influenced every *Final Fantasy* into forming these symbols in the first place—as well as the choices that keep things in a constant state of flux—are what made the series what it is today.

If you play any of the *Final Fantasy* titles, you will experience that world's light and the scent of its winds. To me, the sensations in that moment represent the world of *Final Fantasy*. I believe this is one of the reasons why I've been involved with the series for so long. To have crafted similar sensations across every title, and to have offered this *Final Fantasy* experience to the world, I am truly happy.

Thank you so much for the last twenty-five years.

KAZUKO SHIBUYA
渋谷 員子

Graphic coordinator and adviser for characters, monsters, backgrounds, maps, and more in *Final Fantasy I*, *Final Fantasy II*, *Final Fantasy III*, *Final Fantasy IV*, *Final Fantasy V*, *Final Fantasy VI*, and *Final Fantasy IX*
Final Fantasy IV: The After Years—Main characters
Final Fantasy Dimensions—Main characters

FFI, *FFXIII*, and *FFXIV* have almost no points of commonality aside from their titles. As a creator, I view this as a point of pride. New creators will make all-new *Final Fantasy* experiences in the future.

I can't even imagine what form *Final Fantasy* will take in its fiftieth year, but I know it will continue the magnificence that we've come to expect from the series. I don't think I'll be around to see it, but I leave this message of anticipation at the twenty-five-year mark, for the young and yet-to-be-born creators who will take the reins of *Final Fantasy* in the years to come. Everyone, please continue to support the *Final Fantasy* series.

There were only two graphics leads for *FFI* and *FII*. We handled all of the non-character graphics, including monsters, backgrounds, maps, user interface, and fonts. Even after our numbers increased, we continued to help each other whenever we had a free moment. We brute-forced our way forward with youth and vigor. Thanks to the team's efforts and passion, people became more familiar with the series. The comical "two heads tall" characters became an FF staple, and *FFV* became my magnum opus.

In the Famicom days, we only had three colors in our palette. Even the Super Famicom was only 32-bit, and the team worked hard to craft charming visuals within a sixteen-color limit. We never lamented the color or pixel restrictions, and used trial and error to shape our vision. One by one, I stored away the insights I gained from that experience and used them in my work.

Those insights became incalculable riches, and allowed me to unleash a vast array of characters into the world. The evolution of *Final Fantasy* created a rich foundation for my career as a designer.

They say that your life can take a turn with any random encounter. I believed that any job would do, as long as I could draw. But as fate would have it, it has now been twenty-six years since I first joined Square. Despite starting with zero knowledge of the gaming industry, I've been able to stay involved in this career thanks to the founding members of Square, Yoshitaka Amano, and the countless individuals I've met since Square Enix came to be.

I won't forget the happiness that comes with knowing that *Final Fantasy* fans all over the world see my creations through their game screens. I want to continue my work with that feeling of gratitude in my heart. In the original *Final Fantasy*, a picture appears when the protagonists cross the bridge after the prologue . . . and they "set out on the beginning of an incredible journey." Drawing this image twenty-five years ago carried me across that bridge alongside them.

✢ The comments from development staff in this section were published on the *Final Fantasy* 25th Anniversary portal site between May 30, 2012, and December 31, 2012. Comments were posted for limited times, in order of the games in which the creators were involved.

TAKASHI TOKITA 時田 貴司

Final Fantasy I—Graphics
Final Fantasy I & II: Dawn of Souls—Producer
Final Fantasy III—Sound effects
Final Fantasy IV—Game design
Final Fantasy IV Advance—Supervisor
Final Fantasy IV—Executive producer, director (DS Version)
Final Fantasy IV: The After Years—Executive producer
Final Fantasy VII—Special thanks
Final Fantasy: The 4 Heroes of Light—Director
Final Fantasy Dimensions—Executive producer

I still remember the twentieth anniversary like it was yesterday, and here we are at twenty-five years! I can't believe a quarter of a century has passed. I entered Square as a graphics part-timer, before *Final Fantasy* even existed. I applied after seeing a commercial for *King's Knight*, and the first game I worked on was *Aliens* for the MSX, under the direction of Hiromichi Tanaka. I think it was right around when we were developing Square's *Tom Sawyer*. Koichi Ishii said that he wanted me to "draw monsters facing sideways." On the right side were caricatures drawn by Mr. Ishii. The moment I placed monsters I had drawn on the left side was the first time I got involved with *Final Fantasy*.

We were in the middle of the *Dragon Quest II* boom, and the enthusiasm to make an indomitable role-playing game made its way around the ranks, thanks to yours truly. At the time, we had no idea we'd end up merging with Enix, the makers of *Dragon Quest*. There were no project restrictions, nor was there a quality assurance department. I have fond memories of staying up all night debugging. I made *Hanjuku Hero* at the same time that *FFII* was in the works, and *Makai Toushi Sa·Ga* (*Final Fantasy Legend*) at the same time as *FFIII*. Still, I was constantly stimulated by the *Final Fantasy* series, and was intensely motivated to make games that wouldn't lose when compared to that series. I finally became a full-fledged employee, and became involved with *Final Fantasy* for the first time as a planner on *FFIV*. I was a planner by day, and a designer by night; I only went home about once a week, and we all basically bunked together while we made our games.

A different impact, and a different quality every time. "Impact," "quality" . . . I learned these keywords for successful entertainment through *Final Fantasy*. I believe I was able to make such a variety of games thanks to the inspiration I received from *Final Fantasy*. I'm sure many people involved in the series feel the same way. These days you can enjoy games of all shapes and sizes. I hope this trend continues, and that many new games come about as a result of this wave. And hey, I'll do my best, too!

KAZUHIKO AOKI 青木 和彦

Final Fantasy III—Battle and dungeon maps
Final Fantasy IV—Battle and dungeon maps
Final Fantasy VII—Minigames
Final Fantasy IX—Events

To put it simply, I created games with reckless abandon. After I got involved in *Final Fantasy*, I started wanting people all over the world to enjoy these games. Before I knew it, I found myself wanting to make the best games in the world, and I came to believe that this was within my reach if I only worked hard enough. Those feelings all came about thanks to the *Final Fantasy* series.

Those feelings became my tenets of game creation. To me, this is what *Final Fantasy* is all about. Setting aside whether or not I can actually create the best game in the world, I still feel as if I spend my days addressing this question. I pressure myself by staying aware of the possibility.

Maybe it's that twenty-five years have gone by, but I hear people telling me how they've been playing the series since they were in elementary school. Perhaps I had conversations like that from long ago . . .

"A game is an existence you can take or leave . . ."

"There's no such thing as an unneeded existence in this world!"

At any rate, I never thought about the meaning of my job. *Final Fantasy* made me realize I should cherish a career that allows me to see people happily discussing issues and making memories.

"I used to make games."

"Oh really, what did you make?"

"I made memories."

If I live past sixty, I'd like to try that once . . . I think. But I get the feeling that people will tell me to make something interesting, if I have the time to think about such things. No doubt.

Still, when asked what I do for a living, I've never said I make games. I've never said "I made memories" during my whole career, but to say "I make games . . ." I just feel like there's still so much more for me to do. Even if it's impossible now, I think I'll be able to say it one day. That's why I want *Final Fantasy* to be a series that allows me to grow. I want to work hard to offer nice memories to everyone, and be the world's best that surpasses even *Final Fantasy*. Any game that would surpass *Final Fantasy* would appear as the newest *Final Fantasy* . . . That's how I see it. I would feel blessed if you keep an eye on the evolution of the *Final Fantasy* series in the future.

AKIHIKO MATSUI 松井 聡彦

Final Fantasy IV—Battle planner
Final Fantasy V—Battle planner
Final Fantasy XI—Battle planner, director, producer
Final Fantasy XIV—Battle planner

My first affiliation with Square was on the *FFIV* team, and my first job was planning the memory map. The job was to decide how to use the ROM cartridge memory. Thinking back on it now, I don't think it was something to be left to a newcomer. But for me, in the probation period of my new job, "can't" wasn't in my vocabulary.

I referenced the documentation from previous *Final Fantasy* games and got advice wherever I could . . .

This was the first game on the Super Famicom, so I held meetings with staff members who used memory (which was practically everyone). They taught me what kind of data I'd need, as well as data composition and sizes. By the time the memory map was finished, I had learned all the data needed to make a *Final Fantasy* game and spoken with all of the *FFIV* staff.

Thinking back to how Hironobu Sakaguchi planned it all out, I still feel like I'm no match for him.

I handled battles when the *FFV* team came together.

The job changes and the ability system were in the game from the start, so it was a good project for me to plan using my *Final Fantasy* experience. It seemed like a straightforward story at first . . . But I remember . . . There was a major incident where the launch schedule got moved up. I became so busy that I had to ask a senior coworker to handle all of the monster-related work for me. After that, I was off the *Final Fantasy* titles for a while, but returned to the series with *Final Fantasy XI*. From start to finish, I was on that project for over a decade, so I have a deep emotional attachment to the title. I'm actually working on a title currently in development at the moment, so let me give you some behind-the-scenes stories from development and management.

One memorable moment during development was when the beta was just around the corner, and we had started working on plans for the Skillchain system.

Meetings were often held in the smoking room, and in the end all I had to do was give the go-ahead and everyone would be put into place. Never had I regretted quitting smoking more . . . Of course, now that the system has been implemented, I think it's 300% as good as I thought it would be. But we had to work relentless night shifts to implement it (which is not effective, and I wouldn't recommend it). I stressed myself out in those days, trying to make it all happen. I'm not very good with public speaking, so I used the busy pace of the work as an excuse to turn down appearances at public events (it was the truth, but still). One year, I was tasked by a member of the operations staff to appear at the next event. I tried to run away, stating that it was my policy that "game designers use games to express themselves," but he flatly told me the following:

"As long as you're *FFXI*'s battle planner, abandon that policy."

"For the fans playing *FFXI* right now, it's extremely important that this be a game worth playing until the next patch or until the next expansion disc. That's why I want you to talk about the future of their battles." At that time, I felt like MMOs were not something made through development alone. I felt

that the operations staff who loved *Final Fantasy XI* were just as important as the development team, if not more. I haven't turned down any events since then, but I can't say for sure if that's been the best for *FFXI* . . . I've since switched from *FFXI* to another MMO, *FFXIV*.

All of the staff are doing their best for a new version on PS3. I am mainly focused on the battle formulas. Splitting up the operating game formulas into number patches by concept was a valuable experience. That being said, the responsibility associated with these tasks weighed on me pretty heavily . . .

Thanks to the support we received—despite the trouble we caused to players—the battle staff was able to work together and get everything done. If you haven't had a chance to play it yet, I would be very happy if you did. I hope you enjoy *FFXIV* for many years to come.

I realized the four titles I've been involved in span fifteen years, about two-thirds of *Final Fantasy*'s exalted history. I wouldn't be who I am today without *Final Fantasy* (and I don't even know if I would've pursued a career in the games industry if not for *FFII*). I honestly feel as if I was raised by *Final Fantasy*. At my age it's a bit absurd to talk about being "raised," but I will continue to be raised by *Final Fantasy* in the future—both as a developer and as a player.

YOSHINORI KITASE 北瀬 佳範

Final Fantasy V—Event planner
Final Fantasy VI—Event director
Final Fantasy VII—Director
Crisis Core: Final Fantasy VII—Executive producer
Dirge of Cerberus: Final Fantasy VII—Producer
Final Fantasy VIII—Director
Final Fantasy X—Producer
Final Fantasy X-2—Producer
Final Fantasy XIII—Producer
Final Fantasy XIII-2—Producer
Dissidia 012 Final Fantasy—Producer
Final Fantasy Type-0—Producer

It's been about twenty years since my first jaunt with *Final Fantasy*, beginning with *FFV*. That was the fourth game I worked on after joining Square, and the *Final Fantasy* series was already known for its challenges. I inherited the spirit of those who came before me, and I dedicated myself to making something truly new. Looking back on it now, I was too reckless and rough with my creation process. There are several places that are so unrefined I find it embarrassing. But putting that aside, I enjoy this title for the power you can feel from it. Some newer members of the development staff now tell me of how they played *FFVI* or *FFVII* as a child. In talking with those staff members, I never use words such as "*FF*-like." I feel like such language will restrict the expression of these new members, and put them in a box of sorts. A work packed with reckless energy, with restriction . . . We can leave it to critics or future historians to see if that would be considered *FF*-like.

What we can do is keep giving you new surprises and new stories. If that bears a fruit called "excitement" in the hearts of our fans, I believe it will give birth to all sorts of things that will be considered *FF*-like. With consideration to *Final Fantasy*'s twenty-fifth anniversary, I believe that the next twenty-five years will lead to new types of *FF* made by new people.

Please look forward to it.

HIROSHI TAKAI 高井 浩

Final Fantasy V—Designer (battle effects)
Final Fantasy XI—Designer (effects)
Final Fantasy XIV—Assistant director

Twenty-five years, huh?

Final Fantasy, *Final Fantasy* . . . Hmm . . . Looking back, I'd say that *Final Fantasy V* is the most memorable for me. It was the first *Final Fantasy* game I worked on, and is one of the most popular among players. But if I had to choose from all of the *Final Fantasy* titles I worked on . . . If I really had to think about it, I'd say *FFIV*. When I'd first joined the company, I nonchalantly

went to my senior coworkers' booth, and the first thing I saw were the screens of *FFIV* under development.

This was the first *Final Fantasy* on the Super Famicom. I remember thinking how pretty it was, and the memory of being so excited has stuck with me. But soon I got involved in the debug. The memory of sacrificing my Golden Week to fight against the last boss was a good one. That's why I decided to choose *FFIV*. The surprise and delight I felt after that, and the daring and novel decisions I saw with every new sequel, is something I feel is characteristic of the *Final Fantasy* series. I imagine all gamers must feel the same way. With fourteen installments, I'm sure many people have all kinds of memories about the series.

And that amount should only increase in the future. *Final Fantasy* continues on. Thank you for your support!

YUSUKE NAORA 直良 有祐

Final Fantasy VI—Field graphics
Final Fantasy VII—Art director
Final Fantasy VII: Advent Children—Art director
Before Crisis: Final Fantasy VII—Art supervisor
Crisis Core: Final Fantasy VII—Art director
Dirge of Cerberus: Final Fantasy VII—Art supervisor
Final Fantasy VIII—Art director
Final Fantasy X—Art director
Final Fantasy XI—CG visual supervisor
Final Fantasy Type-0—Art director

From *FFVI* to *FF Type-0*, I've been involved in all kinds of *Final Fantasy*. Still, I hold the veteran creators of Japanese RPGs in high regard. At the same time, I have a deep sense of gratitude for all of the people who have played these games.

I've come to understand that the title *Final Fantasy* has become more profound with every game made in the series. I'll keep doing my best to make a new, appealing game world that none of you have ever seen before, so look forward to the next thirty years! I'm not too great at writing, so my apologies for the short blurb.

Thank you for Playing!

YOICHI YOSHIMOTO
吉本 よういち

Final Fantasy III—Director (PSP version)
Final Fantasy IV: The Complete Collection—Director

Me?

A comment?

Certainly!

My first experience on the *Final Fantasy* series was the direction for *Final Fantasy IV: The Complete Collection* on PSP. This was the first *Final Fantasy* I beat as a gamer, and the first one I bought on CD, so I was very happy when I got the offer. When I actually got my hands on the content during development, the quality and quantity was unbelievable for a twenty-year-old game. That's why I utilized the original work to the best of my ability, while modernizing the tempo and presentation. Together with a gallery mode and the sequel *Final Fantasy IV: The After Years*, we aimed to make an ultimate, value-packed *Final Fantasy*.

In *Final Fantasy IV: The Complete Collection*, you can switch between the audio from the SFC and DS versions, a feature I personally enjoy. In reality, we didn't have the original data for the SFC version of the song "Prelude" that we could use. So when Masashi Hamauzu recorded the theme arrangement for the new movie, we brought the SFC and game to the studio (taken from my own collection), and recorded the theme together (the picture below is from that time). There was a moment of nostalgia when we turned on the SFC and "Prelude" played. There was a strange feeling in the air, as if the interior of the studio had been transported back to the SFC era.

I continued as director for the PSP version of *FFIII* that was sold on September 20, 2012. Personally I would've liked to have seen a sprite-based remake for *FFIII*, but the DS version ended up being a port. You can use auto battle or swap sounds (including the beautiful programmable sound generator from the FC), and we also enriched the value with a gallery mode. We asked DS version character designer Akihiko Yoshida to do us a favor and take care of all of the original rough sketches. Players unlock the mode bit by bit, and you probably can't see the image you unlock at the end anywhere else. I had that cute picture as my PC desktop background for a while. That's not an abuse of authority, is it? It isn't easy, but do whatever you can to get your hands on it!

TOMOYA ASANO
浅野 智也

Final Fantasy III—Producer (DS version)
Final Fantasy IV—Producer (DS version)
Final Fantasy: The 4 Heroes of Light—Producer

Congratulations on the twenty-fifth anniversary!

This is producer Tomoya Asano. My first experience with *Final Fantasy* was *FFIII*. Doing the math, I was a fifth-year elementary school student at the time. All of my friends were enamored with *Dragon Quest*, but I was all about the side battles. I found the puttering sprite characters appealing. When I think about it, the noisy sound effects and background music, and the flavor of the map graphics, had a curious eeriness to them. My sense of adventure was galvanized, and I enthusiastically chose *FF* over *DQ*. I was so absorbed in the final dungeon that the ice cream I had placed on top of the table melted. I even got surprised when my mom came home. That's how I beat my first RPG, *Final Fantasy III*.

Years later I joined Enix. We merged with Square and I became the lead on the *FFIII* remake project. The first thing I did was go back to the home I grew up in, to look for my old Famicom and my copy of the game. Search I did, and find them I did. The cartridge with my name written on it. The strategy guide and soundtrack. The Yoshitaka Amano art book. The save data at the base of the Crystal Tower, and my elementary school memories. Finding all of these mementos revived them. I didn't want to simply reminisce about a game gone by; I resolved to make such strong memories for today's children. When Hiromichi Tanaka worked on the remake with me, he said, "When you think of *Dragon Quest*, you think of the rolling, verdant fields, whereas *Final Fantasy* is about the blue of the oceans." Main programmer Nasir Gebelli fixed bugs for us over the phone on internal calls. A debugger told us it was too easy right before the master-up, so we removed the save point at the Crystal Tower. And so on, and so on.

It might be obvious now, but it came as a shock to realize that someone who created the game I was obsessed with as a kid was right here in front of me. To think that the same person made such an amazing thing (and at an age younger than I am now!). Through the *FFIII* remake, I learned that these games are born from passion, effort, and tenacity.

After that, I took over the *FFIV* remake on the DS, as well as *Final Fantasy: The 4 Heroes of Light*. I learned from *Final Fantasy*, both personally and professionally. It is my starting point, and my eternal goal. I hope the upcoming *Bravely Default* gets me even a little bit closer to that far-reaching goal. And nothing would make me happier than if it remains in the memories of those who play it.

YOICHI WADA
和田 洋一

President and representative director, Square Enix Holdings Co., Ltd.

I joined Square just before the release of *Final Fantasy IX* in 2000. Out of the last twenty-five years, I have been with the company for about half of them.

Over the years, I've come to understand that *Final Fantasy* is the child of its creators and the fans all around the world. And what a wonderful child it has grown into—one that overflows with affection.

On this, our twenty-fifth anniversary, we've taken our first steps toward the next twenty-five years. There's only one thing that we on the development side can promise to continue to bring our fans: joy. We promise that we will develop our games with creators equipped not only with talent, but with a love for *Final Fantasy* that surpasses any other. We will devote ourselves to keeping *Final Fantasy* a series you love. Please look forward to our next work.

FINAL FANTASY
ULTIMANIA ARCHIVE VOLUME 1

STAFF

ENGLISH LANGUAGE EDITION

PUBLISHER
Mike Richardson

EDITOR
Ian Tucker

ASSISTANT EDITOR
Megan Walker

COPYEDITOR
Dan Wallace

TRANSLATIONS PROVIDED BY
TransPerfect

DESIGNER
Cindy Cacerez-Sprague

DIGITAL ART TECHNICIAN
Chris Horn

Special thanks to Tina Alessi and Michael Gombos at Dark Horse Comics, and Nate Fong at TransPerfect.

ORIGINAL JAPANESE EDITION

PLANNING AND PRODUCTION
Square Enix Co., Ltd.
http://www.jp.Square-Enix.com/
Chief Editor: Kazuhiro Oya
Editors: Tomoko Hatakeyama, Hiroyuki Ishii, Takuji Tada
Producers: Kenichi Abe, Yoshihiro Iizaka, Toshihiro Ohoka

EDITING AND WRITING
Studio BentStuff Co., Ltd.
http://www.bent.co.jp/
Akira Yamashita (Director)
Ryota Ode (Sub-Director)
Yuko Ono (Sub-Director/*FFVI* Characters)
Masayuki Sawada (Sub-Director/*FFI–FFV* Characters/*FFVI* Monsters)
Tomoyuki Toyota (*FFI–FFVI* Character Diagrams & Worlds)
Shinichi Suezaki (*FFI–FFVI* Worlds/*FFII* & *FFVI* Monsters, Extra Materials)
Osamu Shiga (*FFI* & *FFIV* Monsters)
Masahiro Kimura (*FFIII* & *FFV* Monsters, Extra Materials)
Keita Ode (*FFI* & *FFIV* Extra Materials)
Tomohito Koishi (*FFI–FFVI* Memories)
Naoki Yamanaka (Editorial Support)
Toshimitsu Itaba (Editorial Support)
Kaoru Nakatani (Editorial Support)
Shougo Shirasaki (Editorial Support)

COVER DESIGN
Blanket-Project Co., Ltd.
Tadashi Shimada/Norie Kadokura

TEXT DESIGN AND DTP
Cue Factory

COOPERATION
Yoshitaka Amano Office YK
Koichi Ishii (GREZZO Co., Ltd.)
Square Enix Co., Ltd.
 Copyright Licensing Division
 Kazuko Shibuya

COOPERATION AND SUPERVISION
Square Enix Co., Ltd.
 Publicity Department
 Final Fantasy Series Development Teams

FINAL FANTASY ULTIMANIA ARCHIVE VOLUME 1

FINAL FANTASY 25th MEMORIAL ULTIMANIA Vol.1

© 2012 SQUARE ENIX CO., LTD. All Rights Reserved.
First published in Japan in 2012 by SQUARE ENIX CO., LTD.
Original Japanese edition edited by Studio BentStuff.
English translation rights arranged with SQUARE ENIX CO., LTD. and Dark Horse Comics, Inc. through Tuttle-Mori Agency, Inc.
© 1987,1989,1994,2000,2002,2004,2007,2009,2010,2011,2012 SQUARE ENIX CO., LTD. All Rights Reserved.
Illustration: © 1987 YOSHITAKA AMANO
© 1988,1994,2001,2002,2004,2005,2007,2009,2010,2011,2012 SQUARE ENIX CO., LTD. All Rights Reserved.
Illustration: © 1988 YOSHITAKA AMANO
© 1990,2006,2008,2009,2011,2012 SQUARE ENIX CO., LTD. All Rights Reserved.
Illustration: © 1990 YOSHITAKA AMANO
© 1991,1997,1999,2002,2005,2007,2009,2010,2011,2012 SQUARE ENIX CO., LTD. All Rights Reserved.
Illustration: © 1991 YOSHITAKA AMANO
© 1992,1998,1999,2006,2011 SQUARE ENIX CO., LTD. All Rights Reserved.
Illustration: © 1992 YOSHITAKA AMANO
© 1994,1999,2006,2009,2011 SQUARE ENIX CO., LTD. All Rights Reserved.
Illustration: © 1994 YOSHITAKA AMANO

Nintendo, **SUPER NINTENDO**, are registered trademarks of Nintendo Co., Ltd.
"Super Famicom", "Family Computer" and "Famicom" are registered trademarks of Nintendo Co., Ltd.
GAME BOY · **GAME BOY ADVANCE** are registered trademarks of Nintendo Co., Ltd. Trademarks registered in Japan: #2294769, #4470747
"WonderSwan" is a registered trademark of Bandai Namco Entertainment Inc.
"i-mode" is a registered trademark of NTT DoCoMo, Inc.
"EZweb" is a registered trademark of KDDI Corporation.
"Yahoo Mobile" is a registered trademark of SoftBank Group Corporation.
"Android" is a registered trademark and brand of Google.
"iPhone", "iPod Touch" and "iPad" are registered trademarks of Apple Inc.
NINTENDO DS Nintendo DS is a registered trademark of Nintendo Co., Ltd. Trademarks registered in Japan. Design registration: #1259804, #1260043
Wii is a registered trademark of Nintendo Co., Ltd. Trademarks registered in Japan.
"▲", "PlayStation", "PSP", "PSVITA", "●" and "UMD" are registered trademarks or brands of Sony Interactive Entertainment, Inc.
"Microsoft" and "Windows" are registered trademarks of Microsoft Corporation in the United States of America and other regions.
"Ultimania" is a registered trademark of Square Enix Co., Ltd.

Dark Horse Books® is a trademark of Dark Horse Comics, Inc., registered in various categories and countries. All rights reserved. No portion of this publication may be reproduced or transmitted, in any form or by any means, without the express written permission of Dark Horse Comics, Inc. Names, characters, places, and incidents featured in this publication either are the product of the author's imagination or are used fictitiously. Any resemblance to actual persons (living or dead), events, institutions, or locales, without satiric intent, is coincidental.

Published by Dark Horse Books
A division of Dark Horse Comics, Inc.
10956 SE Main Street
Milwaukie, OR 97222

DarkHorse.com
Square-Enix.com

Facebook.com/DarkHorseComics
Twitter.com/DarkHorseComics

Advertising Sales: (503) 905-2537
International Licensing: (503) 905-2377

To find a comics shop in your area, visit comicshoplocator.com

First edition: June 2018
ISBN 978-1-50670-644-3

10 9 8 7 6 5 4 3 2 1
Printed in China

Library of Congress Control Number: 2017960483